A Cultural History of School Uniform

A Cultural History of School Uniform

KATE STEPHENSON

UNIVERSITY
of
EXETER
PRESS

First published in 2021 by
University of Exeter Press
Reed Hall, Streatham Drive
Exeter EX4 4QR
UK
www.exeterpress.co.uk

© Kate Stephenson 2021

This paperback edition published 2023.

The right of Kate Stephenson to be identified as the author of this work has been asserted by her in accordance with the Copyright, Designs and Patents Act 1988.

British Library Cataloguing in Publication Data
A catalogue record for this book is available from the British Library.

ISBN 978-1-80413-121-3 Paperback
ISBN 978-1-905816-54-5 ePub
ISBN 978-1-905816-55-2 PDF

Front cover: *Schoolgirl's Own Annual*, 1935
Copyright © Rebellion Publishing IP Ltd. All Rights Reserved.

Set in Perpetua by BBR Design, Sheffield

Contents

	List of Illustrations	vii
	Acknowledgements	ix
	List of Abbreviations	x
	Be Keen!	xi
	Introduction	1
1.	The Charity Schools 1552–1900	6
	Early School Clothing	7
	Christ's Hospital	10
	Other Charity Schools	18
	Traditional Appearances	24
	Viewing Charity Children	28
2.	The Public Schools 1800–1939	33
	Sport and the Introduction of Uniform Clothing	36
	Creation of the Public School Ethos	41
	Uniform Design	45
	Collective Identity	51
	Emulation	55
	Harrow—A Case Study	60
3.	Public Schools for Girls 1850–1939	66
	Early Girls' Schools and the Feminine Ideal	67
	Sportswear and Uniform	74
	Day Uniforms	81
	Formality and Conformity	90

4.	Education for All 1860–1939	94
	Middle-Class Secondary Education	96
	Elementary Education for the Working Classes	104
	Mixed Classes in Secondary Education	110
5.	Fashion and Fancy Dress 1939–Present	115
	Post-War	120
	Dressing Up	126
	Conclusion	136
	Notes	150
	Glossary	177
	Bibliography	189
	Index	212

Illustrations

Chapter One

1.1	Winchester College, *c.*1462	9
1.2	Detail from Christ's Hospital Easter Anthem, 1709	13
1.3	Charity statues, St Mary Rotherhithe, *c.*1742	22
1.4	Illustration of Christ's Hospital boys from *London Town*, 1883	26

Chapter Two

2.1	Malvern College Football Team, 1868	39
2.2	Malvern College Football Team, 1888	39
2.3	Junior boys from Pocklington School wearing uniform shorts, *c.*late 1940s	47
2.4	Chas. Baker & Co. advertisement, 1892	58
2.5	A selection of School Arms cigarette cards, produced by Wills's Cigarettes, 1906	60

Chapter Three

3.1	Cheltenham Ladies' College House Group, 1890	72
3.2	Illustration from *The New Gymnastics for Men, Women and Children* (1862), showing the Dio Lewis gymnastic suit	75
3.3	St Leonards House Cricket Team, *c.*1891, showing the second tunic design	78
3.4	Girl wearing a gymslip with a very low girdle, 1929	83

3.5 Wycombe Abbey House Group, 1898 85
3.6 Roedean pupil Netta Lewis with her mother, c.1928 88
3.7 Downe House School photograph, 1909 89

Chapter Four
4.1 Tunbridge Wells County School for Girls pupils wearing drill
 costume, 1913 97
4.2 The Arrival of Bessie Bunter, 1919 104
4.3 St William's RC Girls' School, 1922 111

Chapter Five
5.1 Aysgarth Prep School, 1944 116
5.2 Pupils from St Mary's Gate School, c.1961–65 123

Acknowledgements

My sincere thanks to Prof. Lawrence Black, Dr Hannah Greig and Prof. Elizabeth Buettner for their help and advice; my parents for endless support, encouragement and the provision of dogs when it all got too much. Also, Not Cricket for enthusiasm, theatre and gin and the staff and regulars of the Deramore Arms c.2013–16 for suggestions, pictures, tea, excellent chips and slightly risqué jokes.

Abbreviations

GDS Girls' Day School (Trust)
NLCS North London Collegiate School
SPCK Society for Promoting Christian Knowledge
TWGGS Tunbridge Wells Girls' Grammar School

Be Keen!

Take lessons from the colonies
Be patriotic, keen;
Uphold your school with might and main
As they uphold the Queen.

Shake off your bonds, unloose your chains,
Ye hopes of future glory!
By sloth your fathers never won
Their deeds of deathless glory

Support your school, its games, its work,
Its institutions too;
Disloyalty erase, for he
Serves all who dares be true

Rise up like men from slumber deep
And let your school be queen
For Wilberforce and Dolman cry:
"Be keen, my sons, be keen!"[1]

Introduction

As iconic as baked beans for breakfast, builders' tea and the Chelsea Flower Show, the image of the schoolboy or schoolgirl clad in blazer, shirt and tie is a widely identifiable and understood symbol of the British education system. This is unsurprising given that the classic modern outfit originated in the United Kingdom and was spread, initially, through colonialism, and later through cultural exchange. This book examines how the current situation emerged, charting British school uniform from its origins in sixteenth-century charity schools through to the modern day, looking at the implementation, development and spread of school uniform and school-uniform styles. Uniform development did not, however, exist in a vacuum. Interpreting the motivation behind its introduction and various design iterations helps us to understand the larger forces at play and, where possible, alterations have been situated within the bigger historical picture. In many ways, this is a work of social and educational history viewed through the tangible dimension of the school garment.

The styles of clothing worn by an individual reflect and communicate identity and uniforms fulfil this same role in a more clearly defined manner, recording a pupil's place in society and their relation to other individuals and institutions. The type of identity projected by an establishment is replicated and reinforced by the design of the uniform worn, whether it is imposed upon children by those in power or develops internally as part of a school's culture and ethos. Whilst uniforms met many important practical requirements, they were also consistently tied to the existing and idealized identities of a school population. Most notably, uniforms tended to reflect the gender and class norms (and sometimes aspirations) of pupils in any given period, but they were also influenced by religious beliefs and, at times, nationalism. Reinforcement of these idealized identities through clothing control and the imitation and emulation of the identity of other institutions were the most important driving factors in uniform adoption and diffusion, and these ideas will be revisited throughout the text.

Beyond contemporary issues surrounding the effectiveness of school uniform in improving behaviour and concerns regarding adapting it for increasingly multicultural school environments, there is a distinct lack of research into the history of school uniform, particularly in Britain, and there is currently no comprehensive academic study. This deficit has allowed common misconceptions to develop and these have been repeated and propagated through numerous sources. Perhaps most prominent amongst these is the 'fact' that Eton adopted its uniforms in 1820 in mourning for the death of George III, which, as it turns out, is extremely unlikely. When discovered, these errors have been addressed and corrected within the pages ahead.

As a subject with widely popular appeal and one on which the majority of the British population have first-hand experience, the topic's academic neglect to date is surprising. The question of why it has been overlooked is a complex one and can, in part, be attributed to the lack of interdisciplinary scholarship in the field of dress history in general. It is still a relatively new discipline: it has been fully accepted into the academic canon only in the past few decades and the field continues to develop theoretical and practical approaches at a rapid pace.[1] School uniform is clearly a subject to which this new breed of analytically rigorous dress history is yet to be applied and its broad temporal span and cross-disciplinary nature, along with a lack of original garments (school uniforms tended to be worn out completely or passed onto siblings) might have discouraged other researchers. In addition, the public view of school uniform has been influenced by the modern tendency to associate it with dressing up, drinking and, in the case of girls' school uniforms, titillation. Consequently, it may have been written off as a subject without serious historical or academic merit.

This book seeks to rectify this situation to some extent, offering a broad perspective on the subject. With such a wide-ranging topic, there are, of course, some areas in which detail has been sacrificed, for instance, the majority of examples used are English, alongside a number drawn from pioneering schools in Scotland. A more thorough exploration of the subject in Ireland and Wales would be beneficial in the future. In addition, there is simply not the space to present a close analysis of individual schools or garments, unless they are particularly influential.

The majority of the historical narrative has been drawn from original sources, and whilst this has opened up a huge amount of material for potential consultation, it also had its problems. In the words of Susan Vincent:

> Typically, commentary about clothing is dispersed widely through a range of records whose main subject is almost always something other than dress. Thus sources ... are littered with brief mentions of apparel. Very few, however, offer sustained commentary.[2]

This was particularly true with regard to the earliest phase of school-uniform development in the sixteenth and seventeenth centuries when information had to be drawn from numerous and diverse sources. In later centuries, the archives of the Society for Promoting Christian Knowledge—which was heavily influential in the spread of charity schools—proved invaluable, notably the suggested clothing lists and the collated reports on individual schools.

From the Victorian period onwards, school archives (and umbrella organisations such as the Girls' Day School Trust) offered the most complete body of evidence available, with many establishments retaining their archives on site. Whilst older and larger schools such as Eton, Harrow and North London Collegiate School employ archivists and have well catalogued and accessible archives, accessing the material held at many schools brought its own unique set of challenges which shaped the research. A significant number of schools were contacted for each chapter, but only a limited selection in each instance had available and relevant material and a means through which it could be accessed. Girls' schools were, on the whole, better at responding positively to enquiries than boys' schools and this means that the examples cited in later chapters are weighted slightly towards female education.

This phenomenon is a strange one and it is perhaps due to continued attempts by female educational establishments to garner positive publicity or, conversely, the dismissal of clothing as an area of non-importance by some boys' schools. Regardless of the motivations, this imbalance highlights the gender differentials which constitute a large part of the discussion within the text. Archive use was also generally confined to institutions still in operation, as the records of many closed schools have been lost unless held within a central archive. This is particularly relevant with regard to grammar schools, which survived in certain limited areas of the United Kingdom due to localized governmental decisions, notably Trafford, Kent, Surrey, Essex and Devon. This means that research into such schools has focused on these geographical locations.

The items held varied significantly from institution to institution but typically comprised photographs, uniform lists, accounts and letters, offering an administrative insight into uniform implementation, as well as the physical appearance of uniform items. Archives were often lacking, however, in information outside the purely practical. This included the thoughts and opinions of pupils and

teachers regarding uniform and the reasons for initial uniform implementation. Direct testimonies from children were particularly few and far between and this is a recurring feature within the field of childhood studies.[3] This was remedied, to some extent, through the consultation of autobiographies, personal recollections, diaries and school-magazine contributions. However, these passing comments were often hard to locate and, if they are to offer a valuable contribution, they need to be situated clearly within the wider context. The commercial side of uniform production was also a fruitful source for the late nineteenth and twentieth centuries, with the records and advertisements of uniform suppliers and retailers such as B. Hyam, Chas. Baker and Marks & Spencer proving relevant.

It is, however, worth noting a couple of issues with regard to reading and utilizing these sources. Whilst photographs are extremely useful, images are often formal, showing representations of the ideal dress of children rather than an actual record of appearance. As Burke and Ribeiro de Castro note in relation to specially posed photographs:

> The school photograph positions and frames the body of the schoolchild, sometimes alone and sometimes in relation to others. This is at once a technical, artistic, professional and cultural process. There is evident ritual, regularity and recurrence in the process of production and, once made, the photograph takes on a powerful role in representing identity, awarding status and reassuring the viewer of order and customariness.[4]

Distinguishing between carefully posed images and more naturalistic ones is not always easy; the latter offering a greater insight into actual clothing practices. These problems can be mediated by the association of photographs with oral or written histories of the event depicted, although this is not always possible as many photographs exist, isolated from context, in school archives and collections.[5] Much of this book, however, concentrates on the creation of idealized appearances; consequently, the portrayal of these in school photographs is compatible with the overall themes of the work. Providing that the divergence between actual and ideal is not too great, the use of photographs as a source of information on uniform design remains appropriate to this context. There is, however, considerable scope for further work on the modification of school uniforms and to what extent school-uniform regulations were contested by pupils and parents.

Also relevant is the fact that terminology for various items of school uniform appears to have developed differently in different locations, with some schools adopting location-specific words. Consequently, it is not always easy to identify in written accounts exactly what item is being referred to. For instance, the term 'djibbah' is used variously to describe the original flared and sleeved tunic of Roedean school, a sleeveless straight tunic and a sleeveless pleated tunic (more commonly known as a 'gymslip') depending on school and location and this is discussed further in Chapter Three. To ease confusion, the words will be applied consistently throughout and the definitions used can be found in the Glossary. Where any possible confusion exists over the use of a term in original documentation, this is also noted.

Chapters have been arranged so that each one concentrates on a significant phase in the development of school uniform and this is generally associated with a certain type of educational establishment. Whilst there is some temporal overlap, each chapter contains its own unique subjects and debates centred on the institutions discussed. Chapter One considers the earliest regulation of clothing in schools, with a major focus on the supply of uniform garments in charitable institutions of the sixteenth, seventeenth and eighteenth centuries. At the opposite end of the social spectrum, Chapter Two concentrates on the conversion of elite public schools in the nineteenth century from anarchic and poorly regulated establishments to the games-obsessed and hierarchical institutions so romantically portrayed in schoolboy literature. Girls' public schools also came to prominence during the nineteenth century, and Chapter Three explores the huge upheaval in gender roles that occurred during this period. These changes were provoked and promoted by female education, and clothing was utilized in the campaign for educational acceptance and, later, equality between the genders.

Chapter Four focuses on the education of the middle and working classes. The final chapter, Chapter Five, is divided into two parts: part one considers the effects of twentieth and twenty-first century social change on school uniform; while part two reverses the flow of ideas discussed elsewhere in the text—the effects of social change on uniform—by considering the effect of school uniform on popular culture, focusing particularly on the appearance of school uniform as 'fancy dress' and the use of school uniform as a media trope. In this manner, the book works to present both a roughly chronological overview of the topic, as well as an exploration of the impact of social and political change on the education system and the appearance of school children.

CHAPTER ONE

The Charity Schools 1552–1900

On Thursday 23 April 1789, Sir Gilbert Elliot, Member of Parliament for Morpeth, joined Lord Palmerston in attending the annual London charity school service at St Paul's Cathedral. Elliot found the prayers 'long and tedious', and used the time to take in his surroundings. He later described what he saw in a letter to his wife:

> under the dome were piled up, to a great height all round, 6,000 children from the different charity-schools in the city, in their different habits and colours. This was by far the most interesting part of the show. You may see this any year, for they are brought to St. Paul's, and placed in the same order one day every year and I think it will be worth your while if you *ever* come within sight of St. Paul's again.[1] (emphasis in original)

Although it is clear that Elliot enjoyed the theatrical nature of the children's appearance, quite why he chose to emphasize 'ever' in this manner must remain a matter for speculation. It is also possible to speculate that Elliot might have unwittingly crossed paths with William Blake who attended the same service, the experience informing his poem *Holy Thursday*, which was published as part of *Songs of Innocence* the same year. The first verse of this work conjures up a very similar image to that described by Elliot:

> Twas on a holy Thursday, their innocent faces clean,
> The children walking two and two in red and blue and green:
> Grey-headed beadles walked before, with wands as white as snow,
> Till into the high dome of Paul's they like Thames' waters flow.[2]

These two descriptions vividly capture the picturesque spectacle of uniformed charity school children en masse and give us an idea of the sheer number of such

children within London at this time. The eighteenth century was the heyday of the charity schools, although they already had a formidable history, with some schools having been in existence for nearly 250 years.

Charity schools were an early feature in the development of the modern British education system and they sought to provide free schooling for orphans and other poor children.[3] Most charity schools supplied much-needed clothing to the children that they educated and this constitutes the first widespread use of school uniform. These garments also allowed those in authority to imprint their own social values upon the pupils. Whilst charity uniforms are not directly related to the development of school clothing in different educational contexts, their narrative is not a historical footnote. Themes such as the maintenance of gender and class boundaries, religion and anachronism in clothing are applicable to both charity uniforms and the wider history of school clothing.

Early School Clothing

Whilst the charity schools represent the first instances of the complete regulation of school clothing, there are earlier examples of the provision of garments in educational situations. Consequently, it is worthwhile taking a swift diversion into the wider history of organized education, a history that can be traced back to the sixth century. When Augustine was sent from Rome to the Kingdom of Kent in 597 he brought with him the teachings of the Roman Catholic Church and the first seeds of structured education. As the conversion of the Anglo-Saxon pagans spread, new religious centres were founded, initially at Canterbury but later at York, Rochester and London. Closely linked teaching institutions were set up in conjunction with the monasteries and cathedrals that were built at these sites. These were intended to provide bright and educated recruits for the growing church, with the majority of pupils drawn from the poorer classes. The language of the church was Latin, and this needed to be taught to pupils; consequently, the schools became known as grammar schools. For all but the select few at these schools, and those of noble birth who were educated in the houses of other noblemen, nothing but a scant education was available, usually provided by a local priest or in the form of an apprenticeship.[4]

During the subsequent centuries this general pattern was retained and new grammar schools continued to be founded, most famously Westminster (1179), Winchester (1384) and Eton (1440). These preserved their religious affiliations, but their modes of operation began to alter; recruitment of poor scholars became less important for the maintenance of the Church and more of a charitable obligation, with fees being introduced for better-off pupils.[5] Founders' interests

also began to play a part and these were often diverse, ranging from a focus on a specific element of the curriculum to a determination to educate their own children. Schooling on a smaller scale also emerged with an increasing number of reading and writing schools appearing during the fifteenth century. These provided both stand-alone teaching of skills and also an elementary education for those entering the grammar schools.[6]

There are examples of grammar schools providing pupils with clothing from the earliest surviving records; the 1307–08 accounts for Westminster School record 'Cloth bought for the Master and boys with the shearing of the same—50s. and for fur for the master—22d'.[7] Similarly, the school statutes of Winchester from 1400 state that all scholars of the college were to be provided annually with enough cloth to 'enable one ankle-length gown with a hood to be made from it in a decent fashion'.[8] A fifteenth-century drawing of Winchester College at chapel gives an idea of the nature of these gowns, showing the boys in high-necked, long-sleeved tunics with surplices over the top (Figure 1.1). Gowns of this nature were worn over linen undergarments and resemble ordinary boy's wear of the time, which consisted of ankle or knee-length, loose and unbelted gowns fastened at the front or shoulder. The surplices were only added for services.[9] Over time such garments transformed into the gowns worn by academics today, which preserve some of the length and style but became open at the front and developed more decorative sleeves from the late fifteenth century onwards.

Sixteenth-century Britain was an arena of massive social change resulting from religious, economic and political upheaval. This had a profound effect on the education system, along with many other facets of daily life. High inflation caused by the import of precious metals from the Americas peaked in the middle of the century. In conjunction with sudden population growth and a consequent lack of employment, this resulted in an increase in poverty and vagrancy.[10] This was exacerbated by the dissolution of the monasteries between 1536 and 1541, which removed institutions that had previously cared for the poor. The prevailing view held by the middle and upper classes at this time was that such hardship predominantly sprang from laziness and ignorance.[11] Indicative of this belief is Thomas Starkey who, writing in 1532, explained in his work of political theory *A Dialogue between Reginald Pole and Thomas Lupset* that 'the multitude of beggars ... argueth no poverty, but rather much idleness and ill policy—for it is their own cause and negligence'.[12]

Regardless of the cause, the sheer scale of poverty in the period ensured that some governmental action was seen as a necessity.[13] Consequently, the 1530s saw the introduction of a number of poor laws which outlined suitable

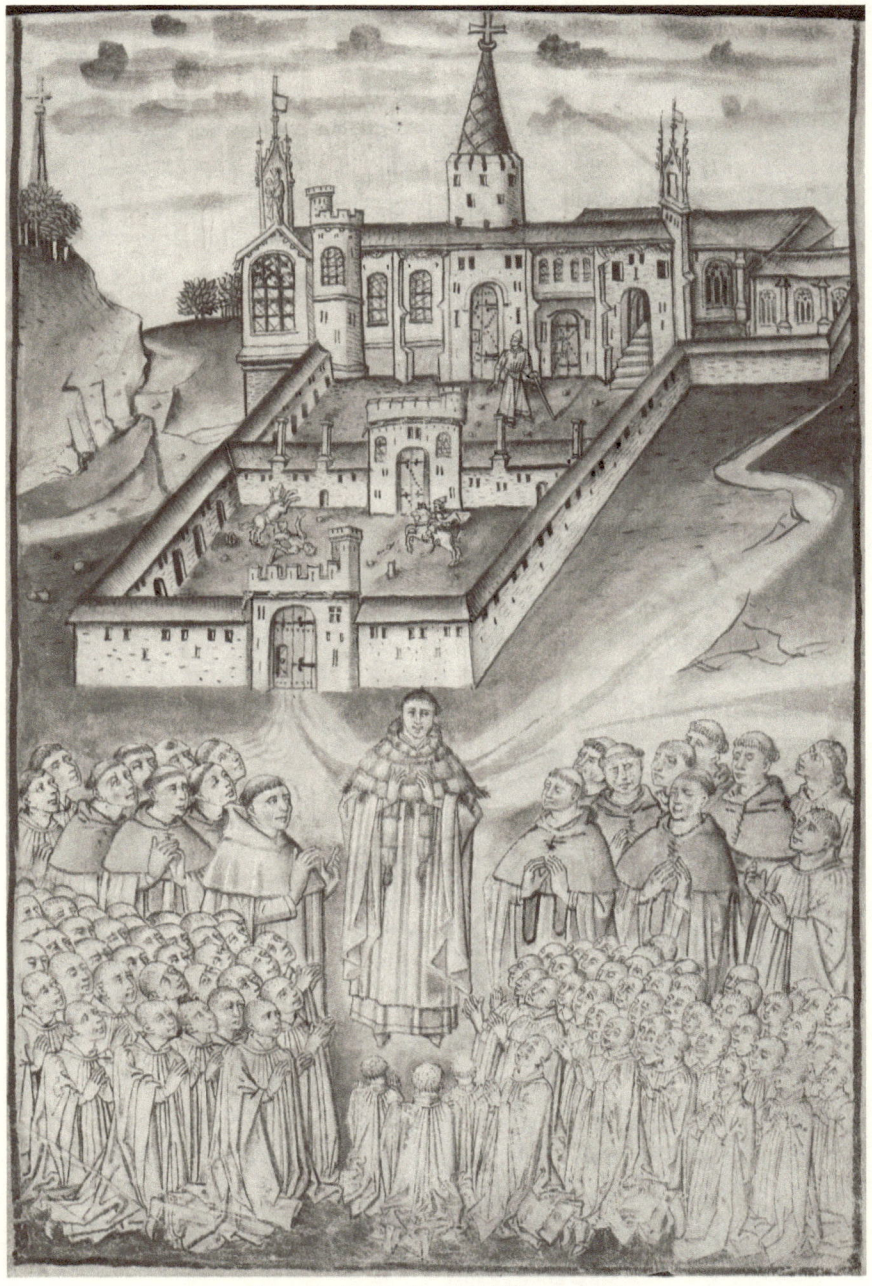

Figure 1.1: Winchester College, c.1462
New College Library, Oxford © Courtesy of the Warden and
Scholars of New College, Oxford [MS 288, f. 3r][14]

punishments for those vagrants considered idle. The laws also ensured that local parishes provided for those unable to work—notably widows, children and the disabled who were not viewed as having agency over their position and were consequently designated as 'deserving poor', in opposition to the majority of those suffering hardship, the 'undeserving'.[15] In addition to the punishments and state-sponsored assistance, the long-term solution to poverty was increasingly seen as education. Through carefully managed religious and practical instruction, it was supposed that the children of the poor could be instilled with a more suitable work ethic than their parents and go on to fulfil useful roles in society. It was in the context of this movement that the initial charity schools were founded.[16]

Christ's Hospital

Christ's Hospital—which opened in 1552 on Newgate Street in a building formerly belonging to the Greyfriars order—was the first of such schools and remains one of the most widely recognized. It was founded as part of a scheme promoted by Edward VI based on the recommendations of Nicholas Ridley, Bishop of London and Westminster. This took the form of the establishment or re-modelling of five London hospitals between 1544 and 1557—St Bartholomew's, St Thomas's, Bridewell, Bedlam and Christ's. These were intended to maintain the sick, old, infirm, orphaned and mentally unstable, each with their own specialism: in the case of Christ's this was the education and maintenance of orphans. The hospitals were maintained by public subscription and local donations. The concept behind them was taken from poor relief institutions in Europe, but was unique in Britain at the time.[17] As the first of its kind, Christ's Hospital became an innovator that was widely imitated across the country and, as such, was hugely influential in that it laid down the ethos and dress that subsequent charity schools adopted.

The uniform at Christ's Hospital fulfilled a range of functions, the most prominent of which was the provision of clothing for the pupils (foundlings who were lodged and wholly maintained by the institution). For the general public, clothes cost a significant proportion of an annual salary and decisions about what items to make or purchase were lasting, as clothes were accumulated gradually and often repaired, re-made and reused.[18] Lack of clothing, therefore, was a considerable problem amongst the poor and many of the children entering into the school would have been too deprived to afford suitable attire.[19] Placing the children in a simple uniform ensured that they were warm and presented a decent appearance. It also had the advantage of economy, as bulk-produced

items were cheaper to purchase.[20] Account books from the foundation period of Christ's Hospital show an initial payment for uniforms around the time of the first admissions in November 1552, when the costs of shoes, canvas, kersey (a coarse woollen fabric), caps, cotton, knitted hose and tailors are recorded.[21] It is worth noting that in this period 'cotton' refers to a woollen cloth on which the nap has been 'cottoned' or raised, rather than a fabric derived from the natural fibres of the cotton plant.[22]

The appearance of the first children at Christ's Hospital was described by John Stow in his *Survey of London*, originally published in 1598:

> On Christmas day in the afternoone, while the Lord Mayor and Aldermen rode to Powles, and children of Christ's Hospitall stood, from saint Lawrence lane end in Cheape, towards Powles, all in one livery of russet cotton, 340 in number. And at Easter next, they were in blew at the spittle, and so have continued ever since.[23]

As Stow notes, the colour of both boys' and girls' uniforms changed from russet to blue less than six months after the school opened and the outlay for new fabric is recorded in the accounts for March and April 1553.[24] The new uniforms had clearly been issued by the beginning of April 1553, when the children's appearance was recorded at a church service at St Mary Spital. This may be the same event as that described in Stow's account above. The description appears in the diaries of Henry Machyn, a seller of funeral trappings who kept a detailed account of public events, festivities and upper-class funerals between 1550 and 1563.

> The third day of April went unto St. Mary Spital unto the sermon all the masters and rulers and schoolmasters and mistresses and all the children, both men and women children, all in blue coats and wenches in blue frocks and with escutcheons embroidered on their sleeves with the arms of London and red capes. And so two and two together. And every man in his place and office. And so at the scaffold was made of timber and covered with canvas and sets one above another, for all the children sit one above another like steps. And after through London.[25]

The reason for this change in colour remains unclear and neither contemporary nor modern sources offer a satisfactory explanation. Considerable meaning could be ascribed to the alteration; in the Middle Ages blue was the colour of the true

lover and the faithful servant, and also stood for religious faith and devotion.[26] It is possible, then, that the change was a symbolic one; but it is more likely to have come at the specific request of a benefactor or resulted from practical concerns, in that blue was more economically viable.

Colours such as brown, grey, dark blue and green were generally worn by the working classes, partly because such colours did not show dirt easily and partly because they were cheap to produce.[27] Blue from woad was one of the most cost-effective dyes available and was very widespread, particularly in clothes worn by servants.[28] In a survey of clothing bequeathed in wills from the Tudor period, it was a popular choice (along with tawny and black) and far more prevalent than russet.[29] It is probable that the monetary saving made by switching from russet to blue clothing was not inconsiderable when the number of children to provide for was taken into account. The changeover would not, however, have been phased (new pupils dressed in blue, whilst existing russet clothing was worn out) due to the public duties that the children were expected to undertake (which are discussed later in this chapter) for which a neat and unified appearance was essential. Regardless of the reason, blue, with its association of low status and servitude, was a choice that reflected and propagated the charity school rhetoric of humility.

Although there is a distinct lack of pictorial sources showing the Christ's Hospital uniform during the first hundred years of the school's existence, descriptions suggest that the current uniform bears a remarkable similarity to that worn 500 years previously. Boys were dressed in an ankle-length, belted coat and a cap. The coat had fastenings to the waist and was open from there to the ankle, with hose, a shirt and an ankle-length petticoat (a sleeveless, full-skirted garment worn for warmth and modesty) beneath. The cap was likely to have been a flat bonnet, later called a 'tam o' shanter' after the eponymous hero of Robert Burns's 1790 poem of the same name. The corresponding girls' uniform was composed of a woollen gown, worn with a shift and hose beneath, along with an apron and white kerchief.[30] The meaning of 'kerchief' shifted around this period, but, in this particular instance, it probably refers to a piece of fabric worn as a head covering. Although drawn 150 years later, an engraving from the 1709 Easter anthem sheet, published annually, gives an idea of the girls' appearance at this time (Figure 1.2).

In contrast to the blue of the main uniform, the knee-length, knitted wool stockings or hose worn by both sexes were, more unusually, dyed yellow. Whilst a yellow colour was attainable through common dye plants such as dyer's weld (with the use of the correct mordants), it was not particularly common in working-class wear.[31] A bright yellow could also be achieved through the use of

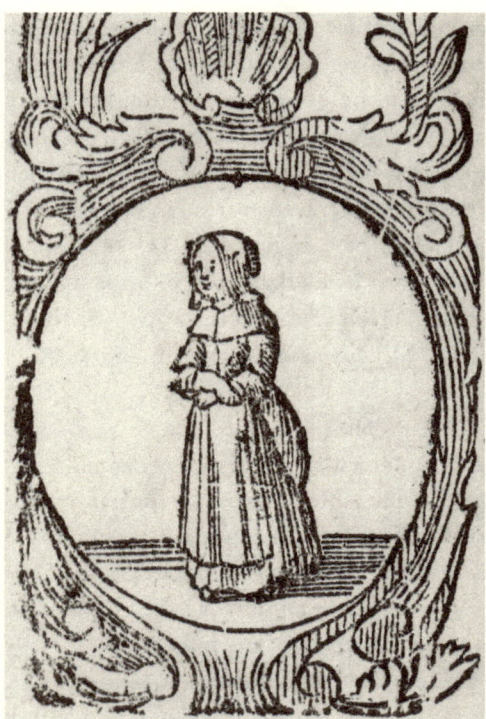

Figure 1.2: Detail from Christ's Hospital Easter Anthem, 1709
© Toby Phillips Photography: image courtesy of Christ's Hospital

the more expensive saffron, a dye which was alleged to keep away vermin and lice.[32] Christ's Hospital owned sizeable parcels of land around Hertfordshire, and children too young to be accepted into the school were put out to nurse in this area. At various points throughout the seventeenth century, branches of the school existed in Hertford, Hoddesdon and Ware. Saffron was grown in many villages in North East Essex and South Cambridgeshire, as well as in the neighbouring counties of Suffolk and Hertfordshire, and land belonging to Christ's was less than ten miles away from known saffron-producing areas.[33] It is therefore possible that some of the land owned by Christ's Hospital in this region was used for growing saffron, providing the colouring agent at a cost below market price and this, in conjunction with its supposed rodent-repelling properties, could account for the choice of dye.

It has been suggested by a number of authors that the design of the boys' uniform was modelled on a religious cassock.[34] This link, however, has been contested in other literature including works by Cunnington and Lucus and Mansfield who make a compelling argument that the style of the uniform simply reflected the general styles of working-class wear in the period.[35] Children's

clothing at this time took the form of a smaller version of adult attire. Both Christ's Hospital's male and female designs closely mirrored standard working clothes of the period and this can be seen by examining church brasses of the fifteenth and sixteenth century. As with any source, brasses have their limitations—subjects are predominantly wealthy, and male figures in civilian clothing are relatively rare as men were often portrayed in armour. Nonetheless, significant similarities can be seen between the design of the Christ's Hospital attire for boys and the basic garments worn by civilian men in brass images, including those at All Saints, Thwaite in Norfolk; St Nicholas, Fowey; St Hugo, Quethiock (see Figure 1.2); St Gluvias, St Gluvias in Cornwall; and St Mary Tower, Ipswich.[36]

The fact that the uniforms of Christ's Hospital were simple in design, manufactured with cheap fabrics and dyes and with little form of ornamentation, signalled to both pupil and observer the status of the wearer, functioning as a visible reminder of the pupils' low class.[37] Humility was considered an important characteristic to promote amongst the poor and both the appearance of the uniforms and the curriculum served to prepare pupils for subordination in their future lives, forming part of a wider system that was intended to socially regulate the children in its care.[38] This message of humility was reinforced by the addition of an escutcheon, an emblem or badge which usually bore a coat of arms and served to identify the origin of the clothing and mark the children as belonging to an institution specifically intended for the poor. Badging of parish poor was an occasional practice in the sixteenth century, with insignia issued as a testament to the deserving status of the wearer. The decision to badge school children can undoubtedly find its origins in these customs. By the beginning of the seventeenth century, however, the symbolism of badges for the poor had begun to shift from a stamp of approval to one of stigma. This process culminated in a 1697 statute which made it compulsory for those receiving handouts to wear badges denoting their status as reliant on the parish.[39] This change to a humiliating symbol of dependency is at odds with the developmental arc of the school badge, which was to become an element of symbolic importance in the nineteenth and twentieth centuries when it represented, to many, affiliation, community and pride in belonging.

The emphasis on humbleness and ease of social identification continued as an overriding theme throughout much of the history of the charity schools and this was further amplified by the increasing importance placed on dress, taste and consumption in wider society in the eighteenth century. When Christ's Hospital was founded, access to fabric and clothing was limited by cost, availability and, in some instances, legislation, dress was therefore an important

signifier of status for an individual, providing a unique index to income, age and occupation. Towards the end of the sixteenth century, however, an expansion in national and international commerce and manufacturing made clothing more affordable and thus accessible to new consumers; a trend that continued throughout the seventeenth and eighteenth centuries.[40]

As the denotation of class through clothing moved from simple visual markers to increasingly subtle distinctions, a situation was created whereby it was possible for members of the working classes with a certain level of disposable income to pass as higher status through their emulation of the dress and bearing of the middle and upper classes. Such changes to the established order were viewed with apprehension by those in authority and were believed to lead to wider social breakdown and loss of morality. Consequently, the powerful and elite continued to seek the preservation of class and patriarchal structures with the ultimate aim of maintaining an obedient working class.[41]

These concerns were articulated by the author Daniel Defoe who, in 1725, published a passionately written pamphlet discussing, amongst other issues, the dress of servants and the problems that this caused in terms of blurring class boundaries:

> I remember I was once put very much to the blush, being at a friend's house, and by him required to salute the ladies, I kissed the chamber-jade into the bargain, for she was as well dressed as the best. But I was soon undeceived by a general titter, which gave me the utmost confusion; nor can I believe myself the only person who has made such a mistake.[42]

He goes on to suggest:

> Things of this nature would be easily avoided, if servant-maids were to wear liveries, as our footmen do; or obliged to go in a dress suitable to their station. What should ail them, but a jacket and petticoat of good yard-wide stuff, or calimanco, might keep them decent and warm. Our charity children are distinguished by their dress, why then may not our women-servants? ... I am, therefore, entirely against servants wearing of silks, laces, and other superfluous finery; it sets them above themselves, and makes their mistresses contemptible in their eyes. I am handsomer than my mistress, says a young prinked up baggage, what pity it is I should be her servant, I go as well dressed, or better than she. This makes

> the girl take the first offer to be made a whore, and there is a good servant spoiled; whereas, were her dress suitable to her condition, it would teach her humility, and put her in mind of her duty.[43]

Here, Defoe posits that the answer to these class anxieties is to impose simple fabrics and styles of dress on the working classes, and he draws a clear correlation between what he considers to be class-appropriate dress and class-appropriate behaviour. He also references charity children as an example of good practice in this area. Defoe's solution is indicative of wider thinking and this worked to support and strengthen the already established ideas linking charity school uniforms to humility. This was particularly relevant to Defoe's concerns, as most charity children were destined to enter service and if they could be taught responsible dress habits and deference to their superiors at an early age, problems such as the ones he described could be avoided altogether.[44]

These fears and solutions are reflected in the charity schools in an increasingly explicit rhetoric surrounding the importance of subservience and the beneficial role that charity clothing could play in designating and reinforcing status. For instance, Isaac Watts, the notable hymn writer and theologian writing in 1728 about charity children, declared:

> The clothes which are bestowed on them once in a year or two, are of the coarsest kind, and of the plainest form, and thus they are sufficiently distinguished from children of better rank ... there is no ground for these charity children to grow vain and proud of their raiment, when it is but a sort of livery, that publicly declares those who wear it, to be educated by charity.[45]

In the same vein, in 1796 it was recorded that the children of the Charity School of St Pancras continued to be 'instructed in the principles of the Christian religion, taught true humility and obedience to their superiors, and such other education as may be really necessary to make them of benefit to the community as honest and useful servants'.[46] Whilst Defoe was predominantly occupied with the infringement of class boundaries, he reserved the majority of his criticism on this front for women, and this fits into a wider view of female morality and consumption. Male and female morality was perceived differently and although these perceptions altered over time, there was an enduring belief that women, and particularly lower-class women, were more likely to demonstrate a lack of self-control by contravening social and sexual codes than their male counterparts.[47] Women, too, were believed to be more susceptible to a lack of

discipline in their consumption of goods, unable to manage their money or to curb their desire to purchase the latest fashions. In contrast, male consumption was normalized, except in extreme instances in which the men in question were often characterized as effeminate for their habits.[48]

These beliefs, working in conjunction, led people to believe that if lower class women dressed like the upper classes, they would further transgress class boundaries by sexually associating with upper-class men, as well as the possibility of overspending their limited resources and even resorting to prostitution in order to continue to fund extravagant purchases.[49] This is noted by Defoe when he discusses a servant being 'made a whore'. To combat these perceived flaws in the female sex, charity schools placed a great deal of emphasis on female modesty, self-discipline and chastity, both in their curriculum and in their uniform expectations.[50] The significance attached to female chastity, however, resulted in a double standard between the sexes which guaranteed that any indiscretions were viewed more harshly in women.[51]

Although the concept of female modesty in dress is prevalent throughout the religious and educative rhetoric of the sixteenth and seventeenth centuries, precisely how this translated into clothing design is harder to pinpoint. Some idea may be gleaned from Juan Luis Vives' book, *The Education of a Christian Woman*. First published in 1524, this work was intended to assist with the education of Mary I. It promoted a range of forward-thinking ideas concerning the education of women and their intellectual equality with men. Despite this, the book maintained a traditional approach to modesty, stating that 'Christian modesty ... should be such that it should emanate from the soul to the external garb'.[52] It then goes on to recommend how such modesty should be demonstrated through appearances:

> Her dress will not be resplendent, neither will it be squalid. She will not be an object of admiration, nor one of repugnance ... my ideal young woman will not paint her face, but clean it, she will not smear it with soap, but wash it with water. She will not bleach her hair in the sun or dye it to change its colour, but at the same time she will not leave it unkempt or bristling with dandruff ... She will look in the mirror not to preen and adorn herself painstakingly but to make sure nothing in her face and on her head appears ridiculous or repulsive, which she cannot see without looking in the mirror. Then she will groom herself in such a way that there is nothing in her countenance that would defile her chastity and modesty.[53]

Despite concerning himself with women of high status, Vives' excerpt also closely reflects the charity school ethos of clothing. It consequently demonstrates that, although modesty was considered a more prominent issue with regard to the working classes, the promotion of standards of behaviour and dress was not confined only to the lower echelons of society. The interpretation of such advice would, however, have been different in different contexts, with certain fabrics and fashions deemed suitably modest for the elite, but not so for the working classes. In a charity-school context this advice manifested itself most prominently in the inclusion of an apron for cleanliness and a simple head covering for modesty.

Other Charity Schools

Early reports from Christ's Hospital deemed the school a success and other similar schools followed. On the surface, the function of these schools was to continue the work of alleviating and controlling pauperism. Organized education, however, also reflects and propagates ideas and values current in society or within the organizing body.[54] The sixteenth century saw the creation of the Anglican church and a move towards Protestantism, which, despite two major challenges—the restoration of Roman Catholicism during the reign of Mary Tudor (1553–58) and the later rise in Puritanism during the Civil War and the Interregnum (1640–60)—ultimately became the accepted, state-sponsored religion.[55] Charity schools were seen as a way of disseminating the new Protestant faith, and ideas associated with the Reformation were spread through the emerging charity school system.

The split with Rome and the growth of the Anglican church also played a part in raising funds for the new schools. Under Edward VI, chantries (money to cover expenses for masses and prayers, usually said for the soul of the founder of the endowment) were banned. Consequently, the rich needed to find other ways to ensure their place in heaven.[56] Donations to charitable endeavours increased in popularity and the charity schools were a particularly common choice as the children could take on a similar function to that of the chantries in that they could sing in praise of their benefactors.

Many of the early charity schools were established by those involved with Christ's Hospital or by benefactors who had directly witnessed it in action. Founded in 1590, Queen Elizabeth's Hospital, Bristol was modelled directly on Christ's at the request of Bristol merchant John Carr, who left provision for the founding and running of the school in his will of 1586. Carr became interested in Christ's Hospital on his visits to London and stipulated that the new

school should be 'in such order, manner and form, and with such foundation, ordinance, laws and government as the Hospital of Christ Church nigh S. Bartholomew's in London is founded, ordered and governed in every respect'.[57] The uniform was a direct copy of that of Christ's Hospital and the link between the two schools was consciously monitored and maintained in line with Carr's will, so when adaptations were made to Christ's Hospital uniform they were studiously copied at Queen Elizabeth's Hospital. For instance, in 1843 the governors of Queen Elizabeth's Hospital resolved that buckles should continue to be worn on shoes because they had been retained at Christ's Hospital, despite having disappeared from general usage fifty years previously.[58]

Chetham's Hospital, Manchester (founded 1656) and Reading Blue Coat School (founded 1660) followed a similar pattern. Chetham's Hospital was set up based on instructions in Humphrey Chetham's will of 1651 and, although traditional uniform was abandoned in 1875, the school had previously copied the uniform of Christ's Hospital in line with details in Chetham's will.[59] Reading Blue Coat School was founded from an endowment from Richard Aldworth, a former benefactor and governor of Christ's Hospital. He specified that the school should be a replica of Christ's Hospital, including stipulating that its uniform should be emulated. It has been suggested that as many as sixty schools were modelled directly or partly on Christ's Hospital.[60] I have been able to conclusively establish direct links with only five, but Christ's Hospital influence was clearly wider than this.[61]

Through this imitation of Christ's Hospital uniform, the 'bluecoat' became synonymous with charity schools and they became known generically as 'bluecoat schools'. Schools founded from the late seventeenth century onwards were less commonly modelled directly on Christ's Hospital, but the majority nonetheless chose to use the blue coat as a standard uniform, although the cut was altered to be more in keeping with current styles. Westminster Blue Coat School (1688), for example, wore blue coats, but shorter in length, just covering the knee and with buttons nearly to the hem. These were worn with breeches and the design reflects a more contemporary cut in comparison to the longer coats worn at Christ's.[62]

As charity schools became an established part of the education system, greater variety began to emerge in the uniform design. Schools, however, tended to retain the basic premises of economy, modesty and imitation of working-class style. From the late seventeenth century a number of grey coat charity schools were opened, including the Grey Coat Hospital, Westminster; St Anne's, Soho (both founded 1699); and Hamlet of Ratcliff School, Stepney (1710).[63] Grey clothing was even cheaper to produce than blue coats, as items could be

manufactured from undyed wool. Occasionally a school opened that followed neither pattern, but instead chose a different colour of coat. This could be at the discretion of a founder or to distinguish children from other local establishments; St Margaret's Hospital, Westminster—also known as the Green Coat School (1624)—was one such establishment. Whilst children attending this school did indeed wear green coats—allegedly because schools with other coat colours already existed in the vicinity—in other instances the notion of an alternative colour in fact accounted only for the trim, facings, hat and stockings of the uniform, with the coat itself remaining blue.[64] This was certainly the case at the Orange School in Northampton (or Driden Free Charity School, 1709) and demonstrates how ingrained the bluecoat ethos had become.[65]

By the end of the seventeenth century, a considerable number of charity schools were in operation, but were uneven in their distribution. From this point forward, charity schools proliferated through the exertions of the Society for Promoting Christian Knowledge (SPCK), established in 1699. Very much in line with previous attitudes, the founders of the SPCK saw charity schools as a method of providing religious and social discipline, helping to mediate the problems of irreligion and Catholicism, as well as poverty, through Protestant ethics.[66] They also continued to reinforce class boundaries, as children were taught 'things as are most suitable to their condition'.[67] Whilst not directly founding institutions, the SPCK provided encouragement and a blueprint for their members and other interested parties to set up schools. Initially these were concentrated around London but by the early eighteenth century schools were being established further afield. Each school was an independent entity, governed by trustees and funded by subscribers. Most operated as day schools as opposed to the full board and lodging offered by Christ's Hospital and other similar institutions. Establishments followed the principles and directions set out by the SPCK and reported back to it regularly.[68] These reports were collated and published on a yearly basis, along with updated guidelines.

The SPCK advocated uniform for the children for several reasons, including following the example of older foundations; the necessity of making children from very poor homes decent in appearance; and the preservation of discipline outside of school hours.[69] This last point was particularly relevant, as many of the institutions insisted that 'The Children shall wear their Caps, Bands, Cloaths, and other Marks of Distinction, every Day; whereby the Trustees and Benefactors may know them, and see what their behaviour is abroad'.[70] Unlike boarding institutions, day schools could not directly control the moral and social sphere of the children outside of teaching hours, particularly with regard to regulating the influence of parents and relatives who might hold political and

religious views at odds with the teaching in the school. In these circumstances, marking the pupils in their personal and domestic arenas served as a reminder of the principles of the school and extended the rules and regulations outside the physical limits of the institution. It also made children readily identifiable and thereby acted as a deterrent to unsuitable conduct in the local area, reinforcing discipline and behavioural standards.

The SPCK reports included a suggested list of clothing to be provided by new schools and a breakdown of the expected costs (at London prices) to purchase it. In 1706 the following items were recommended:

> Boys –
> 1 Yard and half quarter of Grey-Yorkshire broad Cloth 6 Quarters wide ... makes a Coat
> 1 Black Knit Cap, with Tuft and String
> 1 Band
> 1 Shirt
> 1 Pair of Woollen Stockings
> 1 Pair of Shoes
> 1 Pair of Buckles
>
> Girls –
> 3 Yards of blue long Ells, about Yard wide ... makes a Gown and Petticoat
> A Coif and Band
> A Shift
> 1 Pair of Woollen Stockings
> 1 Pair of Shoes
> 1 Pair of Buckles[71]

By 1709 'A Wastcoat of the same Cloth' (as the coat) and 'A pair of Breeches of Cloth or Leather lined' had been added to the list for boys and 'A pair of Leather Bodice and Stomacher' for girls.[72] By 1715 '1 pair of Knit or Wash-Leather Gloves' had also been included for both sexes, along with 'A White, Blue, or Checquer'd Apron' for girls.[73] These clothing lists resulted in a strong degree of uniformity in the appearance of the SPCK schools as most followed the Society's recommendations.

From the end of the seventeenth to the middle of the nineteenth century it became fashionable for charity schools to adorn their buildings with statues of the children that they were educating, providing a rare and valuable record of

the children's appearance. Many, however, were copied one from another or cast in the same moulds: surviving examples may also have been altered, damaged or subsequently repainted, and so they must be treated with care as historical sources.[74] Charity statues of this period suggest that the coat mentioned fell to the knee and was single breasted and collarless and that the girls' gowns were full length and full-skirted in line with early to mid-eighteenth-century styles (see Figure 1.3).

Whilst this uniform was contemporary in appearance in comparison to the older institutions, when evaluated alongside other clothing it seems to be, once again, representative of what the working classes and rural communities were wearing and was certainly not at the forefront of fashion.[75] It is hard to ascertain this exactly as the descriptions given are not detailed, but there are a number of indicators. Coifs—a closely fitting under-cap that curved over the ears—although still in circulation, were mostly worn by children and old women by this time.[76] In addition, buckles first appeared half a century earlier, as recorded by Pepys in his 1660 diary: 'This day I began to put on buckles to

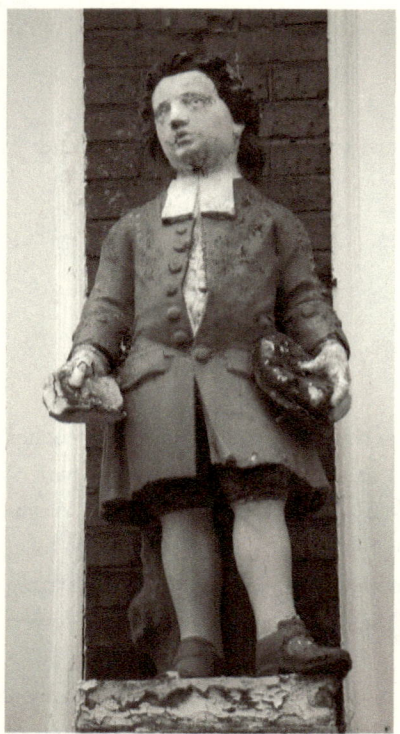
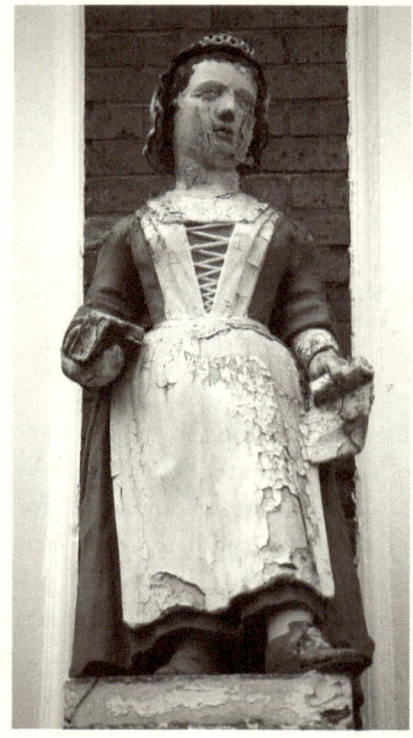

Figure 1.3: Charity statues, St Mary Rotherhithe, *c*.1742

my shoes, which I had bought yesterday of Mr Wotton'.[77] Whilst still widely worn, by the early eighteenth century they had begun to filter downwards through the class system. The SPCK continued to be very prominent in the field of charity schools until the mid-1720s, when its overseas missionary work and publishing business began to redirect focus and resources. Even so, it continued an involvement with the charity school sector for many further years.[78]

From the 1720s onwards, there was a greater emphasis placed on working schools; it was no longer enough to educate children, they had to be conditioned to work and to contribute to their own keep. This move may be linked with an intensified interest in the promotion of national wealth through the organisation and discipline of the labour force, but also with a need for the schools to generate revenue in an increasingly competitive environment.[79] With large numbers of charity schools now in operation, available subscribers were fewer in number and maintenance of income was vital to survival. Work carried out by the children not only served to teach basic skills, as well as inuring them to repetitive jobs, but it could also be used to raise funds for the school. This labour varied from establishment to establishment and often included spinning, sewing, knitting or other similar tasks. A report from the Bicester Charity School in 1725 demonstrates the evolution in views taking place:

> A gentleman in this Neighbourhood, who subscribes very largely to the School, declared that unless the children were employ'd in some Sort of Work to accustom them to Labour, he would withdraw his subscription ... it was agreed the children should be employ'd in spinning Jersey.[80]

These opinions were echoed elsewhere over the following decades. One of the trustees from the Ladies' Charity School at Bristol in 1756 wrote in a very similar vein:

> When youth, idleness and poverty meet together, they have become fatal temptations to many unhappy creatures, who, if they had been taught good principles, and, at the same time, brought up to a habit of industry ... might have been virtuous and happy within themselves, and useful members of society.[81]

This additional work could also involve the children contributing to the manufacture of their own uniforms. Often this was a money-saving tactic as well as an educational process, and whilst more complicated items continued to

be sewn by tailors, garments such as shirts, aprons and tippets were manufactured by girls' schools in large numbers. Historically, clothing represented a significant part of the costs for charity schools; the £66 4d 'Paid to Mr. Allen the Mercer for new Cloathing 54. Boys, and the new Boys'[82] at the Oxford Charity School being in excess of any other figure disbursed in the year 1712. Outlay for clothing continued to make up a major proportion of the budget in subsequent years. In many cases in-house production could mediate these costs, as well as publicly demonstrating and displaying the pupils' skills. By the nineteenth century this ethos had started to subside and greater importance began to be placed on academic lessons and on the quality and breadth of the education provided in line with new ideas on the treatment of children.

The nineteenth century saw an increase in the speed of diffusion of fashions through increasingly affordable and available print media. Images of new items and silhouettes were consequently available more quickly and cheaply to those outside of the fashionable world. Although this is a simplistic overview of these changes and the overall picture was more complex, it resulted, in a general sense, in a shorter time-lag between the advent of fashions and their uptake by the working classes.[83] This was reflected in new, and to some extent existing, charity schools, particularly in the clothing of girls. Although such items as hoops, crinolines and other fashionable extravagances were avoided and clothing remained unadorned, in many institutions the waistline rose in accordance with the vogue for empire waists in the 1820s. In the same manner, trousers started to appear for charity boys from the early nineteenth century, and by the 1850s some charity schoolboys started to be clothed in short waistcoats and square-cut tail coats. These replaced the sloping shape of coat-fronts in previous years and mirrored the changes in men's dress in general.[84]

Traditional Appearances

Despite later charity schools adopting a more contemporary cut to the uniforms provided, early institutions tended to retain their original design. The main garments were rarely altered in appearance, although changes might be made to certain elements. This was the case at Christ's Hospital, where the style, shape and colour of the coat remained essentially unchanged. Neck bands, however, replaced soft turn-down shirt collars in the seventeenth century. These were white collars that fastened around the neck with a narrow band and had two rectangular tabs hanging down at the front. They originated from Puritan square-cut collars of the 1640s which became fashionable during the Interregnum. As an item of uniform, they were later copied from Christ's Hospital

and popularized by the SPCK, where they were suggested attire for both boys and girls. They continued to be widely worn at many charity schools throughout the nineteenth century and were considered so representative of the schools that even when an institution did not supply full clothing for the children, they usually provided cap and bands.[85]

Breeches were introduced at Christ's Hospital from 1736 onwards, initially for sickly children but later for everyone. The boys' petticoats were dyed yellow from the early 1600s and these feature in John Strype's 1720 description in his *Survey of London*:

> Their Habit being now a long Coat of Blue warm Cloth, close to the Arms and the Body, hanging loose to their Heels, girt about their Waste, with a red Leather Girdle buckled; a loose Petticoat underneath of Yellow Cloth, a round thrum Cap tyed with a red Band, Yellow Stockings, and Black Low heeled Shoes, their Hair cut close, their Locks short.[86]

Petticoats ceased to be worn in the nineteenth century, along with the caps. There are references to the overall dress being outmoded from the nineteenth century onwards, but there does not appear to have been a serious attempt to change it (see Figure 1.4).

This process of addition and maintenance was often complex and unique to each institution, as Cunnington and Lucas eloquently express in their book *Charity Costumes*: 'Each costume is seldom fossilized as a whole. In its present state it is more like a collection of fossils from successive strata, since its different parts may represent old fashions not all of the same date.'[87] Essentially, schools preserved their uniform for many years after it had fallen out of fashion, sometimes adding to them or discontinuing specific items but still retaining the overall look and feel of the original appearance. This phenomenon of perpetuating the dress of a specific period can be charted throughout fashion history, having occurred in other professional and social arenas—for example, the effects can be seen today in legal and clerical clothing and men's evening attire.[88]

A few later foundations continued to slavishly imitate Christ's Hospital and its now archaic appearance. One of these was Colston's in Bristol, which was opened in 1708 by a Governor of Christ's Hospital. The only difference between the new uniforms and that of Christ's Hospital was that the petticoats and stockings were scarlet instead of yellow.[89] By the eighteenth century, Christ's Hospital had begun to attain a status exceeding the average charity school.

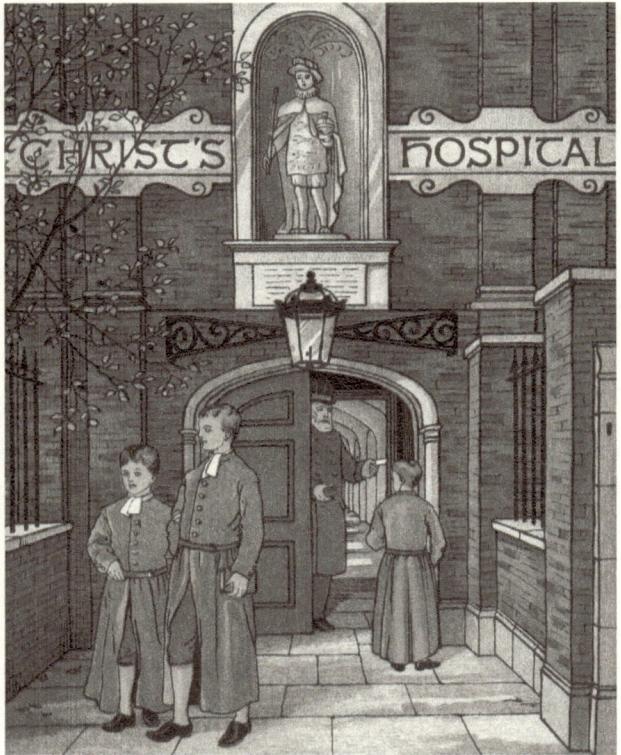

Figure 1.4: Illustration of Christ's Hospital boys from the children's book *London Town* (1883), showing the traditional coat and stockings worn with breeches and bands, but no petticoat or cap

Remembering his time at Christ's Hospital in the 1790s, the poet and essayist Leigh Hunt stated:

> Christ's Hospital is a nursery of tradesmen, of merchants, of naval officers, of scholars; it has produced some of the greatest ornaments of their time; and the feeling among the boys themselves is, that it is a medium between the patrician pretension of such schools as Eton and Westminster, and the plebeian submission of the charity schools.[90]

It is possible that this continued imitation, therefore, was not merely dogged adherence to tradition but aspirational, in that it looked to Christ's Hospital as an example of the high academic and, to some extent, elevated social standards

that a charity school might achieve, demonstrating the way in which the meaning of dress can be reinterpreted.[91] The initial social significance of the uniform was no longer relevant in the later time period and with the earlier meaning of humility lost, the connotations of the garment subsequently improved through the increased status of the wearers and the associations of tradition, academic merit and *esprit de corps* that it has gained.[92]

Although the retention of an archaic uniform at Christ's Hospital may, in part, be ascribed to the fact that it had become imbued with a middle-class sense of social improvement, the maintenance of outmoded clothing at other, less prestigious, institutions can be viewed in a number of ways. Such practices were not outside social and class norms—it had long been conventional for servants to be gifted the discarded clothes of their masters, representing a time-lag between the way in which they were dressed and current fashions. This practice was perpetuated in the seventeenth century when uniforms began to be provided for servants. Initially those in uniform were the most visible servants such as footmen and personal servants in large houses, and these were often dressed in the styles of previous years.[93] It also served to visibly distinguish between employer and servant and reinforce the status differences between the two. This practice, however, was gendered—female servants continued to wear their own clothes, dressing more fashionably; although this also changed in the nineteenth century when they began to be provided with uniforms as well.[94] Benefactors could consider dressing charity children in the same terms as giving livery to their servants and similar rules therefore applied. Alternatively, the maintenance of outmoded clothing can be seen as equivalent to the intentions of the sumptuary laws of previous centuries which sought to prevent the working and middle classes from purchasing certain luxury items. These laws were intended to reinforce the social hierarchy and maintain class divisions through the restriction of particular dress styles and fabrics.[95]

From the mid-nineteenth century many charity schools discontinued the provision of board, free meals and clothing. Although some schools, particularly the established institutions, continued to provide uniforms for all—at the London School of Industry in 1837 girls were 'provided with stuff gowns, aprons, bonnets, tippets, cloaks, shoes, &c. at the discretion of the Treasurer; also with an extra warm garment, when needed'.[96] Others started to provide nothing beyond the standard cap or bands or clothed only a portion of the school. In 1825, Rotherhithe Charity Schools clothed forty-eight out of 150 boys and twenty-five out of fifty girls with 'the vacancies for Clothing to be filled up from the senior Children in the Charity Schools, provided they have been punctual in attendance, and have a good character'.[97] This shifting emphasis may be

attributed to increasingly tight budgets, but also to improved conditions for the poor in general. This was certainly the view taken by the Taunton Commission whose report, published in 1867, stated:

> In a considerable number of the schools ... and in some Grammar schools a portion, often a large portion of the income is expended in clothing or apprenticing the scholars It appears to be certain that the great majority at least of the scholars who receive these benefits are not in real want of them.[98]

In some schools that retained their uniforms, dress was relaxed and many items updated in keeping with more modern ideas about education and child rearing, such as allowing children greater freedom of movement and expression. By the mid-twentieth century most traditional uniforms had been abolished altogether or were retained only for ceremonial purposes and these were exchanged for modern school uniforms. Typical of this trend is Liverpool Blue Coat School, which discontinued its traditional uniform in 1948, replacing it with shirts, ties and blazers, although the traditional garments are still worn by a selection of pupils at the annual Founders' Day. Christ's Hospital remained the notable exception to this trend.

Viewing Charity Children

As both Sir Gilbert Elliot and William Blake noted, charity school children were, in large numbers, seen as a pleasing spectacle and their involvement in many formal and ceremonial occasions is documented. From very early in their existence there are records of such children marching in funeral processions and attending church services. Henry Machyn recorded the presence of Christ's Hospital children at a funeral in 1553, less than a year after the Hospital opened:

> The same day, which was the twenty-second day of March, was buried Mr. John Heath, painter, dwelling in Fenchurch Street. And there went before him a hundred children of Grey Friars, boys and girls, two and two together, and he gave them shirts and smocks and girdles and handkerchiefs. And after they had wine and figs and good ale.[99]

In this instance, the children were provided with clothing in return for their attendance. This was a valuable commodity and the mutually beneficial

exchange explains why it became common practice for charity school children to take part in funerals. The children's presence increased the spectacle of the procession and consequently the visible status of the individual. The benefactors correspondingly provided for the institution in their will, whilst also creating an opportunity for the children to be viewed by the public and thereby for the school to raise awareness of their work. The fact that later institutions also adopted similar practices of participating in funeral processions and church-going activities reinforces the idea that they were not simply a remnant of older charitable and religious customs, but indicates the usefulness of such rituals in raising funds and sourcing new subscribers.[100] In 1623 (the earliest complete records available), Christ's Hospital children attended more than fifty funerals during the course of the year, in numbers ranging between 60 and 120. This custom seems to have tailed off by the latter quarter of the seventeenth century; with only eleven funerals attended in 1675 and four in 1706.[101]

As processions became less frequent, the tradition of viewing charity children took a different form, with mealtimes and chapel services thrown open to benefactors and in some instances even the ticketed public. As recorded in 1809 in *The Microcosm of London*, at Christ's Hospital 'public suppers commence the first Sunday after Christmas, and end on Easter Sunday: the time of supping is from six o'clock till half past seven', a similar display could be witnessed by attending Sunday lunch at the Foundling Hospital.[102] The simple and uniform appearance of the children at these events was invariably couched in glowing terms and their behaviour and demeanour praised. Writing in 1723 Bernard Mandeville forcibly sets out to condemn charity schools but succinctly sums up a general fascination with public viewing of the children:

> There is something Analogous to this in the Sight of Charity Children; there is a natural Beauty in Uniformity which most People delight in. It is diverting to the Eye to see Children well match'd, either Boys or Girls, march two and two in good order; and to have them all whole and tight in the same Clothes and Trimming must add to the comeliness of the sight.[103]

During these formal viewing opportunities, the pupils were presented to the public looking and behaving in a way that society felt they should. Their appearance and actions represented humility, modesty and godliness, all of which reinforced the differences of rank, background and prospects between the viewer and the child.[104] This encouraged viewers to remember their position

of privilege and the charitable and religious obligations that this entailed. When these responsibilities were fulfilled the recompense was tangible in that the outcome of the charity could be viewed in the public arena and pride taken in the spectacle that the viewer, as a benefactor, had helped to create. This was articulated by the writer and naturalist Thomas Pennant in 1790:

> The procession of ... the children of Christ's Hospital on Easter Monday and Tuesday, to St. Bride's church, affords to the humane the most pleasing spectacle, as it excites the reflection of the multitudes thus rescued from want, profligacy, and perdition.[105]

This pride could be flaunted publicly if benefactors were acknowledged through a visible token of their generosity on the uniform itself, and for some patrons this was a requirement of their bequest. This acknowledgement ranged from embroidered initials or insignia, to markings, silver buttons, belt buckles and other such accessories bearing a benefactor's name. A supporter's requirement to be recognized in this way sometimes, however, caused a conflict between plain dress and the more flamboyant elements of personal promotion.

This tradition of viewing of charity pupils, in conjunction with an increasing aesthetic appreciation of children and childhood in the nineteenth century, meant that charity children also began to appear in portraits, novels and songs in significant numbers. Some portrayals were gently comic, such as the music hall duet *The Charity School*, which references both uniforms and the charity-school traditions of processing—the final verse runs:

> Girl: A truce to care, this is the day
> They give the milk and buns away
> Boy: And in their kindness each one knows
> They gave to us these brand new clothes.
> Girl: With music, flags, and banners gay
> We'll in procession march away,
> Boy: But now to school with speed let's on,
> Before the milk and buns are gone
> I'm so happy
> Girl: So am I
> Both: To be good children then we'll try,
> With joy to shout shall be our rule,
> Success to every charity school[106]

More often than not, however, charity school children were represented as wholesome, blameless and goodly creatures, with many of the images bordering on the winsome and saccharine. Prominent among artists of this latter style was Kate Greenaway, who rose to fame as a children's illustrator in the late nineteenth century, producing images that looked back to the fashions and appearances of the 1820s and 1830s. Greenaway often portrayed well-scrubbed charity school children in her illustrations. Such representations almost certainly relate to the changes taking place in the social and cultural understanding of childhood in this period.

In the sixteenth and much of the seventeenth century it was believed that parents were the 'instruments to convey the stain and pollution of sin to the poor Infant' through birth and that measures must be taken to correct this innate sin in the young.[107] The late seventeenth and eighteenth century saw a gradual transition from this concept of 'original sin' in children to the view that if a child was raised and educated correctly in a suitably benevolent environment, their natural virtue would overcome any inclination for evil. This move was aided by works such as Locke's *Some Thoughts Concerning Education*, which was first published in 1693 and advocated a more compassionate approach to child rearing.[108]

The concept of childhood continued to develop throughout the nineteenth century, moving beyond mere naturalism to a determined and proactive maintenance of innocence. A middle or upper-class Victorian upbringing became a sentimentalized experience that, ideally, was separated entirely from the adult world; a period of protection and dependence in which children were shielded from the responsibilities and behaviours of later life.[109] These alterations in attitudes to children stimulated a greater interest in, and in some instances almost an obsession with, the trappings of childhood. This manifested itself in areas such as the development of books and games aimed directly at children and created a new outlet for charity school images.[110] Through this, the charity school child also became a literary trope, although whether this was as a charming innocent or oppressed minor depended on the author and the role of the child in the story. Charlotte Brontë's *Jane Eyre* detailed both the harsh living conditions and the uniform of Lowood School in 1847:

> They were uniformly dressed in brown stuff frocks of quaint fashion ... made high and surrounded by a narrow tucker about the throat, with little pockets of Holland tied in front of their frocks and destined to serve the purpose of a work-bag: all too wearing woollen stockings and country-made shoes fastened with brass buckles.[111]

Whilst Charles Dickens's description of the Charitable Grinders in *Dombey and Son* in 1848 is more humorous and wryly benevolent:

> 'The dress, Richards, is a nice, warm, blue baize tailed coat and cap, turned up with orange coloured binding; red worsted stockings; and very strong leather small-clothes. One might wear the articles one's self,' said Mrs Chick, with enthusiasm, 'and be grateful'.[112]

These detailed descriptions observed in association with others, such as in Mark Twain's *The Prince and the Pauper* (1881), suggest that by this point the image of the charity school child was so inextricably bound up with their uniforms that to find a place in the cultural understanding of readers, the uniform needed to be described for the social context of the child to be apparent.

For several centuries, charity schools played a large part in the education of the lower classes. Although many were rendered obsolete by the advent of compulsory education and the later switch to the comprehensive system, some retain the key aspects of their founders' intentions and appearance to this day. It is through these that we can garner an insight into the importance that uniform played in the organisation and running of these schools and the creation of the identities of the children that were projected onto society. Many people today recognize Christ's Hospital pupils by their uniforms alone or maintain an understanding of their traditions and ethos, in a modern cultural context, through their appearance. This is an understanding that has altered in line with the status of the school, as well as changing views on children's education and development; it is very different now from that at the date of foundation.

CHAPTER TWO

The Public Schools 1800–1939

Due to their close associations with the church, many grammar schools perished during the dissolution of the monasteries in the sixteenth century (although some mentioned in Chapter One, such as Winchester and Eton, were large and powerful enough to survive). Those that closed were replaced by new or re-founded institutions, retaining the name of grammar school. But many were started by liveried companies including Oundle (founded in 1556 by the Worshipful Company of Grocers) and the more obviously named Merchant Taylors' School (1561). These schools continued to focus on teaching Latin and the Classics.[1]

From the sixteenth to eighteenth centuries, different grammar schools came and went, but the few that stayed the distance gained social prominence. These schools switched to charging significant fees for teaching and boarding and consequently the demographics of their student population changed. Poorer students were financially excluded, except via a limited number of bursaries, and pupils were increasingly drawn from wealthier, upper-class backgrounds. As well as grammar schools, which were endowed for public use and subject to public management by trustees, private schools, which did not benefit from an endowment and were privately managed, also opened. Many of these, however, were short-lived and their intake varied.[2] It is from the relationship between these privately operated schools and the grammar schools that the term 'public school' emerged. This sought to distinguish between private establishments of a lesser status and the grammar schools which were incorporated under statute at law. Initially the term 'public school' was used interchangeably with that of grammar school, but by the nineteenth century the phrase had begun to be applied only to the most established grammar schools and these were officially designated under the 1867 Public Schools Act as Eton, Harrow, Rugby, Winchester, Charterhouse, Shrewsbury and Westminster.[3] Institutions of later foundation, such as Marlborough (1843), Lancing (1848), Hurstpierpoint (1849),

33

Haileybury (1862) and Malvern (1865), adopted the title of 'public school' in imitation of their more established peers and were generally accepted as such.

Historically, there was little regulation of what public school pupils wore and images of the schools from the seventeenth and eighteenth centuries show pupils attired in fashionable clothing of the period. Uniforms were first adopted in the nineteenth century, initially for sport and later for all school clothing. The process of uniform introduction varied greatly between public schools and was propelled by a complex combination of wider social and cultural changes. The key factors were the entry of the middle classes into the public school system and the development of the public school ethos, but alterations in fashion, the rise of the volunteer movement and the Victorian penchant for invented traditions all had a role to play.

From the end of the eighteenth century, the Industrial Revolution, in conjunction with the growing British Empire, began to generate new wealth through the manufacture and transport of goods, allowing the middle classes to expand and diversify at a significant rate. Men who had made their money in industry further consolidated their economic position through political and electoral change. This burgeoning middle class was not, however, a single, unified mass and the term covered a wide range of income brackets. Here, we are predominantly concerned with the upper-middle classes and the 'middling sort': lawyers, doctors, business and factory owners, and other men of a similar status who earnt a sufficient amount of money to maintain a large house and multiple servants.[4] The increased power and scope of the middle classes, however, also created a great deal of social anxiety. Class distinctions and the enforcement of behavioural norms became increasingly important and the middle classes developed a rigid social and moral code based around etiquette, clearly delineated gender roles and, perhaps surprisingly given the Victorian taste for thrift and modesty, conspicuous consumption.[5] One of the most lasting ways to reinforce a family's (newly attained) position in the social hierarchy was through the education of their children.[6] With sufficient funds boys could be educated to fulfil their parent's aspirations and increase the family's ability to be upwardly mobile.[7] Consequently, upper-middle-class families sought admittance to the public schools, the elite institutions of choice, and were, on the whole, given access.

Conditions at the vast majority of public schools in the early nineteenth century were downright violent, student revolts were common and corporal punishment the established norm.[8] Augustus Short, later the first Bishop of Adelaide, who attended Westminster School between 1811 and 1820, recalled that 'the boys fought one another, they fought the masters, the masters fought

them, they fought outsiders, in fact we were ready to fight anyone in those days'.[9] Alcohol was also a problem and older boys, often provoked by drink, bullied younger pupils in all manner of grisly ways. This was facilitated by a lack of supervision which allowed an already unruly school population to replicate the physical cruelty meted out by masters and seniors amongst themselves. Augustus's cousin, Thomas Vowler Short, who was also sent to Westminster around the same time, described his living environment:

> Forty boys were shut up for the night in a large room (the college dormitory) by themselves, and the master never came in except for prayers, after notice given. There was much tyranny, much self-indulgence in eating and drinking and in jesting which were 'not convenient'. Few boys went through the trial unharmed.[10]

Nor was this picture unique to Westminster, Long Dormitory at Eton, which housed 52 scholars, was organized in the same manner and was renowned for its filth and brutality.[11]

Around the middle of the century conditions gradually began to improve and the public school ethos started to develop and these two changes are closely connected. The public school ethos was a set of values relating to appropriate and expected schoolboy behaviour—but it was also more than this, and its exact form and remit is very difficult to articulate. It was closely associated with the Victorian ideal of 'manliness', characterized by bravery, resilience, integrity and loyalty.[12] This was predominantly an upper and middle-class concept and manliness might be perceived differently amongst the working classes. The public school ethos placed significant emphasis on sport as it was believed that games, particularly those played in a team, taught and reinforced the traits associated with manliness. The ethos was also linked to a range of, often bizarre, school-specific activities and a more structured educational environment with schools increasingly organized into smaller divisions such as teams, societies and houses, each of which demanded allegiance. The development of the ethos was gradual, and it became increasingly prevalent and intricate throughout the second half of the nineteenth century.

Thomas Arnold, headmaster of Rugby from 1828–41, is often credited with initiating these changes. Arnold's work was publicized through a particularly fawning biography by Arthur Penrhyn Stanley and the novel *Tom Brown's School Days*, a fictionalized account of public school life based on Rugby during Arnold's headmastership. Although Arnold is acknowledged to have been an influence in many respects, these two works have served to inflate the impact that Arnold

actually had on the system as a whole.[13] In reality, this alteration in the *modus operandi* of the public schools may be attributed as much, if not more, to moral, social and behavioural changes taking place in wider society than to the work of Thomas Arnold and his followers.

Looking at the wider picture, the development of the public school ethos can also be seen as a way to exclude the lower-middle classes from a public school education. Having been given access to the public school system, the upper-middle classes were reluctant to see that privilege extended to those further down the social spectrum. Consequently, the public schools became a way in which class boundaries could be reinforced in a period of class consciousness and confusion. Public schools were discriminating about which pupils they admitted and emphasized class-related concepts of manliness and leadership through the rules, rituals and activities associated with the public school ethos, including the introduction of uniforms. By maintaining this association of selectivity, a public school education became a way of determining whether a gentleman was of an appropriate class.[14] Consequently, attendance at a public school became a prerequisite for many jobs in the military and British Empire.

Sport and the Introduction of Uniform Clothing

Games always existed at the public schools, but prior to the nineteenth century they were organized by the boys themselves, often had few rules and were played in everyday clothing, with the removal of hat and coat being the only concessions to the rigours of the game. Masters had little involvement with the boys' recreational activities, usually viewing them with disinterest and occasionally with suspicion. This second attitude is demonstrated by John Brinsley, writing in 1612, in *Ludus Literarius: or the Grammar Schoole*, in which he notes:

> Very great care is to be had in the moderating of their recreation. For schools, generally, do not take more hindrance by any one thing, than by over-often leave to play. Experience teaches, that this draws their minds utterly away from their books.[15]

In the nineteenth century these attitudes started to change and schools began to endorse sports such as rugby, football, rowing and cricket as a way to improve discipline.[16] Time was set aside during the school day for games and the rules of these sports began to be formally codified. As sport took on an important role in the school curriculum, it also began to be valued in other ways, and was increasingly seen as a way to teach boys to manage physical

discomfit and to learn lessons in teamwork and leadership.[17] Fashionable clothes were found to be unsuitable for these regular and organized games sessions as they did not provide sufficient freedom of movement and expensive items were ruined by sweat and mud.[18] Gradually, garments worn specifically for games were adopted—these were a combination of casual and country fashions of the period and practical items drawn from working-class clothing such as canvas trousers (predominantly worn by sailors and tradesmen) and jerseys, which were probably derived from the clothing of outdoor workers, particularly fisherman.[19]

These garments were often brightly patterned, with clashing colours and designs were randomly adopted by players. In *Recollections of Rugby*, written in 1848, 'An Old Rugbeian' recounts how:

> Considerable improvement has taken place within the last few years, in the appearance of a match, not only from the great increase in the number of boys, but also in the use of a peculiar dress, consisting of velvet caps and jerseys. The latter are of various colours and patterns, and wrought with many curious devices.[20]

It has been suggested that these 'curious devices'—stripes, quarters, stars, crosses and fleurs-de-lys—were heavily influenced by heraldic iconography and that they can be viewed as a manifestation of the popular Medieval revivalism of the period. It is consequently easy to suggest that the use of such imagery might reflect the gentlemanly-like qualities that sport was supposed to represent and this can lead to drawing parallels between the Victorian passion for chivalry and the concept of 'fair play'.[21] I can find little evidence, however, to support a direct link between the two and it is more probable that although these patterns and symbols were culturally prevalent at the time, they were, more importantly, simple to identify and duplicate.

After an initial period of exuberance, certain colours or patterns began to be consistently associated with certain sports, teams, schools or houses and this was an easy way to demonstrate allegiance. With more regulation and emphasis within the school, the results of certain larger team games took on a new importance and they started to draw crowds of spectators. This meant that the ability to identify who was on each team was necessary for both increasingly competitive players and those cheering them along. *Routledge's Handbook of Football*, published in 1867, advocated dressing teams in different colours, as this prevented

confusion and wild attempts to run after and wrest the ball from your neighbour. I have often seen this done, and heard the invariable apology—'I beg your pardon, I thought you were on the opposite side'.[22]

A basic football uniform comprising white trousers and black gaiters was introduced at Harrow in the late 1830s, and from around 1840 Winchester placed competing school teams in different coloured jerseys of red-and-white and blue-and-white stripes.[23] Rowers also adopted rudimentary uniforms and at the first Oxford and Cambridge boat race in 1829, Cambridge wore white shirts and pink sashes and Oxford wore dark-blue jerseys and straw hats.[24]

These developments in sports clothing and uniforms can be seen in Figures 2.1 and 2.2, both images of the Malvern football team, from 1868 and 1888 respectively. The first image shows evidence of the use of sports clothing, with all players attired in a similar style, but in a wide variety of colours and bearing assorted fleurs-de-lys and cross symbols on their shirts, although their caps appear to be of a uniform dark colour and appearance. The later image shows that in the space of twenty years a clearly regulated football uniform of white shorts, dark socks and team shirt has been introduced, and the caps have also become more detailed in line with the wider aesthetic.

Sporting strips of this kind were not a completely novel idea. In horse racing, the Newmarket Agreement, made in 1762, assigned specifically coloured silks to each owner or stud and all jockeys were required to ride in the correct colours. This allowed for ease of identification during a race, particularly at the finish line. In a similar vein, members of the Marylebone Cricket Club wore sky-blue coats from the late eighteenth century, although this was more akin to bearing the insignia of an exclusive gentlemen's club than a response to the exertions of sporting activity, as the jackets were only worn off the field to demonstrate allegiance and were discarded before playing.[25]

Over time, games clothing developed into a formalized system of garments relating to specific sports—cricket was played in whites, as was tennis, and coloured blazers were adopted for many activities.[26] Following on from the notion that games taught appropriate masculine traits, excelling at sport began to be viewed as a prominent symbol of masculinity. This was closely tied to ideas of 'muscular Christianity' which suggested that physical activity and Christian values were intimately connected and, therefore, demonstrating prowess on the sports field was also an indicator of a strong moral and religious compass.[27] Consequently, pupils made every effort to do well at games, thereby proving their masculinity in the process. Prefects were chosen based on how closely

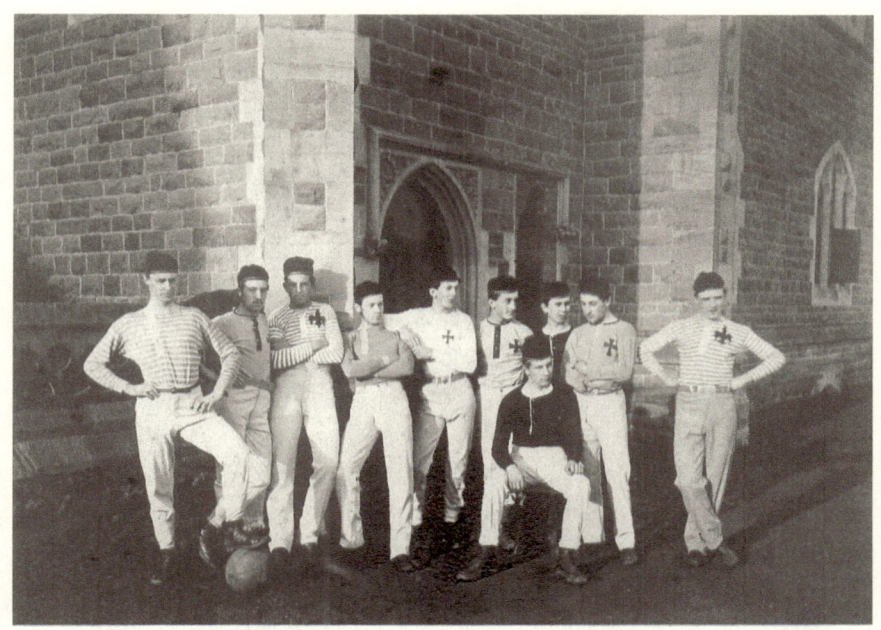

Figure 2.1: Malvern College Football Team, 1868

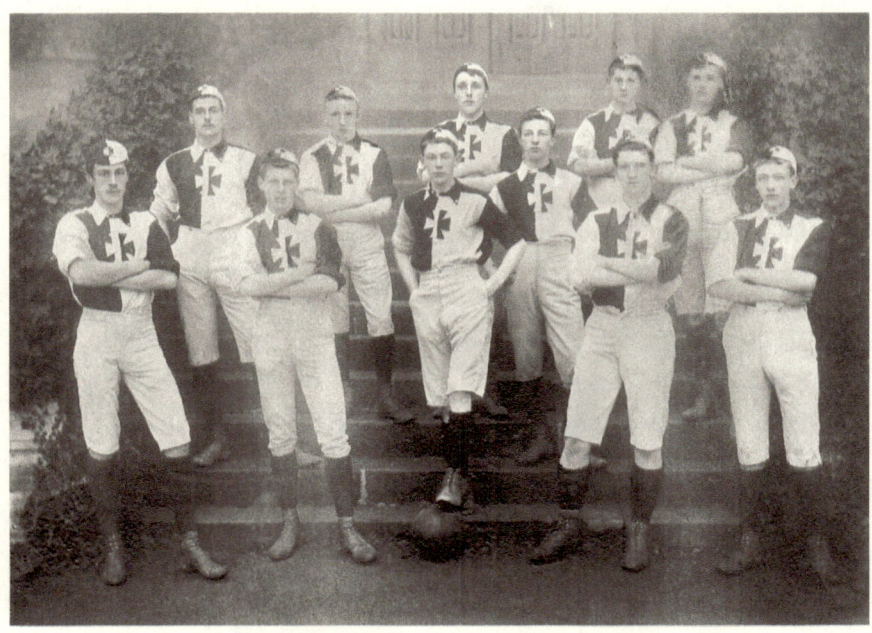

Figure 2.2: Malvern College Football Team, 1888

they resembled this sporting and behavioural ideal and the most physically able—often known as 'bloods'—assumed official and unofficial positions of responsibility and wielded a significant amount of power within the school. To demonstrate their sporting prowess and access the authority that was available to the most athletically gifted, boys sought visible markers of their competency and clothing was the easiest method of communication. At first, pupils might be awarded the privilege of flannels, allowing them to play sport in flannel trousers instead of ducks (a type of canvas trousers). Later, as the system developed, players earned the right to wear items of clothing such as jerseys, caps, blazers or ties in designated colours and patterns and these became known simply as 'colours'. Most colours were for wear on the sports field, but some, such as ties, could also be worn as part of normal uniform. This process can be seen in action at Eton, where an incredibly complex system of sporting and house colours has developed over the past 150 years. From the early nineteenth century, the cricket XI and rowing VIII were awarded colours in Eton blue (a pale green-blue colour). From 1860, further colours were created, initially for the field game (a game related, in some ways, to football). This consisted of a shirt and cap in scarlet and Eton blue, which were worn on the sports field, with the keeper of the field (the boy in charge of the activity) entitled to wear a silk cap instead of a cloth one. Colours for the wall game were introduced in 1861, for racquets in 1875, while rowing and cricket colours diversified over the following years (cricket and rowing colours both included blazers in addition to other garments). Rugby colours, however, were not introduced until 1915, and colours for football not until 1937. There are now ninety-five official colours in use at the school.[28]

By the end of the nineteenth century this system of sporting rewards had become normalized to such an extent that Sir Henry Newbolt could reference it within his stirring, saccharine and often-quoted poem *Vitai Lampada* without any further explanation:

> There's a breathless hush in the Close to-night—
> Ten to make and the match to win—
> A bumping pitch and a blinding light,
> An hour to play and the last man in.
> And it's not for the sake of a ribboned coat,
> Or the selfish hope of a season's fame,
> But his captain's hand on his shoulder smote
> "Play up! play up! and play the game!"[29]

This demonstrates how ingrained the sporting culture and its associated clothing had become. When the poem was published in 1897, the 'ribboned coat' was clearly a widely understood cultural reference and this establishes how recognisable the signifiers of sporting attainment were to those both inside and outside the public school system. Expressing allegiance and hierarchy through sporting clothing can be seen as a precursor to much wider trends in uniform adoption and the creation of individual and group identity within the public schools.

Creation of the Public School Ethos

With the growth of the middle classes and their subsequent demands for greater access to the upper echelons of society, public schools became increasingly concerned with class and ensuring that they excluded non-elite influences. In discussing his time at Harrow c.1912, Henry Vigne stated that the aim of the school 'was turning out quite a good standard of not too hide-bound people with decent manners and so on ... I think they were always very aware of class which was a very real thing in those days'.[30] Class was, therefore, a key concern and public schools sought to separate themselves from other educational establishments of a lesser status.[31]

These exclusion processes took a number of forms, both practical and social. Practically, the lower-middle classes could be excluded through high fees, in addition to the, often excessive, costs of clothing and equipment. This expense was further increased by the rural location of many public schools, requiring complex transport arrangements and the necessity of boarding during term time. Pupils entering the school were also expected to have a familiarity with the Classics, a topic that was not widely taught elsewhere and could only be accessed through a private tutor. The education that pupils then received was specifically tailored to the future requirements of the upper and middling class and contained little in the way of the skills needed for trade, such as accountancy. Similarly, social distinctions were highlighted, demonstrating the differences between pupils and non-pupils through school practices, many of which developed as part of the public school ethos. The ethos served both as a way to reinforce class-appropriate masculine behaviour and as a series of conventions and customs including unique slang, complex hierarchical codes and ritualistic activities, which were hard to understand, let alone imitate, by those outside the system. These behaviours created distinct communities with their own rules and social norms which worked, not just to exclude others, but also to reinforce a mental distinction between pupils and the outside world—'them and us'.[32] This limitation of access extended beyond the schooling process itself

and into the world of work. Not only were non-public school attendees restricted in their choice of careers—as a public school education was a prerequisite for some roles—public school networks were also retained in later years. Men who had attended public school were more likely to be trusted and promoted, as well as developing relationships with influential figures who had attended the same or similar institutions to themselves.[33]

The adoption of uniform can be seen as the most obvious way of differentiating between types of school, physically distinguishing public school pupils from non-attendees, and it was certainly the most visible part of the public school ethos in action. Neither the development of the public school ethos or the adoption of uniform happened over night, and changes in attitudes relating to inclusion and exclusion can be charted through the move from internal dress divisions to the creation of an increasingly unified and select appearance at the public schools. The first step in uniform adoption was often the control of particularly colourful or showy items, articles such as gaudy ties, waistcoats and socks were initially prohibited and then, later, more comprehensive dress regulations were introduced. The Clarendon Report of 1864 was the conclusion of a Royal Commission investigation into nine schools in England and was the result of concerns regarding management practices at Eton. The schools investigated were the seven institutions later named in the Public Schools Act in addition to two day-schools: St Paul's and Merchant Taylors'. The 1860s was an important decade in both the early adoption of school uniform and the growth and implementation of the public school ethos. Consequently, the Report offers a unique insight into this process. It is also a rich resource on the subject of contemporary concerns and anxieties regarding the role of garments in the concealment or differentiation of class and status. The Report comprised a number of elements, including a series of interviews with masters and pupils (both current and former). Of the nine schools examined, there are direct or indirect references to clothing in five of these transcripts. This lack of consistency may be explained by the remarks of Lord Clarendon in an interview with G.F. Harris, an assistant master at Harrow: 'There is another point, of perhaps no great importance, and yet I believe it is thought so by some of the boys, which is their dress.'[34] This indicates that although school clothing was beginning to be discussed and regulated at this date, it had not yet become a widely understood symbol of the public schools and was still seen by some as of 'no great importance'.

Dress, as with all aspects covered by the Report, is dealt with most completely at Eton, the institution that triggered the investigation. It is often suggested that in 1820 Eton adopted its famous black tail-coats in mourning for King George III, making it the first public school to implement a uniform.[35] The Report, however,

proves this to be incorrect. In 1862, more than forty years after the supposed introduction of uniform, Eton headmaster Rev. Balston, in his interview with the Commission, makes no mention of the jackets and explains that there is only minimal regulation of clothing in place:

> 3613. (Lord Clarendon.) One more question, which bears in some degree upon other schools, namely with regard to the dress. The boys do not wear any particular dress at Eton?—No, with the exception that they are obliged to wear a white neckcloth.
> 3614. Is the colour of their clothes much restricted?—We would not let them wear for instance a yellow coat or any other colour very much out of the way.
> 3615. If they do not adopt anything very extravagant either with respect to colour or cut you allow them to follow their own taste with respect to the choice of their clothes?—Yes.
> 3616. (Lord Lyttelton.) They must wear the common round hat?—Yes.
> 3617. (Lord Devon.) How far down in the school does the wearing of the white neckcloth go?—It does not extend to those who wear turn down collars.
> 3618. Do many of the boys wear stick ups?—Yes, and they must then wear a white tie.[36]

As Balston explains, pupils at Eton could dress much as they pleased, provided that they did not step too far outside the bounds of sartorial normality and avoided ostentatious display. The only garments that were required wear were the 'the common round hat' (a top hat) and a white neckcloth (if wearing a stick-up collar). The Report notes similar situations at both Westminster and Rugby, where there was no official uniform, but certain items were banned.[37] As pupils came from wealthy families, the schools would have presented a fashionable, if conservative, appearance.

In addition to these rules, Collegers at Eton (pupils who were supported by the school in line with the terms of the original foundation) were provided with a gown which had to be worn throughout the school day. This marked them out from the Oppidans, full fee-paying pupils who did not wear such a garment. The Report contains a significant debate about the nature of the divide between Oppidans and Collegers and whether this was reinforced by these differences in dress. The Hon. C.G. Lyttelton—a former Eton pupil—sums up these views in his answers to the Commission:

> To what do you attribute the distinction [between the collegers and oppidans] disappearing in the upper part of the school as compared with that which existed in the lower part of it?—I believe the collegers themselves ascribed it in great measure to the fact of their wearing the gown. When a boy first comes to the school and sees a lot of other boys walking about in a peculiar dress, he naturally regards them as a separate class. He learns to get out of that as he gets older, but it is a long time before the impression vanishes entirely.[38]

Similar distinctions were found at Charterhouse, where foundation scholars—those provided for by the school—were given a black suit of contemporary cut and a gown. This process was explained by Rev. Elwyn, headmaster of Charterhouse:

> 234. I see he is provided with clothes; what amount, and what sort of clothes are they?—It is a plain black suit; black trousers, and black jacket.
> 235. In an antique fashion?—No, a perfectly modern dress. That change was made many years ago. They used to wear knee breeches, and that kind of clothing, but there is nothing now to mark them from other boys, except that they are dressed quite in black. A boy is permitted to wear a black waistcoat, but it is not required
> 236. Is he supplied with a school gown?—Yes.
> 237. Which he is bound to wear in the school?—Yes; and at dinner, and at prayers in the house and in chapel.[39]

In both schools, financially supported pupils were marked as different, or in the words of the Hon. C.G. Lyttelton, of 'a separate class', through the dress that they were compelled to wear, separating them both sartorially and socially from their higher status peers. These distinctions were rooted in tradition, often being based on provisions in the foundation documents or the original statutes. As class consciousness became more focused on excluding outsiders, however, these internal dress divisions were, in most cases, abolished and replaced with uniforms which presented the school as a coherent whole. The fact that such internal dress distinctions are questioned in the Report is indicative of changing attitudes in this period.

From the 1860s onwards uniform adoption occurred in one of three main ways. The most prevalent of these was the gradual tightening of dress codes until most items of clothing were completely regulated—the early stages of

this can be seen in some of the Clarendon Commission examples. Conversely, in some schools (usually of a later foundation), uniform was implemented by the headmaster over a relatively short period. The final approach was, perhaps, the most interesting and involved the boys themselves engaging directly in the adoption of uniform through peer pressure and a willingness to conform and this was the case at both Eton and Harrow. This move towards uniformity can also be connected to changing attitudes to male dress. In the mid-nineteenth century an emphasis on dress and fashion was seen as feminine and therefore at odds with the culture of overt and physical masculinity that was developing in the public schools. Later in the century, male consumption became more prolific and the mass-market fashion of the department stores broadened the scope of acceptable masculinity with regard to concerns of dress. This moved the processes of choosing, purchasing and wearing clothes from a pursuit that may be considered effeminate in the mid-nineteenth century, to one that might be enjoyed by men, albeit in different spaces and on different terms to women. Despite this, the relationship between masculinity and consumption remained complex.[40] The growing acceptability of male consumption, however, helped to create a suitable social environment for the increasing interest paid to clothing in the public schools.[41]

Uniform Design

In terms of the actual design of these newly introduced uniforms, schools sought to project their values in a visual manner. They presented an appearance that was appropriate for upper-class pupils but also distinguished the institution from other public schools, as well as those of a lesser rank. Despite the creation of new opportunities for the meeting and exchange of ideas between the public schools, such as the Headmasters' Conference (formed in 1869) and an increased number of inter-school sporting fixtures, institutions remained determined to cling to their individuality.[42] This makes generalisations relating to the design of uniforms quite difficult, but there are some key trends which can be traced through much of the public school system.

The largest influence on uniform design was undoubtedly fashion; by adopting a fashionably masculine and sartorially correct aesthetic, schools could reinforce their class status. During the nineteenth century men's clothes became increasingly subdued, well-cut simplicity began to define masculine dressing and any singularity of appearance was frowned upon, particularly for the middle and upper classes. This is not to suggest that all distinctiveness of dress was removed—men still bought and wore stylish items that demonstrated

their individuality, but colours, decoration and textures were more limited and changes to the fashionable silhouette were slower than both women's fashion of the same period and men's fashion of previous centuries.[43] School uniforms reflected this new conservative appearance and boys were generally dressed in fashionable but simple styles, with limited decorative additions, and made up in dark colours, most commonly black. Many of the more established schools adopted a version of the top-hat-and-tails model, particularly for older boys (this is still worn at Eton), which when first introduced in the late nineteenth century represented the normal daywear of young men. These designs had the additional bonus of practicality, in that they did not readily show dirt and the lack of decoration made them easier to clean, particularly in the quantities demanded by an active school population.

This tendency towards conservatism operated in conjunction with an increasing informality of dress, particularly for children, with garments that had formerly been considered suitable only for recreational situations passing into normal daywear. This trend became more pronounced in the twentieth century.[44] Sports uniforms—as the precursor of day uniforms—had a significant influence on the latter's design, with items such as the blazer, which was initially worn for rowing and cricket, being adopted as uniform by schools in the Edwardian period.[45] The blazer's spread was hastened by Stowe School, which opened in 1923. Stowe sought to compete with the older public schools on an academic footing, but move away from some of their more archaic practices. Stowe rejected the uniform designs of these institutions and instead dressed pupils in grey flannel suits during the week and blue serge suits on Sundays. The success of this approach caused other institutions to imitate it, creating the ubiquitous shirt, blazer and tie combination that is still widely used today.[46]

Another example of the increasing acceptance of informality was the adoption of shorts for younger boys, predominantly from the interwar period of the twentieth century onwards. Shorts first appeared in athletics in the 1860s and passed into children's clothing in the 1870s, but were not widely worn until later.[47] Their use in school uniform can be attributed to some extent to the scouting movement, which popularized the garment. Aimed at the middle and working classes, Baden-Powell's scouts, founded in 1907, promoted the public school values of masculinity, Empire and militarism to a wider audience and, as such, the uniforms became imbued with similar values.[48] It was a simple step, therefore, to transfer the garment into the public and prep school environment for younger boys (see Figure 2.3).

These contrasting forces of conservatism and informality, along with increasing fashionable consumption, created complicated sartorial codes.

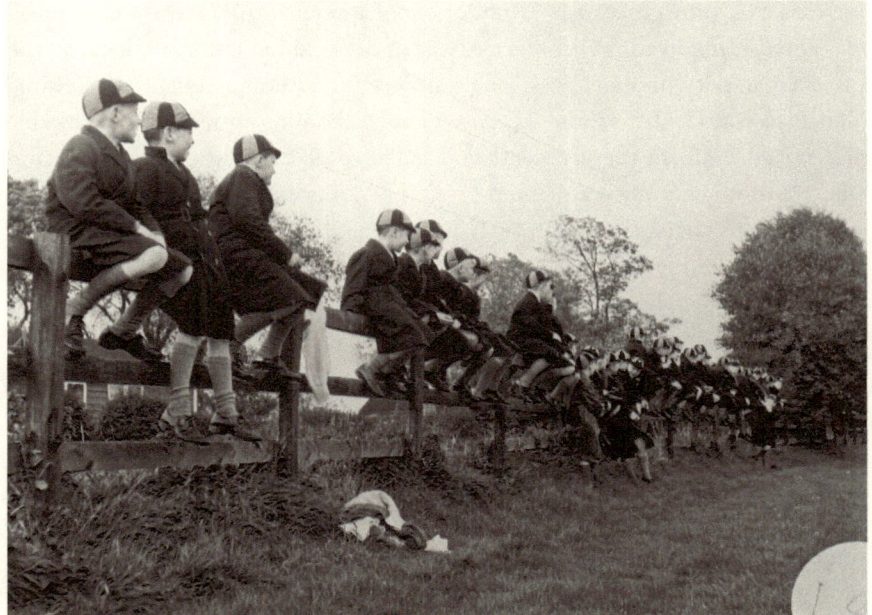

Figure 2.3: Junior boys from Pocklington School wearing uniform shorts, c.late 1940s Their quartered school caps are also of note. Archives of Pocklington School Foundation

Amongst the upper classes, different clothes and levels of formality were required for different locations and activities and this occasion-specific dressing was seen as a way of highlighting the variety of modern recreational life.[49] As the men's magazine *Fashion* noted in 1898:

> There was never a time in the history of man's clothing when he felt it necessary to change them so often. There is a peculiar costume for every-thing. For dinner and after dinner; for shooting and after shooting; for the morning and for the afternoon. There are clothes suitable … for every possible human diversion. In fact, there was never a moment when clothes gave a dandy so many opportunities as to-day. He might dress himself seven times a day without risk of being thought eccentric.[50]

These dress codes were promoted as correct, particularly amongst the upper and upper-middle classes. They were often ignored by the lower-middle classes, however, who did not always wear clothing (particularly sporting clothing) in the prescribed manner, leading to accusations of flamboyance and condemnation

for sartorial transgressions.[51] Public schools, keen to maintain their upper-class image, followed the 'correct' styles of dress to the letter, with each type of social activity or sport requiring a different and unique outfit of clothing. This also contributed to the expense of the schooling process. That sizeable and varied uniform requirements continued to be considered the norm into the twentieth century is reflected by Arthur Ponsonby, British politician and writer, in his social commentary *The Decline of Aristocracy*, in which he argues that boys attending public school 'must be fitted out with suits appropriate for each occupation, designed and cut on an approved pattern'.[52]

The other main influence in uniform design grew from the widespread understanding that many public school pupils would enter into careers in the military. From the 1860s a large number of public schoolboys (around 30 per cent of the total intake at Harrow and Rugby and more from other schools) went on to public-service positions in the military and civil service, filling leadership roles throughout the Empire.[53] Robustness was considered vital for imperial command in the far-flung reaches of the Victorian Empire and the rise of organized games mirrors the growth of the public schools as the training grounds for colonial service. Senior government staff members valued manliness over academic excellence and more often than not colonial recruits were good sportsmen.[54] As H.C. Jackson records in his memoirs of his time in the Sudan Service—joining in 1907—he was one of

> eight young men [who] boarded the crowded Desert Express on its long journey from Wadi Halfa to Khartoum ... we eight included in our number a former Rugby football captain of Oxford and Scotland, an ex-captain of the Cambridge University cricket team, a member of the Oxford University soccer XI, a rowing trials man, a member of Oxford and Middlesex county cricket teams, and a Somerset county Rugby footballer. It was this emphasis on physical fitness which gave rise to the aphorism that the Sudan was a country of Blacks and Browns administered by Blues.[55]

This emphasis on physical achievement in colonial employment in turn affected the operation of the Empire. As J.A. Mangan notes: 'The outcome of Waterloo would certainly have been the same without the existence of the Eton wall-game: the nature of the Empire would scarcely have been the same without the public school games ethic'.[56] As a result, public school (often followed by attendance at Oxford or Cambridge) became the main method by which to access careers in the commissioned military and in colonial services. Public schools began to

provide the skills and knowledge that pupils would need to enter these roles. This included teaching the necessary information to allow pupils to pass the civil service examinations, as well as offering practical military experience in school cadet corps.[57]

The Volunteer Force, created in 1859, was the forerunner of the modern Army Reserves. It was a part-time volunteer army that consisted of rifle and artillery corps which were intended to assist in the event of an invasion. Cadet corps were also formed, and these were units of school-age boys, organized and trained in the same manner as the adult volunteer groups. In the early stages, cadet corps were all attached to public schools, with Eton establishing one of the first in 1860. Both the volunteer and cadet corps adopted uniforms along military lines, usually in grey or green as opposed to the redcoats of the standing army. At Eton, the corps uniform consisted of a grey tunic with blue facings.[58] Having a visible military presence was new to many communities and the volunteer movement sparked an increased interest in military activities and dress and this was reflected in a number of wider fashions for military shapes and detailing. For instance, Zouave jackets and bodices became fashionable for women in 1859. These imitated the oriental-style jackets worn by the Zouaves, a light infantry regiment of the French army. The style retained its popularity for some decades, later passing into children's wear.[59] Military-inspired braiding and frogging also became a popular decoration on coats and dresses and this had a second resurgence in popularity in the 1880s when it was known as 'Hussar' trim.[60]

In a similar vein to fashionable clothing, the military influence can also be seen on school uniforms, with perhaps the most famous example being Wellington College. The college, which opened in 1859, was conceived by Prince Albert and was designed to provide a public school education alongside military training in the German style. The intake was predominantly drawn from the orphaned sons of army officers. The uniforms, which were designed with input from Prince Albert himself, had a strong military aesthetic and referenced the dress of Scottish regiments. It consisted of a dark-green jacket with brass buttons, tartan trousers and a postman's cap trimmed with red piping and a gilt crown.[61] As the son of the first headmaster of Wellington, E.F. Benson was uniquely placed to describe these uniforms in his childhood memoirs *As We Were; A Victorian Peep Show*:

> The boys first wore a uniform approved and partly designed by the Prince Consort, and it remarkably resembled that of the porters and

ticket-collectors of the South Eastern railway on which Wellington College was situated. This gave rise to little confusions.[62]

This, perhaps, suggests more about Prince Albert's unfamiliarity with the uniforms of railway service personnel than anything else, but it does indicate the use of military styles in everyday life. It also demonstrates the variable interpretations of clothing depending on the viewer and circumstance; whereas the pupils en masse projected a military, upper-class appearance, away from the public school the individual boys could be mistaken for lower-class working men. This shows the necessity of context in image creation and projection and the complexities of the demonstration of status through clothing in this period.

Between February and June 1860, the *Standard* ran a series of classified advertisements by Samuel Brothers advertising:

> SCHOOL UNIFORMS in increasing demand ... for the military training of youth as everywhere practiced on the Continent. Tunic Uniform, with kepi or navy cap and belt, 38s. to 50s.; Jacket Uniform with navy cap and belt, 30s.-40s.—Sole Designers and Makers, SAMUEL BROTHERS, 29 Ludgate-hill, E.C.[63]

They also listed 'patterns and directions for self measurement ... Boy's School Uniform (*en militaire*)'.[64] Similar Samuel Brothers advertisements were featured in other London papers such as the *Era* and *Daily News* during the same year.[65] Wellington College was a new concept in British education and it seems probable, given the timing, that Samuel Brothers was directly influenced by the Volunteer movement and the newly designed uniforms at Wellington. Two years later, in 1862, Samuel Brothers published an advertising map of London and this too featured listings for military-style 'cadet or school uniforms' consisting of 'jacket, vest, trousers and cap'.[66] As well as influencing the design of uniforms at schools such as Wellington, military styles had a wider and more subtle influence within other institutions and details such as piping, emblems and certain types of hat were appropriated from army uniforms. The army traditions of overt display, particularly the scarlet coats of most regiments, however, were not imitated and school uniforms retained a less showy appearance. For instance, when uniform was first adopted by Marlborough in the 1850s it consisted of a black suit, but certain parts, notably the cap, were relieved with red piping.[67]

Parallels can be drawn between the culture of honour and manliness that was cultivated amongst the commissioned ranks of the British army and that of the public school ethos. This link is unsurprising given that the vast majority of

commissioned officers would have received a public school education and many public schoolboys came from military families. Military influences in school uniform can, therefore, be seen as a reflection of the comparable values between school and army.[68] This comparison can be further extended when examining the similar disciplinary roles that uniforms fulfilled and the way in which they were utilized to identify individuals as part of a larger group such as a corps, unit, house or team.[69] Significant similarities may also be noted between the demonstration of hierarchies and sporting excellence through clothing that developed in the public schools and the display of insignia within the armed forces. Denotation of rank through braid, buttons and ties were all common in the military and similar symbols of prowess and authority were adopted by the majority of public schools for sporting achievement (as discussed earlier) and to indicate prefects, head boys and other positions of schoolboy power. Indeed, Newbolt's 'ribboned' coat may even be a reflection of the ribbons worn on military uniform to signify that the wearer has been awarded medals in recognition of particular acts of bravery.

Collective Identity

Once school uniforms were fully codified, they were increasingly closely regulated by staff, but also by the boys themselves. Isolated groups tend to move towards conformity and the small, closed communities of the public schools were a prime example. Upon entering the school, pupils were expected to fall in line with the social norms of the environment and behave in the same manner as their peers, and this included wearing the newly introduced uniforms in the prescribed way. Overwhelming peer pressure was brought to bear on those that refused to submit and boys expended a great deal of effort to fit in.[70] Writing in *Some People* about his time at Marlborough around 1900, Harold Nicolson described this situation in a conversation between himself and Marstock, the school's head boy:

> 'Oh why, *oh why* will you persist in being different to other people? I give you up; you simply refuse to be the same.' He paused and looked at me with real perplexity in those open eyes. '*I think you must be mad*,' he concluded solemnly. I went to my room determined ... I must pull myself together: it was only a question of being careful: if one was terribly careful one could succeed in being exactly the same. My whole energy during the terms that followed was concentrated on achieving uniformity.[71]

In this way, uniforms (as well as the wider school ethos) became self-sustaining. It was policed and reinforced by the boys and this worked to cement the collective, yet exclusive identity that it had helped to create and uniforms became a vital way to foster school affiliation and to nurture *esprit de corps*.[72] As Christopher Tyerman writes in his modern history of Harrow School:

> The tension between the individual and the group, inevitable in schools, was decisively resolved in favour of the latter. Boys were increasingly expected to see themselves not so much in a personal, moral relationship with peers and God but as active participants in a collective enterprise—team, house, form, school—through which and only through which, standards and values were expressed.[73]

Dedicated affiliation to house and school became part of the public schoolboy ideal of behaviour, and notions of attachment and belonging were reinforced through appearance, ethos and the interactions between junior and senior pupils. This affiliation became so ingrained that it remained strong even many years later, as reflected in the creation and sustained popularity of 'Old Boy' networks.[74] Uniforms, therefore, not only physically distinguished the pupils from others, but reinforced group identity and institutional values. Boys were subsumed into the collective whole, subsequently adopting its beliefs, and uniforms represented an outward manifestation of the acceptance of these values.

This development became increasingly extreme and by the early twentieth century personal preference had been essentially eliminated.[75] Returning once again to Ponsonby, writing in 1912, he noted this process of adoption of uniform and uniformity:

> Compare a photograph of a group of school boys to-day with one of only forty or fifty years ago. The comparison is instructive. In the latter boys will be seen lounging about in different attitudes with a curious variety of costumes ... each one individual and distinct. The group today consists of two or three rows of boys beautifully turned out with immaculate, perfectly fitting clothing ... They stand and sit so that the line of the peaks of their caps, of their folded arms, of their bare knees is mathematically level. And even their faces! You can hardly tell one from another.[76]

Collective identity and the importance of the public school ethos began to take precedence and individual identity was considered secondary. Public schools

strove to create a model 'product' who adhered to the public school ideal in all ways. This is summed up by A.C. Benson in his collection of essays on public school life, *The Upton Letters*, as 'well-groomed, well-mannered, rational, manly boys, all taking the same view of things, all doing the same things'.[77] This idealized image was further propagated through the growing body of schoolboy literature, from early books such as *Tom Brown's School Days* (1857) and the mawkish and sensationalist *Eric, or Little by Little* (1858), which charts the gradual moral decline and ultimate death of its schoolboy protagonist, to later adventure-fuelled periodicals such as the *Boy's Own Paper*, *Marvel* and *The Boy's Friend*. In these publications, schoolboy protagonists were usually identified by their well-dressed, good-looking appearance and ability to excel at sport. An example of this in action comes from *The Fifth Form at Saint Dominic's: A School Story* (1881):

> That handsome, jovial-looking boy of sixteen who is sitting there astride of a chair, in the middle of the floor, biting the end of a quill pen, is the redoubtable Horace Wraysford, the gentleman, it will be remembered, who is in want of a fag. Wraysford is one of the best 'all-round men' in the Fifth, or indeed in the school. He is certain to be in the School Eleven against the County, certain to win the mile race and the 'hurdles' at the Athletic Sports, and is not at all unlikely to carry off the Nightingale Scholarship next autumn, even though one of the Sixth is in for it too.[78]

This tendency to define characters into narrow stereotypes by their appearance and athletic capabilities lasted well into the twentieth century, as seen in a description from *Boxall School: A Tale of Schoolboy Life* (1929):

> A promising sort of fellow to choose for a friend—strong athletic, broad shoulders, with his head well planted on them, honest brown eyes, crisp curly hair, a well-formed nose, a characteristic mouth, and a fine open forehead; altogether an open-hearted, good-looking promising specimen of boyhood.[79]

Conversely schoolboy adversaries were less traditionally handsome.[80] Barker, the bully in *Eric, or Little by Little* is described as 'a rough-looking fellow, with a shock of black hair, and a very dogged look ... he wasn't a very nice-looking specimen of Roslyn School'.[81] These characterisations were later parodied in Kipling's *Stalky & Co.* (1899), which dispensed with the sentimental tone of many

school tales, presenting convincing characters and a more realistic portrayal of school life.[82]

As these stereotypes proliferated, greater emphasis was placed on being able to judge a character by looks and dress alone. This view was replicated in the wider social sphere in which clothes were viewed as outward projections of internal belief and moral worth.[83] Consequently, the external appearance of schoolboys became increasingly important and it became widely believed that there was a connection between correct appearance and correct behaviour. Curiously, the collective appearance and identity of a school was further emphasized by small elements of controlled deviation. Sporting colours, along with symbols of authority for prefects and head boys, such as badges or ties, established a very visible hierarchy of the institution and allowed pupils to ascertain their place within the community.[84] Strict dress regulation also allowed for the removal of restrictions as pupils moved through the school, demonstrating their progression. Writing in 1929, but reflecting on his time at Charterhouse in the early 1900s, Robert Graves described this process of advancement and the subsequent relaxation of rules:

> The social code of Charterhouse rested on a strict caste system; the caste marks, or post-te's, being slight distinctions in dress. A new boy had no privileges at all; a boy in his second term might wear a knitted tie instead of a plain one; a boy in his second year might wear coloured socks; the third year gave most of the main privileges—turned down collars, coloured handkerchiefs, a coat with a long roll, and so on ... but peculiar distinctions were reserved for the bloods. These included light-grey flannel trousers, butterfly collars, jackets slit up the back and the right of walking arm-in-arm.[85]

These visible distinctions were usually developed by the boys themselves, but were permitted by masters who saw them as a method of control, focusing the attention of pupils on their own advancement. In many schools, these minor differences of dress became increasingly complicated towards the end of the nineteenth century, but adhered to the general rule that the further up the school you were, the greater your freedom of dress, with 'bloods' the most highly privileged of all.[86]

Whilst this hierarchy was understood and, at the very least, tolerated, this is not to say that it was always respected. The school magazine of Pocklington School, *The Pocklingtonian*, notes in 1899:

> A new house-blazer was instituted last term. Certain members fancied themselves hugely until invidious references were made to the colours, and an unkind parallel drawn between them and the hue of the gabardine usually worn by the ordinary purveyor of meat.[87]

Interestingly, status is, once again, invoked; the writer mocks the superior attitude of another group of pupils, rendering their symbol of identity—in this instance a house blazer—humorous through comparison with a lower-class working garment. This is a clever reversal of the class insecurities which preceded the adoption of uniform in the first place, but also relates to the confusions noted between the uniform of Wellington College and railway ticket collectors. Whilst uniforms in the context of public schools were about the demonstration of status, in their other uses in prisons, workhouses and menial jobs, as well as the charity schools of Chapter One, they presented an image of subservience. The messages conveyed by uniforms were, therefore, nuanced with regard to class and garments had both the potential for wilful misinterpretation, as here, or unintentional misinterpretation, as in the case of Wellington.

Emulation

As the public school ethos and its associated exclusionary processes, including uniform, developed at the established public schools, new schools opened which copied them. As such, a large number of new boarding schools were founded during the second half of the nineteenth century. These new schools predominantly sought to cater to the middle classes which had been unable to gain access to the major public schools, and they allowed them to provide their sons with an education of a similar nature, consequently gaining some of the status associated with such schooling. This proliferation of schools, however, resulted in an increasingly competitive educational arena which allowed some of these newer institutions to gain significant status and prestige, moving up the class ladder to rival and even surpass some of the more established institutions.[88] In this way, the number of schools that could reasonably stake a claim to the status of public school increased dramatically towards the end of the nineteenth century and many were widely acknowledged as such. This had an unintended effect on the system, in that the practices and activities originally developed to exclude non-elite pupils and influences began to disguise instead of reveal. The public school ethos placed a great deal of emphasis on the process of schooling in the creation of gentlemen and when this process began to be imitated by

newer schools, it actually gave greater upward mobility to the middle classes as it allowed them to access professions previously reserved for their upper-class counterparts. The public school ethos had become so ingrained that, to some extent, it replaced the importance of family background, but was easier to replicate than class assignment by birth. This was very much at odds with the original intentions of the established public schools.[89]

That uniform was an important part of public schooling and the institutional ethos by this point is indicated by its widespread emulation both within the new public schools and in children's fashion more generally. This can also be seen as part of a wider picture of class imitation, with the Victorian and Edwardian middle classes conspicuously consuming similar personal and decorative items to the upper classes. This was aided by the industrial and technological innovation of the period, which allowed the development of the ready-made clothing industry and other mass-production techniques, enabling the creation of copies of couture and expensive home furnishings at a much more reasonable price.[90] To the casual observer these mass-produced imitations could pass as the real items and it was only those in the know who were able to determine subtle differences in quality and technique.

Some of the newer public schools introduced a strict school uniform from the first and this was one of the most visible ways to demonstrate that the new school was of the same class and model as its older counterparts. With more choice available to parents and competition between schools rife, schools that could present the most correct public school image were more likely to attract the wealthier pupils and in doing so increase their income and potentially their social standing and influence.[91]

Details of the public schools were regularly reported in the press and there was a widespread understanding amongst the general public as to their class status. This meant that even if their children did not attend a public school, parents still sought the appearance of prestige that accompanied them. Consequently, the dress of public schoolboys became fashionable across the social spectrum. The most prominent example of this is the huge popularity of the Eton jacket, a short, square, single breasted jacket or 'bumfreezer' that was associated with the lower years at Eton. The garment initially became fashionable in the 1780s for young boys, worn with trousers buttoned over the top, an outfit popularly known as the 'skeleton suit'. Older boys (those over the age of around seven) wore the same style of jacket separated from the trousers. This jacket could either be cut straight across the waist or shaped to a point at the back, known as a 'hussar jacket'.[92]

Towards the end of the 1840s J. Nicholls, owner of a Regent Street department store, followed on from his previous success with the fashionable paletot coat,

by producing and advertising a new design, the Eton jacket. This was a short square jacket, of a style very similar to the earlier skeleton suit design. This style, although widely worn by Eton schoolboys in the lower years was not uniform wear at the school at this date (as discussed earlier) and did not become so for several decades.[93] Additionally, the style was not exclusive to Eton and was simply a normal design of jacket worn by upper-class boys of the period. It must, therefore, be supposed that, as a shrewd businessman, J. Nicholls utilized the elite reputation of Eton to market and sell the item. This line of argument can be corroborated by examining the method and type of advertising for the garment. Advertisements emphasize the quality, fabric and appearance of the jacket (as well as the reasonable price). This is demonstrated in the *Manchester Times* of August 1850:

> A Novelty in Boys' Jackets—H.R. FREEBORN begs respectfully to announce that he has just received a THIRD SUPPLY of the above novel and useful article, the production of Messrs Nicoll, patentees of the celebrated Paletot. They are called for distinction the ETON JACKET, and are made of their beautiful Llama Cloth. They are very durable, exceedingly graceful in appearance, and the prices are very moderate—21 Exchange Arcade, and 91, Market-Street, opposite Spring Gardens.[94]

The dual meaning of the term 'distinction' is noteworthy, indicating the necessity of distinguishing the design from other similar styles, whilst also carrying connotations of the garment being of higher class than the competition. The Eton jacket quickly entered the popular lexicon and was widely adopted by those that could afford it. It was subsequently reproduced by other manufacturers looking to cash in on the trend. The continued presence of advertisements throughout the 1850s testify to the garment's popularity, with the style still listed as one of the 'leading styles for the winter' in an advertisement of 1859,[95] ten years after the design was first produced. Whilst this may be hyperbole on the part of the advertiser, it does point to an enduring popularity.

Some retailers, seeking to continue the commercial success they had found with the Eton jacket, later produced the Harrow and Rugby jackets and suits and these items are listed in an advertisement from 1860 for B. Hyam, a manufacturer associated with a number of retail outlets across Britain:

> HYAM'S RUGBY, HARROW & ETON JACKET SUITS. Three Entire New Styles, becoming in design, serviceable for school or dress wear, and admirably adapted for Young Gentlemen.[96]

In the same manner as Eton, neither Rugby nor Harrow had a formal school uniform in place at this stage and this is, once again, confirmed by the Clarendon Report—in this instance in a conclusive interview with the headmaster of Rugby, Rev. Temple:

> 347. (Lord Clarendon.) Do the foundationers wear any particular dress?—None whatever.
> 348. At no time?—At no time.[97]

This suggests that this was a similar, although less successful marketing ploy to that of the Eton jacket.

Eton jackets (and to some extent Rugby suits) were widely worn for the next thirty to forty years. The sustained nature of the fashion can be seen in Figure 2.4, an 1890s advertisement for Chas Baker & Co., a company which made its name producing good quality, yet affordable clothing. The Eton jacket was adopted as standard smart wear for middle-class boys, usually worn with black trousers, a black waistcoat, a top hat and a wide, stiff turn-down collar.

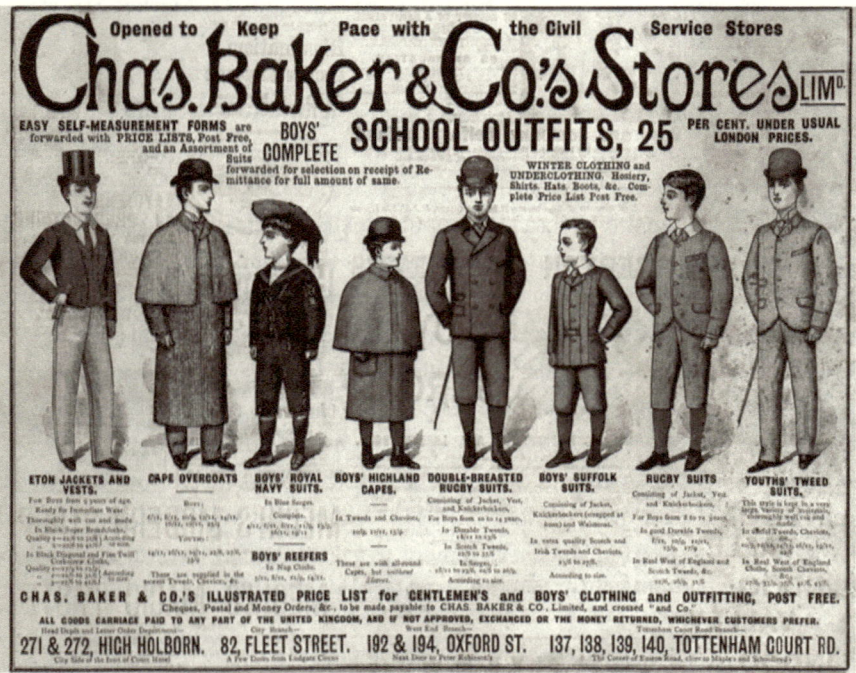

Figure 2.4: Chas. Baker & Co. advertisement, 1892, showing both an Eton jacket and Rugby suit

This latter item became known as the Eton collar and as this was cheaper than the whole ensemble, the collars were adopted by lower-middle and some working-class families as a sign of respectability.[98]

The enduring appeal of the Eton jacket can be garnered from an article in the *Leeds Mercury*, from 1887, which continues to recommend the jacket and collar combination for schoolboys and indicates that the respectable nature of the outfit had not become eroded over time:

> There are tens of thousands of people who will pin their faith to that neat and 'dressy' combination, the Eton jacket, and the broad, white, uncreased and uncrumpled 'turn-down' collar so widely affected, if not so deeply beloved, by youthful snipers at the educational spring, and who will make solemn affirmation to the effect that nothing half so becoming in the way of apparel, or one-tenth so well adapted for all the purposes of its designation has ever existed, or is ever likely to exist ... The costume has many recommendations, not the least of these being that it is anything but cosmopolitan. It is distinctively national, eminently English, and unquestionably respectable; and how refreshingly suggestive of sweet simplicity and boyish faith; how like unto some modernised, humanised, and well-dressed, as well as animate, edition of the Raphael Cherub is the jacketed and collared schoolboy of our age and country![99]

Whilst it is hard to imagine anything less like a Raphael Cherub than a small boy in an Eton jacket, this rapturous and sustained popularity indicates what a powerful status symbol the public schools had become. The emphasis on Englishness is also instructive, demonstrating that the sales techniques related to the Eton jacket had kept pace with changes in the public school ethos, associating Empire and British superiority with both school and garment and reflecting wider notions of patriotism. This association between school uniform and Empire was reinforced by the use of school uniform in colonial situations. Colonial recruits from the public schools founded educational establishments in the countries that they worked in, modelling them closely on the system they knew best, that of the British public school. This also served to imprint colonial ideology and rhetoric onto pupils, promoting concepts of Empire and maintaining existing power structures.[100] Consequently, colonial countries had school uniforms introduced alongside other facets of public school life. Their visible presence in a community setting ensured that school uniforms became

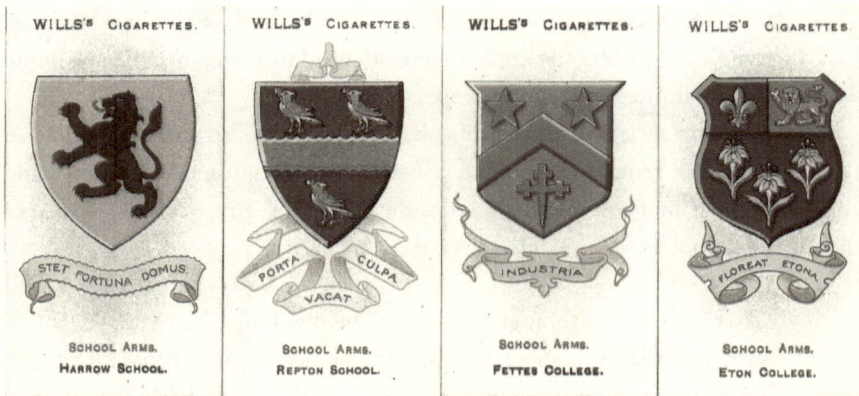

Figure 2.5: A selection of School Arms cigarette cards, produced by Wills's Cigarettes, 1906

a prominent symbol of the colonizing power and of the Empire as a whole, directly linking them with Britain and notions of 'Britishness'.

The interest in the appearance of the public schools continued well into the twentieth century amongst all classes. Several companies including Black Cat Cigarettes and Wills's Cigarettes produced sets of cigarette cards (Figure 2.5) relating to the public schools and the *Boy's Own Paper* printed a series of images of sports colours from famous schools and clubs between the 1880s and 1920s. Imitation is said to be the sincerest form of flattery, and in these instances dissemination and emulation popularized and reinforced the image of the established public schools as bastions of the upper classes, allowing aspiring families to buy into this image.

Harrow—A Case Study

Due to the many influencing factors on the introduction of public school uniform it is, perhaps, helpful to examine it through an individual case study. At Harrow in the mid-eighteenth century it was recorded that many boys dressed very scruffily, although there was peer pressure to have new items of clothing for certain special occasions and senior boys generally maintained a better appearance. This is evinced by the fifteen-year-old Sheridan who wrote to his guardian in 1766 to ask for a new suit, due to the fact that, 'I have lately got into the 5 form, which is the head form of the school, I am under necessity of appearing like the other 5 form boys'.[101] This indicates that maintenance of hierarchical status through clothing and the necessity of conformity were

already factors in the school experience and these themes became much more prominent in the following century.

The school was still without a dress code in 1828, as recorded by senior pupil Lionel Montmorency in his reminiscences 'Scenes at a Public School; First day at Harrow' in the first issue of the *Harrovian*. In this article he recalls 'exquisites in green surtouts and silver buttons' and 'little *V*, with his hands in his pockets, and a dusky red handkerchief round his neck'.[102] These descriptions indicate a flamboyance of dress that is at odds with later ideals of conservatism and conformity. In the following thirty years pupils adopted a uniform dress of round jackets in the lower years and tail coats in the fifth and sixth form. Interestingly, this adoption grew entirely from fashion and peer pressure amongst the pupils themselves. Initially the garments were a reflection of men's fashionable dress, but as tail coats were consigned to evening wear, no longer being worn in the daytime, their continued use created an anachronistic appearance that was at odds with standard daywear. By the time of the Clarendon Report these customs were viewed as an understood and established part of the schooling process. In the words of the headmaster, Rev. H.M. Butler, the wearing of tail coats:

> is due, whatever may be its merits, to a very long tradition. The rule is, that when a boy enters the fifth form, having up to that time worn jackets, for the rest of his time at the school he wears tail coats, and no other but tail coats are worn by the boys in the fifth and sixth forms.[103]

The idea that the practices of a mere quarter of a century can be attributed to 'a very long tradition' is, perhaps, symptomatic of the Victorian fondness for the creation and rapid adoption of traditions. This invention of 'traditional' appearances and celebrations as part of the public school ethos can be paralleled with other invented traditions of the same period, notably those associated with royalty. Mass involvement in these new events or practices cemented their importance and created a conscious sense of history and routine.[104]

At this stage, dress practices continued to be policed by the boys themselves, as explained thoroughly by G.F. Harris, Classical Assistant Master, again in the Clarendon Report:

> 993. The tail coat which they are obliged to wear when they get into the fifth and sixth forms; is that a matter, in your opinion, of great necessity?—It is a matter of their own arrangement. I do not

think we interfere in the slightest degree, with it. We do not require them to wear tail coats at all. It is a question of jackets or tail coats.
994. (Lord Lyttelton.) Would the master prevent the wearing of any other?—The adoption of a tail coat at a certain period of the school is a matter of usage among themselves.
995. (Lord Clarendon.) It is a proof of their status in the school?—Yes.
996. (Lord Lyttelton.) Might a fifth form boy wear a round jacket if he liked?—A parent once tried the experiment. He was very anxious that his son, who was a little boy, should not wear a long coat, and he applied to the Head Master, who said he was at liberty to wear a jacket. The boy wore a jacket for two days, but during all that time he was made so unhappy by his schoolfellows laughing at him that he begged his father to allow him to wear a coat. At that time it was said that it was not at all a school regulation depending on the masters, but on the boys themselves. What we do is to restrict them from wearing all sorts of colours and any cut of coat, except the old dress coat.
997. (Lord Clarendon.) A boy below the fifth form would not be allowed to wear a tail coat, would he?—Only by the leave of the head of the school ... With regard to dress, the real point is whether or no, what are now so very common, morning coats, should be worn instead of dress coats. Some 20 years ago nobody would have thought it a great hardship to have to wear a dress coat in the morning. At present a boy is obliged to have a double outfit; he is obliged to have a morning coat which he wears at home, and which he does not wear out in one vacation, and outgrows before a second, and to have a dress coat to wear at school. The dress coat is the real grievance on the part of the parent. I do not think the boys feel it themselves; some may. Those I have spoken to I think would rather maintain the present state of things.
1001. And wear the sort of coats that are now worn?—I believe they would.
1002. Should you consider that there would be any great objection to changing that form of dress if there was a general wish on the part of the boys for it?—I do not know. It is rather looked upon now in the light of the cap and gown of the university. It is rather distinctive; it enables you to distinguish a boy, and so far it may be an advantage.[105]

In this interview Harris admits that the authorities control the colour of the coats worn, restricting pupils to dark colours and this demonstrates a stage on the way to full regulation of dress. The demarcation of hierarchy through appearance, however, was controlled and monitored by the pupils themselves, with extreme peer consequences for those transgressing the unwritten rules. The development, instigated by the boys, of a recognized hierarchical structure that is encoded in clothing and the extreme pressures to conform reflects earlier discussions. Another issue raised is parental concerns associated with the outmoded style of the uniform and this demonstrates some of the frictions between practicality, tradition, cost and prestige that existed in periods of garment regulation. The discussion also indicates the increasing informality of daywear, as tail coats were ousted as normal wear by morning coats.

Harris finishes by articulating ideas regarding the distinctive nature of the uniform and its consequent usefulness in identifying pupils. This reflects similar statements made regarding charity uniforms in Chapter One. Many schools became increasingly visible to the public in the late nineteenth century, as urbanisation meant that towns grew up near previously isolated institutions. Schoolboys consequently became more in evidence in these communities as they took part in leisure pursuits and accessed local amenities. Distinguishing boys by their unique clothing became relevant to discourage disciplinary infractions and to allow identification if problems arose.

Over the next twenty years the uniform was further codified, with the addition of a straw hat and uniform trousers. Responsibility for the dress also passed to the school authorities in its entirety, as indicated by correspondence in the *Morning Post* of 1886:

> THE DRESS OF HARROW SCHOOLBOYS
> Sir—Will you, through the medium of your paper, enlist the support of the public in trying to persuade the authorities to alter the present senseless and incongruous dress of Harrow Schoolboys more resembling that of Christy Minstrels than anything else, consisting as it does, of tweed trousers, and evening tailcoat of black cloth, white shirt, and white sailor straw hat? It is in every respect unsuitable, as it is hideous to look at, and the boys obliged to wear it are keenly alive to the ridiculous appearance they present. Surely the new headmaster might inaugurate his reign by effecting a striking improvement in the prescribed costume—I remain &c.
> INFELIX PUER[106]

The self-styled 'unfortunate boy' calls for the new headmaster to intervene on the issue of dress, citing a range of problems including the unsuitability of the garments and the strange appearance presented by those wearing them. His comparison of Harrow schoolboys to Christy Minstrels, an American black-face group founded in the 1840s is particularly interesting. Through this description he conjures a very un-British image of the uniforms, at odds with the overt imperialism of the public schools and more general nationalist sentiments of the day. His intention is clear, in attempting to highlight the similarities between the uniform and foreign, lower-class garments, Infelix Puer seeks to discredit the style and highlight its unsuitability for a school in which class and national superiority are important concerns. This is in direct opposition to the earlier quote concerning Eton jackets in which they are commended as 'eminently English'. The correspondent, however, had misjudged his audience and the printed responses indicate both the increased importance attached to tradition in this period and the already ingrained nature of uniform in the public school ethos. Respondents passionately defended the uniform, citing it as a 'time-honoured institution' and 'one for which I see no good reason for changing', as well as reinforcing difference between Harrow pupils and the original correspondent: 'I may confidently assert that during the whole time I was there (nearly six years) I never heard a genuine Harrow boy complain of the dress he was obliged to wear.'[107] The emphasis on the word 'genuine' questions Infelix Puer's credentials as a public schoolboy, indicating that had he been the genuine article he would understand the importance of the clothing in question, demonstrating the successful role that uniform played in inculcating norms.

The notions of the importance of tradition are aired again in a more moderate version of the same debate in an 1889 edition of the *Harrovian*:

> One thing should certainly be borne in mind in a place like Harrow. Unless there are overwhelming reasons to the contrary, we ought to be conservative of everything which is *old* and *distinctive*. Cricket in the yard, squash, and the Contio, are instances of the kind; and another is undoubtedly the Dress Coat. Let us begin then by assuming that if any changes were made in the School Dress the tail-coat at any rate should be retained. It is a genuine and venerable relic of the past.[108]

The distinctive nature of the Harrow uniform is praised and recommended for conservation and this demonstrates an evolution in the concept of public school uniform, tradition had been invoked. In the space of less than sixty

years the uniform had become 'a genuine and venerable relic of the past' and in doing so demonstrating the established nature of the institution. This use of tradition separated the established public schools from the newer imitations and consequently helped to maintain the differences that had been constructed, although it also allowed their younger rivals to create false notions of status and age. Uniforms had transformed from a factor in the process of differentiation to an outward representation of the beliefs of an institution and, as such, the specific clothing of individual schools became imbued with these same values for the wearer. This exemplifies the intricate linkage between the public school ethos and school uniform with each reactive to the other. For instance, the increased emphasis placed on games in the school curriculum (a product of the developing ethos) ensured that practical sports clothing and team identifiers became necessary. In the same vein, ideas relating to loyalty to house and school were both reflected and reinforced through school uniform; uniform visibly advertised a pupil's allegiance, whilst also establishing a sense of belonging and collective identity within the school community. Uniforms also supported class appropriate ideas of masculinity, signalling the status of the wearer, initially through a fashionably correct silhouette and, later, through the retention of anachronistic styles. These practices operated in direct contrast to the charity schools discussed in Chapter One and the use of uniform in other less socially prestigious locations complicates the upper-class-based relationship seen between uniform and the public schools. This meant that whilst those with experience and understanding of the public school system had an awareness of the nuances of public school uniform, to others the intended class-related messages might be less intelligible.

Despite this complication in perception, once established, public school uniforms were seen as an aspirational status symbol by the middle classes. Their visibility meant that they were easy to imitate both as a fashionable item and at other educational institutions; as a result, they became widely worn, first at middle-class boys' schools and, later, at girls' public schools. In this way, uniforms might be considered a victim of their own success. In opposition to the original intentions, school uniform became a tool through which the middle classes could display a similar appearance to the elite and this saw school uniform as a whole (as opposed to the uniform of certain, individual schools) move from a marker of status to merely a sign of respectability.

CHAPTER THREE

Public Schools for Girls 1850–1939

Before the eighteenth century there was very little provision for the education of girls and well-educated women remained an exception. As with boys, the availability of educational resources varied by class, but families systematically favoured the education of their sons over that of their daughters. This was because the prevalent view was that women were intellectually and physically weaker than men and, therefore, had neither the capacity nor the need for academic knowledge. The expectation was that they would pass from the care of their fathers to that of their husbands.

Apart from charity schools, the education that did exist happened within the home and girls were taught by their mothers or, later, by governesses, with priority placed on domestic skills and, in wealthier households, literacy and European languages. From the 1720s a few Ladies' Academies were founded. These were boarding establishments which taught a smattering of general education but focused much of their efforts on teaching 'accomplishments', skills such as needlework, music, dancing and etiquette, which were intended to make upper and middle-class girls ready for the marriage market. During the next fifty years or so these academies proliferated, set up by a range of entrepreneurs, 'do-gooders' and petty crooks—and, as such, the quality of education was hugely variable.[1]

There were some early efforts for improvement, notably from the Blue Stockings Society, a group of women, founded in 1750, who promoted learning through their events and writings. They included radical and forward-thinking members such as Catherine Graham, who launched a number of scathing attacks on the education system for women. Graham heavily influenced Mary Wollstonecraft's famous essay *A Vindication of the Rights of Women* (1792), which had a significant impact on future educationalists.[2] Nevertheless, it was not until the mid-nineteenth century, when the first public girls' schools opened, that an academic education became a reality for upper and middle-class girls. For the first time, girls could study similar subjects to boys and this, in turn,

began to allow them access to the universities and professions. Opponents of women's education, however, questioned women's mental and physical capacity for academic work, as it conflicted with Victorian notions of women's inferiority and their designated role within the domestic sphere. Outward appearances and school dress, therefore, played a prominent role in the image projected by these new institutions. Between the mid-nineteenth and early twentieth centuries, the dress of pupils moved from a position closely aligned with the contemporary feminine ideal to an appearance and identity directly at odds with it, reflecting a wider cultural shift in the way that women's education was viewed.

The process of uniform adoption in early girls' schools is easier to trace and qualify than in boys' public schools as the numbers of girls' institutions remained low until the second decade of the twentieth century, allowing the impact of specific schools and staff members to be traced more clearly. The girls' schools of the nineteenth century were also less established than their male counterparts and consequently less fiercely autonomous. This allowed for a greater exchange of ideas between institutions, creating a primarily supportive, rather than competitive, environment in the field of women's education.

Early Girls' Schools and the Feminine Ideal

One of the first steps in the development of girls' schooling was the foundation of the Governesses' Benevolent Institution in 1843, whose work included developing the knowledge of governesses through public lectures and certification.[3] This project highlighted the poor basic level of education of many governesses and, as a response, the first public girls' school—Queen's College in Harley Street, London—opened in 1848. It was set up with aid and assistance from the professors at King's College and taught courses in a range of subjects not generally available to women, including Latin, maths, science and modern languages. It was essentially a secondary school but, struggling with the low educational level of new starters, the institute soon set up feeder classes as well.[4]

Writing in 1850, the *Quarterly Review* praised the quality of teaching at Queen's College, noting:

> For the last two or three years, then, of a young lady's school room life, attendance at some of the classes of Queen's College may be most beneficial. It is superfluous to observe that, if her curiosity and intellectual ambition have really been stirred, she may expect to find in such an institution teaching far superior to that obtainable elsewhere.[5]

The periodical then moves on to clarify that whilst women might be 'employed in the improvement of their minds' that this was merely to allow them to be 'what God intended them to be, help meets for man'.[6] The contrast between the positive report of the teaching and the sanction on its purpose is indicative of the complexities rife within early women's education and, in fact, the *Quarterly Review* is decidedly moderate in tone given the controversial nature of the subject.

Further public girls' schools followed Queen's College, including North London Collegiate School for Girls in 1850 and Cheltenham Ladies' College in 1853. These early experiments in women's education brought together a number of like-minded individuals, who also began to wage a political and social campaign focused on extending girls' educational rights by allowing them entry into universities and public examinations. Although there was no official women's rights movement at this period (the first national suffrage movement, for instance, was not founded until 1872), informal networks were formed through the feminist publication, *English Woman's Journal* and the discussion group 'The Kensington Society'. These united many early educational pioneers including Frances Buss and Dorothea Beale (both early Queen's students), Emily Davies, Elizabeth Garrett Anderson and Barbara Bodichon.[7] These early female educationalists challenged the prevailing view that women's education should be fundamentally different from men's and relevant only in so much as it provided better wives, mothers or governesses.[8] Instead, most believed that girls should be allowed to sit the same exams and work from the same curriculum as boys. Emily Davies, founding member of Girton (the first women's college at Cambridge), for instance, was firm in her belief that girls should be admitted to the same local examinations as boys, rather than taking a specially created exam, stating:

> My strongest objection to a separate scheme is that the girls' Certificates would not,—in the present state of opinion,—*could not*, have the same value. Even if the Examiners really made the standard quite as high, the public would not believe it ... [a lady] has no way of proving her relative competency.[9]

Davies remained unwilling to compromise throughout a protracted battle on the subject, realizing that unless they could prove girls academically comparable to boys and give them access to all levels of education, it was unlikely that they could move away from rigid Victorian notions of what women were capable of and how they should behave.[10] Academic equality would offer the first step towards women entering traditionally male professions and proving their wider capabilities, particularly to vote.[11]

The Victorian construct of femininity was both pervasive and prescriptive; in essence, a set of social and behavioural rules to which the vast majority of middle and upper-class girls were expected to conform. These consigned women to a predominantly home-focused and child-bearing role and were, in some cases, so prohibitive that the fight for equality was a slow process.[12] Adherence to the feminine ideal was vehemently policed by high-ranking men and women alike. Queen Victoria, for instance, trembled with righteous indignation when she wrote:

> I am most anxious to enlist everyone who can speak or write to join in checking this mad, wicked folly of 'Women's Rights', with all its attendant horrors, on which her poor feeble sex is bent, forgetting every sense of womanly feelings and propriety ... Were woman to 'unsex' themselves by claiming equality with men, they would become the most hateful, heathen and disgusting of beings and would surely perish without male protection.[13]

By publicly expressing opinions or taking part in political or work activities women stepped outside of what was deemed acceptable and were censured as 'unladylike' or socially inferior.[14] Public contraventions of the social code of feminine behaviour could be widely publicized through print media and consequently allegations of 'lacking femininity' had the potential to have a serious impact on any campaign. Thus, a catch-22 situation arose whereby women who fought for change instantly failed to correspond to expected behavioural standards and, therefore, had to clearly demonstrate their femininity by conforming in all other ways in order to be taken seriously by dominant groups.

As a result, the introduction of schooling for women was complex. Opponents saw it as a threat to the established order and were consequently very vocal in their arguments against it. Most of these questioned women's mental and physical capacity for academic work and suggested that concentrated study would produce a generation of unfeminine girls who were incapable of fulfilling their designated roles as wives and mothers.[15] Writing in 1874, Dr Henry Maudsley articulated these views in *Popular Science Monthly*:

> It cannot certainly be a true education which operates in any degree to unsex her; for sex is fundamental ... Consequently, it does not seem impossible that, if the attempt [to educate] be seriously and persistently made, the result may be a monstrosity—something which having ceased to be woman is yet not man.[16]

These ideas were further propagated and reinforced through the popular press—for instance, in 1852 the periodical *John Bull* asserted that academic study:

> is not female education. By female education we understand such an education as shall fit women most effectively to fill the position in society which PROVIDENCE has assigned to them. That position is essentially the domestic circle and the true education for them, therefore, is an education that shall qualify them to fulfil, in the most efficient manner, the duties of domestic life.[17]

Similar beliefs continued to be repeated over a number of decades in a wide variety of forms, as seen in this poem from *Punch* (May 1884), entitled *Women of the Future*:

> O pedants of these later days, who go on undiscerning,
> To overload a woman's brain and cram our girls with learning,
> You'll make a woman half a man, the souls of parents vexing,
> To find that all the gentle sex this process is unsexing.
> Leave one or two nice girls before the sex your system smothers,
> Or what on earth will poor men do for sweethearts, wives, and mothers?[18]

Consequently, the educational pioneers had to work to counteract claims that their campaign for equality in schooling was eroding both their own femininity and that of the pupils they were educating, whilst also demonstrating that women were capable of the same academic scholarship as men. The problem of this double conformity required them to attempt to modify the feminine ideal rather than remove it completely.[19]

Fashion and clothing played a large role in the display and propagation of the feminine ideal. Clothes reinforced the idea of women as passive objects; fashionable apparel was costly, highly decorative and made ease of movement difficult. Thus, women's dress operated as a physical reflection of the restrictive social norms and a symbol of economic dependence on men. Consequently, the fashionable ideal and the feminine ideal were heavily intertwined concepts which worked together to reinforce one another. Fashionable dress represented the accepted external appearance of the feminine ideal and through adopting a fashionable appearance the values associated with the feminine ideal were reinforced.[20] To prove critics wrong and demonstrate that academic education and femininity were compatible, early girls' schools and educators

chose, therefore, to present a carefully constructed image of the feminine ideal, at least in appearance. This was an active process and one that generated its own anxieties. Returning to Emily Davies who, writing in the aftermath of a public meeting on female admission to local examinations, aired her concerns on the subject:

> I want to know whether any of the ladies struck you as strongminded looking. We were afraid Miss Craig wd. have ruined us by her recklessness by inviting anybody that liked to come. She insisted that they had a right to have 'Mission stamped on their brows', if they liked, but I don't think she did any serious mischief. Miss Garrett was sitting very near you, looking exactly like one of the girls whose instinct it is to do what you tell them.[21]

Davies viewed it as important to the success of the cause to present a non-threatening appearance, conforming to notions of correct behaviour and dress. She chose not to contravene normal social practices, instead seeking to challenge the status quo in some areas and not others, limiting public censure.

In early schools, similar beliefs resulted in an enforcement of tight restrictions on pupils regarding the presentation of a 'ladylike' image and a conscious effort by the institution to communicate their high standards of behaviour and appearance to the outside world.[22] Pupils were expected to conform to accepted societal standards of dress and photographs from the mid to late nineteenth century show girls attired in fashionable styles. An 1890 image of a house group from Cheltenham Ladies' College is indicative of this (Figure 3.1)—twenty-two girls are pictured, many of whom appear to have been playing tennis, as a number of rackets are visible. Of these girls, the outfits of four are not identifiable, of the remaining eighteen, eight are visibly tightly corseted (although, regardless of appearances, all would have worn corsets) and there are multiple examples of decorative detailing, most notably the heavily trimmed hats worn by five of the girls. This photograph represents a normal picture of middle and upper-class girls of this period and there appears to have been few allowances made for either the educational environment or the sports session that is suggested by the presence of the rackets.

Normal social practices such as wearing gloves and hats were also rigorously enforced, particularly when girls were out in public spaces. This was an active and ongoing process, remembered by former pupils at St Margaret's during the 1890s:

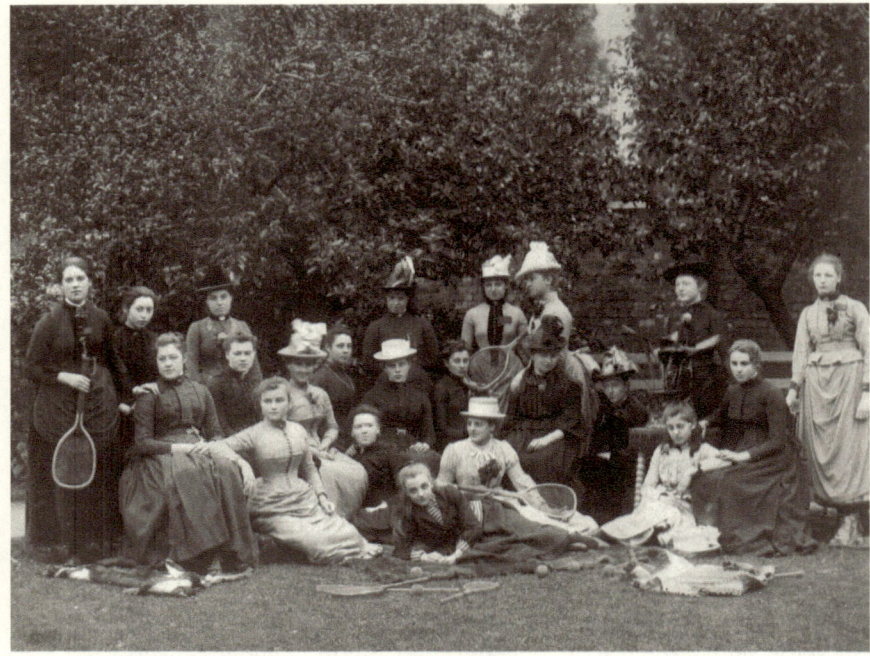

Figure 3.1: Cheltenham Ladies' College House Group, 1890

[pupils] were expected to dress with 'a sense of propriety' … the Misses Duncan used to make spot checks on deportment and behaviour at the end of the school day. One of the ladies started at the top of Union Street, the other at the foot of the street, and they walked towards each other, checking that the girls of St Margaret's were wearing gloves, had their coats buttoned and were behaving in a seemly manner.[23]

Thus, the Misses Duncan monitored both clothing practices and behaviour in order to retain the outward appearances of feminine respectability.

When clothing requests were issued it was usually in regard to specific issues and in line with normal dress practices. For instance, at North London Collegiate School, headmistress Frances Buss wrote to parents in the 1870s with instructions regarding homework and punctuality, but also requesting that girls 'should be provided with thick-soled and warm boots, as the passages are covered with oil-cloth, and the rooms are not carpeted'.[24] Inappropriate footwear might be linked to colds and chills and one of the concerns regarding female education was that it could cause illness in pupils—girls needed to

remain healthy, both to pursue their studies and to dispute this view. In a similar vein, it should be emphasized that whilst norms of feminine dressing were reinforced, frippery was frowned upon and overtly fussy clothing was discouraged. This indicates that whilst gender and femininity were overriding concerns, it was possible to go too far, and excessively trimmed or flamboyant clothing indicated to external viewers that the wearer was overly concerned with fashion and consequently lacking in the wider understanding and ability necessary to complete her education.[25]

These ideas were also closely associated with those of class. Whilst the early public girls' schools did not cater to the working classes, their intake varied between institutions. North London Collegiate School initially catered to the daughters of the lower-middle classes including clerks and tradesmen, whilst Cheltenham Ladies' College consciously excluded such membership, drawing pupils from the children of gentlemen and the gentry. A breakdown of pupils at Cheltenham in 1865 shows that 27 per cent were daughters of private gentlemen; 28 per cent of army and navy officers; 20 per cent of clergymen; 18 per cent of civil servants, doctors and lawyers; and just 7 per cent of bankers and merchants.[26] Maintaining a class-appropriate image at Cheltenham would have consequently been important in attracting the right clientele, in much the same manner as the elite boys' public schools, which might explain the strong emphasis placed on clothing at the institution. This is indicated by headmistress Lillian Faithful who introduced uniform to the school in 1907, stating:

> One of the advantages of a school uniform is that it keeps a girl from too much thought about her dress ... the existence of a school uniform makes it impossible for parents to dress their children in a grotesque fashion.[27]

Whilst clearly deploring vanity, her use of 'grotesque' in this context is more open to interpretation. It may simply refer to impractical, heavy and restrictive clothing, but it is also possible that it encompasses issues concerning visible distinctions of status. Class markers, particularly over-decorated, showy garments favoured by some members of the aspiring middle classes might have been a problem. As well as the emphasis on practicality, the implementation of uniforms or dress codes helped to remove individual and, perhaps, inappropriate symbols of class.

Parallels can be drawn between these early efforts to control external appearances and reinforce femininity in an educational setting and similar tactics employed by supporters of women's suffrage. As in the case of girls' schooling,

the actions of suffrage supporters challenged the dominant definitions of what women were and what they were capable of; consequently, dress was important in the public image that the suffrage movement presented.[28] Predominantly, suffrage supporters chose to dress conventionally in unconventional circumstances, demonstrating that women did not need to become like men to be worthy of the vote and emphasizing femininity through clothing even whilst involved in what were considered to be unfeminine acts.[29] This was particularly important as those fighting for the vote, in the same manner as female educationalists, did not see themselves as purely oppositional, instead seeking an equal position within the current social, political and educational system.[30] As in schools, frivolousness was also discouraged to refute accusations of a lack of female intelligence and practical capability. This created a fine balancing act between acceptable femininity and the perception of feminine silliness and flightiness.

Where the two situations differ, however, is the ability of leaders or teachers to exert control and authority. In a public school, dress could be actively monitored and girls who contravened normal dress practices could be reprimanded, as indicated by the Misses Duncan and Lillian Faithful. On the other hand, suffrage leaders could only make recommendations, rather than directly control the dress of their members. As a solution to this problem, the National Union of Women's Suffrage Societies adopted a suffrage uniform in 1914 of a dark green coat and skirt, white blouse, red tie and green felt hat. It was cheap, serviceable and in suffrage colours, but it also followed the fashionable silhouette of the period, allowing women involved in the movement to appear business-like while retaining their femininity.[31]

Sportswear and Uniform

As in boys' schools, the regulation of sporting dress preceded the implementation of general uniforms. The reason for this was two-fold: practicality of dress was more important in sporting activities than daywear, as long skirts and corsets restricted movement and prevented the health benefits of sport being realized. In addition, such activities initially took place in private environments where the girls were fiercely protected from public view and less feminine attire was unlikely to excite comment or stricture. In boys' schools, however, the emphasis remained more firmly on the practical, whereas in girls' schools sporting dress still had to satisfy the demands of a feminine appearance.[32]

The first specially designed and widely worn sports clothing for women (with the exception of riding habits and, perhaps, bathing costumes) can be traced

back to Dr Dio Lewis's seminal book *The New Gymnastics for Men, Women and Children* (1862). Although American, this book enjoyed international popularity and the proposed gymnastic regime was adopted throughout America and Europe, including in many early British girls' schools.[33] Miss Buss, headmistress of North London Collegiate School, praised the system in her submission to the 1864 Taunton Commission Report and detailed that the schoolgirls spent at least twenty minutes engaged in the activity four to five times a week.[34] Dio Lewis also recommended suitable clothing for women undertaking his exercises, which he described as follows:

> [the dress] is made very loose about the waist and shoulders, worn without hoops, but with a thin skirt as near the color of the dress as possible, and only stiff enough to keep the outside skirt from hanging closely to the legs.[35]

The full-skirted design of this garment with a clearly defined waist (see Figure 3.2) echoes contemporary fashions and the shorter length of the dress worn with a bifurcated undergarment reflected both the bloomer and bathing dress of the 1850s and 1860s.[36] This suggests that the appearance, although new in this context, formed part of a fashionable understanding that was already present and allowed the outfit to be accepted more readily, particularly when produced in stylish colours and fabrics.

Outfits of this style began to be adopted for private gymnasium and sporting wear. However, proponents continued to stress the feminine nature of the

Figure 3.2: Illustration from *The New Gymnastics for Men, Women and Children* (1862), showing the Dio Lewis gymnastic suit

garment, as in this excerpt from an 1867 edition of the *Queen* in an article regarding the newly opened Liverpool Gymnasium, the dress was

> of all colours, scarlet, mauve, violet, white and Rob Roy tartan, the long tunic and Turkish trousers, confined a little above the ankle, a sash around the waist sometimes giving occasion for a display of a little finery in the shape of gold fringe, & c., and thin boots comprise the eminently graceful, and, be it added, not in the least unfeminine costume.[37]

The author goes on to emphasize that femininity can exist alongside both the outfit and the sport itself, as it had been suggested 'by several estimable persons' that:

> Gymnastic studies are identical with 'fastness', are apt to make young ladies at all inclined to be rapid, more so, and while they develop chest and muscles, encourage other developments more masculine than becoming. We have not, as far as our experience goes, seen anything either in dress or work to confirm this. The former, we repeat, is eminently graceful and becoming; the latter need call for no display of any masculine or rollicking proclivities, supposing for one moment that our fairest and dearest possess them.[38]

This illustrates an additional concern with which girls' schools had to contend: the conflict between sport and the feminine ideal.

Games were played from the outset in many of the girls' public schools, but at first these tended to be sedate and uncompetitive. Soon, however, physical exercise attained a greater emphasis due to the increasing fashion for it in boys' schools and in society as a whole. Consequently, lacrosse, hockey and cricket were being played at a significant proportion of girls' schools by the beginning of the twentieth century.[39] Here, too, femininity was called into question—detractors feared for the suitability of competitive games for girls and their arguments showed a great deal of similarity with those against female education. Concerns were raised that delicate girls would suffer from the rigours of organized sport and that vigorous exercise could harm their reproductive capacities.[40] In addition, competitive sport was strongly associated with the boys' public school ethos and energetic activity had become a way in which masculinity was defined. Resolving issues of practicality versus femininity became vital in allowing sporting activity to continue whilst pacifying opponents and

demonstrating that femininity and sporting freedoms could co-exist in the same manner as femininity and educational freedom.[41] McCrone explains this process in her book *Sport and the Physical Emancipation of English Women*:

> The gradual acceptance of girls' school sport as compatible with femininity resulted from protracted negotiations and compromises that reconciled the apparent conflict between games and appropriate female behaviour ... the upshot was that the sporting schoolgirl like her college sister, simultaneously accommodated to and challenged traditional bourgeois mores.[42]

This process of negotiation can clearly be seen in the implementation of school sporting dress. The first recorded appearance of designated sports clothing for girls in a school environment occurred at St Leonards. Founded in 1877 in St Andrews, St Leonards was the first girls' school to be structured along similar lines to a boys' public school, replicating both the house system and the rhetoric of organized games that had gained popularity in the public schools by this time.

The first headmistress of St Leonards, Louisa Lumsden, was an early advocate of dress reform, particularly for exercise. Writing in her autobiography many years later, Lumsden noted: 'Dress may seem a trifling thing, but even from childish days it had worried me. I wanted to be free to run, jump and climb trees, and when later crinolines came into fashion I, of course, detested them.'[43] With this quest for freedom in mind, Lumsden designed and implemented a gymnastics uniform from the beginning. This outfit bore a resemblance to the Dio Lewis design, consisting of a blue knee-length belted tunic worn with knickerbockers or trousers. The two differed, however, in that the St Leonard's tunic was made in one piece as opposed to the skirt and blouse suggested by Lewis (see Figure 3.3). The design was allegedly adapted from one worn at a Belgian school, probably Chateau de Koekelberg which Lumsden attended for two years as a teenager.[44] In the ten years since the *Queen* article the Dio Lewis style had gained some form of social acceptability in a, predominantly private, sporting context and this tempered the pioneering nature of the decision to implement something similar as a uniform. Initially the uniform allowed a good deal of variety—the length of trousers worn, shade of blue, and trim were all open to personal preference, although the pattern was soon standardized across the school. The tunics subsequently went through a number of relatively minor design iterations in which double and single breasted as well as yoked styles were trialled. Although originally designed only for gymnasium wear, the uniform began to be widely worn in other locations, particularly the playground as it

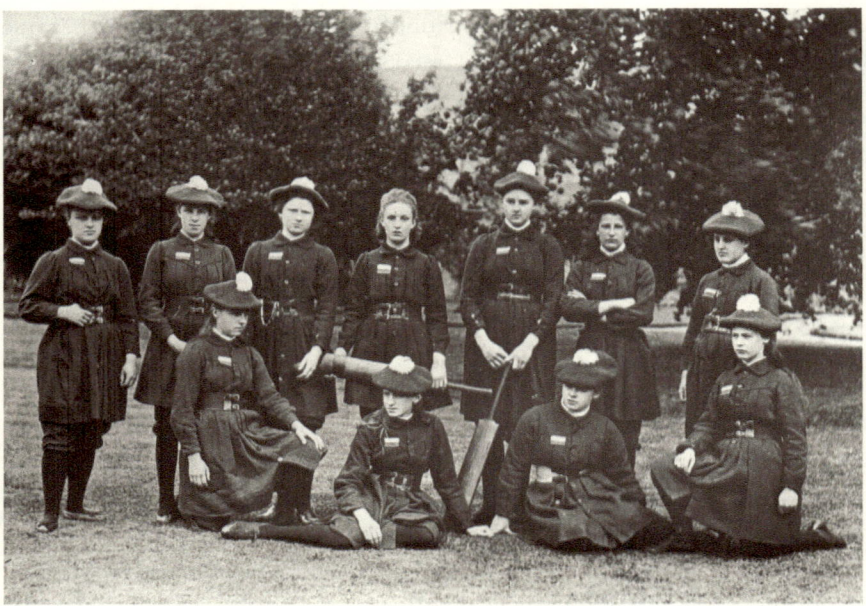

Figure 3.3: St Leonards House Cricket Team, *c.*1891, showing the second tunic design, St Leonards, St Andrews

allowed a greater ease of movement and was more comfortable than the current fashions. Its discontinuity with ordinary dress, however, prevented it being worn outside the high-walled precincts of the school.[45]

Following in the footsteps of St Leonards, sports uniforms were adopted at other schools. At North London Collegiate School, Miss Buss introduced a games uniform in the 1880s.[46] As her friend Annie Ridley recorded in her biography:

> Suitable clothing was also a matter of careful consideration. Miss Buss would have liked a school-uniform, which she would have made graceful as well as rational; but, except in the gymnasium, she never attained this desire, and had to content herself with at school advising, and … compelling, the most needful reforms.[47]

The maintenance of a graceful appearance emphasizes the importance of appearing feminine and the tone of the excerpt hints at the careful path that girls' schools had to tread to combine innovation and social acceptance. The fact that Miss Buss never achieved full school uniform is also instructive, as this would have been too controversial in the period in question. The gymnasium

costume of Buss's era variously consisted of 'short, loose dresses, in colour dark blue, trimmed with light blue' as recorded by the *Girls' Own Paper* in 1882 and later, a full skirt worn with a white blouse and coloured sash.[48] These outfits do not, however, seem to have been compulsory across the school.[49] This changed in 1899 when an obligatory games uniform was introduced. In the January 'Prefects and Monitors Minutes' it is noted that the headmistress 'Mrs Bryant expressed her satisfaction at the introduction of the gymnasium dress and explained that a few girls leaving at Easter had been allowed to be exempt from wearing it'.[50] This outfit is described a few years later in 1912 in a letter to parents as:

> A navy-blue serge costume ... It consists of a blouse, knickerbockers, skirt; navy-blue hair ribbons and waist belt (two-inch petersham, with plain steel hooks), sky-blue Windsor scarf, black stockings, black shoes without heels. The skirt reaching only to the knee should be slightly gored, and buttoned onto the waistbelt of the blouse.[51]

Photographs confirm that this was also the design of the 1899 uniform and the description and images closely resemble the St Leonards style in cut and colour.

The increase in both female engagement in a range of sports and the increasing acceptance of female sportswear was not just confined to educational settings. For instance, female rowers on the Thames are recorded in 1889 as wearing:

> a jersey that gives their arms full play. In colour it is white, blue, red or pink, but the skirt is generally dark blue southern serge or some washing material and the costume is completed by a sailor hat and a loose fronted jacket to wear when cooling down after a long pull in the sun.[52]

This same nautical theme is seen at Roedean which, in the 1890s, introduced a blue and white sailor blouse and above-the-ankle navy skirt for gymnasium wear.[53] In comparison to the St Leonards model, this ensemble was less forward-thinking and more reflective of current modes, offering an appearance between fashionable and athletic dress, a compromise also seen in the sporting wear of American colleges of the period.[54] This greater reticence in sartorial issues can perhaps be explained by the varying educational views of the headmistresses and the comparatively isolated location of St Leonards, which allowed less public intrusion and consequently greater privacy for experimentation.

The sailor blouses offer a link to the nautical influences seen in children's clothing—a vogue that became popular from the mid-1860s.[55] The look remained widely prevalent in various guises for decades afterwards and its enduring popularity can be tied to the mass consumption of military, imperial and patriotic themes in literature, educational texts and other aspects of visual culture. This worked in conjunction with changing holiday practices, particularly an increase in the popularity of the seaside as a holiday destination, which demanded a new form of practical leisure clothing.[56] Towards the end of the century, the sailor suit entered girls' fashions and in doing so many of the overt military overtones became diluted and, instead, assumed connotations of fashionable leisure. The suit usually took the form of a sailor blouse, blue pleated skirt, double-breasted short reefer jacket and sometimes a boater, and the new games uniform at Roedean closely followed this pattern.[57] The uniform consequently presented a fashionable and socially normal recreational appearance, whilst providing greater freedom of movement in the loose cut blouses of the style. It might also be argued that the sailor suit's origins in children's clothing placed it within a context of intellectual inferiority and domesticity, consequently making it less threatening and, therefore, softening the appearance of the sporting woman. Interestingly, there has also been the suggestion that this British fashion formed the basis for the iconic Japanese girls' sailor suits, which are still widely worn as school uniform today. These were first introduced in the 1920s and although their origin is not entirely clear, popular myth indicates that the first instances of this style were designed by a student teacher who had spent several years working in Britain prior to moving to Japan to become a headmistress.

Views on female sport gradually changed into the twentieth century and the number of sports that girls were allowed to take part in and the places that they were allowed to play them diversified. By 1913 attitudes to girls' games had changed sufficiently for C.E. Thomas to advise girls thus in his sports manual *Athletic Training for Girls*:

> The lessons learned on the playing fields in the matter of self control, the sinking of the individual for the sake of the team, and the other good qualities brought about by a hard-fought match, can be as lastingly beneficial to a schoolgirl as to her brother.[58]

This increase in sporting freedom over the latter part of the nineteenth century and early twentieth century is embodied by the invention of the gymslip. An item which became one of the most ubiquitous and widely worn pieces of

girls' school uniform. A sleeveless tunic with a box-pleated, knee-length skirt attached to a square yoke, the gymslip was revolutionary in that the weight of the garment hung from the shoulders and the cut did not constrict the figure in any way, although it was often tied loosely around the waist with a braid belt. It was an invention emanating from the Hampstead Gymnasium, an institution founded by Madame Bergman-Osterberg in 1885 to train sports teachers for girls' schools in a range of disciplines including swimming, gymnastics, tennis and fives. Attendees at the Gymnasium originally wore a version of the Dio Lewis gymnastic suit, but by the early 1890s Osterberg felt that this outfit was too cumbersome for the expanded range of sports on offer. The gymslip was designed in 1892 by one of Osterberg's students, Miss Tait, and it was implemented as uniform soon after, worn with a blouse and knickerbockers beneath.[59] The gymslip spread to other institutions as the teachers who had been trained by Osterberg took up teaching posts and introduced the garment to their new schools for sporting activities. As the only sources of trained female sports teachers, Osterberg's students were widely employed and consequently the spread of the gymslip was rapid and over the following twenty years it replaced the Dio Lewis style of suit as the sporting garment of choice in most schools.[60]

Although sports uniforms evolved throughout the second half of the nineteenth century, school uniforms outside of the gymnasium were not generally introduced until the early twentieth century. As girls' public schools became a more established concept and some of the fears regarding female education proved unfounded, headmistresses began to have the security to experiment educationally within certain limits. This move was assisted by wider reforms in the fields of clothing and women's rights. During the late nineteenth and early twentieth century there was a move towards greater freedom and practicality in girls' dress. This was brought about through a combination of the 'Rational Dress Movement' and the increasing emancipation of women.[61] Founded in London in 1881, the Rational Dress Society made it its mission to draw attention to restrictive corseting and campaign for greater mobility in dress, particularly for children and young people. This was reflected in mainstream fashion by a move towards more practical and tailored women's wear with less restrictive undergarments and later by rising hemlines.[62]

Day Uniforms

Full school uniform was introduced in one of two ways, both of which were gradual processes indicating the still tentative approach favoured for visibly new ideas in girls' education. Pupils were encouraged to wear their sports uniform

during other lessons, which was increasingly policed until it was officially adopted as a day uniform. Alternatively, schools began to introduce dress codes or simple uniforms which became progressively stricter with more and more specifically regulated items. The former situation can be noted at North London Collegiate School. In December 1899, less than a year after the introduction of gymnasium wear, the headmistress Mrs Bryant recommended 'wearing the gymnasium dress all morning' during lessons.[63] This suggestion is also reflected in the 1907 book, *The Heritage of Dress*, which discusses girls' school wear:

> The introduction of exercises in the gymnasium has necessitated the adoption of a drilling dress in very many cases, but there are schools where such a costume is generally worn at all times, and others where it forms the working dress, while long skirts are put on when no active exertion is expected.[64]

The adoption of gymnastic wear in the classroom is symptomatic of the acceptance of both girls' sport and sporting wear in the last decade of the nineteenth century. Although women continued to be expected to dress in line with dominant fashions on the street, less public spaces, such as schools, resorts and private sports clubs, became locations in which some blurring of the sartorial boundaries was tolerated.[65] The increased practicality that this change in attitude offered was, however, still moderated by concerns of propriety. This is indicated through the addition of longer skirts over gymnasium wear in some situations which created an appearance more in line with normal dress expectations. For instance, in the same 1912 letter to parents (referenced earlier), North London Collegiate School clarified that 'A longer skirt may be worn over the gymnasium dress, except during drill'.[66] This ensured that girls travelling to and from school, particularly in populous areas such as London, maintained correct appearances and avoided censure in public.

The process of adoption of sportswear as daywear is also evident at the many schools that adopted the gymslip as day uniform. Over the following decades the garment continued to gain in popularity and by the 1920s it was extremely widely worn. Whilst the style of the gymslip changed very little over the period from its invention until the Second World War, the colours, fabrics and way that it was worn varied. At first the gymslip was black or navy, but it later appeared in many colours. For practical purposes, these were usually darker in hue, although a decadent scarlet version, with a velvet yoke is noted by *The Heritage of Dress* at Croft School in 1907:

It consists of a tunic without sleeves, of red material with a velvet yoke, and shoulder straps. As a finishing touch there is a girdle tied loosely in a bow. It is not placed around the waist proper, but drops towards the left knee as did the sword-belts which the knights in olden times wore over their armour. A white silk blouse shows above the yoke round the neck and has full sleeves. The knickerbockers in this case are made of red knitted stockinette instead of cloth. The costume is a modification of that used in Physical Training Colleges, where the tunic, however, does not reach to the knee.[67]

The girdle is of note and although it is worn loosely below the waist in this instance, in general it can be seen to follow the current waistline. Photographs from the 1920s, for instance, show a narrow belt worn very low around the hips in imitation of the fashionable silhouette (see Figure 3.4). The undergarments, too, follow fashion and dress norms. Initially gymslips were worn with a high-necked blouse beneath, this then became a softer, round-necked garment and, later, masculine-styled shirts and ties were introduced to many schools.

Underwear was also a concern. Starting school in 1927 Lorna Arnold writes:

Figure 3.4: Girl wearing a gymslip with a very low girdle, 1929, Tunbridge Wells Girls' Grammar School

> My daily outfit consisted of woollen 'combs' and a 'peter pan bodice' with home-made navy-blue knickers and either a blouse or woollen jumper. Over the knickers and blouse went a box-pleated gymslip and a cardigan.[68]

The woollen 'combs' are combinations, close-fitting vest and drawers worn next to the skin and the 'peter pan bodice' appears to be version of the liberty bodice. The knickers were designed to go over normal undergarments and were initially almost bloomer-shaped in style and later became smaller and less cumbersome. They were often made in the same fabric as the gymslip itself. The intention of these garments was to preserve the modesty of the girls, preventing the accidental display of underwear. This was particularly important in girls' schools, as modesty and respectability went hand in hand. In middle-class households, reputation rested on the chastity of daughters and such garments also served, in much the same manner as the shapeless gymslip, to conceal any dangerous notions of sexuality. This idea is articulated by Sara Burstall in her memoirs of her time as headmistress of Manchester High School in the early twentieth century:

> The improvement of the Manchester tramway system also helped us much, enabling girls to travel more pleasantly and safely; especially as they had the protection of the school colour on the school hat.[69]

Burstall suggests that school uniform, in visibly demonstrating the age and allegiance of the girls, protected them from unwanted adult attention, particularly that of men, a situation that has been reversed in more recent times.

St Leonards, Roedean and Cheltenham Ladies' College took the alternative route, slowly codifying daywear into uniform. In 1887, Miss Dove, then headmistress of St Leonards, is said to have introduced school boaters—a first step in uniformity—in the aftermath of a picnic in which her sensibilities were offended by the patchy appearance presented by the school. School cloaks were added soon after to protect the girls from the worst excesses of the Scottish winter. The design was copied from a travel souvenir, a peasant cloak from the Pas de Calais brought home from France by Mrs Aitken, a lady local to the school. As an item of clothing it became a widely imitated fashionable accessory amongst her friends and acquaintances. These included Miss Dove, who introduced the cloak to the school as uniform wear in dark blue, lined with the house colour.[70]

These early uniforms tended to offer quite a lot of personal choice and closely followed the fashionable silhouette of the day. Around the turn of the

century, Wycombe Abbey listed 'Regulation Garments provided only by the House Mistress' as 'A Hat, Cap, Cloak, Skirt, Gymnastic Suit, Muffler, Belt and Playground, Gymnastic and School Shoes'.[71] The hat was a boater and the cloak lined in house colours. It is easy to draw parallels between these items and the early uniform garments at St Leonards—this is because there is a direct link between the two, with Frances Dove, former headmistress of St Leonards, resigning her position to found Wycombe Abbey and the influence of her previous school can clearly be seen in the uniform list.[72] The many other items required by a Wycombe Abbey schoolgirl including '1 Best Dress', '4 Blouses', '1 Warm Evening Dress for every day' and '1 Jacket', however, were left to the discretion of pupils and parents providing they were clean, neat and suitable.[73] A photograph from around this period (Figure 3.5) shows the girls sporting flared, floor-length uniform skirts with narrow waists and an array of different blouses with high necklines and 'leg of mutton sleeves', the neckwear is also varied. The image created closely resembles an alternative style of dress of the period, known as the 'Gibson Girl', a look which retained the fashionable silhouette but was tailored and masculine in appearance. It was named after the American cartoonist Charles Dana Gibson, who famously drew young ladies, often in educational settings, attired in it. A similar image to this must

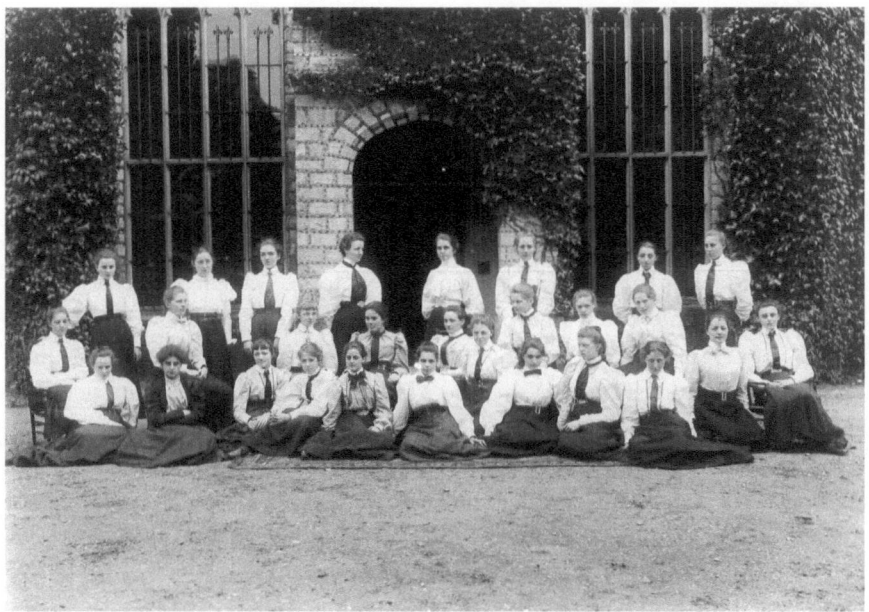

Figure 3.5: Wycombe Abbey House Group, 1898

have been presented by Cheltenham Ladies' College, as by 1912 the uniform consisted of a full-length navy serge skirt (linen for summer wear) worn with a choice of blouses and a house tie.

The contrast between this image of Wycombe Abbey and that of Cheltenham Ladies' College less than twenty years earlier is striking and demonstrates the increasing acceptance of female education. This, in conjunction with wider dress reform, allowed a less consciously feminine style of dress. The image also situates girls' clothing within a wider field of masculine imitation. In the second half of the nineteenth century women began to adopt items of male attire, particularly ties, hats, shirts and tailored jackets. For instance, the Eton jacket, symbolic of school-age boys, became incorporated into fashionable women's dress from the late 1880s, in much the same manner as the sailor suit. In newspaper advertisements between 1880 and 1900, the term 'Eton jacket' becomes more clearly associated with female fashion and women's periodicals than suppliers of boys' clothing and is applied to a wide range of open-fronted jackets:

> The Loose-fronted Eton Jacket—Not the short shape, but the one that comes well below the waist, is still a great favourite, and I am not surprised, for it is both pretty and comfortable, a very rare combination.[74]

The greater degree of comfort noted in the advertisement might be one of the reasons for the adoption of such masculine items. These tailored outfits were also more practical and, in the case of working women, operated as a signal of independence.

Additionally, such appropriation can be viewed as a non-verbal claim to sexual equality and an assault on masculine authority. This was particularly pertinent in the field of girls' schooling. It was felt strongly by many of the promoters of female education that for girls' public schools to be considered academically equal to their male counterparts they should appear comparable in all ways. In this vein Frances Dove, writing to prospective parents in 1896, confidently stated that the education at Wycombe Abbey would be 'as complete on all its sides as that given to boys at the great public schools'.[75] Thus girls' schools strove to emulate boys' public schools closely and this dictum gathered support towards the end of the nineteenth century and set in motion a widespread imitation not only of the curriculum, but of many facets of boys' public school life, from the ethos to discipline and the house system.[76] As a result, many elements of girls' schooling were gradually formalized to bring them in line with boys' schools. This is particularly evident in the field of clothing—imitating the dress of the

boys' public schools was a very visible method of symbolizing the similarity between the two. Items such as ties and masculine-style shirts became girls' uniform wear, with house ties often being one of the first fully regulated pieces of uniform.

This imitation, however, occurred within limits. The appropriation of garments in schools was from the top half of the body only and these were initially mixed with elements of more fashionable dress to ensure that femininity was not entirely compromised.[77] Trousers were not adopted as there was still too greater controversy attached to women wearing them. It was asserted that trousers and bloomers would lead to immodesty and immorality in the female sex, a significant concern when the purity of girls was paramount to social position.[78] Trousers were seen as a prominent symbol of masculine authority. Their appropriation, therefore, represented a loss of power and status for the patriarchy.[79] This reflects some of the fears associated with female schooling and, as such, schoolgirls wearing trousers would be viewed as a direct attempt to usurp the dominant male culture. Bifurcated garments were consequently avoided by educationalists still wary of causing outrage.

A few schools initially rejected these moves towards masculine styling but did embrace ideas of dress reform, and these decisions reflect the less militant educational views of the headmistress and other senior staff members. At Roedean the first uniform was implemented in 1906. The design consisted of a dress known as a 'djibbah', which was a fitted, but uncorseted garment with a round neckline and a slightly flared skirt that fell just below the knee but allowed greater ease of movement than current fashions. It was supposedly inspired by the garments worn by Dervish warriors in Somalia, an item which would have had a social prominence at the time due to the skirmishes between British and Ethiopian powers, and the Dervish state.[80] The term 'djibbah' is now used to describe a long, collarless coat worn by Muslim men. A surviving Dervish djibbah held at the Queen's Royal Lancers and Nottinghamshire Yeomany museum shows striking similarities with the design of the Roedean uniform, suggesting that such a garment, or something similar, had, indeed, been seen by the designer.

The djibbah had entered the popular lexicon a few years previously as evinced by a 1902 article in the Chicago Tribune which claimed that 'The djibbah has captured London society'. The piece goes on to describe a design which closely resembles the Roedean djibbah except that it was longer.[81] The style was adopted by creative and reform circles but appears not to have had a large impact on fashionable dress, although notable wearers included journalist and bordello owner Cora Crane, and actress Mary Ansell (the wives of Stephen Crane and J.M. Barrie respectively). Its unusual appearance and focused uptake

meant that it became a literary trope applied to the wealthy, eccentric and artistic.[82] Its adoption in the school environment was, therefore, rooted in an existing fashionable and feminine aesthetic, but it also reflects more *avant-garde* elements of reform clothing. During the day a short-sleeved navy djibbah with a cream yoke was worn with a cream blouse beneath; this was also worn for games. During the afternoon and evening the girls changed into a silk or velvet djibbah, depending on the time of year, which was worn slightly longer. These could be any colour and were customized with embroidery on the yoke, the designs for which could be chosen from a pattern book at the school outfitters, Forma, or designed by the girls themselves; usual themes included birds, trees and flowers (see Figure 3.6). These designs might be seen to reinforce the

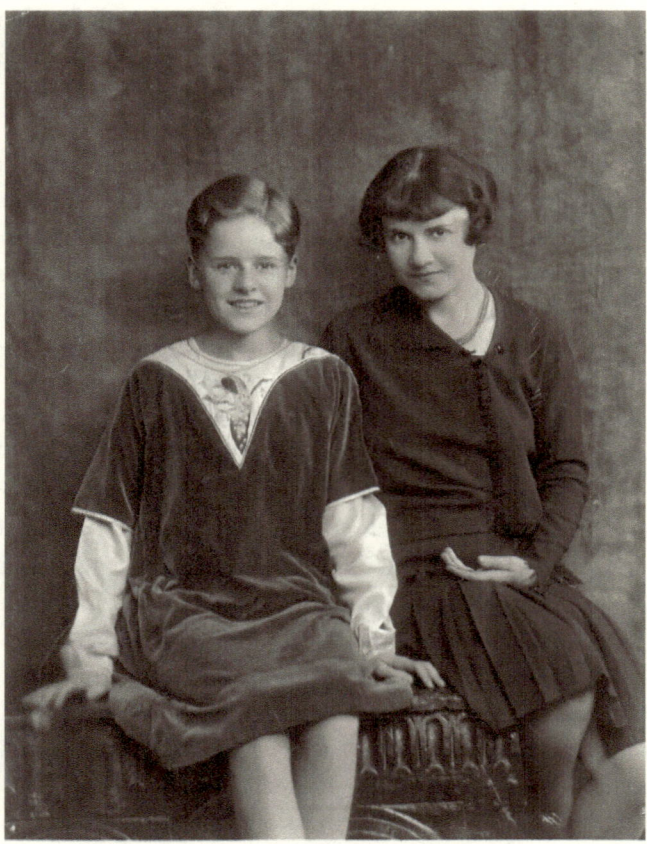

Figure 3.6: Roedean pupil Netta Lewis with her mother, *c.*1928
She wears a velvet afternoon djibbah with an embroidered peacock on the yoke. Roedean School Archive

feminine aspects of the garments, whilst also mirroring the contemporary Art Nouveau movement.

These early uniforms and regulation garments were spread through staff movement. The number of female teachers and educationalists working in the girls' public school sector was still relatively small in the early twentieth century and many teachers were former public school pupils themselves. The small size of the teaching population and the fact that most teaching staff had attended similar institutions created a somewhat insular community and the experiences of clothing regulation as a pupil or young member of staff seems to have heavily impacted on the uniform practices implemented later. As staff moved from one school to another, often ultimately founding their own, they took ideas, and sometimes even specific garment designs with them and this can be seen through instances of garment diffusion.

This process has already been noted between St Leonards and Wycombe Abbey and with regard to the house cloaks, but it can also clearly be seen with the spread of the djibbah. Ex-staff and former pupils of Roedean implemented djibbahs at other schools including Downe House in Kent, where the founding headmistress, Olive Willis, was a former pupil and teacher at Roedean. She implemented green wool djibbahs upon opening in 1907 (see Figure 3.7). Djibbahs

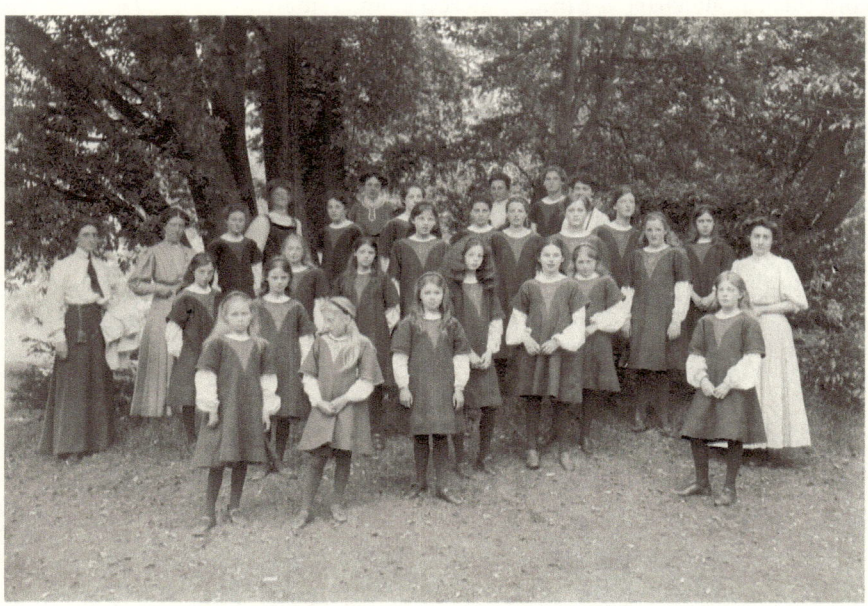

Figure 3.7: Downe House School photograph, 1909
Downe House Archives

were also introduced at other public girls' schools including Coombe Hill School and Cheltenham Ladies' College, which made the change to them in 1926.[83]

Whilst djibbahs and gymslips were originally of very different design, as time progressed, the two concepts seem to have merged to some extent and by the interwar period the two words appear in some geographical locations as interchangeable, usually to describe an item of the same or similar design to a gymslip. For instance, photographs of Sherborne Girls' School from 1915 to 1918 show girls wearing velvet yoked gymslips, but these are consistently referred to as djibbahs in school literature.[84] Hybrid garments also developed, at Bridlington High School a tunic called a djibbah was uniform between the wars. This was roughly the same shape as a gymslip, but without a yoke or defined pleats and was worn with shirt and tie beneath. The garment also retained elements of the Roedean djibbah in that there was floral embroidery across the chest area.[85] An early twentieth century prospectus for the school shows the girls in traditional gymslips, so this outfit must have been adopted at a later date.[86]

Formality and Conformity

Once uniforms were established, the drive to imitate the strict uniform standards in boys' public schools became ever more prevalent and self-sustaining and this can be charted through increasingly regulated uniform lists. This is particularly apparent after the First World War when the female emancipation that the conflict brought intensified the striving of many of the large public girls' schools to run like male institutions. This process can be illustrated through the changing uniform demands placed on pupils and their families at Wycombe Abbey. In 1922 the list of regulation attire, provided in a specific pattern and fabric by the school, remained the same as in the 1900s, but the colour of everyday skirts, coats and blouses is dictated as dark blue and white, respectively.[87] Only three years later, however, in October 1925:

> The special regulation garments provided at the School are Hat, Cloak, Gymnastic Suit (Tunic, Knickers with Linings), Overblouses, dark blue Cardigan, Shoes (gymnastic and playground), overall, ties, dark blue Mackintosh and Mackintosh Cap. Tan stockings can also be supplied if required. Girls must also have galoshes, which may be obtained at school.[88]

By December 1932, further additions to this list include a blazer, sweater and scarf. The instructions for the unregulated uniform have also become

much more detailed, with the description for the coat evolving from '1 long, dark blue coat' in 1922 to '1 long, navy blue coat, plain, without fur or other trimming' in 1932.[89] In the same way, many other schools made the gradual move to expansive and carefully controlled and monitored uniform lists, with uniforms predominantly taking the format of a gymslip or a skirt and shirt with blazer and tie.

This drive for conformity and equality was successful, at least in terms of appearance, and this can be noted in a move from discussing boys and girls school uniforms in separate terms to an assumption of innate similarity between the two. This is demonstrated in the *Devon and Exeter Daily Gazette* in 1929:

> To the mothers of children at boarding schools the times when it is necessary to renew the school outfits come round very quickly. What a business it is! The visits to the drapers and outfitters, shoemakers and dress makers, take up hours of time, and then if everything is not of absolutely regulation pattern and all their belongings are not exactly like that of everyone else, the children are not satisfied. Some boys are more particular than girls about the absolute rightness of their things ... Most schools state clearly what the requirements of every child are, and they give patterns of the school uniform or state where it may be obtained. Where there is no regulation uniform a mother will be quite safe in choosing for her children clothes that are absolutely simple and practical. Nothing elaborate or dressy is liked by the modern schoolgirl.[90]

Not only are boys and girls referenced in the same terms in the article, but an emphasis is placed on the complex process of acquiring the many items needed and the necessity of them being in line with the exacting requirements of the school. It also indicates the importance, for the children themselves, of having the correct articles as, in the same manner as boys' schools, conformity was reinforced through peer interaction and exclusion. The final sentence is noteworthy in that simple clothes have come to define female youth and the driving force for this is attributed to the personal taste of the schoolgirl. This demonstrates an absorption of the values of the girls' public schools directly into the upper and middle-class concept of girlhood. This increase in formality and conformity ensured that by the 1920s girls' public schooling had become discontinuous with gender norms still prevalent in society. Despite huge moves forward in female education, emancipation and employment, the expected role fulfilled by women still included marriage, homemaking and economic dependence

on men. This meant that the point at which girls left school formed a distinct delineation between youth and adulthood and during these two phases of their life very different behaviours were expected of them.[91] In general, upper and middle-class girls were to be girls (or boys) at school—playing games, learning academic subjects and conforming to masculine public school stereotypes—and women afterwards, with many still expected to focus on marriage and children.

To justify this disjunction and allow female education to continue to operate within the masculine sphere, the relatively new concept of adolescence was invoked. In fact, increasingly prevalent girls' education may have worked to reinforce and disseminate fledging notions of female adolescence.[92] The idea of a period of existence between childhood and adulthood first appeared in the last two decades of the nineteenth century. By the 1920s, women were understood and represented in popular culture as passing through an adolescent stage, characterized as a period of immaturity, instability and identity creation during which it was suggested that girls could benefit from a protective school environment. Adolescence, consequently, allowed the boundary for the adoption of adulthood to be extended to the school leaving age, giving older schoolgirls permission to dress and behave in a way that would not be appropriate for an adult.[93] This change in attitude is illustrated in a problem page from 1933:

> *I am fifteen and my heart is broken*
> Fiddlesticks! Stuff and nonsense! At fifteen one's heart is still green ... At your age, you ought to be thinking about your House, winning the hockey match, or the conjugation of the verb to be, or whether you will be chosen to be the Queen of Fairies or the wall in *A Midsummer Night's Dream* when it is acted on Prize-Giving Day, with your father and mother sitting in the second row from the front, bursting with pride in their daughter.
> Do give up all that nonsense and be a sensible girl. Anyhow I'm surprised at you being so dowdy and old-fashioned as to have 'a love affair', as you call it, at your age.[94]

Not only are considerations of love deemed inappropriate for a fifteen-year-old girl, but public school norms are cited as a preferable alternative, notably playing hockey and an affiliation to her school house.

Interwar school uniforms also played a role in this discontinuity between youth and adult life, creating an appearance for girls that was androgynous, incorporating elements of both traditional masculine and feminine dress. This appearance operated as a statement of educational equality and status at school,

but in projecting this image, the dress of schoolgirls had gradually come to be at odds with the feminine ideal. This meant that girls' uniforms started to occupy an arena separate from the confines of normal fashionable appearance, a combination of masculine and feminine that was difficult to reconcile with socially acceptable appearances outside of the school environment. This is articulated by Judith Okely reflecting on her own schooldays:

> As female flesh and curves, we were concealed by uniform. Take the traditional gym slip—a barrel shape with deep pleats designed to hide breasts, waist, hips and buttocks, giving freedom of movement without contour.[95]

This created a dichotomy between girls' uniform as a declaration of academic parity and freedom and its creation of an identity at conflict with the gender roles still dictated in wider society. As Vera Brittain noted recalling her pre-First World War schooldays:

> In spite of the undaunted persistence with which both the Principals upheld their own progressive ideals of public service, almost every girl left school with only two ambitions—to return at the first possible moment to impress her school-fellows with the glory of a grown-up *toilette* and to get engaged before everybody else.[96]

This marked a new era in the sustained and problematic relationship between female education, school clothing and the feminine ideal. Upon leaving school a very different appearance, one in line with ideas of fashion and contemporary notions of femininity, had to be adopted to ensure marriageability. Although comfort and freedom of movement had improved greatly since the fashionable and feminine females of the early public schools, existing and new designated gender roles and stereotypes continued to impact on girls' clothing and affect uniform design, something that can be seen well into the post-war period.

CHAPTER FOUR

Education for All 1860–1939

Whilst elite schooling underwent a transformation during the nineteenth century, the biggest changes were reserved for the education of the lower-middle class and working classes. These alterations were characterized by increasing state intervention in schooling through reports, legislation and centralized enforcement and inspection, eventually resulting in free, compulsory elementary schooling for all children. This, in conjunction with demand from the middle classes for increased access to secondary education, created thousands of new schools and these offered new areas and motivations for the adoption of school uniform.

Prior to the 1860s schools were unregulated by the government and anyone could found a school or teach. Under pressure to improve the system, the government called for a series of studies to be carried out to determine the exact position of the English education system. Prominent amongst these were the Newcastle Report (1861) and the Taunton Report (1868), each of which had a significant effect on the way in which state education developed.

The *Royal Commission on the State of Popular Education in England* (1861), under the chairmanship of the Duke of Newcastle, was tasked with investigating the general state of elementary instruction in England and to report what, if any, measures were required to provide affordable elementary education for all children.[1] The report took a tone of patronizing benevolence, noting:

> It is only within comparatively modern times that the importance of providing elementary instruction for all classes of the population has been recognized ... even upon those who were destined to pass their lives in the humblest social positions.[2]

Whilst ascertaining that a significant proportion of poorer children already attended some form of school, the report highlighted the inconsistent nature of this schooling in terms of quality, attendance, location, gender and religion,

and made a series of recommendations which were passed into legislation, most notably as the Elementary Education Act (1870).[3] This Act recommended schooling for both sexes until the age of twelve.

In areas where school provision was insufficient to meet these new requirements, school boards were established to open and run board schools, creating the necessary extra school places. This had the effect of creating a piecemeal system of existing voluntary schools (usually faith-based institutions which received governmental maintenance assistance but were not fully funded) and the new board schools.[4] Schools were responsible for monitoring and implementing their own attendance policies and school fees had to be paid by pupils, except in cases of proven poverty. Although these fees were usually very low, their existence coupled with variable enforcement of attendance ensured that although many previously unschooled children entered education for the first time, some children still failed to access schooling.[5] These loopholes were closed in the Elementary Education Act of 1880, which made school attendance compulsory, and that of 1891, which made elementary education free.

The Taunton Commission (1868), on the other hand, focused on what can be broadly termed 'secondary education'; in essence, all institutions that fell between the nine public schools surveyed by the Clarendon Commission and elementary education for the working classes which had been the reserve of the Newcastle Commission. The Taunton Commission concluded that there were three grades of parent. The 'first grade' parents were those who wished their children to receive schooling up to and beyond the age of 18, and who had 'no wish to displace the classics from their present position in the forefront of English education'.[6] These 'first grade' parents represented the attitudes of those associated with the large public schools. The 'second grade' parents wished their children to be educated to the age of 16 and were thought to seek a curriculum that was more varied. They were alleged to believe that 'though classics may be excellent, yet mathematics, modern languages, chemistry and the rudiments of physical science are essential' for the professional and business roles that these students were likely to occupy in later life.[7] The 'third grade' parents encompassed the parents of all other students and the requirements for their children were thought to be merely 'very good reading, very good writing, very good arithmetic'.[8] The Taunton Report itself acknowledged that

> it is obvious that these distinctions correspond roughly, but by no means exactly, to the gradations of society. Those who can afford to pay more for their children's education will also as a general rule continue that education for a longer time.[9]

These two reports consequently both reinforced and maintained the class-based structure of the existing education system. In doing so they reflected contemporary views, in that class hierarchies were seen as the stable structures that formed the basis of society.[10] New educational establishments, therefore, continued to be conceived and implemented within class boundaries, a situation that persisted well into the twentieth century.

Middle-Class Secondary Education

The second half of the nineteenth century was a period of growth and change within the secondary education system. New schools, particularly girls' schools, were founded and institutions moved location, amalgamated, expanded and modified their curricula. Whilst the newly opened public schools met the needs at the upper levels of the middle classes, the expanding middle and lower portions continued to lack appropriate channels for education. The remodelled grammar schools and the new county and high schools fulfilled this requirement, catering to the 'second grade' of parents defined by the Taunton Commission.[11] These schools maintained the academic emphasis of the public schools but expanded the subjects taught to include some that pertained more closely to professional working life.[12] Whilst not competing directly with the public schools, these establishments operated in a manner more closely aligned to them than to state elementary schooling. Consequently, many aspects of public school life were borrowed and modified for this new environment and school uniform was no exception. Uniforms served as a way of demonstrating and publicly defining the status of these institutions, separating them from lower-class schools and in this manner attracting potential pupils who sought both the assurance of middle-class respectability and the potential for aspiration that they offered. This fits into the wider context of class imitation, with the lower-middle classes particularly anxious to achieve and retain a superior lifestyle, emulating the culture and morals, as well as the appearances of the bourgeoisie.[13]

The 1908 prospectus for Tunbridge Wells County School for Girls included a short note on uniform, stating: 'Pupils must wear the School hat band, and provide themselves with slippers, drill costume and rubber soled shoes'.[14] By 1914 this had been expanded to assert: 'Pupils are expected to wear a plain straw hat, with the School hat band, and to provide themselves with indoor shoes, drill costume, rubber soled shoes, and a second pair of stockings' (see Figure 4.1 for design).[15] The mention of uniform in the prospectus demonstrates its role in advertising the school, whilst also reinforcing the expectations of those attending. In addition, the choice of drill costume, or gymslip, and straw boater mirrors the wear of

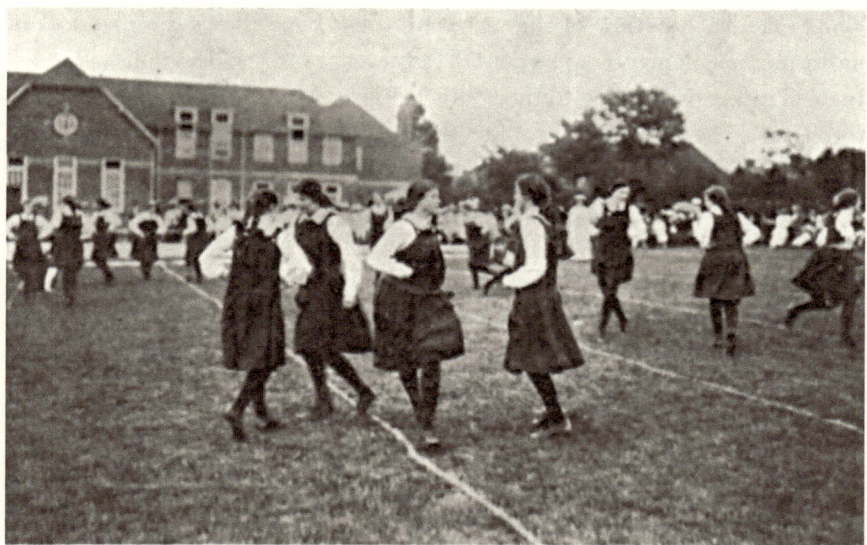

Figure 4.1: Tunbridge Wells County School for Girls pupils wearing drill costume, 1913

the girls' public schools. The addition of a 'second pair of stockings' in the 1914 edition reinforces the respectable nature of the institution. Girls were expected to own and, in instances of damage or dirtiness, change into this second pair, preventing pupils attending school in holed or soiled clothing, clearly marking the school as different from institutions where such wear may be acceptable.

The approaches by which schools implemented such uniforms closely followed the patterns laid down by the public schools. Regulated games wear often preceded general uniform and, in many cases, these sports clothes were subsequently adopted as day uniform. In other instances, there was a gradual increase in daywear standardization into the twentieth century until outfits were codified in full and strictly policed.

The Girls' Day School Trust offers a range of examples of this first route. The Trust was founded in 1872 and established twenty-one schools between its foundation and 1895. Although it sought to provide female secondary education for all classes, due to the level of fees charged, these schools had a primarily middle-class intake. Member schools of the Girls' Day School Trust were operated independently and, as such, drew up their own rules and regulations, meaning that each school adopted uniform at a different time. In 1923 the Trust celebrated the fiftieth anniversary of the opening of its first school and consequently a number of resources survive from this period, including a photograph album containing images taken in the same year at nine of the

Trust schools. A review of the images in this album allows the practices of uniform implementation to be considered across a range of locations (although these are mostly confined to the South of England) at this date, as well as any trends discerned. It should be noted that it is likely that at least some of these photographs were staged for the album and that it is possible that uniform may have been more carefully controlled for the images than was normal practice in an establishment. Photographs from Clapham (1900), Croydon (1874) and Portsmouth High Schools (1882), show closely regulated uniforms with all girls pictured in matching gymslips and blouses.[16] This is also the case at Brighton and Hove High School (1876), which recorded in the same year that the school dress was a green tunic, which is to be worn with:

(b) green girdle
(c) green knickers of the same colour as the tunic
(d) Tussore blouse to be made with round collar and long sleeves with loose cuffs[17]
(e) black stockings

The above dress, being compulsory for Gymnastics is worn generally throughout the School.[18]

At Kensington (1873), Putney (1893) and Streatham Hill (1887) the gymslips are uniform, but disparity in leg wear (stockings, long socks), blouses (collar style and colour) and neckwear may be noted in the images, suggesting that some items were regulated, but not others. Only two of the schools featured in the album had yet to adopt a day uniform by 1923 and whilst many of the girls in the South Hampstead (1876) and Sheffield (1878) images are wearing gymslips, others can be seen wearing sweaters, skirts and djibbah-style dresses.[19] It is, however, difficult to find any clear correlations, such as the wealth of attendees or proximity to influential institutions, with the differing levels of uniform enforcement expressed within the schools of the Girls' Day School Trust at this juncture. It must, therefore, be assumed that within this context more localized pressures, such as the views of the headmistress or influence from parents or pupils, were at play in this period. This would mirror the situation in girls' public schools, in which the influence and views of headmistresses and senior staff were hugely influential in the process of uniform adoption.

Conversely, at Burton Grammar School (for boys) some items of daywear were initially regulated, with a full uniform eventually being introduced. Pupils remembered that at the turn of the century:

> There was no school uniform except for the school cap, which was a pork-pie, or pill-box shape, with a postage stamp badge showing the school crest sewn on the side, and worn on the back of the head.[20]

This state of affairs continued until the First World War, with former student H.J. Wain stating:

> There was no attempt at uniformity in dress. The only distinguishing mark of a Burton Grammar School boy was his cap, which was marked with alternate bands of red and blue, each band one inch in width. These caps were conspicuous at a distance, and any boy infringing a rule was careful to take off his cap before doing so!"[21]

Uniform was introduced in the aftermath of the First World War and by the 1930s:

> Uniform, which was strictly enforced, was either blue blazer, grey flannels, white or grey shirt with blue & red school tie, and blue cap with a broad red band at the back or a grey suit. These had to be purchased at either Tarvers or Ellis & Sons.[22]

Unsurprisingly, new girls' schools seem to have followed the example set by public girls' schools and the same was true of boys' schools and their public counterparts. Overall, it appears, as in the public schools, that girls' schools were more likely to follow the route of games wear as uniform, and boys' schools to follow the route of the gradual codification of daywear, although this is drawing conclusions from a small sample of a much larger whole.[23]

These divergent approaches, however, follow a certain degree of logic, in that they can be attributed to the significant gender differences in children's clothing of the period. The corseted and full-length nature of girls' clothing in the Edwardian period was considerably more restrictive than the average set of boys' clothes.[24] Whilst both sexes developed specially designed items for the sports field, boys could change back into their normal clothes after games and still retain a degree of freedom that was not available to girls. One of the primary roles that girls' uniform sought to fulfil was to allow increased freedom of movement, something that was hard to obtain by adapting normal daywear. Boys' uniforms, on the other hand, without such pressures, tended to develop from the ordinary suits that were already widely worn by schoolboys.

In these examples, the First World War and interwar period appears to be the key phase in uniform adoption, and this is corroborated by other sources. At Dartford County School, for instance, there was no uniform except for games in the early years, and a photograph from 1908 shows girls in sports uniforms of the Dio Lewis design.[25] Photographs of younger pupils in daywear from the same date, show the majority of girls wearing either their games tunic or a gymslip and blouse, with a variety of neckwear including wide frilled collars, ties and bow ties. By 1914 the games garment had been redesigned as a green serge gymslip, which was made compulsory school uniform in the same year.[26] This time frame bears a great deal of similarity to those in the girls' public schools. The later dates of foundation of the high schools and county schools ensured that the pioneering, yet tentative period in winning acceptance for girls' education in the nineteenth century, whilst not having passed entirely, had, at least, ameliorated conditions. This allowed these new schools to adopt uniforms from the outset, or within years of opening, in keeping with the changes in the public schools, rather than undergoing the initial period of reinforcement of femininity, domesticity and morality through fashionable and gender-correct dress.

Uniform adoption was not always a smooth process, however, as Sara Burstall, headmistress of Manchester High School in the late nineteenth and early twentieth century discovered. Writing in 1933, she noted:

> In 1902 we made an attempt to introduce the minimum of school uniform and were met at once with a host of difficulties. Some mothers said that the school colour did not suit the girls' complexion, and others objected as they thought the uniform hat the badge of a charity-school, and a social degradation ... we had to go very slowly at first and it was a very long time before the uniform gymnastic tunic, so popular to-day, became possible with us.[27]

The early date of these attempts explains, to some extent, the problems faced, as girls' school uniform was yet to enter popular understanding. Predictably, notions of femininity came into play, but interestingly, ideas about uniform presenting the wrong class image are also raised and this reflects discussions in Chapter Two regarding the mixed-messages of school uniform depending on context.

By 1929, however, the column 'Women's Realm' in the *Devon and Exeter Gazette* was confident in stating:

> Most boarding schools and many day schools, have now a school uniform, and in many cases a mother finds it more economical for her schoolgirl daughter to wear her school coat and hat on many holiday occasions.[28]

This suggests that not only was school uniform becoming the norm but that coats and hats were also widely regulated and that day schools were taking their lead in such matters from the boarding schools. The discussion of economy is also interesting and the wearing of school uniform outside the educational environment became increasingly prevalent as uniform moved down the class spectrum. It seems safe to assume that middle-class children had fewer clothes than their upper-class counterparts and so uniform items were subsumed into normal wardrobes to save unnecessary expense.

These examples also make it apparent that there was a widespread adoption of the gymslip as a standard design of uniform and even when such garments were not compulsory, they were widely worn by girls.[29] This is indicative of the pervasive role that the gymslip had assumed within society as the correct mode of dress for schoolgirls. This must, in part, be attributed to the high-profile work of Madame Bergman-Osterberg, in conjunction with factors such as its practicality and changes in the fashionable physique.[30] The fashions of the 1920s moved away from the mature and statuesque contours of the Edwardian period to a new, young, slender and toned physical ideal. Clothes were designed to highlight youth and to enable older women to look younger.[31] The gymslip mirrored the straight dresses and boyish styles of the period, both emphasizing youth and becoming symbolic of it, as well as popularizing the garment and adding to its public appeal.

Girls themselves also appear to have played a role in uniform adoption, particularly within the field of middle-class education. This influence is suggested within a series of letters in the *Hull Daily Mail* in 1921. These letters focused on the introduction of additional pieces of uniform at Newlands High School (including a blazer and a hat) which extended the uniform requirements beyond the gymslip and blouse that were already standard wear. When the new items were branded expensive and unnecessary by one correspondent, the school responded in a published letter to the paper, arguing:

> The school blazer and panama hat have been designed in answer to repeated requests from the representative of the girls who sit on joint committees with the headmistress and members of the staff. The headmistress has not definitely stated that either of these extravagant articles of dress is in the least degree compulsory.[32]

Similar references may be found in the *Manchester Guardian* in 1934, which noted that the French berets worn at Brownhills School, Tunstall 'originated from a suggestion made by the girls themselves',[33] and in *The Times* in 1939, which indicated that although the public school garments of Roedean and Wycombe Abbey were established and immovable, other 'school-heads of today are not above taking the advice not only of the parents but of the girls themselves'.[34]

Whilst these references are limited, they point at a wider trend of involvement from middle-class girls in their own school appearances. Conversely, I have been unable to find any similar references to girl-led involvement in uniform matters at the public schools or any examples of middle-class boys' schools being influenced in this manner, although this does not mean that they do not exist. This discrepancy might be explained by the passing suggestion in *The Times* that notions of tradition were beginning to be associated with girls' public school uniforms, making them less open to change than the clothing of middle-class schools. Aspiration may also play a part—the associations that exist today between uniform and 'good schools' were already growing prevalent and uniform was beginning to be viewed as an indicator of the respectability and academic ambition of an institution. This is articulated by Florence Atherton, who left elementary school in 1912 to find work:

> I noticed there was some kind of distinction between the girls who went to a high school and those that had to go out working for a living. I've always wanted to go to a nice school and wear uniform. It's strange that isn't it?[35]

Atherton clearly associated a 'nice school' with one that wore uniform and for girls who were destined for lives other than those of moneyed leisure, respectability was vitally important, perhaps even more so than for the wealthy. Consequently, girls were eager for their school to be categorized as such.

The desire for school uniform amongst middle-class girls can also be set in the context of the rise in schoolgirl literature. Initially developing as a genre in the 1850s, schoolgirl stories were popularized through periodicals such as the *Girls' Own Paper* and cheaper weekly papers from the Amalgamated Press including *Girls' Friend* (1899–1931) and *Girls' Reader* (1908–15).[36] Despite these different publications being targeted variously at the middle and lower classes, the stories were predominantly set in expensive and selective boarding schools, which offered either aspiration or an escape fantasy depending on the readership.[37] The genre was brought to wider attention by Angela Brazil, who published her first novel *The Fortunes of Philippa* in 1906. Brazil broke with tradition and wrote

from the viewpoint of the schoolgirl for the first time, replicating the language and limiting the moral overtones but retaining the upper and middle-class settings. She was hugely popular in her lifetime, publishing a further forty-seven full-length novels and numerous short stories, as well as inspiring later authors, including Dorita Fairlie Bruce, creator of Dimsie, Elinor Brent-Dyer (The Chalet School series) and Elsie J. Oxenham (The Abbey School books).[38] The interwar years were the heyday of the girls' school story, with 900 new books being published between 1921 and 1940 and a proliferation in magazines and papers, many dedicated entirely to girls' school stories, including *School Friend* (1919–29), *Schoolgirls' Own* (1921–36) and *Schoolgirls' Weekly* (1922–39).[39]

The schools featured in these stories were 'good' schools where girls were happy, fair play was prioritized and excellent results were achieved at games and work. In the majority of such books, the girls were also shown in both the text and images wearing uniform (as seen on the front cover) and this helped to cement the link between uniforms and high-quality schooling for many readers, very few of whom would have had first-hand experience of such schools.[40] Characters were also identified through their dress and the individuals which stepped outside the sartorial boundaries of uniformity and conformity were invariably foreign, morally unsound or both—this is something that is noted in Chapter Two in relation to boys' school stories. Bessie Bunter is one such example of moral and sartorial non-conformity. Bessie was the fictional sister to Billy Bunter, a central character in the Greyfriars School stories published in the weekly story-paper *The Magnet* between 1908 and 1940. These tales sometimes featured a nearby girls' school Cliff House, and it was in this context that Bessie first appeared. In 1919, in an attempt to replicate the success of *The Magnet*, a new magazine aimed specifically at girls was brought out, *The School Friend*, which featured stories set at Cliff House in which Bessie was a reoccurring character. Bessie was given a very similar personality to her brother—she was greedy, told lies and cheated.[41] She is portrayed in the cover image of the issue (Figure 4.2) as an overweight figure dressed gaudily and inappropriately for her school surroundings, next to two of her more conventional peers. Thus, smart, neat school uniforms were not only associated with good schools but with good girls, the heroines of the literature so greedily devoured by so many school-age girls. These publications also propagated the new ideas of adolescent femininity that emerged at the turn of the twentieth century.

This idea of a separate period of adolescence was reinforced by the emergence of the first widespread and distinctive youth cultures, which appeared in the interwar period and were associated with young wage-earners and their unique leisure activities organized around cinemas, dance halls and jazz music.[42] Whilst

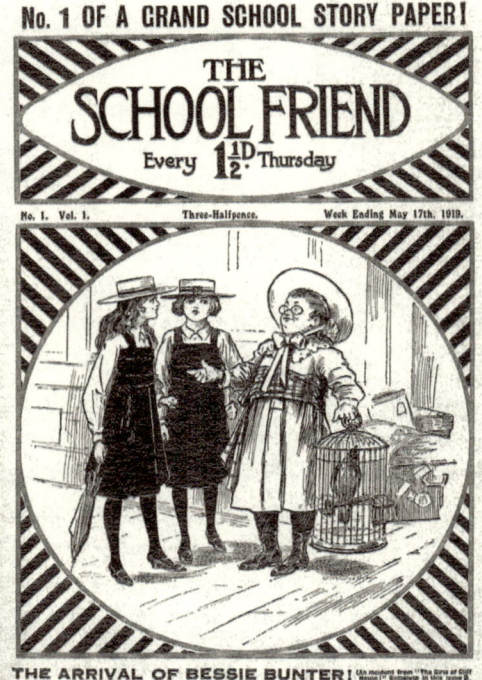

Figure 4.2: The Arrival of Bessie Bunter, 1919 Cover image from the first issue of *The School Friend* 'Bessie Bunter' Copyright © Rebellion Publishing IP Ltd. All Rights Reserved

these adolescents originated from a different class to the majority of schoolgirls in education beyond the age of twelve, parallels may be drawn between the two and both indicate an acceptance and growth of youth cultures which were discontinuous from adult and childhood patterns of expectation. This increased emphasis on youth had a consequent impact on adult culture in which a youthful appearance became fashionable. This can be noted in the stylish pre-pubescent body shape of the 1920s and the growing emphasis of youth in health and beauty advertising and products.

Elementary Education for the Working Classes

As a result of the 1870 and 1880 Education Acts, hundreds of mixed board schools were founded. These provided elementary education, predominantly for the working classes, and large groups of children from the most deprived areas of society entered school for the first time.[43] In their early years, it was the norm for board schools to charge minimal fees to the pupils (up to 9d per child per week).[44] It was understood that these would be waived in instances

of extreme poverty, although school authorities were often suspicious of such claims, as displayed by the Newcastle Commission in 1861:

> It appears from our evidence that though poverty may be at times alleged as a cause of absolute non attendance it is more commonly an excuse than a justification inasmuch as many parents of the very poorest class send their children to school ... [however] the managers of schools are not so strict in enforcing the payment of the full fee to allow a child often to be excluded from school by the poverty of its parents.[45]

The level of these fees was not set. Schools were entitled to fix their charges as they saw fit, which tended to reflect the comparative prosperity of the school's location. As a result, costs varied by area and from school to school, creating a system whereby schools reinforced the local social structure. Those charging higher fees attracted a greater number of the respectable working classes than those with low fees, and a higher percentage of free places tended to operate in areas of significant poverty. In locations where the catchment areas of two board schools overlapped, one often came to be viewed as more respectable than the other through the distinction of higher fees and, in some instances, selective intake.[46]

This difference between the rough and respectable working classes has been widely discussed in other histories and has generated a significant amount of debate on the exact definition of the two, along with the origins and development of such polarisations. Whilst each class has many gradations of status, the designation of respectability operated as a definite cultural boundary within the working classes, difference was seen between families who endeavoured to maintain order, cleanliness and self-discipline and those that did not, although this was not necessarily related to occupation or income.[47] Respectability was more than this—it encompassed a rejection of illegal and immoral activities, a suppression of sexuality and placed emphasis on the qualities of punctuality and obedience, qualities that were deemed appropriate by the middle and upper classes.[48] Respectability, as in all classes, was projected through external appearance, although the rhetoric of appropriate dress varied between them. The upper classes were expected to appear stylish and tasteful, whilst the clothes of the respectable lower classes should be economical, durable and practical and, where necessary, carefully patched or mended.[49]

Although board schools are discussed in general terms, it is important to note that such differences also existed between individual establishments.

Schools with a higher 'respectable' intake were more likely to adopt elements of uniform clothing, whilst those with a higher proportion of 'rough' children were increasingly likely to focus their attention on problems such as cleanliness, ragged or lack of clothing, and attendance. These issues were less prevalent in the respectable schools due to the social and personal virtues associated with, and reinforced by, respectability. Once established, this disparity in schools was difficult to eliminate and, although improved by the abolition of fees in 1891, many institutions retained these associations—positive and negative—well into the twentieth century, replicating the class division found in the wider education system.

Many of the early board school children came from families with no prior experience of education, either in terms of literacy or the behaviour expected in such an environment. Their attendance created social and disciplinary problems, but also highlighted, for the first time, the serious scale of childhood poverty, lack of clothing and ill health.[50] An idea of the task faced by teachers can be garnered from a lecture given by the school inspector William Jolly in 1876 on *Physical Education in Common Schools* in which he condemned the prevalent habits amongst schoolgirls of: 'wiping the hands on the dress ... cleaning the boots on the dress, wiping the pen by sprinkling the ink on the floor, sucking it, drawing it through the hair, rubbing it on the dress'.[51] With such issues requiring attention, teachers were left to impose whatever standards of dress and hygiene they thought achievable and appropriate.[52] Without the financial aid to improve clothing directly, those in authority tended to confine their efforts to encouraging personal cleanliness. This is reflected in the advice given by the Liverpool School Board in 1879, which recommended that teachers should, 'set an example of neatness in your own dress and person and *insist on the children having clean hands and faces*' and this may be viewed as the very early stages in the regulation of the appearance of board school pupils.[53]

In some areas, localized campaigns arose for the introduction of state funded uniform to such schools, as demonstrated by correspondence in the *Essex County Chronicle* in 1910:

> To the Editor
>
> ... It is a well-known fact that in these parts children have to go long distances to school, and, in the winter, often arrive with their clothes and boots dripping wet. It would be a great advantage if arrangements could be made so that on these occasions children could change their clothes at school, and have them dried before

they return home, wearing a school uniform during the day. No doubt this would involve expense, but the health and well-being of the children should be the first consideration.
Edward G Maxted, Chair of the Dunmow and District Socialist Society[54]

The following year a similar plea was made in the *Cornishman* as part of an article discussing schooling and motherhood amongst the working classes:

> Attached to every school there should be ample provision of hot and cold baths ... and at least one bath a week should be compulsory for every child. A simple, sensible school uniform should be compulsory. That for the girls and younger children, at any rate, should be made, washed and mended by the elder girls as part of their domestic training.[55]

Although these suggestions do not appear to have been implemented, they did help to raise attention to the continuing issues of unsatisfactory clothing for children in poorer areas. They also indicate the already prevalent and understood nature of the concept of school uniform within British society, demonstrating how widespread it had become in a relatively short period.

Despite education being compulsory for both sexes, nineteenth-century curricula differed significantly for girls and boys, reflecting and reinforcing 'normal' gender roles.[56] Girls were trained in domestic duties and one of the things that teachers could do to assist the situation was to teach the sewing skills that allowed clothes to be mended and maintained and to encourage these practices. Annie Wilson, who from the age of three attended St Mary's Board School, remembered in 1901 that in her early years at school:

> Good manners were most important. And to be truthful in all things. And tidy in your person. And if ever you got a tear in your clothes she'd say, 'It's high time you learned to sew, you see'. They sort of instilled a personal pride in you.[57]

In making children aware of their personal appearance, it was argued that board schools had a significant refining effect on the school population. In a series of essays entitled *Studies of Boy Life in our Cities*, the social theorist Edward Urwick suggested in 1904 that

> Collars and ties are almost as common as rags were a few years ago; the bare-footed ragamuffin of popular imagination figures still as the frontispiece to well-meaning philanthropic appeals, but is no longer a common object of the streets ... the civilising influence of the Board school has made him the exception instead of the rule.[58]

This is clearly hyperbole as other contemporary accounts suggest that clothing remained a significant issue. Florence Atherton, who attended board school from 1903, clearly felt the distinction between herself as a respectable working-class pupil and the poorer pupils, stating that she had 'seen some of the boys who've come with one shoe and one clog on. And they've had their trousers torn'.[59] Rhetoric aside, however, it is fairly logical to suppose that repetitively and insistently teaching children the importance of appearing clean and neat had an impact on personal and dress practices within the financial constraints that existed. This assumption is supported by discernible improvements in the health and hygiene of children over the second half of the nineteenth century, attributed by contemporary commentators, in part at least, to the work of schools. Writing in the *Journal of the Royal Statistical Society* in 1897, the educational hygiene campaigner Dr James Kerr asserted that, 'The influence of the home appears great, the direct effect of the school on national health is small, but its indirect effect through the home is very great'. He then went on to caution, however, that when home influence and training 'are opposed to the schooling, the latter is almost wasted energy'.[60] This suggests that although schools could encourage improvement they could only bring about change within the financial and social restrictions that already existed.

As children's health and appearance improved into the twentieth century and compulsory schooling became increasingly normalized, the concept of school uniforms became a real possibility for the first time. Uniforms were introduced from the interwar period onwards, initially on a voluntary basis but later they were made compulsory. In general terms, headwear often came first, with caps for boys and hat bands for girls. Hats were a normal part of dress and almost universally worn. Recalling her late nineteenth-century childhood in Cambridge, Gwen Raverat stated:

> Males and females alike, we had always to wear something on our heads out of doors. Even for children playing in the garden this was absolutely necessary. According to the weather we were told that we should catch a cold or get sunstroke if we went out bareheaded. But the real reason was that it was proper—that the hat was an essential part of the dress.[61]

Hats were, therefore, an indicator of basic propriety. As Oliver Wendell Holmes observed in 1858, 'The hat is the *ultimum moriens* of respectability'; essentially, it was both a mark of decency and the last remnant of respectability when all other things had ceased to be so.[62] In practical terms, they were also cheap to produce and purchase, easily identifiable if manufactured in a striking design, and long-lasting as pupils were unlikely to outgrow them.

Beyond hats there was a greater initial emphasis on promoting girls' uniform than boys, although both were eventually adopted, and these followed the gymslip and suit patterns laid down at the public, county and grammar schools. Gymslips were advocated as the most serviceable garment for school wear and girls were encouraged to wear them throughout the day with a washable blouse.[63] This differential in uniform application may be attributed to a number of factors but is likely to originate with the greater variety of clothes worn by girls, in conjunction with the established view that women were more prone to vanity and unnecessary considerations of dress. The narrower definitions of socially correct boys' wear, on the other hand, allowed less opportunity and desire for deviation from the norm. Throughout the Victorian period, vanity and idleness were viewed as predominantly feminine vices which were in opposition to the feminine ideals of economy and self-sacrifice. As in earlier periods, a love of finery was linked to prostitution and working-class girls were inculcated to view extravagance of dress as both foolish and morally dangerous.[64]

The adoption of uniform was initially optional, but schools encouraged pupils to conform to the new regulations through commendation of those that did. This caused problems for families who were struggling financially and could not afford to purchase the required items. A 1934 article in the *Hull Daily Mail* articulated these issues:

> It is becoming a nightmare to poor mothers who are doing their best to keep the children neat and clean, only to have them come home in tears because some other child, possibly with a father in good and regular work, has been brought out in front of the class in regulation white blouse and navy tunic as an example, the others being told that they should all come to the school like that! If it is necessary let the school authorities provide them ... There is absolutely no money today for new clothes ... we have to remake old clothes; the older girls have to have things given them by others. It is a cruel injustice that they should be shown up in front of a whole school, as it is not their fault.[65]

By attempting to create external uniformity, institutions initially generated internal divisions instead, with pupils from better off families embracing the new uniforms, but those from poorer backgrounds unable to do so. This served to highlight the disparities in family income amongst the pupils and created tensions, as students were excluded by their peers based on their appearance. This period of change eventually passed with new starters being bought a uniform upon their entry into school. Particularly in the case of gymslips, this was often expected to last for the whole period of schooling and would be initially bought large in order to do so.[66]

Mixed Classes in Secondary Education

The Education Act and Free Places Regulations of 1907 established a system of scholarships and free places to allow academically able children who might be unable to afford the fees, access to secondary education. All grant-aided secondary schools had to admit some students free of charge and these places were awarded based on the results of an attainment test or entrance exam. The students that were given free places were required to have spent at least two years at a public elementary school.[67] This meant that some children from poorer backgrounds gained admittance to the predominantly middle-class secondary schools. In many cases this resulted in class conflict, particularly with respect to the visible differences in clothing and appearance between the two. The introduction of uniform, however, helped to eliminate this visual disparity, lessening clothing-based stigma, and allowing children of different classes to associate on an academic footing.

Annie Wilson gained a free place at Huntingdon Street School in 1908 at the age of ten. It was a school for 'children of business people mostly ... boys and girls of better class people'.[68] Here she found her treatment by other pupils to be based on her background and much of this centred on differences in clothing and clothing practices:

> Before I went to Huntingdon Street school I can remember our children in my class we were made to make a dress or whatever we got on last so very long, we weren't allowed to come to the table without a white pinafore on ... Mother wouldn't let me go to Huntingdon Street without a pinafore. And I can hear the gasp when I walked in with this. It was quite a nice pinafore. It was white. And the teacher said to me 'You could have hung your pinafore up in the cloakroom, Annie.' I said, 'But Mother wouldn't let me—I'd soil my

dress perhaps, you see.' She said, 'Well it's the rules here we don't have you in here with a pinafore.' A lot of snobbishness there was ... Quite a few of the girls who were comfortable, had good positions and got lovely clothes and that kind of thing and—they'd sort of pull aside, they wouldn't pass you on the stairs if they could help it. And they used to look at us as if we were tramps in the street.[69]

Annie was singled out by both the teacher and other pupils for conforming to the working-class practice of wearing an apron to cover her clothes. Pinafores made from light, easily washable fabric became popular in the early 1800s and were widely worn throughout the century by young children of a range of classes.[70] They were also worn by older children in contexts where shabby clothes needed to be disguised or laundering heavy clothing such as full skirts was difficult. The pinafore protected such clothing from dirt and wear and tear, enabling them to be worn for longer without washing. Although they protected garments, white pinafores also showed dirt and stains clearly and this created a further division within pinafore wearers with those of limited means wearing dark or patterned pinafores that showed wear less obviously.[71]

The practice of pinafore wearing continued into the interwar period and this can be seen in a 1922 image of an elementary school group from a working-class area of Wigan, in which the vast majority of girls are dressed in pinafores over their clothes (Figure 4.3). Despite the standard nature of this custom within Annie's normal social environs and at her previous school, within the

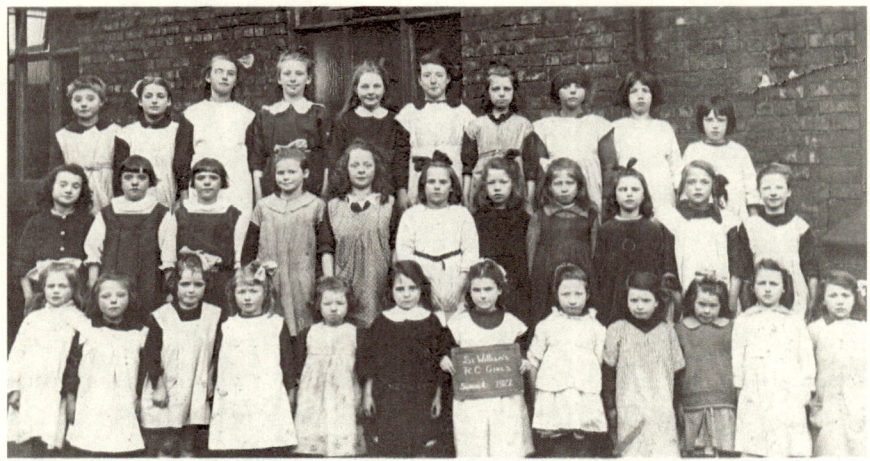

Figure 4.3: St William's RC Girls' School, 1922

middle-class context of secondary education, where children had more than one outfit and greater access to servants, laundresses or better laundry facilities, this was deemed socially incorrect and she was chastised for her behaviour.

Similar clothing and class divisions were observed at boys' secondary schools, as H.J. Wain—a pupil at Burton Grammar school between 1907 and 1911—noted:

> At the Grammar School there was a distinction between 'scholarship boys' and those whose parents paid for their education. As a rule the former came from poorer homes and were not so well-dressed, but the masters made no discrimination, and the majority of fee-paying boys were tolerant, though there were a few little snobs.[72]

In instances such as these the introduction of uniform served to disguise social background and remove the visible distinctions in class which differences in clothing had created.

Although acting as a social leveller in some respects, uniforms caused other problems to families who had limited income. Whilst the school places remained free, uniform was an extra cost which had to be provided by the family, acting as a deterrent to further education for many, particularly prior to the First World War.[73] Advertising in 1920, Maynard's Girls' School give an insight into its costs:

> Maynard Girls' School, Exeter
> The Governors are prepared to offer a certain number of FREE places in the School, on the result of a competitive examination ... The parents of any successful candidate ... will be obliged to provide the text books required, approximate cost per year £2 and the school uniform for which the initial outlay would be about £3.[74]

For poorer families, £3 was a very significant sum of money to find, comparable to the costs of private school uniforms today, and such outlay was prohibitive to many. Some uniforms could be purchased second-hand or made at home to save money, but the variation between a shop-supplied and homemade gymslip was often discernible, particularly if official patterns were not followed to the letter. This could, despite the adoption of a uniform, continue to mark scholarship children as different.[75] Thus, a dichotomy was created in which uniform predominantly acted to disguise status, but it could also reveal class through subtle markers, even more so than in general wear, as difference stands out more prominently against uniformity. In the context of the majority of

secondary schools, however, uniforms became a method by which social class was disguised rather than advertised and through which the identification of pupils to their institution rather than to their position in the class structure could be promoted.

The educative policy and legislation of the 1920s reflected new research in teaching and learning, notably theories surrounding genetic levels of intelligence. Such theories suggested that children were born with a pre-determined level of attainment that they could reach—and that this was higher for some than for others. Consequently, the 1926 report the *Education of the Adolescent* (the Hadow Report) recommended that pupils should go to secondary school at the age of eleven, but that this genetic difference should be catered for through a system of streaming between separate schools, each catering to a differing level of ability.[76] These ideas were implemented variously, depending on location, relative motivation and funding, with the existing school infrastructure often being adapted to fit the new scheme and many areas therefore saw a disparity of facilities between schools.[77] This system was streamlined in the Norwood Report of 1943, which suggested the implementation of the 'Eleven Plus', an exam to judge aptitude. The results of this exam placed pupils into one of three schools: grammar; modern; or technical. Each school was to have equivalent amenities, but each was to cater for a different level of attainment, with grammar schools admitting only the most academically able. In 1921 schooling was made compulsory until the age of fourteen.[78]

In this new educative and, in some areas, increasingly accessible secondary environment, uniforms became a badge of honour, identifying lower-class wearers as academically successful. Roy Hattersley, former Labour politician, who passed the Eleven Plus to get into Sheffield City Grammar School in the early 1940s recalled:

> Thanks to caps and scarves the difference between 'passing' and 'failing' was visible to every neighbour. Green, maroon and navy blazers were the raiment of success. Second-hand jackets handed down from elder brothers and sweaters hastily knitted by grandma were the apparel of defeat. The lucky parents regarded the weeks of outfitting as a period of public rejoicing. They announced the dates of their visits to the recommended outfitters as if they were events in the social calendar. Close relatives were invited to attend the scene of the actual purchase as if it were a wedding or christening ... Aunt Annie accompanied my mother to Cole Brothers and paid for a blazer with crumpled old pound notes.[79]

Thus, many less well-off families began to view entry into academic secondary education as offering the potential for professional and social advancement; to them, school uniform came to symbolize this prospect. Outfitting successful children correctly became a family event in which members contributed to lessen the direct financial burden on the parents and the child was exhibited in their new uniform, representing their achievement to the local community.

From a purely visual perspective, few alterations in the styles of school uniform are discernible during the period discussed. Designs were initially borrowed from the public schools and although uniform requirements were naturally streamlined and, often, not as closely regulated as they moved downwards through the class system, the overall appearance of the schoolboy or girl changed very little as increasing numbers of schools adopted gymslips and blouses or blazers and caps. The meanings that such uniform projected, however, changed rapidly and varied by type of school and the wealth of the local community.

Until the early twentieth century there is a clear correlation between class, income, class aspiration and the uptake of school uniform. As uniforms became more prevalent, however, they became gradually accepted as a national norm for school children.[80] The meanings that they projected also changed; as lower-class children began to gain access to secondary education through scholarships and free places, they moved from class delineator—excluding those who could not afford the secondary school fees—to a method of disguising social background, in which the school identity was placed above the class circumstances of the individual. To these scholarship pupils, uniform also became a symbol of their academic success, representing the opportunities that it allowed for social and professional advancement. In the space of fifty years, therefore, school uniform moved from a symbol of class, accessible only to the wealthy, to an egalitarian and widely observed British custom which represented the potential, if not the widespread practice, for schooling to allow access to class mobility.

CHAPTER FIVE

Fashion and Fancy Dress 1939–Present

By late 1940, the majority of British wool was being redirected for use in army uniforms, imports of raw materials had dwindled, and skilled workers and factories had been requisitioned for war work, resulting in the prospect of civilian-clothing shortages. This initiated government intervention along three lines: rationing; austerity; and utility.[1] On 1 June 1941, clothing and footwear rationing was introduced by the British Board of Trade. This limited the number of clothing items that could be purchased by an individual through issued clothing coupons. Coupon allowances were gradually reduced throughout the war, although children were granted extra to allow for growth. These controls were further extended with a series of austerity directives which effectively restricted the amount of fabric, decoration and trimmings used in the manufacture of all civilian clothes, saving cloth and labour time. This was followed, in 1942, by the introduction of the Utility Clothing Scheme, and the now iconic CC41 label, which provided good quality, reasonably priced and fashionable clothes that adhered to all clothing limitations.[2]

At the most basic level, these policies meant that any new school uniform produced had to conform to the austerity regulations; therefore, extra pleats, buttons and superfluous pockets were removed. It also necessitated some simplification of complicated uniform clothing lists (particularly those at the public schools), as children were not issued with sufficient ration coupons to purchase all the required items. The colour and design of overcoats and other coupon-heavy garments were relaxed and some accessories were removed. Due to lack of silk supplies and a focus on creating nylon for parachutes and other military items rather than for the domestic market, stockings were unavailable to the majority of people. Socks became a widespread and socially permissible alternative for older girls and young women (they had previously only been worn by younger girls) and some schools adopted them during the conflict.

Many institutions, particularly public and private schools, however, clung tenaciously to their main uniform garments—Eton and Christ's Hospital

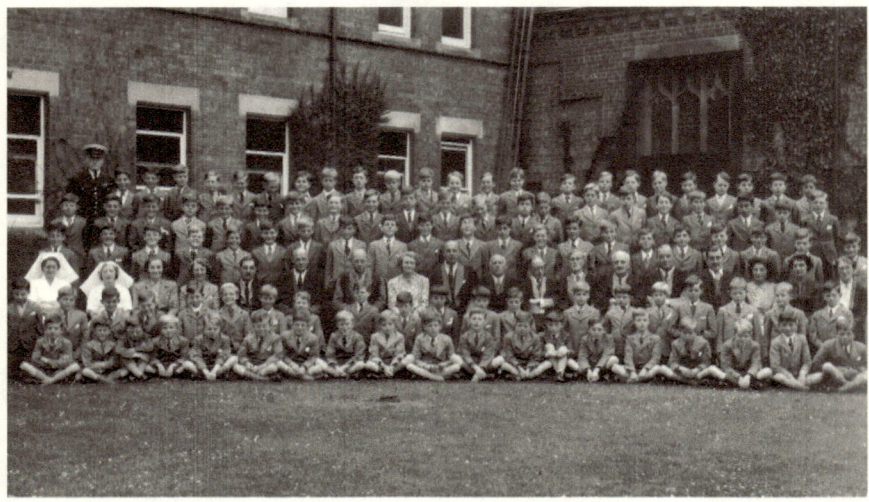

Figure 5.1: Aysgarth Prep School, 1944

being two prominent examples, although this can also be seen in other school contexts.³ A 1944 photograph of Aysgarth School (Figure 5.1) shows that, with the exception of a slight discrepancy in the colour of the jackets, a fully uniform appearance had been retained throughout the war.

A similar picture is painted by correspondence between the headmistress and parents at North London Collegiate School. In a letter accompanying uniform lists in the early 1940s, parents were informed:

> This list of school uniform is a comprehensive one, containing all the items which were found necessary or desirable before the war; nearly all of these are still obtainable, but I am well aware of the difficulties arising from clothes rationing and the need for economy, and shall naturally be sympathetic to them, and I am sure that parents will do all that is possible. The items which are most important are marked with a cross.⁴

In 1941, parents were again reminded that this was the case and that: 'The regular wear for girls on all occasions, except for games or gymnastics, is the school tunic with a long sleeved blouse, or the summer dress.'⁵

Towards the end of the war, in 1945, summer hats proved too difficult to purchase and were made optional. This was explained in another letter to parents:

> After careful consideration, in view of the shortage of summer hats, I have decided that, as an experiment, for the rest of this term the wearing of a school hat should be optional, provided that every girl wears the school badge on her way to and from school ... I should like to take this opportunity of thanking all the parents for the way in which they have co-operated in the matter of school dress so far as coupons permit. I am most anxious that we should maintain our high standard in the matter of school dress, and I know you will help me in this just as you have done in the past.[6]

A 1942 uniform list from Wycombe Abbey echoed this trend. The supplementary list of 'items considered to be essential' still contains a colossal thirty-one pieces of clothing and footwear, including a cloak, tunic and knickers, blazer (although a cardigan not bought at school may be substituted) and seven pairs of shoes and boots.[7] This determination to carry on as usual during the conflict can be partly attributed to school uniforms being a prominent symbol of normality in a period of turmoil and a comforting reminder of pre-war life. It also demonstrates how closely uniform had become aligned with the identity and operation of such institutions—the requirement by North London Collegiate School that the badge should continue to be worn to and from school is instructive. As discussed in Chapter Two, uniform was also associated with notions of 'Britishness'. Few other European countries had any form of school-uniform tradition, making the British appearance unique within the context of the conflict. In addition, educational structures and traditions had been transferred to colonial countries throughout the Victorian and Edwardian era and, in most locations, these were retained, linking the British school-uniform model with communal notions of Empire. In a period when national identity was under threat, school uniform consequently assumed a wider symbolism of defiance and public pride.

School uniforms were not only historically less common in Continental Europe but, when in existence, carried cultural meanings which were strongly class-based, more akin to the status distinctions seen in Victorian schooling rather than the more egalitarian meanings that had become associated with twentieth-century British school uniform.[8] Uniformed youth organisations, however, were common and often prominently associated with state-sponsored movements, particularly in countries promoting fascist ideologies. Whilst the Nazis banned the nearest thing to German school uniform—*Schülermützen*, or school hats—on class grounds, they were very keen to promote uniforms for the Hitler Youth. These uniforms, along with those of the Italian Balilla and Avanguardisti, were used as a tool to control and indoctrinate young members and alienate those who

did not conform to an ideal physical appearance. These organisations were clearly delineated from educative establishments and in some areas there was direct antagonism between the two.[9] In using uniform in this manner, the clothes and overall appearance of these organisations assumed heavy political associations and in Britain they were seen as an oppressive symptom of the regimes that created and imposed them.[10] In direct contrast, British school uniforms were viewed as a sign of freedom and a representation of the core national values that were being fought for—stability, equality and education. Despite this, however, it is possible to draw parallels between the use of fascist-youth uniforms to inculcate conformity and demonstrate organisational hierarchy and their corresponding role in British public schools. Similarities may also be seen between the ritual, pageantry and the emphasis on manly qualities displayed in both contexts.

Retaining school identity through uniform was particularly important when a school was evacuated, especially if it was billeted on or amalgamated with another school and uniform acted as a clear distinguishing factor in these cases. Unsurprisingly, school-uniform suppliers were also keen to retain uniform wear, arguing that it would be false economy to abolish uniforms and that existing supplies and specially dyed fabric would then be wasted. Instead they encouraged schools to run down the stocks of school uniforms and fabric until completely exhausted.[11]

The sustained ubiquity of school uniform is reflected in the 1941 publication *Sew and Save*, which offered a range of advice to the housewife struggling to clothe her family:

> Simplicity should be the keynote for the schoolgirl. The most important item in her wardrobe is, of course, her school uniform, usually a gym-slip and blouse. It is also usually the most expensive, while being at the same time indispensable. If, for the sake of economy, you decide to make it yourself, remember there are certain very definite rules which must be followed if the child's schooldays are not to be made miserable by wearing incorrect or ill-fitting uniform.[12]

Consequently, uniforms continued to be worn at a significant proportion of schools and uniform wear was considered the norm rather than the exception, particularly in schools with lengthy uniform traditions.

This attitude, however, was viewed as non-cooperation by the Board of Trade and can be noted through a series of circulars sent to schools, the first in November 1941, five-and-a-half months after rationing was introduced:

> In Circulars 1556, 1556A and 1556B details were announced of arrangements for supplying clothing and footwear to meet the special needs of schools and growing children. These arrangements were made on the assumption that the schools for their part would co-operate in withdrawing or reducing to a minimum any requirements hitherto imposed on pupils for special outfits distinctive of the particular school. The Board are glad to say that most schools have readily co-operated in this way, but it has been brought to their notice that in certain cases school regulations still require garments of a distinctive type or pattern to be worn, and that, in consequence, parents are finding difficulty in meeting their children's needs out of the coupon limits allowed. The Board hope that all Local Education Authorities and Responsible Bodies will take steps without delay to see that such regulations are rescinded and that all reasonable discretion is allowed to parents in the matter of providing clothes for children at schools of all types.[13]

This was followed by a similar reprimand in the summer of 1942:

> In view of the approaching close of the School Year the Board desire to remind Local Education and School Authorities of the need for reducing to a minimum school clothing requirements, particularly for pupils entering school in autumn. Attention was called to this matter in Administrative Memorandum No. 332 dated 21st November 1941, and the Board have evidence that most schools have already taken appropriate steps to reduce clothing requirements. But complaints from parents continue to reach the Board of Trade and it is accordingly thought desirable to draw attention once again to the urgent need for eliminating all unnecessary demands on clothing coupons. Although most schools have now ceased to prescribe special uniforms it is found that the practice among pupils of wearing clothes of uniform cloth and colour still persists and parents are reluctant to allow their children to appear exceptional. Other directions in which a reduction might be made are in the variety of Sports and Games costumes and in the initial stocks of underwear and linen recommended for pupils entering boarding schools.[14]

Although somewhat softer in tone, this second missive highlights the importance of peer pressure and school ethos in the continuation of norms of uniform dress.

Even when regulations were officially removed, children continued to adhere to dress codes, suggesting that the pre-war techniques employed to impose conformity on school children were both lasting and effective.

With increasing pressure on both coupons and fabric supply, schools had to seek out new methods of provision of uniform. Many turned to utilizing second-hand uniform on either a purchase or exchange basis, a trade that was allowed to occur without the involvement of coupons. This was a widespread response to the problems encountered and was run by either the school or the uniform outfitters. This process mirrors that of the more generalized children's clothing exchanges that were set up in many towns and cities. In 1941 the *Tamworth Herald* recorded that at Tamworth Girls' High School in Staffordshire:

> A minor wartime difficulty (which parents might call a major difficulty) is the provision of School uniform. When clothes rationing came into force we opened a second-hand uniform depot ... I beg parents (and Old Girls) to collaborate with us by sending us any wearable items of school uniform and by not hesitating to enquire whether we have in stock what their daughters need.[15]

Whilst at Lancaster Girls' Grammar School, not only were second-hand garments traded, but uniform tunics were cut off and made into skirts for girls.[16] This second-hand trade in uniform created a dichotomy at higher-end schools between the lower-class connotations of second-hand clothing and the ideal of keeping up appearances; the latter triumphed due to the extreme circumstances. Despite the best attempts of schools, however, there were some unavoidable casualties due to the increasing restrictions, although these were generally less dramatic than anticipated. For instance, at Roedean, the djibbah became too costly and complicated to produce and was replaced with an ordinary gymslip.[17]

Post-War

Rationing continued in the immediate post-war period and it was some years before fabric and clothing supplies were fully restored. Clothes rationing was finally abolished in 1949, but schools were keen to return to normal as soon as possible, reintroducing any items of uniform that had been relaxed during the conflict. In 1948 the *Tamworth Herald* reported on the situation at Tamworth Grammar School:

> This year there had been reintroduced the rule that all boys of the school must wear school uniform—cap, blazer, tie and grey flannel trousers—and the effect on the appearance of the school had been most encouraging. The importance of a school uniform could not be stressed too much. It gave a feeling of belonging to the school, which if allowed to grow became in later years civic pride and social responsibility.[18]

This draws a clear correlation between the development of school identity and that of local and national citizenship, qualities deemed particularly important in the nationalist post-war environment. Some of the more informal elements introduced during the war, however, were retained in some schools in instances where practicality outweighed tradition, notably the change from stockings to socks, but such examples are limited.

The Second World War affected all levels of society, altering social norms as well as disseminating new technologies and ideas. This had a particular impact on the young and consequently shaped the processes and practices of schooling. These changes resulted in a greater informality in institutional practice, in fashion and in the treatment of youth.[19] This was intensified by the move to comprehensive schools in 1965, when the tripartite system associated with the Eleven Plus was replaced with a single type of education for all abilities in one school.[20] It should be noted, however, that some counties retained their grammar schools and the associated entrance exam in addition to the new comprehensives. The public schools, along with some other non-state-operated institutions remained outside of both of these systems and these establishments became known as 'independent' or 'private' schools.

Most prominent amongst these cultural shifts was a greater emphasis on youth in commercial, social and democratic fields.[21] This increased interest in young people encouraged teenagers to develop their own sense of identity and new cultures emerged associated with shared passions and ideas. British youth cultures developed from the late 1940s, including Teddy Boys and Beatniks (although the group names were not coined until 1953 and 1958 respectively). Each of the cultures had its own unique and closely peer-regulated appearance and parallels can be drawn between this and the earlier pupil-led policing and codification of school uniforms within the public schools.[22]

Developments in technology were also important, and post-war economic expansion resulted in the invention and introduction of a large number of synthetic fabrics. Although nylon first entered the market in 1939, it was not widely available outside of the United States until the mid-1940s. The popularity

of nylon in stockings paved the way for other synthetic fibres such as orlon, dacron, acrylic, polyester, triacetate and spandex to be introduced. These made clothes easier to care for, as items retained heat-set pleats after washing, could be drip-dried and required little ironing. Products made from these fabrics became immensely fashionable, particularly for children's wear, where practicality and ease of laundering were especially important. They also reflected ideas of science and technological innovation, which were popular throughout the 1950s and 1960s.[23] The impact of these fabrics can be seen in a move away from traditional wool, cotton and knits, to new synthetic school uniforms which were cheaper, lighter to wear, easier to manage and held their shape better. By the 1950s, Wycombe Abbey, for example, was suggesting nylon stockings as an alternative to lisle and later uniforms incorporated synthetic blends into shirts, skirts and sweaters.[24] Tights generally replaced stockings in the 1960s and became popular with schoolgirls for their convenience and comfort.[25] These factors operated in conjunction with a lessening in overtly national sentiment and the dissolution of the Empire during the mid-century. As a result, uniform, whilst still an ingrained part of the British schooling system, ceased to represent the ideals of patriotism that it had during the war years and immediately after.[26] This heady combination of youth empowerment, technological advances and alterations in the meaning attributed to uniform, worked together to shape school clothing along more casual and practical lines.

Fashion also began to have an impact, gymslips were widely replaced with blouses and skirts, which were more in line with the fashionable aesthetic of the 1950s, although a straight pinafore style was often retained for younger girls. A 1950s uniform list from Kesteven and Grantham Girls' School indicates that fifth and sixth-form pupils could adopt a 'tailored navy blue skirt' in place of the traditional gym tunic. A similar picture can be seen in at St Mary's Gate School, Southbourne, Bournemouth, with pupils wearing skirt, shirt, tie and blazer in the early 1960s (Figure 5.2). Also, of note are the long white socks, possibly a relic of wartime shortages, and the retention of the traditional boaters despite the more modern appearance of the rest of the uniform.[27] Some schools took this informality even further and, under increasing pressure from older teenagers for freedom of expression, relaxed rules completely for sixth form pupils, retaining only a basic dress code.

In a similar vein, at Cheltenham Ladies' College summer dresses were redesigned in the early 1950s to reflect the 'New Look'.[28] This style was created in 1947 by Dior and consisted of dresses and separates with strongly defined waists and extravagantly full skirts. These, whilst initially generating some backlash with regards to fabric shortages, continued in popularity throughout

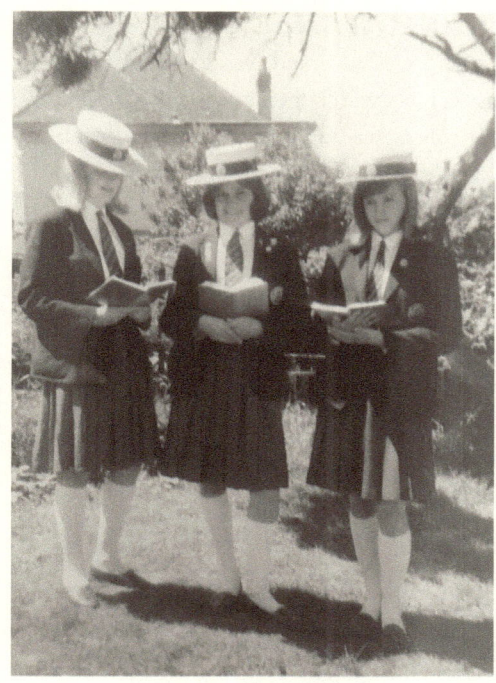

Figure 5.2: Pupils from St Mary's Gate School, c.1961–65

much of the 1950s and defined the fashionable silhouette of the decade. The adoption of such designs was not, however universal and some schools rejected the new shapes, amongst these was the Henrietta Barnett School in London, as reported in the *London News Chronicle* in 1948:

> Middlesex County Council announced yesterday that it would not ban the 'New Look' in all schools. But it supports the decision of Miss E. Leach, headmistress of the Henrietta Barnett School, Golders Green, who banned the 'New Look' because she thinks it encourages pupils to become 'glamour girls'.[29]

This dismissal of the New Look reflects notions of morality that were still pervasive in girls' education—the belief that girls were easily corruptible and had to be monitored and protected. In preventing pupils from dressing fashionably, even glamorously, they were maintaining an ideal concept of innocent girlhood, divorced from external factors.

Relaxation of uniform was most noticeable in state comprehensives, where informality of dress went hand in hand with a newly casual relationship between teacher and pupil and an increased focus on child-centred teaching practices.[30]

During the previous century the elite schools had led the way in dress practices and others had followed, now this trend was reversed, with the state schools becoming the force for change. This reflects wider social changes in which the upper classes were ousted from their role as fashion leaders and were replaced by celebrities, a position that could be achieved through hard work, luck or talent, as well as birthright.[31] These adjustments were then gradually adopted by more traditional establishments and modified and moderated for their new environment. The new informality, however, failed to permeate through the whole system and schools with the most established and anachronistic uniforms made few or no changes. In these institutions a certain historic design of uniform had become so much a part of the school's identity that to change them would cause consternation and could risk alienating former pupils. This is couched in cynical terms by Christopher Tyerman, historian of Harrow School:

> For all the rapidly changing curriculum, appearance and structure of the school, the requirements of the school finance demand obeisance to the past ... [innovations could only be introduced] either with the trappings of tradition intact ... or as a sign that the modern school was striving to maintain Harrow's position of excellence that it had inherited from the past.[32]

This maintenance of older traditions can still be seen at former charity schools such as Christ's Hospital and the oldest, and most elite, public schools.

The trend towards informality continued throughout much of the 1970s and 1980s, fuelled by teachers trained in the liberal atmosphere of the 1960s. Some schools abolished uniform altogether and others moved to simpler garments, in keeping children's fashions, such as polo shirts or sweatshirts. By the 1990s, however, it was beginning to turn full circle. Uniform had always had an association with ideas of order and control. Schools of the nineteenth and twentieth century, however, whilst acknowledging this aspect were more concerned with its ability to reinforce institutional identity and reflect the personal qualities and social and academic status of the wearer.

With the abolition of corporal punishment in state schools in 1987 and a rise in disciplinary problems, teachers felt that they were struggling to retain authority and control in the classroom.[33] School uniform began to be lauded as a quick-fix method of solving these issues.[34] There was, however, little evidence to support a link between positive behaviour and school uniform and this remains an area that would benefit from a wide-ranging, in-depth study.[35] Despite the lack of data, the idea was taken up with vigour and from the early

1990s uniforms were reintroduced and formalized in line with the traditional British aesthetic. There was, however, some resistance to these new policies from both pupils and parents. The development of individual identity was viewed as an increasingly important part of growing up and it was argued that uniforms stifled this.[36] In addition, cost was cited, mirroring the complaints of the 1920s and 1930s—a point of conflict that continues today.[37]

Adolescents were also keener to associate themselves with peer groupings and interests rather than institutions. Schools consequently had to convince a more cynically aware and media-informed public of the merits of uniform and its supposed disciplinary functions were not an easy sell to younger generations. To achieve this, certain schools appear to have utilized these altered notions of identity in clothing and promoted school uniform through items for shared interests, activities and year groups. This included the awarding of garments such as ties for non-sporting achievements, as well as the more traditional colours, 'leaver's hoodies' and club sweatshirts, and a renaissance of the 'college-style' scarf. In anecdotal terms at least, there appears to have been a significant growth in popularity of these items. This trend was paralleled on the high street with the production of garments which imitated these symbols of affiliation, particularly scarves, blazers and hoodies, but for invented institutions. The most notable example of this was Jack Wills (a brand founded in 1999), which directly referenced the attire of public schools and prestigious universities, although they have moved away from this type of branding in recent years.[38] These practices could be considered a new form of alignment with institutions and events, both real and invented, and as such are yet to receive any thorough academic coverage.

Additionally, schools appealed to parents through a mantra of 'equality'. School uniform was advocated for its ability to disguise social and cultural background and set all pupils on a level playing field. Although this idea was discussed in relation to the grammar schools in Chapter Four, it is still the most regularly cited reason in the argument for uniforms today.[39] Issues of equality have also been one of the biggest factors in shaping the design of school uniforms in today's increasingly multi-cultural society, whether it is allowing girls to adopt trousers or catering to the prescribed garments of certain religious beliefs. At multi-cultural schools such as Icknield High School, Luton, garments such as turbans and headscarves are encoded alongside more traditional pieces of uniform.[40] Whilst many of these items are now commonplace, the niqab—the full-face covering that is part of the practices of some Muslims—remains a controversial subject and it has been banned by a number of schools and widely debated in the press and online.[41] The Department for Education has subsequently issued guidelines on school uniform, allowing schools discretion

in setting their own policies, but encouraging inclusion. They also discourage full-face coverage and restrictive garments on the grounds of security, promoting communication and learning and seeking to avoid community pressure.[42]

This debate has remained relatively moderate in Britain, but issues of school dress have caused greater controversy elsewhere. In 2004, France passed legislation that banned all prominent symbols of religious faith from schools. Whilst this encompassed turbans, skull caps and crucifixes, the most publicized item to be banned was the hijab. In doing so, the French government sought to remove religion from state schooling and promote political secularism, a concept that was seen as being important to notions of 'Frenchness'.[43] The decision reflected concerns about the integration and assimilation of foreign nationals into French society and their roles as French citizens.[44] It also indicated contemporary fears of difference, particularly of the Muslim faith; fears that have been heightened by high-profile extremist actions and attacks. Conversely, wearers viewed the hijab as an extremely important symbol of identity, both in terms of religious affiliation and cultural background, and argued that the state's stigmatizing of the headscarf has led to a wider wave of intolerance regarding it in the public sphere.[45] The subsequent global debate indicated how politicized the hijab had become as a piece of clothing and it came to symbolize the disconnect between secularism and religious tolerance.

The trend towards formalisation of uniform continues. Ninety-nine per cent of British state schools now require some form of uniform and the percentage including a blazer on their uniform lists increased from 26 per cent in 2007 to 35 per cent in 2015, across both primary and secondary education (with the majority of blazers worn in secondary schools).[46] The Department of Education is a strong advocate of uniforms and their alleged positives have become ingrained in the public consciousness through their widespread propagation within the education system, educational aides and other media including children's books. Ladybird's *Mad About Costume and Fashion* states: 'Uniforms, such as the sort children wear to school, can be easily identified and show that the people wearing them are part of a group'.[47] This is indicative of the current thinking on uniform which seeks to foster a group mentality and disguise the background and economic status of individual pupils, as well as encouraging appropriate behaviour.

Dressing Up

In 1879, the *Isle of Wight Observer* reported on the Ryde School of Art Calico Fancy Dress Ball, 'One of the most successful and fashionable balls which have taken place for some time in Ryde'.[48] In the report, the *Isle of Wight Observer* meticulously listed the costumes worn by prominent figures in attendance.

Amongst a fine selection of national stereotypes, historical figures and botanical representations, featured 'Major OUCHTERLONY—*School Boy*—Eton jacket, broad white collar, white trousers, and cap of 50 years ago with peak'.[49] This is an early reference to a trend that was to become a national phenomenon in the twentieth century, that of adults dressing up in school uniform.

From the early nineteenth century an interest in historicism flourished, perhaps rooted in a need to seek stability in a period of transition and change as part of the Industrial Revolution. It was fed by new historical publications in conjunction with fictional works such as those of Sir Walter Scott. This desire to study and recreate the past found an outlet in costume balls, which, although related to earlier masquerades and the pleasure gardens of the eighteenth century, took on a new respectability in this period.[50] These balls focused initially on historical clothing, but later came to encompass other, increasingly extravagant and creative forms of fancy dress.[51] Major Ouchterlony appears to have been ahead of his time; in neither of the books published in the early 1880s with lists of ideas for fancy dress costumes—Marie Schild's *Character Suitable for Fancy Costume Balls* and Ardern Holt's *Fancy Dresses Described, or What to Wear at Fancy Balls*—is mention made of school uniform as a possible outfit.[52] Holt's tome, produced for the department store Debenham and Freebody, was extremely popular and ran to numerous editions and school uniform makes its first appearance in the later, enlarged edition of 1887. It incorporates a suggestion of 'Charity girls' in which Foundling dress and the outfits of St Botolph's School and Bristol Red Maids, amongst others, are recommended and detailed descriptions of the wear of the schools are included.[53] The 1896 edition goes even further, adding to the list 'Aldgate School (Costume of)' and 'Dame School Dunce', a costume for women which is listed as follows:

> A sugar-loaf cap marked 'Dunce' held in one hand, birch rod in the other. Black silk gown covered with white letters. A white apron with the multiplication table. A white muslin fichu, white elbow sleeves, 'C-a-t' on one, 'D-o-g' on the other. Mob cap.[54]

Whilst the Aldgate and Charity school entries make an attempt at historical realism, the Dame School Dunce description forgoes this in favour of the creation of a humorous stereotype. This demonstrates the direction in which concepts of fancy dress were moving, particularly those of school uniform, from the recreation of historical costume to comically identifiable caricatures. This trend continued into the twentieth century, with fancy dress becoming more daring, amusing and creative and increasingly based on popular culture.[55] This

was a precursor to the vogue for generalized and modified school uniform as fancy dress, which became hugely prevalent in the late twentieth century and continues today. Adults dressing up as school children, therefore, is not a new concept, but its widespread popularity and normality in an increasing number of social contexts can be traced back to the early 1950s.

The fashion for school uniform as fancy dress seems to have been initially promoted by the huge popularity of the St Trinian's books and films, but then became increasingly self-sustaining for a number of reasons, both practical and psychological. Depicting life at a comedically rowdy and felonious girls' boarding school, the first St Trinian's cartoon was published in 1941, the second not until 1946. This five-year hiatus was due to artist Ronald Searle's involvement in the Second World War, including his capture and internment at the hands of the Japanese. Many of the St Trinian's images were sketched during this time and their increasingly dark tone may be attributed to the artist's surroundings and treatment. Individual images continued to be published sporadically between 1947 and 1952, but it was the first book, *Hurrah for St Trinian's*, produced in 1948, that really began to draw attention to the fictional school. More books followed and these were made into a series of films starting with the *Belles of St Trinian's* in 1954, which ranked as the third highest grossing film in the United Kingdom that year.[56] St Trinian's swiftly became a widespread and accepted addition to British cultural understanding, to the extent that when *The Times* glibly referred to 'Trinianisms', it was confident that its readership would know and understand the term.[57]

St Trinian's was not the first silver-screen depiction of uncontrollable school children, the Tilly Films were unusual in their presentation of wild girlhood in the 1910s and can be seen as a forerunner to St Trinian's in many ways.[58] Closer in time frame to St Trinian's was *The Happiest Days of Your Life*, originally a play by John Dighton which was released as a film in 1950. Telling the story of the chaos that ensues when a girls' school is accidentally billeted on a boys' school during the Second World War. It was produced by the same team as the later St Trinian's films, Frank Launder and Sidney Gilliat. Nor was it the first girls' school story parody; Arthur Marshall had been writing these for much of the preceding decade. Why then, did St Trinian's, in particular, become so popular?

Timing must play a significant role—the publications and films coincided with a growing social and sexual liberation of young women, themes that are reflected and amplified in St Trinian's, placing it at the vanguard of women's liberation movements. The books and films promoted the link between education and opportunities for advancement, both within a school context and within society at large, and they posited non-traditionally feminine behaviour and appearances as a source of accomplishment and collective identity.[59] Thus women,

particularly those of younger generations, viewed St Trinian's as the removal of female constraint which was still apparent in some areas of society, something to be celebrated rather than eradicated. Girls, on the other hand, found new role models which did not conform to the wholesome and unrealistic protagonists of girls' school stories. In the words of writer and critic Siriol Hugh-Jones:

> Searle made it all right to be plain, shapeless and unhandy at dainty needlework. You could still batter the world into submission with a blunt instrument. Before Searle, the school heroine was the curly-haired Captain of Games who looked clean through you with those straight, fearless grey eyes before which a fib shrivelled and died of shame. Shame is a word unknown in St Trinian's ... Searle became a prophet of liberty and new self-respect.[60]

Searle's cartoons were essentially on the side of young women—St Trinian's schoolgirls found ways to achieve victory over any limitation.

Searle also made a mockery of fears associated with girls' education, from lesbianism to a lack of morality and femininity, many of which, although outdated, still persisted in certain circles. His teachers were lesbians, the pupils drank, smoked and committed acts of violence, whilst older girls were sexually aware, dressing provocatively and manipulating men for their own ends—and this particular aspect comes to prominence in some of the films. Whilst this final element almost certainly held direct appeal for some viewers, in one way it can be seen as a sly criticism of the 1950s vogue for pin ups, inverting the submissive and domestic way that women were often portrayed in the genre and once again underscoring the importance of female freedom.[61] In another way it can be viewed as a direct and hugely successful appeal to the British sense of humour, which has a long history of laughing at the risqué and enjoying the ridicule of institutions and stereotypes at the heart of the national consciousness, which in this instance is the female education system, organized games and school uniform, along with outdated notions of youth and femininity.[62] This parody is clearly demonstrated in the St Trinian's Soccer Song:

> Whack it up, girls! Bung the ball
> Thro' Life's goalposts at the call.
> Who can stay the Island Blood?
> Rub their bustles in the mud!
> Gallant hearts and bulldog pans,
> Floreat St Trinian's![63]

In a mockery of the works of Newbolt and his ilk, the rhyme invokes traditional Victorian boys' school imagery and gleefully subverts it. Warlike 'Island Blood' becomes applicable to girls' football instead of the battlefield, a traditionally male pursuit, and 'bulldog pans' conjures up a less than ladylike image of the faces of the girls, but one that makes up for a lack of femininity by being undeniably British. 'Floreat St Trinian's' is a sly reference to Eton's motto 'Floreat Etona', setting St Trinian's even more firmly in the domain of the public school. The reference to 'bustles' is also an allusion to outdated ideas of girls' education in that such items were outmoded and constrictive daily wear from sixty years previously.

St Trinian's permeated all levels of society and became a new nationally accessible joke. From this position, it was not unnatural for St Trinian's schoolgirls to become a widespread choice for any fancy-dress situation. Returning to Hugh-Jones, she states:

> St Trinian's in their hey-day figured in every hospital beano, scouts' gang-show, carnival, fancy-dress parade and college rag, here and abroad ... part of the charm being that almost anyone, from a midget Wolf Cub to a brawny Captain of Rugger, can fashion a do-it-yourself schoolgirl disguise, and those who fancy merrymaking in teams ... can find a ready-made spirit of togetherness in the notion of St Trinian's on the spree.[64]

This excerpt raises a number of interesting points. Its wording echoes one of the most fiercely advocated positives of school uniform, suggesting that even in its fancy-dress form, school uniform promoted a spirit of unity. Parallels can be drawn between this and the pro-uniform rhetoric of nineteenth and early twentieth century schools and educationalists. It is also possible to discern a resemblance between the spread of the British uniform model through the Empire and the adoption of the St Trinian's uniform abroad. Hugh-Jones goes on to note the practicality of the outfit, in that it was easy and cheap to recreate and so had an appeal for time and cash-strapped individuals.

Finally, Hugh-Jones characterizes two individuals who might be seen dressed as a St Trinian's schoolgirl, the 'Wolf Cub' and the 'brawny Captain of Rugger'. At the time of writing in the early 1960s, cubs were only open to boys and rugby was not a well-established female sport, meaning that both of these characters were likely to have been male and, in fact, the St Trinian's aesthetic was taken up more enthusiastically by men than women. Men dressing as women was not a new concept and had been a source of comedy on the stage and, later, in films

for a considerable time. Humour was derived from men being both obviously masculine and awkwardly out of place in their female attire.[65] Gymslips accentuated the male body, exposing hairy legs, while heels and skirts were uniquely feminine items which were difficult to manage for the unaccustomed wearer, fulfilling both these comedic requirements. Consequently, the humour of the cartoons was ideally suited to cross-dressing and the adoption of gymslips and boaters by men was very much in line with the subversion already rife in Searle's images. In many ways, however, this switching of genders diluted the original message of the work, indicating that the girls were more closely identified with men and masculine traits than the creation of a new definition of femininity.

The popularity of St Trinian's was also felt beyond fancy dress—the impact of the schoolgirl appearance can be seen within mainstream fashion. Boaters, tunics, shifts, Alice bands and black stockings all featured in the collections of the late 1940s and 1950s. That this was related, in some manner, to St Trinian's can be seen by the use of St Trinian's illustrations themselves on a range of couture dresses, indicating that they were an understood point of reference in the world of high fashion.[66] This adult uptake of juvenile styles served to popularize St Trinian's further and brought the concept to an even wider audience. It also made wearing school-uniform-related or inspired items increasingly socially acceptable, a trend that is still apparent today. A February 2015 article on the *Telegraph* website asserted: 'School uniform's in for grown-ups this summer ... the catwalk goes classroom'. The piece documented the fashion team as they incorporate items of real school uniform into their daily wardrobes.[67]

Through a combination of the sexual availability of St Trinian's sixth formers, adult adaption of school-uniform items in fashion and an increasing sexual liberation, particularly amongst the young, school uniform in itself began to develop sexual connotations in certain parts of society. This was spurred on by the publication of Lolita in 1955 (and the subsequent 1962 film) which centred around the seduction of a pre-adolescent girl, and this fits into a wider picture of the sexualization of children, particularly girls.[68] The naughty schoolgirl became a trope of erotic fiction and school uniform that was customized to expose rather than conceal took on an important role in pornography (and other media), functioning as an easily understood shorthand for adolescence, representing girls who were just adult enough to be available but still young enough to be non-threatening.[69]

This usage of school uniform was reinforced by the selective importation of images from Japan in the 1990s and 2000s, where the use of school uniforms as a symbol of both youth and deviance occurred in a greater degree. During the 1970s the Japanese school and military uniform became an important outfit

for underground and avant-garde circles. It was initially adopted by male youth culture, particularly members of motorcycle gangs, in a customized format as a symbol of rebellion. During the following decades, images and reports of drop-out schoolboys were replaced with those of sexualized schoolgirls, with the media featuring male-orientated stories of actual schoolgirl deviance such as compensated dating (older men providing money and luxury gifts in return for companionship and, sometimes, sexual contact).[70] This attention coincided with rapidly changing gender identities within Japanese society, notably a disconnect between increasing numbers of ambitious and educated young women seeking professional jobs and the more traditional gender roles expected by older generations. This focus on young women resulted in a greater representation of them in the public domain, particularly the use of morally wholesome schoolgirls in television and print advertising, which provided an easy stereotype for subversion.[71] As a result, a sexually orientated subculture based around schoolgirls and school uniform began to develop.

Greater attention was focused on this by the introduction of 'designer uniforms' in many of Tokyo's private high schools from the mid-1980s onwards. This was as part of an attempt by schools to appear more appealing and thereby maintain pupil numbers in a period of demographic decline in the school-age population. The image of the aberrant Japanese schoolgirl has become ubiquitous across the world through a range of visual media, especially in manga and anime.[72] A fascination with uniformed schoolgirls is now so widespread that they have been adopted in a sanitized version by the government to promote Japanese youth culture and carefully chosen images have been projected internationally in an official capacity. This move from wholesomeness to deviancy and then back to social acceptability is an intriguing process.

Although the traditional St Trinian's schoolgirl is still a recognisable figure today—a Google search for 'St Trinian's fancy dress' returns tens of thousands of results for gymslips and boaters—school uniform as fancy dress was subject to a renaissance and image overhaul in the 1990s. A number of media releases took place within the space of a couple of years that re-popularized school garments and placed them, once again, at the forefront of the national consciousness. In 1996 the film *The Craft* was released; the story revolves around four girls at a school in Los Angeles and the poster featured the girls in heavily adapted school uniforms representing the dark and rebellious nature of the drama. This opened the way for a new trend in heavily modified contemporary uniforms. Two years later, in 1998, Britney Spears had a global hit with her first release ... *Baby One More Time*. The song reached number one in every country that it charted in and sold more than 10 million copies. The associated music video

showed Spears dancing provocatively around a school dressed in a customized school uniform with short skirt and tied-up shirt. Whilst this was not the first musician to appear in school uniform (Angus Young of AC/DC started performing in school uniform in the 1970s and still appears in the guise today), it was the first instance of a heavily sexualized school uniform in mainstream music. This was followed by other popstar appearances in similar garb, including Madonna (2001) and the Russian pop duo t.A.T.u (2003). These women used adapted school uniform and the sexual associations that it had developed to play into the schoolgirl fantasies which originated with St Trinian's and, if viewed cynically, to sell records.

These mass media appearances had two main effects: the sexualized uniform made an appearance in nightlife and clubbing culture; and the modification of uniforms spread back into schools. Published in 2007, Lucy Mangan offers the following advice in *Hopscotch and Handbags: The Essential Guide to Being a Girl*:

> You can wear the regulation skirt, shirt, jumper and tie if you are either a dull conformist ... or supremely confident that your good looks and vibrant personality will mark you out sufficiently from any crowd and secure you the attention and respect that is your due as a unique and exceptional individual. All those in between must customise whatever combination of navy gaberdine, maroon serge or dark-green polyester pleats they labour under as quickly and as heavily as possible. Tried and tested ways include:
> 1. Shortening the skirt by rolling up the waistband or hacking six inches off the hem ...
> 2. Shortening the tie or tying it so that the thin bit shows at the front instead of the fat bit ...
> 3. Wear jewellery.[73]

Modification of school uniform is by no means a new concept—Christ's Hospital boys rolled up their gowns in the eighteenth century in order to better play sports, although this was practical rather than appearance-based.[74] In the twentieth century customized school uniform became a byword for teenage rebellion, adolescents sought a more comfortable appearance in line with current fashion trends as hats were altered, skirts rolled up and top buttons left undone. This process can be viewed as an attempt to regain the individuality that uniform removed and in the case of girls to re-feminize often shapeless uniforms in line with current notions of femininity, in this instance, aggressive sexualization. The shortening of the skirt and the addition of jewellery imitates the style and

attire of the female musicians, but this is being enacted by schoolgirls who are, perhaps, less conscious of the encoded meaning of their modified appearance, confusing the publicly understood messages of school garments further.

Opening in 1999, 'School Disco' was a club night which toured several locations before finding overwhelming popularity at the Hammersmith Palais in the early 2000s. Running twice-weekly, it regularly attracted 3,000 party-goers and was seen as an antidote to dance music and the superclubs which had dominated the nightlife scene for some years previously. School Disco actively encouraged large groups, dressing up was compulsory and the music featured nostalgic sing-along rock and pop hits.[75] So successful was the brand that it spread to other British cities and spawned numerous imitators including 'School Dinners', a themed restaurant and club staffed by 'St Trinian's girls and Eaton boys', and a huge number of student events at institutions from Sheffield and Leeds to Edinburgh and Durham.[76] The school uniform that was worn to these nights bore a much greater resemblance to those worn in *The Craft* or popularized by Britney Spears than actual uniforms and, as such, the appearance of the fancy-dress school uniform began to fundamentally diverge from reality and create a unique appearance of its own. This meant that it became more socially acceptable to find modified school uniform of this type sexually appealing as the connotations of underage girls had been diminished, if not entirely removed. School Disco traded on this change in attitude using the number of women attending in school uniform as a positive marketing technique to encourage male attendance and to promote the adult nature of the event.[77]

Sexual appeal alone, however, cannot explain the huge and continued attraction of the school outfit in this context, nor does it account for modern male attempts to modify their own school uniforms to wear to such events rather than appropriating female wear (although this also continues). Whilst a sexual fascination with girls in school uniform has been well established, the same cannot be said of boys' school uniform, and consequently feminine allure must be considered in conjunction with other factors. The wearing of school uniform in an adult context allows individuals to relive what is often an awkward and uncomfortable stage of their life with greater confidence and experience, succeeding in their romantic and sexual advances where their teenage self might have failed. In this capacity, the wearing of school uniform operates as wish fulfilment in which the disappointments of adolescence are erased and replaced with a different narrative. In the same vein, fancy dress permits the wearer to adopt an alternative persona which allows them to behave in a fashion that would be considered unacceptable in other contexts.[78] In this way they mirror the actions of performers who often take the role of schoolteachers or other

authority figures at such events and align themselves with the theatricality innate in the proceedings. The practicality cited by Hugh-Jones also survives. School uniform of the variety seen at fancy-dress events can be easily and quickly fashioned from the contents of the average wardrobe and allows the wearer to look like they made an effort, but, critically, not too much, in a society that often judges those who try too hard.

Moreover, school uniform plays into the vogue for nostalgia that has developed over the past twenty years. This has manifested itself in a fashion for vintage clothes and accessories, along with catwalk, high-street and homeware trends that closely replicate previous eras, with entire businesses, such as Cath Kidston, being built around the vintage aesthetic. These have operated in conjunction with a resurgence in the popularity of the homemade item and the 'make-do and mend' message. From sewing and knitting to baking, these hobbies have been promoted through books and television series such as *The Great British Bake Off*. Such trends can, perhaps, be attributed to the need to find reassurance and stability in the past during periods of fast-paced technological change and this mirrors the nineteenth century passion for historical recreation discussed earlier in this chapter. The technology that triggered the trend, however, also reinforces it, allowing people to stay in touch or reconnect with friends from school through Twitter, Facebook and older sites such as Friends Reunited. This creates an emphasis on retaining juvenile connections and culture, which helps to further normalize signifiers of both adolescence and the past, such as school uniform.

Whilst School Dinners may have shut for business in 2007 and School Disco in 2011, the school event remains a popular choice for students and continues to surface in new incarnations. In 2007 the first St Trinian's film in twenty-seven years, and the sixth overall, was released. This updated the concept for modern audiences and introduced a new generation of girls to St Trinian's. At the more sophisticated end of the spectrum is the pop-up restaurant, 'The After School Club' at the Round Chapel Old School Rooms in Clapton, London, which opened for eleven days in July and August 2015. Despite being rather more expensive, it was not too dissimilar in concept from the more downmarket School Dinners. It offered menus in homework books, school-dinner-inspired food and waiters attired as prefects. Dressing up was not compulsory for those in attendance but nor was it considered unusual, demonstrating how normalized the idea of dressing up in school uniform has become in British society.[79]

Conclusion

Whilst many factors have played a part in shaping school uniforms, a number of key pressures have emerged that have had a considerable role in the appearance of school children throughout the history of school clothing. Most prominent amongst these are gender and class, although religion and national identity have also had a consistent influence. These elements, often working in conjunction, constructed an ideal appearance for children, albeit one that changed with time, social norms and the relative importance of each factor in a given context. School clothing was most often a reflection and reinforcement of this ideal appearance and the class and gender appropriate behaviours that were associated with it, conveying these meanings to both the wearers and to external viewers. This was seen, most notably, in the early charity schools where uniform operated as a symbol of humility, lower-class status and expected social role. Alternatively, school uniform was sometimes a rebellion against the adoption of these expected identities, instead producing new appearances shaped by practical concerns or mirroring the aesthetics of other more influential groups. The two differing faces of this force can be demonstrated through the gradual adoption of the gymslip by girls' schools, creating an appearance in opposition to adult gender norms and through the imitation of the uniforms of elite schools by their middle-class counterparts.

As gender and class distinctions were increasingly broken down in the twentieth century (at least in a superficial sense), these ideal appearances converged until a standardized and widely accepted design for school uniform emerged across classes and, to some extent, genders.[1] This, despite variations in colour and detail, demonstrated the same basic concepts of design and style across the majority of schools. The impact of nationalism waned in the wake of the Second World War and religion also ceased to play such a prominent role in the determination of morality and appropriate styles of dress in modern culture.[2] Recently, however, an increasingly multicultural society has led to a resurgence in the importance of religion in determining dress characteristics and this has, once again, had an effect on school uniform.

The way in which uniform designs and their corresponding social meanings were diffused is also of importance. Transmission on a national scale (as opposed to its global spread) occurred in two forms: first, between schools, as ideas were passed on through staff movement, direct engagement and umbrella organisations such as the Society for Promoting Christian Knowledge, the Girls' Day School Trust and the Headmasters' Conference; and second, through the communication of an image of pupils to the outside world. School uniforms were the most visible expression of the ethos of a school and they reinforced the gender, class and sometimes religious affiliation of pupils to the viewer, allowing them to place themselves socially and morally in relation to the school child. Initially this viewing occurred through public spectacles, such as processions and ticketed mealtimes, as in the early charity schools. These events were school sponsored and consequently the image presented was fairly easy to control. As print media such as newspapers, periodicals and magazines were popularized, however, it became an increasingly important method of viewing, discussing and analysing schools and uniforms. These forums were far less simple to influence and so tend to paint a more balanced picture of appearances and the conflict and discussion that they generated. This trend is still prominent today through the use of social media and other online outlets.

The importance of newspapers, and more recently the Internet, in initiating and reflecting national and local debate is apparent in the letters and articles cited throughout, which discuss matters of school uniform, from the reoccurring issue of cost to its outmoded appearance and, more recently, its effectiveness in a modern educational climate. Other media also had an impact and this can be clearly observed through the wide-ranging and long-term effects of the St Trinian's cartoons, books and films. These increasingly accessible forums for viewing and discussion, in conjunction with a rise in pictorial advertising and the mercantile imitation of uniforms allowed designs and ideas to be disseminated to the general public with greater rapidity, which in turn allowed easier transmission between schools through emulation. This aspect is particularly notable in relation to the commercial spread of the Eton jacket, but also in recent fashions for modified school uniform.

Each of the five chapters of this book resulted in a set of conclusions which can be linked closely to these broad themes. Chapter One considered early uniform adoption with a particular focus on charity schools. In these institutions, uniforms functioned as both a practical method of ensuring that children were sufficiently clothed and a way by which the working-class status of pupils could be reinforced. Garments sought to inculcate humility in the children, designating their role and intended career paths within society, whilst also

indicating their lowly status and demonstrating the difference between them and people of higher rank. This is demonstrated through not only the design of the uniform but also by the colour and type of fabric used. Blue was the most prominent colour used in charity uniforms; this dye was cheap and generally associated with the clothing of servants and the working classes. In addition, the fabrics used at Christ's Hospital, whilst warm, were coarse and inexpensive to purchase.[3]

Modesty of dress was also important, not only in the good habits that it was supposed to encourage, but also as a reflection of the strong role of religion in most charity schools. Charitable funding of schools was instigated by a growth in Protestantism and a lack of provision elsewhere. Establishments often took the biblical verses of Matthew 25 as their *modus operandi*: 'For I was hungered, and ye gave me meat: I was thirsty, and ye gave me drink: I was a stranger, and ye took me in: Naked and ye clothed me.'[4] The charity school statues surviving at St Mary Abbots School, Kensington, for instance, show part of this phrase on a scroll in the hand of the bluecoat boy. Although uniforms do not appear to have been directly modelled on ecclesiastical garments, they were modest in cut and style to reinforce Protestant moral codes. This is particularly true for girls, who were considered more likely to stray morally from religious expectations of behaviour. Most benefactors were wealthy individuals and uniforms also allowed their good deeds to be displayed in a public fashion through the use of escutcheons, buttons and other visible symbols of support. This allowed patrons to define their role in society in comparison with both the children and other non-supporters.

At the opposite end of the social spectrum, Chapter Two considered the public schools of the mid to late nineteenth century, focusing particularly on Eton and Harrow, but also using examples from Rugby, Malvern, Marlborough, Charterhouse and Pocklington, amongst others. Although initial uniform adoption occurred on the sports field and stemmed from practical concerns, implementation of day uniform was more complex, nuanced and socially reflective. In a period of middle-class growth and aspiration these elite institutions sought to distinguish themselves from schools of lower rank, excluding non-elite pupils and maintaining their class status through intricate visual and practical exclusion processes. One of these was the adoption of expensive and socially correct clothing as uniform. These uniforms subsequently developed complicated hierarchical markers which further served to confuse and exclude the uninitiated.

Uniform also worked to create and maintain group identity within the establishments, consolidating the status difference between those within the public

school system and those outside it. Public school uniforms reinforced Victorian and Edwardian notions of masculinity, a concept which was tied closely with religion in the form of 'muscular Christianity', a moral code promoted at the majority of public schools. Consequently, uniforms were expensive, well-cut and obtained from gentlemen's outfitters, while often simple and restrained in appearance. Public schools and their uniforms were widely imitated by middle-class schools such as Marlborough (1843), which was originally founded for the sons of clergymen. These schools sought to align themselves with establishments of higher status, utilizing their reputation and providing a similar education at a more accessible price. Many, such as Marlborough, along with Lancing (1848), Hurstpierpoint (1849) and Haileybury (1862), were successful in this aim, later becoming public schools in their own right. This meant that the exclusionary processes put in place by the public schools became ineffective. Indicators such as uniform moved from a clear method of distinguishing between schools on a class basis to a technique for disguising the difference between public schools and their rivals of lesser status.

The British Empire was at its peak in the nineteenth century and both public schools and their imitators sent large numbers of former pupils to work abroad in colonial administration and the military. These young men transferred British notions of education, masculinity and religion across the globe, developing education systems and founding new schools which were similar in operation to the British public school model. Uniform was considered a vital part of this ethos and uniforms were introduced throughout colonial countries and many examples of this remain today. As a visible marker of colonial rule and one that had an impact across generations, school uniform became globally associated with the British Empire and consequently with Britain itself. In this manner school uniforms began to be viewed as part of the British national identity and a way by which Britain was represented abroad.

Focusing on a similar period, Chapter Three looked at the comparative history of female education, starting with the pioneering girls' public schools. School uniform for girls was introduced later than for their male counterparts, reflecting the tentative nature of early female schooling. Academic education was viewed by many in the mid-nineteenth century as inappropriate for women. It was supposed to encourage manly traits and consequently prevent women from adopting their ordained role in society—one of marriage, reproduction and decoration. The loss of femininity through education was deemed a serious social concern and early women educators were, therefore, keen to produce pupils who conformed closely to the feminine ideal of the period, demonstrating to detractors and the wider public that schooling did not adversely affect femininity.

As a result, early pupils were encouraged to dress in a fashionable and feminine way. They also had to maintain a modesty of dress in line with contemporary ideas of female morality and purity perpetuated by the Church.

As it became clear that girls' education did not cause a significant drop in the marriage rate or adversely affect the sanity of attendees, it became more acceptable and the pressure on pupils to appear overtly feminine abated to some extent (although an emphasis on morality did not decline). In its place, new forces arose—these were initially practical and focused on the adoption of more suitable attire for games and sports, such as the Dio Lewis gymnastic suit and, later, the gymslip, although lingering concerns of femininity did survive in early designs. These outfits, once adopted in the gymnasium, were often introduced throughout the day as well, being more comfortable and allowing greater movement than normal clothing. This pattern can be seen at North London Collegiate School and Croft School. Later, as women's education continued to develop and opposition to it diminished, the focus moved from fighting to allow schools to operate to demonstrating that women could compete with men on an academic footing and should consequently be granted full access to both the universities and professions. To this end, girls' schools gradually adopted the trappings of boys' public school life, from the sports ethic to the internal organisation, in an attempt to demonstrate similarity and consequently equality. School uniforms were no exception and increasingly masculine items were added to the aesthetic in imitation of those worn at boys' school, notably shirts and ties. This process was noted through the increasingly prescriptive and formal uniform lists of Wycombe Abbey.[5] Thus, in sixty years, girls' school dress moved from the explicitly feminine, in line with contemporary notions of gender, to an appearance that was more closely aligned to boys' school uniform than fashionable femininity, representing a clear shift in the way in which women and their education were viewed in the same period.

Chapter Four, which also considered a time frame parallel to the two previous chapters, reviewed the spread of state education and the impact that this had on uniform practices. This was investigated in two main areas: middle-class secondary education; and the introduction of compulsory elementary schooling for all children. In middle-class schools the pattern was one of imitation similar to that seen between the boys' public schools and their middle-class emulators. School uniforms for both genders were copied from the relevant public schools and examples of this process include the schools of the Girls' Day School Trust and Tunbridge Wells County School for Girls. The appearance generated indicated status to attendees, but also, on a more mundane level, 'respectability', a concept that was of particular importance to the middle classes. Consequently,

the new county, grammar and high schools which opened to fulfil an increased need for this type of education presented an image not unlike the schools to which they aspired, further levelling appearances to the untrained eye.

In state elementary schooling practical concerns such as a lack of clothing were not dealt with as in previous centuries through the allocation of garments, emphasis was instead placed on teaching basic cleanliness and good habits such as mending clothes, alongside encouraging family economy. This, in conjunction with increased state provision in areas including free school meals and improved access to healthcare, enhanced childhood conditions for the majority of the population. These issues required resolution prior to the adoption of uniform, and it was not until the interwar years of the twentieth century that conditions had improved sufficiently to allow this to occur. School uniforms were initially voluntary but were later made compulsory despite concerns about the costs for parents—a subject that was debated in contemporary newspaper articles.[6] In design, uniforms followed the general appearance of other schools, albeit in a pared-down form more appropriate to the context. Accordingly, school-uniform design passed down the social scale from elite institutions to become a universal symbol of the British education system, retaining and intensifying its links with national identity.

Chapter Five discussed the twentieth century from the Second World War onwards. School uniform was retained in many schools throughout the War in direct defiance of the Board of Trade and despite problems obtaining fabric and making garments, as well as insufficient coupon allowances. Examples of this include Aysgarth School, Eton, Christ's Hospital and North London Collegiate School. National identity became more prominent in the wars of the twentieth century, as a traditional image of the British and their way of life was promoted through propaganda. In the Second World War, Lord Macmillan, the first Minister of Information, stressed in a memorandum to the War Cabinet that all propaganda should place an emphasis on the British character—stoicism, determination, humour and good sportsmanship, qualities that bear a great similarity to those promoted in the public schools and were, therefore, already closely associated with school garments.[7] In political and social rhetoric, the Second World War was a time when a nation of diverse individuals were united in a single cause, the Home Front was as important as the Fighting Front, and this rhetoric helped to reinforce ideas of nationhood and nationalism. The ordinary person became a symbol of British resilience and their normal activities in the face of adversity took on a heroic dimension.[8] The determination to maintain school uniforms under these difficult circumstances demonstrated the role they had come to play in society as a symbol of both British identity and normality.

This same process of retaining the traditional when faced with difficulties can be seen in the determination of the British public to make wedding cakes and Christmas delicacies despite severe butter, sugar and egg rationing. The maintenance of traditional activities in the face of adversity formed an important part of the public coping mechanism, generating feelings of familiarity, continuity and security.[9]

The post-war period, chiefly the 1950s and 1960s, was a time of rapid social change, especially in relation to young people, and this affected both schooling and school uniform. Young people became a more prominently recognized group, with a new focus in advertising and social policy. This gave them a greater voice in society and in doing so allowed them to become more politically aware and active. They also developed their own sub-cultures, sharing interests, music and specific styles of dress which resulted in a greater interest in fashion and clothing. Schooling also relaxed in an increasingly liberal social climate, most notably after the introduction of comprehensive schools. Once again, school dress reflected these changes, uniform requirements were relaxed and, in some schools, particularly the less traditional comprehensives, uniform was abolished altogether. This move towards informality was initiated within the state system and gradually filtered into the more traditional schools where it was adapted for its new context, showing a reversal of previous trends where imitation had occurred exclusively in the opposite direction. This demonstrates the diminishing role of the elite as arbiters of fashion and taste and their replacement as style leaders by more widely accessible cultural icons.

A cultural phenomenon that had a huge impact on the way in which school uniform is viewed was St Trinian's, the high-spirited and often violent schoolgirls conceived by Ronald Searle in the 1940s. Their huge popularity, which was increased by the films of the 1950s and 1960s, initiated a trend for dressing up as schoolgirls that continues today and saw school-uniform styles enter adult fashion and music, as well as British drinking and clubbing culture. This movement of school uniform into popular culture further demonstrates the reversal of the top-down method of dissemination of ideas. Instead, it points to the more eclectic sources of twentieth-century innovation in school uniforms brought about by increasing emphasis on popular culture and the faster transmission of ideas through television and the Internet. From the late 1980s school uniform was formalized or reintroduced in many schools. This move was generated by concerns about lax discipline in institutions and uniform was seen as an alternative method of imposing control and order. In many ways this harks back to the charity schools, where uniform was perceived as a method of social restraint. Parallels can also be drawn between the Protestant modesty of sixteenth-century

uniforms and the modern need to cater for the requirements of Muslim, Sikh and Jewish religious dress codes in schools.

It is clear, then, that school uniform is a reflector of social and educational trends. It either closely aligned with status and gender norms or created and projected new aspirational identities in terms of increased status and greater liberation from constricting gender-based expectations. The speed of the transmission of ideas and uniforms correlates closely with the contemporary capabilities of media, technology and transport. Concepts moved more slowly between charity schools, with transfer in the initial stages often occurring through wealthy benefactors such as John Carr, founder of Queen Elizabeth's Hospital, Bristol, who stated in his will that the school should be a model of Christ's Hospital, which he had seen on his visits to London. With increasing availability of print media throughout the eighteenth century, ideas could be disseminated more swiftly and this continued into the Victorian and Edwardian period with the further introduction of pictorial advertisements and illustrated periodicals, better transport links and urban migration.[10] The relationship between technological capability and the transfer of ideas is seen most clearly in the twentieth century with the introduction of visual media from television to the Internet. These new technologies allowed even faster communication and flow of ideas but also gave the general public full access to relevant information and forums in which they could engage directly with issues and contribute to the discussion. This has resulted in authorities that are more responsive to public demand and the development of a society which values popular culture and media icons and this, has in turn, affected school uniforms—a case of the method of transmission affecting the message. The impact of this, however, has operated only within the already established and understood framework of school-uniform usage.

A similar interplay of technology, influence and design is apparent in the recent rise of the fashion blogger and Instagram influencer, significant parallels may be drawn between these and the transmissions apparent within the field of school uniform in the twentieth and twenty-first centuries. Whilst new styles are still adapted and reproduced from the catwalk, ideas are also drawn from a broader base, with online forums now providing inspiration for high-street collections. These sites transmit ideas, reflecting and influencing fashion, and responding to catwalk and shopping trends, whilst also providing a new cultural resource for clothes retailers to draw on. This has allowed ordinary fashion consumers to play a new role in shaping fashion cycles, whilst also reinforcing the hierarchical structures associated with the fashion world, situating the role of bloggers and influencers in the existing system.[11]

The role of practicality is also an important one and functional concerns often precede other interests. The first charity school uniforms were introduced to provide warm, hard-wearing clothing for the needy, and early public schools adopted uniform for games to negate the impracticalities of playing sport in normal daywear, as well as to identify teams. Conversely, unless provided by the school, uniform could not be introduced unless the necessary practical, and particularly financial, conditions existed amongst the families of attendees, as demonstrated in the early state elementary schools. The act of adopting school uniform, therefore, was often reliant on practical considerations first and foremost, but the style and design of the uniform reflects the ideology of the school or its preferred image.

School uniforms have generally been regarded as an important method of value transference and they continue to retain these associations today. As the Department for Education noted in its revised 2018 report: 'school uniform can play a valuable role by: setting an appropriate tone; instilling pride; supporting positive behaviour and discipline; encouraging identity with, and support for, the school ethos'.[12] The transmission of meaning though school clothing was aimed both at the pupils themselves and at any viewers of the children, although the significance of the clothing was not conveyed equally to both in all social contexts. The uniforms communicated the role and status of the child in society, demonstrating variously class, gender, religious affiliation and the role of individual benefactors. The messages conveyed to the children through their clothing were further reinforced within the educational environment, through lessons reflecting expected career paths, meaning that the significance of their attire was understood on a subconscious, if not conscious, level. On the other hand, the viewer, although able to determine major characteristics, may require an understanding of the type and aims of the institution to fully comprehend the message that is being conveyed by its uniform. For example, the nuances and distinctions between public school uniforms might not be discernible to someone outside the system and consequently may be interpreted in an alternative manner than by those with direct experience or background knowledge. This meaning may be unintentionally encoded or purposely aimed at only those with the relevant understanding, the latter is demonstrated by the importance of the 'old school tie' in nineteenth and twentieth-century business and politics.

The most prominent theme to emerge is that of the impact of class on schooling and, more specifically, on uniform. Class shaped clothing practices, whether through practical concerns such as a lack of money for clothing, or more complex notions of class-appropriate wear, the display of status and aspirational dressing. This can be seen in the intricate dynamic between

public schools, the public school ethos and the middle-class imitators of such institutions. Class also played an important role in the type of school that pupils attended, with the education system clearly divided on class lines until the twentieth century and class divisions persisting even today. Schools were therefore in a position where the status of the school was expressed through the daywear of pupils, and, when first introduced, uniforms mirrored the normal dress practices of attendees. In both instances, however, uniform was also a tool through which the status of pupils could be reinforced. In the case of charity schools, this was predominantly to indicate to pupils their expected role in society and to prevent them from accessing jobs and services intended for those of higher status. Its intention was to combat contemporary anxieties regarding the breakdown of class structures, whilst also demonstrating to the public, through the display of the children in their class-suitable garments, that appropriate action had been taken regarding the issue. In the public schools, uniform, whilst also fulfilling an important role in group-identity creation, acted as a very visible marker of upper-class status to a wider audience, demonstrating the place of the school in society and the expected rank of its pupils. This too was a reflection of class anxieties in a period in which the elite felt under threat from the expanding middle classes.

Uniforms in charity schools were only imitated by similar schools, whereas public school clothing was widely copied within the school system, as well as by commercial enterprise. It was rare for the dress of the working classes to be reproduced in fashionable circles. Public school uniform, on the other hand, in clearly defining itself as upper-class wear, became a status symbol both within the education system and as fashionable dress for children and was widely copied. In the same way as fashions, it was adapted to new contexts, with garments streamlined in schools with lower-income parents through the use of cheaper fabrics and manufacturers and fewer regulated items. Elements of the attire were also adopted by those that could not afford the whole ensemble, with Eton collars becoming a particularly popular accessory for the respectable working classes. Consequently, class and the anxieties associated with it can be viewed as a major catalyst in the initial adoption of school uniform and the imitation of high-status uniforms fits into a wider picture of emulation of upper-class clothing. This process was reversed in the 1960s with more elite establishments taking their lead from state comprehensives in moves towards greater informality of dress.

This closely reflects and parallels wider changes in the dissemination of fashion where the top-down model by which fashion trends were passed down the social strata from the elite to the middle class and then to the working

classes, was the most prevalent method of transmission in Britain until the mid-twentieth century. As Diana Crane writes:

> The top-down model was characteristic of Western societies until the 1960s, when demographic and economic factors increased the influence of youths at all social class levels. The enormous size of the baby-boom generation and its affluence compared to previous generations of young people contributed to its influence on fashion. Since the 1960s, the bottom-up model has explained an important segment of fashion phenomena.[13]

The bottom-up model refers to styles that are sourced from lower socio-economic groups and are most often created and propagated by adolescents engaging in specific youth cultures, something that is particularly applicable to school-age communities. In a similar way to school uniform, this picture has become yet more complicated in recent years, with fashionable influence drawn from multiple sources and transmitted through diverse channels including the fashion industry, celebrities and online spaces. This has created a dialogue between fashion and identity and has placed a greater emphasis on individual expression based on factors other than class, including gender, ethnicity and sexual orientation—an emphasis which is at odds with the increasing uniformity in schools.[14]

The other major factor in determination of school-uniform design was gender. This played a role across all educational establishments, albeit one of varying influence, with its impact seen more prominently in girls' education than in boys'. An early differentiation along gender lines is visible in the charity schools in terms of both clothing and curriculum, although this is simply reflective of normal working-class dress and labour practices. In boys' public schools, the designation of status through uniforms was the most significant factor, but garments also embodied contemporary notions of masculinity. Public schools were the training ground for the British Empire and boys needed to demonstrate manliness to be seen as competent to fulfil roles abroad. Those who did not conform to this stereotype were viewed with suspicion. School uniforms replicated the sombre colours, simplicity of cut and formal design of correct masculine attire of the period. This reinforced the appearance of manliness amongst pupils and carefully avoided flamboyant or foppish garments which were associated with less appropriately manly traits.

Gender was hugely significant in the early stages of girls' education and the importance of feminine appearance and behaviour was a constant concern for

early female educators. It was imperative for girls to appear consistently and obviously feminine in line with contemporary notions of femininity in order to combat claims that education would cause girls to develop the manly characteristics so valued in boys' schools. This demonstrates how ingrained the concept of the boys' public school had become in the public consciousness. So much so that people found it difficult to separate ideas of learning and education from the public school ethos as a whole. This ethos promoted and rewarded masculine traits and it was consequently assumed that female education would do the same. Girls' schools, therefore, consciously chose to present themselves in a different manner, focusing closely on a socially correct external appearance. This emphasis continued until girls' education became less controversial and more widely acceptable towards the end of the nineteenth century. From this juncture uniforms were introduced and although the initial focus was on practicality, the design became increasingly masculinized in imitation of boys' public schools. This occurred alongside the implementation of other aspects of public school life, from the games to the overall organisation of the school. In adopting such appearances and practices schools sought to demonstrate equality, but they also fulfilled the early prophesies whereby female education increasingly encouraged traits and styles of dress that were still considered masculine in society. Boys' school uniform, therefore, remained closely aligned with definitions of masculinity, but female uniforms did not retain connotations of femininity, resulting in a disconnect between the expected wear and behaviour at girls' schools and what was considered normal upon leaving. This meant that female pupils had to adjust to a new set of social norms in order to fulfil the domestic requirements that were still expected of most young women, a situation that continued until the mid-twentieth century.

Gender stereotypes gradually began to break down in the second half of the twentieth century and this, in conjunction with an increasing prevalence of mixed education, saw uniforms streamlined to increase the similarity between the wear of the sexes. However, some key differences were retained, most prominently the distinction between skirts and trousers, the origins of which can be traced back to early fears surrounding the wearing of trousers by women. In recent years this has been challenged on equality grounds and many schools now have identical uniforms for both genders, although some schools continue to distinguish between the sexes.

Whilst less of a driving force for change, national identity has still played an important role with regard to school uniforms, reflecting notions of patriotism and colonialism. This association originated within the British Empire and consequently can be traced back to boys' public schools that provided the

administrators and figure heads that predominated in colonial countries, spreading the traditions of the British public school, including the uniforms, globally. The connection between Britain, Empire and school uniform became cemented in both colonial countries and within Britain itself due to their visual prominence within society. This was further reinforced by the fact that very few countries outside the Empire utilized any form of school uniform, making school uniform uniquely British. The relationship between school uniform and national identity continued into the twentieth century and was particularly prominent in times of war when British identity was felt to be at risk. In these instances, school uniform became a symbol of normality, in opposition to military uniforms which represented the conflict. The link between nationalism and school uniform became less explicit in the post-war period as patriotic sentiment was expressed in new, less overt ways. British school uniform today still projects notions of national identity, but this has adapted with our own changing ideas of nation, from dominant ruler of the Empire to modern multicultural society, there is, however, still something exclusively British about school uniform.

Comparisons can be drawn between these concerns of class, masculinity, British identity and the role of invented tradition and those created, preserved and expressed by military uniforms in the nineteenth and early twentieth century. The most prominent comparison is the role of uniform in the demonstration of hierarchy. Hierarchies in the armed forces corresponded closely with wider class gradations, with the majority of commissioned officers drawn from the public-school-going upper-middle classes. Consequently, normal class behaviours became associated with corresponding military and naval ranks and 'correct' class and masculine qualities were projected and reinforced through the official symbols of these positions. This operated in a number of different ways, with the exclusion of poorer applicants due to the expense of purchasing officers' uniforms, as well as through the replication of upper-class dress practices. Military uniforms made the designation of class more visible and more easily understandable than the subtler class markers of everyday life and, in this manner, they operated in the same way as public school uniforms, designating status and reinforcing class-based norms of action and masculinity.[15]

The role of religion in uniform design is harder to isolate and, with a few minor exceptions, has affected design through its influence over contemporary ethics rather than garments directly reflecting ecclesiastical dress. The dominant religious ethos in an institution or period influenced notions of morality and consequently a correct mode of dress. This was particularly true for women who were considered more likely to stray from godly principles. The influence of religion can be seen throughout, from the Protestant emphasis on modesty

in charity school uniforms to the propagation of muscular Christianity in boys' public schools in which a neat and correct appearance was seen to reflect an internal strength of character and good moral fibre. In girls' schools there was a greater emphasis on the risks of revealing too much and the concern that this would convey the wrong impression about pupils, visually associating them with less respectable girls. In this instance, the role of the viewer was paramount with the hazards of distracting men or inciting unwelcome attention regularly alluded to. Recently, religious dress in schools has become more prominent with the need to allow the wearing of items of religious significance. This is particularly relevant in a society in which a wide spectrum of beliefs is represented. Items of uniform religious dress have been introduced alongside standard uniforms and it is this ability to adapt whilst retaining the traditional aesthetic that has ensured the survival of school uniforms for such a prolonged period.

Whilst there are specific limits to this study, particularly in terms of geography and detailed individual case studies, a work of this scale is able to draw broader conclusions than more closely focused research might allow. Only comparisons across a long chronology would be able to show the relationship between fashion diffusion theories and the transmission of school uniform; the impact of works such as St Trinian's on recent concepts of adolescent femininity or the link between the nationalistic and Empire-orientated ethos of the Victorian and Edwardian public schools and Second World War associations between school uniform and notions of 'Britishness'. By sampling a wide range of source materials, it is possible to trace a wider cultural transfer of influences and ideas that are not specific to a particular parliamentary report or unique to the ways in which uniform is advertised in newspapers, but rather indicative of much larger cultural trends and social changes that are expressed in a diversity of ways.

It looks certain that British school uniform will be around for a number of years to come and the pressures that have shaped the styles and designs over its history will continue to have an impact, albeit in an altered way. The current trend of re-adoption and formalization shows no sign of abating for the time being and continues to be supported by public figures and politicians. There are also moves to implement school uniforms in other countries, particularly in the United States where it has sparked serious debate over its merits and problems, notably its infringement on personal freedom and identity.

Notes

Be Keen!

1. 'Be Keen!', *Pocklingtonian* vol. VIII, no. 2, Michaelmas Term (Second Half), 1899.

Introduction

1. John Styles, 'Dress in History: Reflections of a Contested Terrain', *Fashion Theory* 2, no. 4 (1998), pp. 383–90; Christopher Breward, 'Review: The Politics of Fashion: The Politics of Fashion Studies', *Journal of Contemporary History* 42, no. 4 (2007), pp. 673–75; Jonathan Faiers, 'Dress Thinking: Disciplines and Indisciplinarity', in *Dress History: New Directions in Theory and Practice*, ed. Charlotte Nicklas and Annebella Pollen (London: Bloomsbury, 2015), pp. 15–17.
2. Susan Vincent, *Dressing the Elite: Clothes in Early Modern England* (Oxford: Berg, 2003), p. 6.
3. Paula Fass, 'Is There a Story in the History of Childhood?', in *The Routledge History of Childhood in the Western World*, ed. Paula Fass (Abingdon: Routledge, 2013), p. 7.
4. Catherine Burke and Helena Ribeiro de Castro, 'The School Photograph: Portraiture and the Art of Assembling the Body of the Schoolchild', *History of Education* 36, no. 2 (2007), p. 214.
5. Stephanie Spencer, 'A Uniform Identity: Schoolgirl Snapshots and the Spoken Visual', *History of Education* 36, no. 2 (2007), pp. 227–28.

Chapter One The Charity Schools 1552–1900

1. *Life and Letters of Sir Gilbert Elliot First Earl of Minto from 1751 to 1806, Vol. 1*, ed. Countess of Minto (London: Longmans, Green, and Co., 1874), p. 304.
2. William Blake, 'Holy Thursday (Songs of Innocence)', in *The Complete Writings of William Blake*, ed. Geoffrey Keynes (London: Oxford University Press, 1966), pp. 121–22.
3. Neil J. Smelser, *Social Paralysis and Social Change: British Working-Class Education in the Nineteenth Century* (Berkeley: University of California Press, 1991), p. 313.

4. Jonathan Gathorne-Hardy, *The Public School Phenomenon 597–1977* (London: Hodder and Stoughton, 1977), pp. 22–25.
5. Hugh Cunningham, *Children and Childhood in Western Society Since 1500* (New York: Longman Publishing, 1995), p. 118.
6. Richard Aldrich, *An Introduction to the History of Education* (London: Hodder and Stoughton, 1982), pp. 64–65.
7. Accounts, 1307–08, quoted in Lawrence Tanner, *Westminster School* (London: Country Life Ltd, 1951), p. 2.
8. Statutes, 1440, Winchester College Archives.
9. Phillis Cunnington and Anne Buck, *Children's Costume in England 1300–1900* (London: Adam & Charles Black, 1978), pp. 23–26.
10. Aldrich, *History of Education*, pp. 67–68.
11. Tom Nichols, *The Art of Poverty: Irony and Ideal in Sixteenth-Century Beggar Imagery* (Manchester: Manchester University Press, 2007), pp. 57–58.
12. Thomas Starkey, *A Dialogue between Reginald Pole and Thomas Lupset* (London: Chatto and Windus, 1948), p. 89. For similar seventeenth-century rhetoric, see Sir Joshua Childs and J. Bellars quoted in Dorothy Marshall, *The English Poor in the Eighteenth Century: A Study in Social and Administrative History from 1662–1782* (Abingdon: Routledge, 2007), p. 25.
13. For a more in-depth discussion of governmental motives for involvement, see Paul Slack, *The English Poor Law 1531–1782* (Cambridge: Cambridge University Press, 1995).
14. From *The Chaundler Manuscript*, Oxford and Wells (1462–64). The volume was prepared on behalf of the author, Thomas Chaundler (c.1417–90), Warden of New College, and it was presented to another Wykehamist, Thomas Beckington (d. 1465), Bishop of Bath and Wells.
15. Paul Slack, *Poverty and Policy in Tudor and Stuart England* (New York: Longman, 1993), p. 118.
16. John Lawson and Harold Silver, *A Social History of Education in England* (Abingdon: Routledge, 2007), p. 182; Marshall, *The English Poor in the Eighteenth Century*, p. 25; Keith Wrightson, *English Society 1580–1680* (Abingdon: Routledge, 2004), pp. 192–93.
17. Slack, *Poverty and Policy in Tudor and Stuart England*, pp. 119–20; Carol Kazmierczak Manzione, *Christ's Hospital of London, 1552–1598: 'A Passing Deed of Pity'* (London: Associated University Presses, 1995), pp. 25–29.
18. Ninya Mikhaila and Jane Malcolm-Davies, *The Tudor Tailor: Reconstructing Sixteenth-Century Dress* (London: Batsford, 2006), p. 11.
19. Sarah Trimmer, *The Oeconomy of Charity or An Address to Ladies Adapted to the Present State of Charitable Institutions in England* (London: J. Johnson and F. & C. Rivington, 1801), p. 315.
20. Ann Rosalind Jones and Peter Stallybrass, *Renaissance Clothing and the Materials of Memory* (Cambridge: Cambridge University Press, 2003), pp. 18–21.

21. Treasurers' Account Book, 1552–58, Financial Records, Christ's Hospital Collection, London Metropolitan Archives.
22. Cecil Willet Cunnington, Phillis Cunnington and Charles Beard, *A Dictionary of English Costume* (London: A. & C. Black Ltd, 1976), p. 251.
23. John Stow, *A Survey of London* (London: Printed by John Windet, 1603), p. 119.
24. Treasurers' Account Book, 1552–58, Christ's Hospital Collection.
25. Henry Machyn, *The Diary of Henry Machyn: Citizen and Merchant-Taylor of London from A.D. 1550 to A.D. 1563*, ed. John Gough Nichols (London: Camden Society, 1849), p. 33.
26. Alison Lurie, *The Language of Clothes* (Feltham: Hamlyn Paperbacks, 1983), p. 198.
27. Beverly Lemire, 'Second-hand Beaux and "Red-armed Belles": Conflict and the Creation of Fashions in England, c.1660–1800', *Continuity and Change* 15, no. 3 (2000), p. 395.
28. Maria Hayward, 'Dressed in Blue: The Impact of Woad on English Clothing c.1350–1670', *Costume* 49, no. 2 (2015), pp. 174–76.
29. Maria Hayward, *Rich Apparel: Clothing and the Law in Henry VIII's England* (Farnham: Ashgate, 2009), pp. 100–01.
30. Elizabeth Ewing, *Women in Uniform through the Centuries* (London: B.T. Batsford Ltd, 1975), p. 22.
31. Lemire, 'Second-hand Beaux and "Red-armed Belles"', p. 395.
32. Jones and Stallybrass, *Renaissance Clothing*, pp. 59–85.
33. John S. Lee, *Cambridge and Its Economic Region, 1450–1560* (Hatfield: University of Hertfordshire Press, 2005), p. 108.
34. See, for instance, Jennifer Craik, *Uniforms Exposed: From Conformity to Transgression* (Oxford: Berg, 2005), p. 59; Vivienne Richmond, *Clothing the Poor in Nineteenth-Century England* (Cambridge: Cambridge University Press, 2013), p. 243; David L. Brunsma, *The School Uniform Movement and What it Tells us About American Education: A Symbolic Crusade* (Lanham: Scarecrow Education, 2004), p. 5.
35. Phillis Cunnington and Catherine Lucas, *Charity Costumes of Children, Scholars, Almsfolk, Pensioners* (London: A. & C. Black, 1978), p. 26; Alan Mansfield, 'Dress of the English Schoolchild', *Costume* 8, no. 1 (1974), p. 56.
36. Jerome Bertram, *Monumental Brasses as Art and History* (Stroud: Alan Sutton Publishing Limited, 1996), p. 44; William Lack, Martin Struchfield and Philip Whittemore, *The Monumental Brasses of Cornwall* (London: Monumental Brass Society, 1997), pp. 42, 98 and 118; John Page-Phillips, *Macklin's Monumental Brasses* (London: George Allen & Unwin Ltd, 1970), p. 60.
37. David Wardle, *The Rise of the Schooled Society: the History of Formal Schooling in England* (London: Routledge & Kegan Paul, 1974), pp. 75–77; Nathan Joseph, *Uniforms and Nonuniforms: Communication Through Clothing* (Connecticut: Greenwood Press, 1986), p. 16.
38. Cunnington and Lucas, *Charity Costumes*, p. 20.

39. Steve Hindle, 'Dependency, Shame and Belonging: Badging the Deserving Poor, c.1550–1750', *Cultural and Social History* 1, no. 1 (2004), p. 8.
40. Lemire, 'Second-hand Beaux and "Red-armed Belles"', p. 395; Carlo Marco Belfanti and Fabio Giusberti, 'Clothing and Social Inequality in Early Modern Europe: Introductory Remarks', *Continuity and Change*, p. 15, no. 3 (2000), p. 361; Robert Jones, *Gender and the Formation of Taste in Eighteenth-Century Britain: The Analysis of Beauty* (Cambridge: Cambridge University Press, 1998), pp. 3–4.
41. Peter Earle, *The Making of the English Middle Class: Business, Society, and Family Life in London 1660–1730* (Berkeley: University of California Press, 1989), p. 335; Steve Rappaport, *Worlds Within Worlds: Structures of Life in Sixteenth-Century London* (Cambridge: Cambridge University Press, 2002), pp. 304–06; Peter Lake and Michael Questier, *The Anti-Christ's Lewd Hat: Protestants, Papists and Players in Post-Reformation England* (New Haven and London: Yale University Press, 2002), p. 77.
42. Daniel Defoe, *Every-body's Business, is No-Body's Business: or, Private Abuses, Publick Grievances: Exemplified in the Pride, Insolence, and Exorbitant Wages of our Women-Servants, Footmen, &c. With a Proposal for Amendment of the Same* (London: sold by T. Warner; A. Dodd; and E. Nutt, 1725), p. 16.
43. Daniel Defoe, *Every-body's Business, is No-Body's Business*, p. 16.
44. John Styles, *The Dress of the People: Everyday Fashion in Eighteenth-Century England* (London: Yale University Press, 2010), pp. 272–74.
45. Isaac Watts, *The Works of The Rev. Isaac Watts, D.D. in Nine Volumes, vol. VI* (Leeds: Printed by Edward Baines, 1813), p. 33.
46. Charity School of St Pancras, *A Brief Account of the Charity school of St. Pancras, for Instructing, Cloathing, Qualifying for Useful Servants, and Putting out to Service, the Female Children of the Industrious Poor* (London: S. Low, 1796), p. 4.
47. 'The Construction of Honour, Reputation and Status in Late Seventeenth and Early Eighteenth-Century England', *Transactions of the Royal Historical Society* 6, no. 6 (1996), pp. 207–08; Amanda Vickery, *The Gentleman's Daughter: Women's Lives in Georgian England* (New Haven and London: Yale University Press, 1999), p. 2.
48. Elizabeth Kowaleski-Wallace, *Consuming Subjects: Women, Shopping, and Business in the Eighteenth Century* (New York: Columbia University Press, 1997), p. 5.
49. Chloe Smith, 'Callico Madams: Servants, Consumption, and the Calico Crisis', *Eighteenth-Century Life* 31, no. 2 (2007), p. 43.
50. Kathleen Wilson, *The Island Race: Englishness, Empire and Gender in the Eighteenth Century* (Abingdon: Routledge, 2003), pp. 25–26; Deborah Simonton, 'Schooling the Poor: Gender and Class in Eighteenth-Century England', *Journal for Eighteenth Century Studies* 23, no. 2 (2000), pp. 187–88.
51. Earle, *The Making of the English Middle Class*, p. 199.
52. Juan Luis Vives, *The Education of a Christian Woman: A Sixteenth-Century Manual*, ed. and trans. Charles Fantazzi (Chicago: University of Chicago Press, 2000), p. 106.
53. Vives, *The Education of a Christian Woman*, pp. 107–08.
54. Aldrich, *History of Education*, p. 22.

55. Kaspar von Greyerz, *Religion and Culture in Early Modern Europe, 1500–1800* (Oxford: Oxford University Press, 2008), p. 56.
56. Howard Colvin, 'The Origin of Chantries', *Journal of Medieval History* 26, no. 2 (2000), p. 164.
57. The Will of John Carr, 1586, quoted in Walter Sampson, *History of Queen Elizabeth's Hospital, Bristol* (Bristol: John Wright & Sons Ltd, 1910), p. 13.
58. Sampson, *History of Queen Elizabeth's Hospital*, p. 76.
59. Clare Hartwell, *The History and Architecture of Chetham's School and Library* (London: Yale University Press, 2004), p. 61.
60. *Information Leaflet Number 29: Records of Christ's Hospital and Bluecoat Schools at Guildhall Library* (London: London Metropolitan Archives, 2013), p. 2.
61. These include Queen Elizabeth's Hospital, Bristol; Chetham's Hospital, Manchester; and Reading Blue Coat School, as recorded in the text, in addition to Bablake's, Coventry; and Colston's, Bristol.
62. Wallace Clare, *The Historic Dress of the English Schoolboy* (London: The Society for the Preservation of Ancient Customs, 1939), p. 22.
63. Cunnington and Lucas, *Charity Costumes*, pp. 145–54.
64. Clare, *Dress of the English Schoolboy*, p. 35.
65. John Driden stated in his will of 1707 that pupils should wear 'A blue coat faced with orange colour, with brass buttons, a knit cap and a pair of stockings of orange colour'. This outfit was worn until the school closed in 1921. Cunnington and Lucas, *Charity Costumes*, pp. 92–96.
66. Peter Clark, *British Clubs and Societies 1580–1800: The Origins of an Associational World* (Oxford: Oxford University Press, 2002), pp. 65–66; M.G. Jones, *The Charity School Movement: A Study in Eighteenth Century Puritanism in Action* (London: Frank Cass and Co. Ltd, 1964), p. 4.
67. *The Methods Used for Erecting Charity-Schools, With the Rules and Orders by Which they are Governed. A Particular Account of the London Charity-Schools: With a List of Those Erected Elsewhere in Great Britain & Ireland* (London: Printed and Sold by Joseph Downing, 1716), p. 4.
68. W.K. Lowther Clarke, *A History of the SPCK* (London: SPCK, 1959), pp. 23–25. It should be noted that there is a significant dearth of more recent texts on this aspect of the SPCK's history.
69. Lowther Clarke, *A History of the SPCK*, p. 46.
70. *An Account of Charity-Schools Lately Erected in England, Wales, and Ireland: With the Benefactions Thereto; and of the Methods Whereby They Were Set Up, and are Governed. Also, a Proposal for Enlarging their Number, and Adding Some Work to the Childrens Learning, Thereby to Render their Education More Useful to the Publick* (London: Printed and Sold by Joseph Downing, 1706), p. 21.
71. *An Account of Charity-Schools*, 1706, p. 5.
72. *An Account of Charity-Schools Lately Erected in England, Wales, and Ireland: With the Benefactions Thereto; and of the Methods Whereby They Were Set Up, and are Governed.*

Also, a Proposal for Enlarging their Number, and Adding Some Work to the Childrens Learning, Thereby to Render their Education More Useful to the Publick (London: Printed and Sold by Joseph Downing, 1709), p. 50.
73. *The Methods Used for Erecting Charity-Schools, With the Rules and Orders by Which they are Governed. A Particular Account of the London Charity-Schools: With a List of Those Erected Elsewhere in Great Britain & Ireland* (London: Printed and Sold by Joseph Downing, 1715), p. 32.
74. Gregory Holyoake, 'Survivors of the First Free Schools: London's Charity Children Statues', *Country Life*, 13 November 1980, p. 1,787.
75. Lowther Clarke, *A History of the SPCK*, p. 47.
76. Stephanie Davies, *Costume Language: a Dictionary of Dress Terms* (Malvern: Cressrelles Publishing Company, 1994), p. 33.
77. Samuel Pepys, *The Diary of Samuel Pepys: Volume I, 1660*, ed. Robert Latham and William Matthews (London: Harper Collins Publishers, 2000), p. 26.
78. Jones, *The Charity School Movement*, p. 24.
79. Dorothy Marshall, *Eighteenth Century England, 1714–1784* (London: Routledge, 2014), pp. 8–10.
80. 'Report from Bicester Charity School: Oxfordshire, June 19 1725', in *An Account of Several Workhouses for Employing and Maintaining the Poor; Setting Forth The Rules by Which they are Governed, Their Great Usefulness to the Publick, And in Particular To the Parishes Where They are Erected. As Also of Several Charity Schools For Promoting Work, and Labour* (London: Printed and Sold by Joseph Downing, 1732), p. 158.
81. *The State of the Ladies Charity-School, Lately Set Up in Baldwin-Street, in the City of Bristol, for Teaching Poor Girls to Read and Spin; Together with Rules and Methods of Proceeding* (Bristol: Printed by S. Farley, 1756), p. 2.
82. *An Account of the Charity School in Oxford (Maintain'd by the Voluntary Subscriptions of the Vice-Chancellor, Heads of Houses, and other Members of the University) for Four Years: vis. From Michaelmas 1711 to Michaelmas 1715* ([Oxford?], 1715).
83. Kay Boardman, 'A Material Girl in a Material World: the Fashionable Female Body in Victorian Women's Magazines', *Journal of Victorian Culture* 3, no. 1 (1998), p. 93; Elizabeth Wilson, *Adorned in Dreams: Fashion and Modernity* (Berkeley: University of California Press, 1987), pp. 36–40. For a more in-depth discussion of fashion diffusion, see Diana Crane, 'Diffusion Models and Fashion: A Reassessment', *The Annals of the American Academy of Political and Social Science* 566, no. 1 (1996), pp. 13–24.
84. Cunnington and Lucas, *Charity Costumes*, pp. 122–29.
85. Cunnington and Lucas, *Charity Costumes*, p. 125.
86. John Strype, *A Survey of the Cities of London and Westminster* (1720), I. xxvi. p. 175.
87. Cunnington and Lucas, *Charity Costumes*, p. 32.
88. James Laver, *Modesty in Dress* (London: Heinemann, 1969), pp. 54–62.
89. Clare, *Dress of the English Schoolboy*, p. 19.

90. Leigh Hunt, *The Autobiography of Leigh Hunt* (London: The Cresset Press, 1949), p. 56.
91. Hunt, *The Autobiography of Leigh Hunt*, p. 60.
92. Mansfield, 'Dress of the English Schoolchild', p. 56.
93. Tim Meldrum, *Domestic Service and Gender, 1660–1750: Life and Work in the London Household* (London: Routledge, 2014), pp. 56–58; Laver, *Modesty in Dress*, pp. 78–81.
94. Diane Crane, *Fashion and Its Social Agendas: Class, Gender, and Identity in Clothing* (Chicago and London: University of Chicago Press, 2000), pp. 90–92.
95. Daphne Meadmore and Colin Symes, 'Of Uniform Appearance: a Symbol of School Discipline and Governmentality', *Discourse: Studies in the Cultural Politics of Education* 17, no. 2 (1996), p. 212.
96. *School of Industry for the Instruction of the Female Children of the Industrious Poor* (London: Printed by R. Newton, 1837), p. 6.
97. Rules for Government of the Rotherhithe Charity and Amicable Society Schools, 1825, SPCK Archives, Cambridge University Library, p. 5.
98. *Schools Inquiry Commission, Vol. I Report of the Commissioners* (London: Printed by George Edward Eyre and William Spottiswoode, 1868), p. 214.
99. Machyn, *The Diary of Henry Machyn*, p. 33.
100. Sarah Lloyd, 'Pleasing Spectacles and Elegant Dinners: Conviviality, Benevolence, and Charity Anniversaries in Eighteenth-Century London', *Journal of British Studies* 41, no. 1 (2002), p. 26.
101. Record of Attendance at Funerals by Pupils of the School as Mourners, Giving the Name, Status and Occupation of Each Individual to be Buried, and Details of the Arrangements for the Funeral Service, Number of Pupils Requested to Attend and Amount of Money Given or Promised, 1622–1754, Children, Christ's Hospital Collection, London Metropolitan Archives.
102. W.H. Pyne, *The Microcosm of London or, London in Miniature; Volume I* (London: Methuen, 1904), p. 77.
103. Bernard Mandeville, *The Fable of the Bees or Private Vices: Publick Benefits, Vol. 1* (Oxford: Clarendon Press, 1732), p. 188.
104. Lloyd, 'Pleasing Spectacles and Elegant Dinners', p. 26.
105. Thomas Pennant, *Of London* (London: Printed for Robt. Faulder, 1790), p. 204.
106. J. Harroway, *The Charity School: A Comic Duet* (London: T. Purday, c.1835).
107. Richard Allestree, *The Practice of Christian Graces, or, The Whole Duty of Man Laid Down in a Plaine and Familiar Way for the Use of All, but Especially the Meanest Reader* (London: Printed by D. Maxwell for T. Garthwait, 1658), p. 295.
108. See also Jean-Jacques Rousseau, *Émile: or, On Education*, trans. Allan Bloom (New York: Basic Books, 1979).
109. Harry Hendrick, 'Constructions and Reconstructions of British Childhood: An Interpretative Study, 1800 to the Present', in *Constructing and Reconstructing*

Childhood: Contemporary Issues in the Sociological Study of Childhood, ed. Allison James and Alan Prout (London: RoutledgeFalmer, 2003), pp. 38–41.
110. Mary Cadogan and Patricia Craig, *You're a Brick Angela! A New Look at Girls' Fiction from 1839 to 1975* (London: Victor Gollancz Ltd, 1976), pp. 127–30; John Rowe Townsend, *Written for Children: An Outline of English Children's Literature* (London: Garnet Miller, London, 1965), p. 124.
111. Charlotte Brontë, *Jane Eyre* (Oxford: Oxford University Press, 2008), pp. 44–47.
112. Charles Dickens, *Dombey and Son* (Boston: Bradbury and Guild, 1848), p. 44.

Chapter Two The Public Schools 1800–1939

1. Richard Aldrich, *An Introduction to the History of Education* (London: Hodder and Stoughton, 1982), pp. 64–65.
2. Jonathan Gathorne-Hardy, *The Public School Phenomenon 597–1977* (London: Hodder and Stoughton, 1977), p. 32.
3. Gathorne-Hardy, *The Public School Phenomenon*, pp. 26–28.
4. John Tosh, *A Man's Place: Masculinity and the Middle-Class Home in Victorian England* (New Haven and London: Yale University Press, 2007), pp. 12–13.
5. Leonore Davidoff and Catherine Hall, *Family Fortunes: Men and Women of the English Middle Classes 1780–1850* (London: Routledge, 2002), pp. xv–xviii; Tosh, *A Man's Place*, pp. 11–12; Eric J. Evans, *The Forging of the Modern State: Early Industrial Britain, 1783–1870* (London: Routledge, 2001), pp. 347–48.
6. J.A. Mangan, *Athleticism in the Victorian and Edwardian Public School: The Emergence and Consolidation of an Educational Ideology* (London: The Falmer Press, 1986), pp. 128–29; Sally Power, Tony Edwards, Geoff Whitty and Valerie Wigfall, *Education and the Middle Classes* (Buckingham: Open University Press, 2003), p. 7.
7. Alysa Levene, *The Childhood of the Poor: Welfare in Eighteenth-Century London* (Basingstoke: Palgrave Macmillan, 2012), pp. 3–4.
8. Gathorne-Hardy, *The Public School Phenomenon*, pp. 56–61.
9. Fred T. Whitington, *Augustus Short, First Bishop of Adelaide: the Story of a Thirty-Four Years' Episcopate* (London: Wells Gardner Darton & Co., 1888), p. 37.
10. Whitington, *Augustus Short, First Bishop of Adelaide*, p. 36.
11. Gathorne-Hardy, *The Public School Phenomenon*, pp. 62–63.
12. John Tosh, 'Gentlemanly Politeness and Manly Simplicity in Victorian England', *Transaction of the Royal Historical Society* 6, no. 12 (2002), p. 455.
13. T.W. Bamford, *The Rise of the Public Schools: A Study of Boys' Public Boarding Schools in England and Wales from 1837 to the Present Day* (London: Nelson, 1967), pp. 51–53.
14. John Tosh, *Manliness and Masculinities in Nineteenth-Century Britain: Essays on Gender, Family and Empire* (Harlow: Pearson Education Limited, 2005), p. 112.
15. John Brinsley, *Ludus Literarius: or the Grammar Schoole* (London: Printed for Thomas Man, 1612), p. 301.

16. Mangan, *Athleticism in the Victorian and Edwardian Public School*, p. 10.
17. Patrick F. McDevitt, *May the Best Man Win: Sport, Masculinity, and Nationalism in Great Britain and the Empire, 1880–1935* (New York: Palgrave Macmillan, 2004), 10; J.A. Mangan, *The Games Ethic and Imperialism: Aspects of the Diffusion of an Ideal* (Middlesex: Viking, 1986), p. 18.
18. Phillis Cunnington and Alan Mansfield, *English Costume for Sports and Outdoor Recreation: From the Sixteenth to the Nineteenth Centuries* (London: Adam & Charles Black, 1969), pp. 49–50.
19. Rae Compton, *The Complete Book of Traditional Knitting* (New York: Dover Publications Inc., 2010), pp. 55–56.
20. An Old Rugbeian (R.H. Hutton), *Recollections of Rugby* (London: Hamilton and Adams, 1848), p. 131.
21. Mark Girouard, *The Return to Camelot: Chivalry and the English Gentleman* (New Haven and London: Yale University Press, 1981), p. 240.
22. *Routledge's Handbook of Football* (London: G. Routledge & Sons, 1867).
23. Cunnington and Mansfield, *English Costume for Sports and Outdoor Recreation*, p. 49.
24. Cunnington and Mansfield, *English Costume for Sports and Outdoor Recreation*, p. 289.
25. Cunnington and Mansfield, *English Costume for Sports and Outdoor Recreation*, p. 15.
26. Richard Holt, 'The Amateur Body and the Middle-class Man: Work, Health and Style in Victorian Britain', *Sport in History*, 26, no. 3 (2006), p. 365.
27. Hugh Cunningham, *The Invention of Childhood* (London: BBC Book, 2006), p. 144; Donald E. Hall, *Muscular Christianity: Embodying the Victorian Age* (Cambridge: Cambridge University Press, 2006), pp. 7–8.
28. Lachlan Campbell, *Eton Colours: An Essential Illustrated Aide Memoire* (Hanford: Glenorchy Publishing, 2008), pp. 4–12.
29. Henry John Newbolt, *Admirals All: and Other Verses* (London: Elkin Mathews, 1898), p. 21.
30. Henry Vigne 'Henry Vigne', in *Edwardian Childhoods*, ed. Thea Thompson (London: Routledge & Kegan Paul, 1981), p. 162.
31. Gathorne-Hardy, *The Public School Phenomenon*, p. 228.
32. Eric Hobsbawm, 'Introduction: Inventing Traditions', in *The Invention of Tradition*, ed. Eric Hobsbawm and Terence Ranger (Cambridge: Cambridge University Press, 2013), p. 10.
33. Tosh, *Manliness and Masculinities*, p. 197.
34. *Report of Her Majesty's Commissioners Appointed to Inquire into the Revenues and Management of Certain Colleges and Schools and the Studies Pursued and Instruction Given Therein; with an Appendix and Evidence, Vol. IV. Evidence Part 2* (London: Printed by George Edward Eyre and William Spottiswoode, 1864), p. 203.
35. See, for instance, Tony Cooper, *Head on the Block* (Beauchamp: Matador, 2012), p. 122; or Mary Ellen Snodgrass, *World Clothing and Fashion: An Encyclopaedia of History, Culture and Social Influence* (London: Routledge, 2015), p. 233.

36. *Report of Her Majesty's Commissioners Appointed to Inquire into the Revenues and Management of Certain Colleges and Schools and the Studies Pursued and Instruction Given Therein; with an Appendix and Evidence, Vol. III. Evidence Part 1* (London: Printed by George Edward Eyre and William Spottiswoode, 1864), p. 116.
37. *Report of Her Majesty's Commissioners Appointed to Inquire into the Revenues and Management of Certain Colleges and Schools, Vol. III. Evidence Part 1*, pp. 367–75; *Report of Her Majesty's Commissioners Appointed to Inquire into the Revenues and Management of Certain Colleges and Schools, Vol. IV. Evidence Part 2*, p. 252.
38. *Report of Her Majesty's Commissioners Appointed to Inquire into the Revenues and Management of Certain Colleges and Schools, Vol. III. Evidence Part 1*, p. 273.
39. *Report of Her Majesty's Commissioners Appointed to Inquire into the Revenues and Management of Certain Colleges and Schools, Vol. IV. Evidence Part 2*, p. 11.
40. Christopher Breward, *The Culture of Fashion: A New History of Fashionable Dress* (Manchester: Manchester University Press, 1995), p. 176.
41. Brent Shannon, 'Re-fashioning Men: Fashion, Masculinity, and the Cultivation of the Male Consumer in Britain, 1860–1914', *Victorian Studies* 46, no. 4 (2004), pp. 597–98.
42. Alicia C. Percival, *The Origins of the Headmasters' Conference* (London: John Murray, 1969), pp. 1–3.
43. David Kuchta, *The Three-Piece Suit and Modern Masculinity: England, 1550–1850* (Berkeley: University of California Press, 2002), pp. 177–78.
44. Brent Shannon, *The Cut of his Coat: Men, Dress and Consumer Culture in Britain, 1860–1914* (Ohio: Ohio University Press, 2006), pp. 187–88.
45. Brent Shannon, *The Cut of his Coat*, pp. 187–88.
46. Alice Guppy, *Children's Clothes 1939–1970: The Advent of Fashion* (Poole: Blandford Press, 1978), p. 58.
47. Cunnington and Mansfield, *English Costume for Sports and Outdoor Recreation*, pp. 54–55, 318; Elizabeth Ewing, *History of Children's Costume* (London: B.T. Batsford Ltd, 1977), p. 90.
48. Tammy M. Proctor, 'On my Honour: Guides and Scouts in Interwar Britain', *Transactions of the American Philosophical Society* 92, no. 2 (2002), pp. 13–14.
49. Shannon, *The Cut of his Coat*, p. 102.
50. 'Dress News', *Fashion*, October 1898, quoted in Shannon, *The Cut of his Coat*, p. 102.
51. Shannon, *The Cut of his Coat*, pp. 187–89.
52. Arthur Ponsonby, *The Decline of Aristocracy* (London: T. Fisher Unwin, 1912), p. 191.
53. Gathorne-Hardy, *The Public School Phenomenon*, p. 447.
54. Mike Huggins, *The Victorians and Sport* (London: Hambledon & London, 2004), p. 226.
55. H.C. Jackson, *Sudan Days and Ways* (London: Macmillan, 1954), p. 15.
56. J.A. Mangan, *The Games Ethic and Imperialism*, p. 19.
57. Hartmut Berghoff, 'Public Schools and the Decline of the British Economy, 1870–1914', *Past & Present*, no. 129 (1990), pp. 148–49.

NOTES TO PAGES 49–53

58. H.C. Maxwell Lyte, *A History of Eton College, 1440–1884* (London: Macmillan and Co., 1889), pp. 474–75.
59. Norah Waugh, *The Cut of Women's Clothes, 1600–1930* (Abingdon: Routledge, 2011), p. 228.
60. Waugh, *The Cut of Women's Clothes*, p. 147.
61. David Newsome, *A History of Wellington College, 1859–1959* (London: John Murray, 1959), pp. 58–64.
62. E.F. Benson, *As We Were: A Victorian Peep Show* (London: Longmans, Green and Co., 1930), p. 4.
63. 'Classified Advertisement—School Uniform', *Standard*, 4 February 1860.
64. 'Classified Advertisement—Send for Patterns and Directions', *Standard*, 4 February 1860.
65. 'Classified Advertisement—Sydenham School Uniforms', *Daily News*, 15 October 1860.
66. *Samuel Brothers New Map of London* (London: Samuel Brothers, May 1862).
67. *Mr Gray's Singing X*, 1885, black-and-white photograph, Marlborough College Archives; Dr Rogers, Marlborough College, personal correspondence, 9 October 2012.
68. Susan Walton, *Imagining Soldiers and Fathers in the Mid-Victorian Era: Charlotte Yonge's Models of Manliness* (Farnham: Ashgate, 2010), pp. 41–43.
69. Scott Hughes Myerly, *British Military Spectacle: From the Napoleonic Wars through the Crimea* (Cambridge, MA: Harvard University Press, 1996), p. 67.
70. Gathorne-Hardy, *The Public School Phenomenon*, pp. 112–14.
71. Harold Nicolson, *Some People* (London: Pan Books Ltd, 1947), p. 35.
72. Rupert H. Wilkinson, 'The Gentleman Ideal and the Maintenance of a Political Elite: Two Case Studies: Confucian Education in the Tang, Sung, Ming and Ching Dynasties; and the Late Victorian Public Schools (1870–1914)', *Sociology of Education*, 37, no. 1 (1963): p. 15; J. Synott and C. Symes, 'The Genealogy of the School: an iconography of badges and mottoes', *British Journal of Sociology of Education* 16, no. 2 (1995), p. 141.
73. Christopher Tyerman, *A History of Harrow School 1324–1991* (Oxford: Oxford University Press, 2000), p. 335.
74. Vivian Ogilvie, *The English Public School* (London: B.T. Batsford, 1957), p. 182.
75. Nathan Joseph, *Uniforms and Nonuniforms: Communication Through Clothing* (Connecticut: Greenwood Press, 1986), p. 2.
76. Ponsonby, *The Decline of Aristocracy*, p. 207.
77. Arthur Christopher Benson, *The Upton Letters* (London: Smith Elder and Company, 1906), p. 48.
78. Talbot Baines Reed, *Fifth Form at St Dominic's: A School Story* (London: The Religious Tract Society, 1890), pp. 16–17.
79. B. Heldmann, *Boxall School: A Tale of Schoolboy Life* (London: Nisbet & Co., 1929), p. 11.

80. Jack Cox, *Take a Cold Tub, Sir! The Story of the Boy's Own Paper* (Guildford: Lutterworth Press, 1982), pp. 40–42.
81. Frederic W. Farrar, *Eric, or Little by Little* (London and Glasgow: Collins' Clear-Type Press, c.1913), p. 23.
82. John Rowe Townsend, *Written for Children: An Outline of English Children's Literature* (London: Garnet Miller, 1965), p. 124.
83. Christopher Breward, *The Hidden Consumer: Masculinities, Fashion and City Life 1860–1914* (Manchester: Manchester University Press, 1999), p. 41.
84. A. Davidson, *Blazers, Badges and Boaters: a Pictorial History of School Uniform* (Hants: Scope Books, 1990), p. 21.
85. Robert Graves, *Goodbye to All That* (London: Penguin Books, 1960), p. 43.
86. Richard Holt, *Sport and the British: A Modern History* (Oxford: Clarendon Press, 1993), p. 81.
87. 'School Notes', *Pocklingtonian* vol. VIII, no. 2, Michaelmas Term (Second Half), 1899, p. 7.
88. Eric Hobsbawm, 'Mass-Producing Traditions: Europe, 1870–1914', in *The Invention of Tradition*, p. 295.
89. Gathorne-Hardy, *The Public School Phenomenon*, pp. 100–02.
90. Phillipe Perrot, *Fashioning the Bourgeoisie: A History of Clothing in the Nineteenth Century* (Princeton: Princeton University Press, 1994), pp. 85–86 and 180.
91. Gathorne-Hardy, *The Public School Phenomenon*, pp. 100–02.
92. Phillis Cunnington and Anne Buck, *Children's Costume in England 1300–1900* (London: Adam & Charles Black, 1978), pp. 172–78.
93. J.D.R. McConnell, *Eton: How it Works* (London: Faber and Faber, 1967), p. 162.
94. 'Advertisement—A Novelty in Boys' Jackets', *Manchester Times*, 3 August 1850.
95. 'Advertisement', *Freeman's Journal and Daily Commercial Advertiser*, 15 December 1859.
96. 'Advertisement—B. Hyam and the Spring, 1860', *Liverpool Mercury*, 6 March 1860.
97. *Report of Her Majesty's Commissioners Appointed to Inquire into the Revenues and Management of Certain Colleges and Schools, Vol. IV. Evidence Part 2*, p. 252.
98. Ewing, *History of Children's Costume*, pp. 114–16.
99. 'An Essay on Collars', *Leeds Mercury*, 12 November 1887.
100. Roy Richard Grinker, Stephen C. Lubkemann and Christopher B. Steiner, *Perspectives on Africa: A Reader in Culture, History and Representation* (Chichester: Wiley-Blackwell, 2010), pp. 451–52.
101. Quoted in Tyerman, *A History of Harrow School*, p. 122.
102. 'Scenes at a Public School; First day at Harrow', *Harrovian* vol. I, no. 1, March 1828, pp. 10–13.
103. *Report of Her Majesty's Commissioners Appointed to Inquire into the Revenues and Management of Certain Colleges and Schools, Vol. IV. Evidence Part 2*, p. 194.
104. Hobsbawm, 'Introduction: Inventing Traditions', in *The Invention of Tradition*, p. 5.

105. *Report of Her Majesty's Commissioners Appointed to Inquire into the Revenues and Management of Certain Colleges and Schools, Vol. IV. Evidence Part 2*, p. 203.
106. 'Correspondence—The Dress of Harrow Schoolboys', *Morning Post*, 3 December 1886.
107. 'Correspondence', *Morning Post*, 7 December 1886.
108. 'School Dress', *Harrovian*, vol. ii, no. 6, 4 July 1889.

Chapter Three Public Schools for Girls 1850–1939

1. Jonathan Gathorne-Hardy, *The Public School Phenomenon 597–1977* (London: Hodder and Stoughton, 1977), pp. 230–32.
2. Gathorne-Hardy, *The Public School Phenomenon*, p. 234.
3. Kathryn Hughes, *The Victorian Governess* (London: Hambledon & London, 2001), p. 181.
4. J. Kamm, *Hope Deferred: Girls' Education in English History* (London: Methuen, 1965), pp. 174–76.
5. 'Queen's College—London', in the *Quarterly Review* (London: John Murray, 1850), p. 366.
6. 'Queen's College—London', in the *Quarterly Review*, p. 367.
7. John Roach, *A History of Secondary Education in England, 1800–1870* (London: Longman, 1986), p. 6.
8. Ellen Jordan, *The Women's Movement and Women's Employment in Nineteenth Century Britain* (London: Routledge, 1999), p. 117.
9. Letter, Emily Davies to Robert Potts, 9 January 1864, in *Emily Davies Collected Letters 1861–1875*, ed. Jerome McGann and Herbert Tucker (Virginia: University of Virginia Press, 2004), p. 89.
10. Martha Vicinus, *Independent Women: Work and Community for Single Women, 1850–1920* (London: Virago Press, 1985), p. 122.
11. The fight was prolonged, but eventually successful. In 1865 Cambridge allowed girls to sit its exams, Edinburgh and Durham followed suit a couple of years later and finally Oxford in 1870. The first admissions of female undergraduates came soon after, although in most universities the degrees that these early pioneers obtained were not fully recognized until much later.
12. Carol Dyhouse, *Girls Growing up in Late Victorian and Edwardian England* (London: Routledge & Kegan Paul, 1981), p. 2.
13. Letter from Queen Victoria to Sir Theodore Martin, 1870, quoted in Val Horsler, *All for Love: Seven Centuries of Illicit Liaison* (London: Bloomsbury Academic, 2006), p. 104.
14. S. Barbara Kanner, 'The Women of England in a Century of Social Change, 1815–1914: A Select Bibliography', in *Suffer and Be Still: Women in the Victorian Age*, ed. Martha Vicinus (Abingdon: Routledge, 2013), p. 191.

15. J.N. Burstyn, *Victorian Education and the Ideal of Womanhood* (London: Croom Helm, 1980), p. 11.
16. Henry Maudsley, 'Sex in Mind and Education', *Popular Science Monthly*, June 1874.
17. 'Female Education', *John Bull*, 31 January 1852, p. 73.
18. Final verse from 'The Woman of the Future', *Punch*, 10 May 1884. The penultimate verse runs:
 > The Woman of The Future may be very learned-looking,
 > But dare we ask if she'll know aught of housekeeping or cooking;
 > She'll read far more, and that is well, than empty-headed beauties,
 > But has she studied with it all a woman's chiefest duties?
 > We wot she'll ne'er acknowledge, till her heated brain grows cooler
 > That Woman, not the Irishman, should be' the true home-ruler.
19. Sara Delamont, 'The Contradictions in Ladies' Education', in *The Nineteenth-Century Woman: Her Cultural and Physical World*, ed. Sara Delamont and Lorna Duffin (London: Croom Helm, 1987), p. 140; Deborah Gorham, *The Victorian Girl and the Feminine Ideal* (London and Canberra: Croom Helm, 1982), p. 107.
20. Diana Crane, *Fashion and its Social Agendas: Class, Gender and Identity in Clothing* (Chicago and London: The University of Chicago Press, 2000), pp. 100–01.
21. Letter, Emily Davies to Henry Tomkinson, 9 May 1864, in *Emily Davies Collected Letters 1861–1875*, ed. McGann and Tucker, p. 118.
22. Dyhouse, *Girls Growing up in Late Victorian and Edwardian England*, p. 59.
23. Ethel Davidson, *History of St Margaret's* (Unpublished Document, 2005), p. 8.
24. Homework, 1870s, box B1, History of the School 1850–1895, NLCS Archives.
25. Christine Bayles Kortsch, *Dress Culture in Late Victorian Women's Fiction: Literacy, Textiles, and Activism* (Farnham: Ashgate, 2009), pp. 20–21.
26. Jordan, *The Women's Movement and Women's Employment in Nineteenth Century Britain*, pp. 119–20.
27. Julia M. Grant, Katherine H. McCutcheon and Ethel F. Sanders (eds), *St Leonards School, 1877–1927* (Oxford: Oxford University Press, 1927), p. 102.
28. Katrina Rolley, 'Fashion, Femininity and the Fight for the Vote', *Art History* 13, no. 1 (1990), pp. 51–52.
29. Vicinus, *Independent Women*, pp. 263–64.
30. Joel H. Kaplan and Sheila Stowell, *Theatre & Fashion: Oscar Wilde to the Suffragettes* (Cambridge: Cambridge University Press, 1994), p. 159.
31. Kaplan and Stowell, *Theatre and Fashion*, p. 180.
32. Elizabeth Ewing, *History of Children's Costume* (London: B.T. Batsford, 1977), p. 119.
33. Roberta J. Park, 'Biological Thought, Athletics and the Formation of a "Man of Character": 1830–1900', in *Manliness and Morality: Middle-class Masculinity in Britain and America 1800–1940*, ed. J.A. Mangan and James Walvin (Manchester: Manchester University Press, 1987), p. 7.

34. Jennifer Hargreaves, *Sporting Females: Critical Issues in the History and Sociology of Women's Sports* (London and New York: Routledge, 1994), p. 64.
35. Dio Lewis, *The New Gymnastics for Men, Women and Children* (Boston: Ticknor and Fields, 1862), p. 17.
36. Patricia Campbell Warner, *When the Girls Came Out to Play: The Birth of American Sportswear* (Amherst and Boston: University of Massachusetts Press, 2006), p. 174.
37. 'Physical Education and the Liverpool Gymnasium', *Queen, The Lady's Newspaper*, 5 January 1867, p. 5.
38. 'Physical Education and the Liverpool Gymnasium', *Queen*, p. 5.
39. Derek Birley, *Playing the Game: Sport and British Society 1910–45* (Manchester: Manchester University Press, 1995), p. 41.
40. Jane McDermid, *The Schooling of Girls in Britain and Ireland, 1800–1900* (London: Routledge, 2012), p. 94.
41. Richard Holt, *Sport and the British: A Modern History* (Oxford: Clarendon Press, 1993), p. 117; Gorham, *The Victorian Girl and the Feminine Ideal*, p. 72; Patrick F. McDevitt, *May the Best Man Win: Sport Masculinity, and Nationalism in Great Britain and the Empire, 1880–1935* (New York: Palgrave Macmillan, 2004), p. 3.
42. Kathleen E. McCrone, *Sport and the Physical Emancipation of English Women, 1870–1914* (Abingdon: Routledge, 2014), p. 91–92.
43. Louisa Innes Lumsden, *Yellow Leaves: Memories of a Long Life* (Edinburgh: William Blackwood & Sons Ltd, 1933), p. 29.
44. Lumsden, *Yellow Leaves*, pp. 16–23.
45. Grant et al., *St Leonards School*, pp. 99–101.
46. Hargreaves, *Sporting Females: Critical Issues in the History and Sociology of Women's Sports*, p. 64.
47. Annie E. Ridley, *Frances Mary Buss and Her Work for Education* (London: Longmans, Green & Co., 1896), p. 183.
48. 'The North London Collegiate School for Girls', *Girls' Own Paper*, May 1882, p. 494.
49. Ewing, *History of Children's Costume*, p. 121.
50. Prefects and Monitors Minutes, vol. 1, 255, 23 January 1899, box A2, History of the School 1941–1950, NLCS Archives.
51. Letter to Parents, 1912, box A2, History of the School 1941–1950, NLCS Archives.
52. 'Thames Rowing Girls', *Blackburn Standard and Weekly Express*, 1 June 1889, p. 2.
53. Dorothy E. De Zouche, *Roedean School, 1885–1955* (Brighton: Dolphin Press, 1955), p. 37.
54. Campbell Warner, *When the Girls Came Out to Play: The Birth of American Sportswear*, p. 5.
55. Clare Rose, 'Continuity and Change in Edwardian Children's Clothing', *Textile History* 42, no. 2 (2011), p. 147.
56. Clare Rose, 'The Meanings of the Late Victorian Sailor Suit', *Journal for Maritime Research* 11, no. 1 (2009), p. 29.

57. P. Cunningham and A. Buck, *Children's Costume in England From the Fourteenth to the End of the Nineteenth Century* (London: A. & C. Black Ltd, 1965), pp. 73–74.
58. C.E. Thomas, *Athletic Training for Girls* (London: Sir Isaac Pitman & Sons Ltd, 1913), p. 12.
59. Phillis Cunnington and Alan Mansfield, *English Costume for Sports and Outdoor Recreation: From the 16th to the 19th Centuries* (London: Adam & Charles Black, 1969), p. 45.
60. Anne Bloomfield, 'Martina Bergman-Osterberg (1849–1915): Creating a Professional Role for Women in Physical Training', *History of Education* 34, no. 5 (2005), p. 530.
61. Sophia A. Van Wingerden, *The Women's Suffrage Movement in Britain, 1866–1928* (London: Macmillan Press Ltd, 1999), pp. 136–81.
62. J. Laver, *Costume & Fashion: A Concise History* (London: Thames and Hudson, 1992), p. 200.
63. Prefects and Monitors Minutes, vol. 1, 259, 15 December 1899, box A2, History of the School 1941–1950, NLCS Archives.
64. Wilfred Mark Webb, *The Heritage of Dress: Being Notes on the History and Evolution of Clothes* (London: The Times Book Club, 1912), pp. 126–27.
65. Crane, *Fashion and its Social Agendas*, pp. 100–01.
66. Letter to Parents, 1912, NLCS Archives.
67. Webb, *The Heritage of Dress*, pp. 127–28.
68. Lorna Arnold, *My Short Century: Memoirs of an Accidental Nuclear Historian* (Palo Alto: Cumnor Hill Books, 2012), p. 30.
69. Sara A. Burstall, *Retrospect and Prospect: Sixty Years of Women's Education* (London: Longmans, Green & Co., 1933), p. 153.
70. Grant et al., *St Leonards School*, p. 102.
71. Uniform list for Wycombe Abbey School, 190?, Wycombe Abbey School Archives.
72. Elsie Bowerman, *Stands There a School: Memories of Dame Frances Dove, D.B.E., Founder of Wycombe Abbey School* (Chiltern: Wycombe Abbey School, 1966), pp. 30–31.
73. Uniform list for Wycombe Abbey School, 190?, Wycombe Abbey School Archives.
74. 'The World of Women, Marguerite', *Penny Illustrated Paper and Illustrated Times*, 8 October 1892, p. 234.
75. Quoted in Bowerman, *Stands There a School: Memories of Dame Frances Dove*, p. 79.
76. Gathorne-Hardy, *The Public School Phenomenon*, pp. 248–50.
77. Anne Hollander, *Sex and Suits: The Evolution of Modern Dress* (Brinkworth: Claridge Press, 1994), pp. 52–53; Diana Crane, 'Clothing Behaviour as Non-Verbal Resistance: Marginal Women and Alternative Dress in the Nineteenth Century', *Fashion Theory* 3, no. 2 (1999), pp. 243–47.
78. Carol Mattingly, *Appropriate[ing] Dress: Women's Rhetorical Style in Nineteenth-Century America* (Carbondale and Edwardsville: Southern Illinois University Press, 2002), p. 68.

79. Crane, *Fashion and its Social Agendas*, 122; Gayle V. Fischer, *Pantaloons and Power: A Nineteenth-Century Dress Reform in the United States* (Kent, Ohio and London: The Kent State University Press, 2001), p. 99.
80. De Zouche, *Roedean School, 1885–1955*, p. 73.
81. 'The Djibbah has Captured London Society', *Chicago Tribune*, 23 November 1902.
82. James Gregory, 'Vegetable Fictions in the Kingdom of Roast Beef: Representing the Vegetarian in Victorian Literature', in *Consuming Culture in the Long Nineteenth Century: Narratives of Consumption, 1700–1900*, ed. Tamara S. Wagner and Narin Hassan (Lanham: Lexington Books, 2007), p. 23.
83. Webb, *The Heritage of Dress*, p. 126; R. Roberts, *History of Uniform at Cheltenham Ladies' College* (Unpublished Document, 2008), pp. 1–2.
84. *Sherborne Girls' Tennis Group*, 1915, black-and-white photograph; and *Sherborne Girls' House Group*, Summer 1918, black-and-white photograph, Sherborne Girls' School Archives.
85. *Photograph of the Tennis Team*, 1927, black-and-white photograph, Photographs of Games and Gymnastics, Bridlington Old Girls Association Records, Bridlington High School for Girls Old Girls' Association Records, the Treasure House, Beverley.
86. School Prospectuses, Miscellaneous School Records, Bridlington High School Deposited 11 December 2007, Bridlington High School for Girls Old Girls' Association Records, the Treasure House, Beverley.
87. Uniform list for Wycombe Abbey School, 1922, Wycombe Abbey School Archives.
88. Uniform list for Wycombe Abbey School, 1925, Wycombe Abbey School Archives.
89. Uniform lists for Wycombe Abbey School 1922 and 1932, Wycombe Abbey School Archives.
90. 'Woman's Realm', *Devon and Exeter Daily Gazette*, 29 April 1929, p. 5.
91. Penny Tinkler, 'Women and Popular Literature', in *Women's History: Britain, 1850–1945: An Introduction*, ed. Jane Purvis (London: Routledge, 2006), pp. 124–25; Ellen M. Holtzman, 'The Pursuit of Married Love: Women's Attitudes toward Sexuality and Marriage in Great Britain, 1918–1939', 16, no. 2 (1982), p. 42.
92. Sally Mitchell, *The New Girl: Girls' Culture in England, 1880–1915* (New York: Columbia University Press, 1995), pp. 74–75.
93. Catherine Driscoll, *Girls: Feminine Adolescence in Popular Culture and Cultural Theory* (New York: Columbia University Press, 2002), pp. 35–39.
94. 'Women's Magazine', 1933, quoted in Tanith Carey, *Never Kiss a Man in a Canoe: Words of Wisdom from the Golden Age of Agony Aunts* (London: Boxtree, 2009), p. 8.
95. Judith Okely, 'Privileged, Schooled and Finished: Boarding Education for Girls', in *Defining Females: The Nature of Women in Society*, ed. Shirley Ardener (Oxford: Berg, 1993), p. 113.
96. Vera Brittain, *Testament of Youth* (London: Virago, 1988), pp. 33–34.

Chapter Four Education for All 1860–1939

1. Mary Sturt, *The Education of the People: A History of Primary Education in England and Wales in the Nineteenth Century* (London: Routledge & Kegan Paul, 1967), pp. 241–42.
2. *Report of the Commissioners Appointed to Inquire into the State of Popular Education in England, vol. I* (London: Printed by George E. Eyre and William Spottiswoode, 1861), p. 15.
3. Frank Smith, *A History of Elementary Education, 1760–1902* (London: University of London Press, 1931), p. 287.
4. John Lawson and Harold Silver, *A Social History of Education in England* (Abingdon: Routledge, 2007); W.A. Holdsworth, *The Education Act 1870 Popularly Explained Together with the Various Orders in Council Issued by the Education Department* (London: George Routledge and Sons, 1870), p. 12.
5. Smith, *A History of Elementary Education*, p. 288.
6. *Schools Inquiry Commission, Vol. I Report of the Commissioners* (London: Printed by George Edward Eyre and William Spottiswoode, 1868), p. 16.
7. *Schools Inquiry Commission*, p. 19.
8. *Schools Inquiry Commission*, p. 20.
9. *Schools Inquiry Commission*, p. 16.
10. David Cannadine, *The Rise and Fall of Class in Britain* (New York: Columbia University Press, 1999), p. 108.
11. Colin Brock, 'Social and Spatial Disparity in the History of School Provision in England from the 1750s to the 1950s', in *An Introduction to the Study of Education*, ed. David Matheson (Abingdon: Routledge, 2015), p. 142; P.W. Musgrave, *Society and Education in England Since 1800* (Abingdon: Routledge, 2007), p. 39.
12. Anne Digby and Peter Searby, *Children, School and Society in Nineteenth-Century England* (London: Macmillan Press, 1981), pp. 11–12.
13. Geoffrey Crossick, 'The Emergence of the Lower Middle Class in Britain: A Discussion', in *The Lower Middle Class in Britain 1870–1914*, ed. Geoffrey Crossick (London: Croom Helm, 1977), p. 46.
14. Prospectus (1908), The County School for Girls, Tunbridge Wells, TWGGS Archive.
15. Prospectus (1914), The County School for Girls, Tunbridge Wells, TWGGS Archive.
16. Commemorative Album, 1923, GDS Archives (GDS/26/1/2), Institute of Education, University of London.
17. A type of wild silk, variable in weight, quality and expense depending on its source and method of weaving. Some types were washable.
18. Brighton and Hove High School Dress Regulations and Directions, box Brighton and Hove High School, GDS Archives (GDS/12/4/5), Institute of Education, University of London.

19. Commemorative Album, 1923, GDS Archives (GDS/26/1/2).
20. W.A. Balfry (1897–1901), Memories of Burton Grammar School, Burton Grammar School Archive.
21. H.J. Wain (1907–11), Memories of Burton Grammar School, Burton Grammar School Archive.
22. Ted Warren (1936–42), Memories of Burton Grammar School, Burton Grammar School Archive.
23. In fact, all the schools surveyed in this chapter conform to this gender distinction.
24. Elizabeth Ewing, *History of Children's Costume* (London: Batsford, 1977), pp. 129–31.
25. Dawn Catten and Jean Dyke, *100 Years On: Dartford County School, 1904 to 2004* (Dartford: Privately Published, 2004), p. 6.
26. Catten and Dyke, *100 Years On: Dartford County School, 1904 to 2004*, p. 5.
27. Sara A. Burstall, *Retrospect and Prospect: Sixty Years of Women's Education* (London: Longmans, Green & Co., 1933), p. 154.
28. 'Woman's Realm', *Devon and Exeter Daily Gazette*, 7 January 1929, p. 7.
29. Patricia Campbell Warner, 'The Gymslip: The Origins of the English Schoolgirl Tunic', *Dress* 22, no. 1 (1995), pp. 45–46.
30. Paul Atkinson, 'Fitness, Feminism and Schooling', in *The Nineteenth-Century Woman: Her Cultural and Physical World*, ed. Sara Delamont and Lorna Duffin (London: Croom Helm, 1978), p. 120.
31. Susan J. Vincent, *The Anatomy of Fashion: Dressing the Body from the Renaissance to Today* (Oxford: Berg, 2009), p. 166.
32. 'Editorial', *Hull Daily Mail*, 6 May 1921, p. 3.
33. 'French Berets for Schoolgirls', *Manchester Guardian*, 12 April 1934, p. 6.
34. 'Back to School', *The Times*, Monday, 11 September 1939, p. 6.
35. Florence Atherton, 'Florence Atherton', in *Edwardian Childhoods*, ed. Thea Thompson (London: Routledge & Kegan Paul, 1981), p. 109.
36. Mary Cadogan and Patricia Craig, *You're a Brick Angela! A New Look at Girls' Fiction from 1839 to 1975* (London: Victor Gollancz Ltd, 1976), pp. 127–30.
37. Sally Mitchell, *The New Girl: Girls' Culture in England, 1880–1915* (New York: Columbia University Press, 1995), pp. 93–95.
38. Gillian Freeman, *The Schoolgirl Ethic: The Life and Work of Angela Brazil* (London: Allen Lane, 1976), p. 25.
39. Rosemary Auchmuty, 'The School Story from Brazil to Bunty', in *School Stories from Bunter to Buckeridge: Papers from a Children's Literature Conference held at Roehampton Institute, London in 1998*, ed. Nicholas Tucker (Lichfield: Pied Piper Publishing, 1998), p. 42.
40. Although uniforms appear in all the school series mentioned here, as well as in the works of later authors such as Enid Blyton, there are a few exceptions. Books reflected the current situation at girls' public schools and so early stories

reinforced feminine dress in the same manner as the schools and this can be seen in some of the work of L.T. Meade.

41. Mary Cadogan, *Chin up, Chest Out Jemima: A Celebration of the Schoolgirls' Story* (Haslemere: Bonnington Books, 1989), pp. 12–14.
42. David Fowler, *The First Teenagers: The Lifestyle of Young Wage-Earners in Interwar Britain* (London: The Woburn Press, 1995), p. 105.
43. John Roach, *A History of Secondary Education in England 1800–1870* (London: Longman, 1986), p. 303.
44. Clare Rose, *Making, Selling and Wearing Boys' Clothes in Late-Victorian England* (Farnham: Ashgate, 2010), p. 26.
45. *Report of the Commissioners Appointed to Inquire into the State of Popular Education in England*, p. 178.
46. W.E. Marsden, *Educating the Respectable: A Study of Fleet Road Board School, Hampstead, 1879–1902* (London: The Woburn Press, 1991), pp. 34–35.
47. See, for instance, Patrick Joyce, *Visions of the People: Industrial England and the Question of Class, 1848–1919* (Cambridge: Cambridge University Press, 1991), pp. 151–57; Beverley Skeggs, *Formations of Class & Gender: Becoming Respectable* (London: Sage Publications, 2002), pp. 2–3; P.E. Razzell and R.W. Wainwright, *The Victorian Working Class: Selections from the 'Morning Cronicle'* (London: Routledge, 2013), pp. xxxiii–xxxiv.
48. Elizabeth Roberts, *A Woman's Place: An Oral History of Working-Class Women, 1890–1940* (Oxford: Blackwell, 1996), p. 5.
49. Karen Sayer, '"A Sufficiency of Clothing": Dress and Domesticity in Victorian Britain', *Textile History* 33, no. 1 (2002), p. 112.
50. Pamela Horn, *The Victorian and Edwardian Schoolchild* (Gloucester: Alan Sutton Publishing, 1989), p. 25.
51. Quoted in Mary Sturt, *The Education of the People*, p. 337.
52. Rose, *Making, Selling and Wearing Boys' Clothes in Late-Victorian England*, pp. 25–26.
53. *Suggestions of the Liverpool School Board to the Managers of Public Elementary Schools* (London: W. Isbister, 1879), p. 15.
54. 'The Care of the Children', *Essex County Chronicle*, 12 August 1910, p. 7.
55. 'One and All', *Cornishman*, 18 May 1911, p. 4.
56. Meg Gomersall, *Working-Class Girls in Nineteenth-Century England: Life, Work and Schooling* (London: Macmillan Press Ltd, 1997), p. 137.
57. Annie Wilson, 'Annie Wilson', in *Edwardian Childhoods*, p. 92.
58. E.J. Urwick, *Studies of Boy Life in Our Cities* (London: J.M. Dent, 1904), p. xi.
59. Florence Atherton, 'Florence Atherton', in *Edwardian Childhoods*, p. 109.
60. James Kerr, 'School Hygiene, in its Mental, Moral, and Physical Aspects', *Journal of the Royal Statistical Society*, 60, no. 3 (1897), p. 620.
61. Gwen Raverat, *Period Piece: A Cambridge Childhood* (Bath: Clear Press Ltd, 2003), pp. 259–60.

62. Oliver Wendall Holmes, *The Autocrat of the Breakfast Table* (Boston: Phillips Sampson & Company, 1859), p. 206.
63. Alice Guppy, *Children's Clothes 1939–1970: The Advent of Fashion* (Poole: Blandford Press, 1978), p. 28.
64. Mariana Valverde, 'The Love of Finery: Fashion and the Fallen Woman in Nineteenth-Century Social Discourse', *Victorian Studies* 32, no. 2 (1989), p. 178; Deborah Gorham, *The Victorian Girl and the Feminine Ideal* (London and Canberra: Croom Helm, 1982), pp. 54–55.
65. 'School Clothes Which Make Mothers Worry', *Hull Daily Mail*, 15 June 1934, p. 8.
66. Guppy, *Children's Clothes 1939–1970*, p. 28.
67. Musgrave, *Society and Education in England Since 1800*, p. 87.
68. Annie Wilson, 'Annie Wilson', in *Edwardian Childhoods*, p. 93.
69. Annie Wilson, 'Annie Wilson', in *Edwardian Childhoods*, p. 93.
70. Phillis Cunnington and Anne Buck, *Children's Costume in England 1300–1900* (London: A and C Black Limited, 1978), pp. 166–67.
71. Clare Rose, 'Continuity and Change in Edwardian Children's Clothing', *Textile History* 42, no. 2 (2011), pp. 152–53.
72. H.J. Wain (1907–11), Memories of Burton Grammar School, Burton Grammar School Archive.
73. Elizabeth Roberts, 'The Family', in *The Working Class in England, 1875–1914*, ed. John Benson (London: Croom Helm, 1985), p. 22.
74. 'Advertisement and Notices', *Western Times*, 13 October 1920, p. 1.
75. Lionel Rose, *The Erosion of Childhood: Child Oppression in Britain, 1860–1918* (London: Routledge, 2002), p. 208.
76. Musgrave, *Society and Education in England Since 1800*, p. 96.
77. David Rubinstein and Brian Simon, *The Evolution of the Comprehensive School, 1926–1966* (London: Routledge & Kegan Paul, 1969), pp. 15–32.
78. Rubinstein and Simon, *The Evolution of the Comprehensive School*, p. 8.
79. Roy Hattersley, *A Yorkshire Boyhood* (London: Abacus, 2003), p. 143.
80. Guppy, *Children's Clothes 1939–1970*, p. 28.

Chapter Five Fashion and Fancy Dress 1939–Present

1. Jonathan Walford, *Forties Fashion: From Siren Suits to the New Look* (London: Thames & Hudson, 2001), pp. 38–39.
2. Peter McNeil, '"Put Your Best Face Forward": The Impact of the Second World War on British Dress', *Journal of Design History* 6, no. 1 (1993), pp. 284–85.
3. Elizabeth Ewing, *History of Children's Costume* (B.T. Batsford, London, 1977), p. 153.
4. Letter, E.G. Harold to parents, 1940s, box B3, I.M. Drummond, NLCS Archives.

5. Letter, E.G. Harold to parents, April 1941, box C1, 1930s and 1940s, NLCS Archives.
6. Letter, Kitty Anderson to parents, 20 June 1945, box: A2, History of the School 1941–1950, NLCS Archives.
7. Uniform list for Wycombe Abbey School, January 1942, Wycombe Abbey School Archives.
8. See Chapter Four for a more in-depth discussion of this process.
9. H.W. Koch, *The Hitler Youth: Origins and Development 1922–45* (London: Macdonald and Jane's, 1975), p. 169.
10. Perry Wilson, 'The Nation in Uniform? Fascist Italy, 1919–1943', *Past & Present* 221, no. 1 (2013), pp. 240–41.
11. Alice Guppy, *Children's Clothes 1939–1970: The Advent of Fashion* (Poole: Blandford Press, 1978), pp. 272–73.
12. Joanna Chase, *Sew and Save* (Glasgow: Literary Press Ltd, 1941), p. 82.
13. Administrative Memorandum: Special Outfits for School Pupils, 21 November 1941, Board of Education, War and Peace, Union for Women Teachers Archives (UWT/D/20/8 2/2), Institute of Education, University of London.
14. Administrative Memorandum: Clothing Outfits for School Pupils, 17 July 1942, Board of Education, War and Peace, Union for Women Teachers Archives (UWT/D/20/8 2/2), Institute of Education, University of London.
15. 'Tamworth Girls' High School', *Tamworth Herald*, 1 November 1941, p. 3.
16. Pat Harrison, *Lancaster Girls' Grammar School: The First Century, Continuity and Change* (Lancaster: Published by LGGS, 2006), p. 80.
17. Dorothy E. De Zouche, *Roedean School, 1885–1955* (Brighton: Dolphin Press, 1955), p. 76.
18. 'Grammar School Head Appeals to Parents', *Tamworth Herald*, 27 November 1948, p. 3.
19. Penny Summerfield, *Women Workers in the Second World War: Production and Patriarchy in Conflict* (London: Routledge, 2013), p. 1; Jonathan Gathorne-Hardy, *The Public School Phenomenon 597–1977* (London: Hodder and Stoughton, 1977), pp. 369–92; David Rubinstein and Brian Simon, *The Evolution of the Comprehensive School, 1926–1966* (London: Routledge & Kegan Paul, 1969), p. 1; Joan Nunn, *Fashion in Costume, 1200–2000* (Chicago: New Amsterdam Books, 2000), p. 207.
20. Rubinstein and Simon, *The Evolution of the Comprehensive School*, p. 1.
21. Jon Savage, *Teenage: The Creation of Youth, 1875–1945* (London: Pimlico, 2008), p. 465.
22. Valerie Mendes and Amy de la Haye, *20th Century Fashion* (London: Thames & Hudson, 1999), pp. 152–53.
23. Susannah Handley, *Nylon: The Manmade Fashion Revolution* (London: Bloomsbury, 1999), pp. 7–9.
24. Uniform List, 1950s, Wycombe Abbey School Archive.

25. Jane Schneider, 'In and Out of Polyester: Desire, Disdain and Global Fibre Competitions', *Anthropology Today* 10, no. 5 (1994), pp. 3–4.
26. David McCrone, 'Unmasking Britannia: The Rise and Fall of British National Identity', *Nations and Nationalism* 3, no. 4 (1997), p. 597.
27. Uniform List, 1950s (B/16/6), Kevesten and Grantham Girls' School Archives.
28. R. Roberts, *History of Uniform at Cheltenham Ladies' College* (Unpublished Document, 2008), p. 2; James Laver, *Costume & Fashion: A Concise History* (London: Thames and Hudson, 1992), pp. 256–57.
29. 'New Look', *News Chronicle*, 19 November 1948.
30. Rubinstein and Simon, *The Evolution of the Comprehensive School*, pp. 1–2.
31. Frank Furedi, 'Celebrity Culture', *Society* 47 no. 6 (2010), p. 493.
32. Christopher Tyerman, *A History of Harrow School 1324–1991* (Oxford: Oxford University Press, 2000), p. 439.
33. Neville Harris, 'The Legislative Response to Indiscipline in Schools in England and Wales', *Education and the Law* 14, no. 1–2 (2002), p. 57.
34. Sarah Womack, 'Pattern Wants "Compulsory School Uniforms"', *Press Association*, 27 November 1993; 'The Uniform Outlook', *Glasgow Herald*, 5 June 1997, p. 16; Vincent Moss, 'Hague in Uniform Fury', *News of the World*, 2 July 2000.
35. Keith King, 'Should School Uniforms be Mandated in Elementary Schools', *Journal of School Health* 68, no. 1 (2009), pp. 33–37; Ann Bodine, 'School Uniforms and Discourses on Childhood', *Childhood* 10, no. 1 (2003), pp. 43–63.
36. For a recent take, see Suzanne Moore, 'We're Told that School Uniforms are About Preparing our Kids for the "Real World". Do We Want a World of Dull Conformists?', *Guardian*, 30 August 2012, p. 5.
37. See, for instance, Sam Royston and Rebecca Jacques, *The Wrong Blazer* (London: The Children's Society, 2018), 'School Uniform Rip Off', *Daily Mirror*, 14 September 2006, 23; Toby Helm and Eleanor Busby, 'Families "Break the Bank" to Pay for School Uniform', *Observer*, 4 September 2011.
38. Daniel Smith, 'The Gent-rification of English Masculinities: Class, Race and Nation in Contemporary Consumption', *Social Identities* 20, no. 4–5 (2014), p. 399.
39. A recent example is: Martin Fricker, 'Primary School in Deprived Area Praised for Setting Aside £10k to Clothe its Pupils', *Mirror*, 21 May 2015.
40. 'Uniform Requirements: Current, September 2014–July 2018', Icknield High School, 2014, <http://www.icknield.beds.sch.uk/wp-content/uploads/2015/02/uniform2014.pdf> (accessed 15 January 2016).
41. See, for instance, Tony Parsons, 'School Niqab Ban isn't Racist ... Just Common Sense', *Sun*, 28 September 2014, p. 15; 'Veiled Insult; The Right Response to the Niqab is Not to Ban it, it is to Allow Liberal Values to Triumph', *The Times*, 15 September 2013.
42. Dianne Gereluk, *Symbolic Clothing in Schools: What Should be Worn and Why* (London: Continuum International Publishing Group, 2008), p. 1.

43. John R. Bowen, *Why the French don't like Headscarves: Islam, the State and Public Space* (Princeton and Oxford: Princeton University Press, 2007), pp. 12–13.
44. Bronwyn Winter, *Hijab & The Republic: Uncovering the French Headscarf Debate* (Syracuse: Syracuse University Press, 2008), pp. 3–5; John Wallach Scott, *The Politics of the Veil* (Princeton and Oxford: Princeton University Press, 2007), pp. 166–68.
45. Dominic McGoldrick, *Human Rights and Religion: The Islamic Headscarf Debate in Europe* (Oxford and Portland: Hart Publishing, 2006), p. 101.
46. Elizabeth Davies, *Cost of School Uniform 2015* (Department for Education, 2015), p. 8.
47. Deborah Murrell, *Mad About Costume and Fashion* (London: Ladybird Books Ltd, 2009), p. 7.
48. 'Report on Ryde School of Art Calico Fancy Dress Ball', *Isle of Wight Observer*, 26 April 1879, p. 4.
49. 'Report on Ryde School of Art Calico Fancy Dress Ball', *Isle of Wight Observer*, p. 4.
50. Aileen Ribeiro, *The Dress Worn at Masquerades in England, 1730–1790, and Its Relation to Fancy Dress in Portraiture* (London: Garland Publishing, Inc., 1984), p. 3.
51. Alicia Finkel, '*Le Bal Costumé*: History and Spectacle in the Court of Queen Victoria', *Dress* 10, no. 1 (1984), p. 64.
52. Marie Schild, *Character Suitable for Fancy Costume Balls* (London, 1881); Ardern Holt, *Fancy Dresses Described, or What to Wear at Fancy Balls* (London: Debenham and Freebody, 1880).
53. Holt, *Fancy Dresses Described, or What to Wear at Fancy Balls* (London: Debenham and Freebody, 1887), p. 51.
54. Holt, *Fancy Dresses Described, or What to Wear at Fancy Balls* (London: Debenham and Freebody, 1896), p. 4; Holt, *Fancy Dresses Described*, p. 63.
55. Anthea Jarvis and Patricia Raine, *Fancy Dress* (Aylesbury: Shire Publications Ltd, 1984), p. 23.
56. 'Success of British Film (Arts and Entertainment)', *The Times*, 30 December 1954, p. 3.
57. Kaye Webb, 'Once Upon a Time', in *The St Trinian's Story*, ed. Kaye Webb (Harmondsworth: Penguin Books, 1961), p. 9.
58. Ian Wojik-Andrews, *Children's Films: History, Ideology, Pedagogy, Theory* (New York: Garland Publishing, Inc., 2000), p. 63.
59. Lesley Speed, 'Reading, Writing and Unruliness: Female Education in the St Trinian's Films', *International Journal of Cultural Studies* 5, no. 2 (2002), pp. 236–37.
60. Siriol Hugh-Jones, 'A Short Ramble Round the Old Prison House', in *The St Trinian's Story*, ed. Webb, p. 23.
61. Maria Elena Buszek, *Pin-up Grrrls: Feminism, Sexuality, Popular Culture* (Durham, NC: Duke University Press: 2006), p. 235.

62. Hugh-Jones, 'A Short Ramble Round the Old Prison House', in *The St Trinian's Story*, ed. Webb, pp. 21–22.
63. D.B. Wyndham, 'St Trinian's Soccer Song', quoted in *The St Trinian's Story*, ed. Webb, p. 50.
64. Hugh-Jones, 'A Short Ramble Round the Old Prison House', in *The St Trinian's Story*, ed. Webb, p. 32.
65. Corinne Holt Sawyer, 'Men in Skirts and Women in Trousers, from Achilles to Victoria Grant: One Explanation of a Comedic Paradox', *Journal of Popular Culture* 21, no. 2 (1987), p. 8.
66. Hugh-Jones, 'A Short Ramble Round the Old Prison House', in *The St Trinian's Story*, ed. Webb, p. 32.
67. Ellie Pithers, Alice Newbold, Bibby Sowray, Sophie Warburton and Katy Young, 'School Uniform's in for Grown-ups this Summer', *Telegraph*, 11 February 2015, <http://fashion.telegraph.co.uk/article/TMG11403925/School-uniform-trend-for-grown-ups.html> (accessed 9 July 2015).
68. Debra Merskin, 'Reviving Lolita: A Media Literacy Examination of Sexual Portrayals of Girls in Fashion Advertising', *American Behavioural Scientist* 48, no. 1 (2004), p. 119.
69. Gail Dines 'Grooming Our Girls: Hypersexualization of the Culture as Child Sexual Abuse', in *Exploiting Childhood: How Fast Food, Material Obsession and Porn Culture are Creating New Forms of Child Abuse*, ed. Jim Wild (London: Jessica Kingsley Publishers, 2013), p. 122.
70. Sharon Kinsella, *Schoolgirls, Money and Rebellion in Japan* (London: Routledge, 2014), p. 13.
71. S. Kinsella, 'What's Behind the Fetishism of Japanese School Uniforms', *Fashion Theory: The Journal of Dress, Body and Culture* 6, no. 2 (2002), p. 219.
72. L. Miller, 'Cute Masquerade and the Pimping of Japan', *International Journal of Japanese Sociology* 20, no. 11 (2001), p. 18.
73. Lucy Mangan, *Hopscotch and Handbags: The Essential Guide to Being a Girl* (London: Headline Review, 2007), pp. 88–89.
74. Phillis Cunnington and Catherine Lucas, *Charity Costumes of Children, Scholars, Almsfolk, Pensioners* (Adam & Charles Black: London, 1978), pp. 73–74.
75. Tim Marsh, 'Clubbers Night Out at the School Disco', *London Evening Standard*, 11 October 2001, <http://www.standard.co.uk/goingout/music/clubbers-night-out-at-the-school-disco-6352691.html> (accessed 9 July 2015).
76. Alex Davidson, *Blazers, Badges and Boaters: A Pictorial History of School Uniform* (Horndean: Scope Books, 1990), p. 147.
77. Alexis Petridis, 'Boys and Girls Come Out to Play', *Guardian*, 5 July 2002, <http://www.theguardian.com/culture/2002/jul/05/artsfeatures.popandrock> (accessed 9 July 2015).
78. Dinesh Bhugra and Padmal De Silva, 'Uniform—Fact, Fashion, Fantasy and Fetish', *Sexual and Marital Therapy*, 11, no. 4 (1996), p. 397.

79. Jonathan Wells, 'The Pop-up Restaurant that Turns School Dinners into Fine Dining', *Telegraph*, 8 July 2015, <http://www.telegraph.co.uk/men/the-filter/11722853/The-pop-up-restaurant-that-turns-school-dinners-into-fine-dining.html> (accessed 9 July 2015).

Conclusion

1. Changes in class and gender distinctions are discussed in Judy Giles, 'Narratives of Gender, Class, and Modernity in Women's Memories of Mid-Twentieth Century Britain', *Signs* 28, no. 1 (2002), pp. 34–35; Bonnie English, *A Cultural History of Fashion in the 20th and 21st Centuries: From Catwalk to Sidewalk* (London: Bloomsbury, 2013), p. 92; Terry Nichols Clark and Seymour Martin Lipset, 'Are Social Classes Dying?', *International Sociology* 6, no. 4 (1991), pp. 400–1; Barry Eidlin, 'Class Formation and Class Identity: Birth, Death, and Possibilities for Renewal', *Sociology Compass* 8, no. 8 (2014), p. 1,045, amongst others.
2. For discussions of national identity and modern religion, see David McCrone, 'Unmasking Britannia: The Rise and Fall of British National Identity', *Nations and Nationalism* 3, no. 4 (1997), p. 597; Callum G. Brown, *Religion and Society in Twentieth-Century Britain* (London: Routledge, 2006), p. 2; David Nash, *Christian Ideals in British Culture: Stories of Belief in the Twentieth Century* (Houndmills: Palgrave, 2013), p. 5.
3. Maria Hayward, 'Dressed in Blue: The Impact of Woad on English Clothing c.1350–1670', *Costume* 49, no. 2 (2015), pp. 174–76; Maria Hayward, *Rich Apparel: Clothing and the Law in Henry VIII's England* (Farnham: Ashgate, 2009), pp. 100–1; Treasurers' Account Book, 1552–1558, Financial Records, Christ's Hospital Collection, London Metropolitan Archives.
4. Matthew 25: 35–36.
5. Uniform lists for Wycombe Abbey School 1922, 1925 and 1932, Wycombe Abbey School Archives.
6. 'School Clothes Which Make Mothers Worry', *Hull Daily Mail*, 15 June 1934, p. 8.
7. Jeffery Richards, *Films and British National Identity: From Dickens to Dad's Army* (Manchester: Manchester University Press, 1997), pp. 85–86.
8. Sonya O. Rose, *Which People's War?: National Identity and Citizenship in Wartime Britain, 1939–45* (Oxford: Oxford University Press, 2003), pp. 3–5.
9. Ina Zweiniger-Bargielowska, *Austerity in Britain: Rationing, Controls, and Consumption, 1939–1955* (Oxford: Oxford University Press, 2002), p. 147.
10. For discussion on the effects of print media regarding the dissemination of clothing styles, see Reed Benhamou, 'Fashion in the *Mercure*: From Human Foible to Female Failing', *Eighteenth Century Studies* 31, no. 1 (1997), pp. 27–43; Hazel Hahn, 'Fashion Discourses in Fashion Magazines and Madame de Girardin's *Lettres parisiennes* in July-Monarchy France (1830–48)', *Fashion Theory* 9, no. 2 (2005), p. 206.

11. Ida Engholm and Erik Hansen-Hansen, 'The Fashion Blog as Genre: Between User Driven Bricolage Design and the Reproduction of Established Fashion System," *Digital Creativity* 25, no. 2 (2014), pp. 140–54; Agnes Rocamora, 'Hypertextuality and Remediation in the Fashion Media', *Journalism Practice* 6, no. 1 (2011), pp. 103–04.
12. *Guidance to Schools on School Uniform Policy* (Bangor: Department for Education, 30 March 2011, Re-issued 5 June 2018), p. 1.
13. Diana Crane, 'Diffusion Models and Fashion: A Reassessment', *The Annals of the American Academy of Political and Social Science* 566, no. 1 (1996), p. 15.
14. Deniz Atik and A. Fuat Fırat, 'Fashion Creation and Diffusion: The Institution of Marketing', *Journal of Marketing Management* 29, no. 7–8 (2013), p. 838.
15. John M. Mackenzie, *Popular Imperialism and the Military, 1850–1950* (Manchester: Manchester University Press, 1992), pp. 26–27; Quintin Colville, 'Jack Tar and the Gentleman Officer: The Role of Uniform in Shaping the Class and Gender-Related Identities of British Naval Personal, 1930–1939', *Transactions of the Royal Historical Society* 6, no. 13 (2003), pp. 106–08.

Glossary

A la Hussar—an article of clothing trimmed with parallel rows of horizontal braid in the fashion of a Hussar uniform.

Bands—the term initially (early sixteenth century) referred to the shirt neckband, but later it was used to mean a pair of short, narrow pendants of white linen worn by ministers of religion, charity school children and barristers. Also known as 'tabs'.

Blazer—although the origins of the garment are debated, from the 1880s the name was applied to any light flannel-jacket used for sports and summer wear. These were often vertically striped with a club badge on the upper pocket. Later, the design was retained but the word came to encompass heavier jackets worn as part of a school uniform.

Bloods—various meanings—used at some public schools and universities to denote a person whose dress or behaviour was widely emulated; and at others to denote a senior member of the institution who excelled at games. Often used with the additional implication of a rowdy or foppish young man.

Bloomers—a term originating from the reform dress promoted by Mrs Amelia Jenks Bloomer. The outfit consisted of a jacket and knee-length skirt worn over full Turkish-style trousers. It was these trousers that were referred to as 'bloomers'. The intention was to provide women with more healthy and sensible attire, which would give them greater freedom of movement. Despite efforts in the 1850s to promote the style, it failed to become popular.

The word 'bloomers' was revived in the 1890s when women began to wear the full style of knickerbockers with a jacket and blouse for sports and leisure activities.

Bluecoat School—see Charity School.

Blues—see Colours.

Board School—following the findings of the Newcastle Commission, the Elementary Education Act was passed in 1870 to ensure that there was sufficient provision for the elementary education of all children aged five to thirteen. School Boards were to be formed for areas where there was insufficient provision, and they were empowered to raise funds from rates to build and run non-denominational schools. The Boards could also impose compulsory attendance through the introduction of by-laws and pay the fees of the poorest children. The board schools that were created tended to provide education for the poorest sections of society and focused on teaching the '3Rs' (reading, 'riting and 'rithmetic). They were generally staffed using the monitorial system which allowed a teacher to supervise a large class with assistance from a team of monitors (usually older pupils).

Boater—a stiff straw hat with a moderately deep, flat-topped crown and straight narrow brim, worn during the summer and for participation in sporting activities. The hat band was of petersham ribbon and as sports clubs and schools developed specific uniforms, the colour of the trim often denoted the wearer's affiliation. Originally this style of hat was worn by men, but as female sports developed it was adopted by women as well.

Brewer's Cap—a knitted stocking cap, coming to a point, often with a tassel and generally red. Also known as a fisherman's cap. Such caps were normal wear for working men, but by the mid-eighteenth century they began to appear as items of clothing worn for sporting events. This type of cap remained in use in the sporting arena until the 1890s when, with the codification of sports and standardisation of club outfits, it gradually disappeared.

Charity School—a school, supported by charitable bequests or voluntary contributions, for the free or cheap education of children of the poor. In the initial stages of the charity school movement, these establishments dealt mainly with orphaned or abandoned children, providing not only education but also accommodation and clothing. Perhaps the best-known example of this type of school is Christ's Hospital, founded in 1552. Such schools also became known as Bluecoat schools through the practice of dressing the pupils in blue dyed cloth.

Although the custom of establishing charity schools for the poor through private donors had begun in Elizabethan times, a great increase in numbers occurred towards the end of the seventeenth century. The main object was religious and moral instruction, as well as enabling the poor to earn a livelihood. By this stage of development, many of the charity schools were day schools providing education not just for orphans but more generally for the very poorest classes.

Clarendon Commission—the Royal Commission on the Public Schools was set up in 1861 under the chairmanship of Lord Clarendon: 'To inquire into the nature and application of the Endowments, Funds and Revenue belonging to or received by the hereinafter mentioned Colleges, Schools and Foundations; and also to inquire into the administration and management of the said Colleges, Schools and Foundations.' Nine schools (including two day schools) were investigated—Eton, Winchester, Westminster, Charterhouse, St Paul's, Merchant Taylors', Harrow, Rugby and Shrewsbury. The Commission sat until 1864, when its Report was published with general recommendations on questions of curriculum and governance.

Clarendon Report—the Report published by the Royal Commission on the Public Schools which sat from 1861 to 1864 under the chairmanship of Lord Clarendon.

Coif—a white linen cap worn by both sexes during various periods. In shape it resembled a baby's bonnet, close-fitting to the head and tied under the chin with strings. The coif was worn from the early Middle Ages onwards as a nightcap or under another cap, headdress or hat.

Colours—an award given for prowess in a specific sport by a school or university and usually demonstrated by a symbolic piece of clothing such as a tie or blazer. University colours are often referred to by the name of the colour associated with the institution, for instance those awarded colours at Oxford or Cambridge are known as 'Blues'.

Common Round Hat—see Top Hat.

Comprehensive School—a state-funded school that does not select its intake on the basis of academic achievement or aptitude. Such schools generally provide education for students from the ages of eleven to eighteen, although there are other variants. The term is commonly used in relation to England and Wales,

where comprehensive schools were introduced on an experimental basis in the 1940s and became more widespread from 1965. About 90 per cent of British secondary school pupils now attend comprehensive schools. Comprehensive education is in contrast to the selective school system, where admission is restricted on the basis of selection criteria.

Cotton—the soft, white, fibrous substance that envelops the seeds of the cotton plant—an important natural textile. Although cotton was widely grown from ancient times, it did not become readily available in Europe until the seventeenth century when painted cottons were first imported from India. Initially supplies were limited, so the fabric acquired a scarcity value and was much prized. During the second half of the eighteenth century, however, the manufacture of cotton in England developed very rapidly and the fabric became widely available.

Cotton Cloth—from the fifteenth to seventeenth century this term referred to a woollen cloth of which the nap had been 'cottoned' or raised.

Dame School—an early form of private elementary school, usually run by women in their own home. They catered to a working-class clientele and were predominantly in existence between the sixteenth and nineteenth centuries.

Djibbah—a garment introduced by Roedean School in 1906. It was a knee-length dress with a round neck and short sleeves, being A-line in shape, without pleats. It was worn over a blouse or shirt. For wear during school hours it was navy blue with a cream yoke and with the school crest embroidered on the breast. Pupils wore the same style in their leisure hours made up in a fabric and colour of their choice. The djibbah never became universally popular, although a number of other girls' schools did adopt the style.

Drill Slip, Drill Tunic—see Gymslip.

Duck—a firmly woven white linen used for washable trousers and sportswear (nineteenth century).

Ducks—trousers worn for sports, made of duck.

Ell—a measure of length, varying in different countries. The English ell was generally accepted to be 45 inches.

Escutcheon—fifteenth century in origin, meaning a flat shield or badge on which is displayed a symbol of affiliation to an institution or family, often in the form of a coat of arms.

Eton Jacket—a short jacket, the fronts cut square or slightly pointed with a shallow, turned-down collar and wide lapels turning nearly to the bottom, the sleeves have no cuffs. The style first appeared in the late 1790s and seems to have been a development of the skeleton suit (see 'Skeleton Suit'). It became standard wear for boys of the middle and upper classes well into the early twentieth century and is most familiar from its continued use at Eton, although it did not originate at the school.

Fichu—a length of fabric worn around the neck and shoulders to fill in a low neckline. It was usually made of fine linen and could be arranged in a wide variety of ways.

Frogging—decorative braid or cording that could also function as a garment closure. It was initially applied to military uniforms but passed into wider fashionable usage in the nineteenth century.

Grammar School—the title of 'grammar school' has been used to denote a variety of educational establishments over the centuries. The name was attached to the early ecclesiastical foundations that provided an education in Latin grammar for boys entering the service of the Church. With the Reformation many of these schools disappeared to be replaced by new foundations which still focused mainly on an education in the Classics, and specifically upon the grammar of Latin and Greek. These were intended for a wider range of pupils drawn from the upper and middle classes. Over the centuries, these schools continued to exist in various forms and with a widening, but still strongly academic curriculum. They included a number of foundations which we now think of as public schools, including Eton, Winchester and Harrow, and most required pupils to pay fees. Following the Education Act 1944 (the Butler Act), local authorities were empowered to set up secondary schools inspired by this model, and the name became attached to the selective schools in the tripartite secondary system designed to cater for the needs of the most academic pupils. Selection of pupils was carried out at the end of primary schooling through the Eleven Plus examination, which was believed to identify the type of schooling most appropriate to each child. Those not selected for grammar schools were allocated places at

a secondary modern school or, in some local authorities, a technical school. The tripartite system largely disappeared following the passing of various Education Acts in the 1960s and 1970s which introduced the concept of comprehensive education, although some local authorities continued to maintain their grammar schools. It is interesting to note, however, that in recent times permission has been granted for the creation of extensions to several established grammar schools.

Gymslip, Gym Tunic—the gymslip or gym tunic was first introduced in 1892 at the college for female physical training teachers founded by Madame Bergman-Osterberg. Tunics were knee length, sleeveless and worn with a washable blouse. They had three box pleats back and front and were confined at the waist with a narrow sash of braid. The style became universally popular with sportswomen of all ages as it allowed far greater freedom of movement than any of the garments that had preceded it. Gymslips were often of navy-blue serge but other colours were adopted by clubs, schools and colleges—brown, green and maroon being popular choices. The gymslip eventually passed from the sports' field to become the garment of choice for ordinary uniform wear in girls' schools. Also called a 'Drill Slip' or 'Drill Tunic'.

House System—the patchy nature of secondary school provision in the United Kingdom until the late nineteenth century meant that any school with a good reputation attracted pupils from a wide area. Often, in the initial stages of this type of growth, the schools had insufficient accommodation to house all the pupils who wished to attend and they were boarded in houses in the local towns. Rivalry sprang up between the various boarding houses and this was encouraged by sporting and academic competitions. When schools built suitable accommodation for the pupils who boarded they often maintained the notion of individual houses, seeing it as a useful tool for managing the number of boys involved and providing individuals with a sense of belonging. Such establishments also continued to promote the rivalry between houses, allowing the pupils a suitable outlet for their energies in leisure hours.

With the establishment of many more day schools providing education for older pupils, the idea of a house system was maintained. There seem to have been various reasons for this; breaking large units down so that pupils had a better sense of belonging; structuring a vertical system which rewarded worthy senior pupils with appropriate roles as house captains and prefects; imitation of the older, established institutions and creating suitable units for sports and academic competitions.

House names chosen by schools were hugely varied and could include names of local heroes or worthies, notable headmasters, historic houses, saints or, perhaps more boringly, colours. The division of the school in this way had an effect on uniform because each house would often be given a colour as well as a name and pupils would wear ties, badges, hat bands or belts in the appropriate colour.

Kerchief—the use of this term changed over time; from the early Medieval period to the end of the sixteenth century it referred to piece of fabric worn as a head-covering by women, later 'kerchief' came to mean a neckerchief or handkerchief.

Kersey—a coarse woollen cloth with many varieties in quality and pattern. The name possibly derives from the Suffolk village of Kersey where it may have originated.

Liberty Bodice—a shaped, sleeveless, unboned bodice invented as an alternative to a corset and widely worn by girls in the early to mid-twentieth century.

Lisle—a firm cotton thread used especially in the making of gloves and hosiery.

Morning Coat—a coat with a sloping front (from the bottom button near the waist) to form rounded, short tails at the back. The rear vent ran from the hem to waist seam with two hip-buttons. The garment was generally single-breasted with a turned-down collar and short lapels. By the second half of the nineteenth century it had become the accepted dress for daytime wear (replacing the frock coat). It was generally black or grey in colour and the edges were often finished with braid.

Newcastle Commission—the Royal Commission on the state of popular education in England, under the chairmanship of the Duke of Newcastle, was appointed in 1858 'To inquire into the state of public education in England and to consider and report what measures, if any, are required for the extension of sound and cheap elementary instruction to all classes of the people'.

The investigation revealed that many districts were without sufficient school places for the number of children resident in the area. Where places were available, children often failed to attend regularly and, therefore, gained little benefit from the teaching provided. Much of the teaching was felt to be inadequate and the curriculum taught unsuitable for the age and needs of the children attending.

Newcastle Report—the Newcastle Commission published its six-volume report in 1861. The recommendations were embodied in the 1870 Elementary Education Act, which required that every school district should have sufficient schools and made sources of funding available for this programme. For further details, see 'Board Schools'.

New Look—a style introduced in the late 1940s, particularly associated with the couturier Christian Dior and his 1947 collection. This new fashion comprised calf-length, full skirts, a tiny waist and sloping shoulders. It was accompanied by elegant hats and high-heeled shoes. It gave a radically different appearance from how women had dressed during the war years, when women's dresses tended to be knee length, shoes low-heeled and sensible and hats relatively small. The name is said to have originated from Carmel Snow, Editor of Harper's Bazaar, who supposedly quipped, 'It's quite a revolution, dear Christian! Your dresses have such a new look'.

Pillbox Hat or Cap—a small, oval hat with straight sides and a flat top, named for its resemblance to the small boxes used for storing pills. The style has existed for many centuries and has been worn by both men and women. It appeared as part of military uniform in the British Army in the 1850s and continues to be worn by most of the Gurkha regiments in modern times. In the 1870s the pillbox began to appear as part of the outfits worn for various sports, including cricket and football.

Private School—private schools proliferated from the eighteenth century and these differed from the grammar schools in that they were not publicly endowed or managed. Private schools usually fell into one of the following categories:

1. schools run for profit by the owners (Dame Schools are a lower-class example of this type);
2. religious schools, particularly those operated by Quaker and Roman Catholic groups; and
3. schools established by groups of proprietors or institutes in the early nineteenth century to meet middle-class or artisan educational needs where there was a lack of appropriate provision locally.

In the eighteenth and nineteenth centuries such schools often provided an education for middle-class boys that was more practically orientated than the grammar schools, including disciplines such as chemistry, book-keeping, history and geography. Private schools for girls, particularly in the eighteenth century,

offered a mixed curriculum incorporating accomplishments such as music, dancing and needlework, alongside literacy and modern languages.

In modern terminology, a private school is any fee-paying institution and the phrase is often used interchangeably with 'independent school'. Public schools are now all private schools, but not all private schools are termed 'public'.

Public School—in Britain this term was originally used to denote any of a class of grammar school founded or endowed for public use and subject to public management by trustees. From the nineteenth century it indicated a fee-paying secondary school which had developed from an endowed grammar schools, or was modelled on similar lines, and which took pupils from beyond the local constituency and usually offered boarding facilities. The term was officially used in July 1860 in the appointment of a Royal Commission, and in 1867 in 'An Act for the better government and extension of certain Public Schools'. As this act applied to the ancient endowed grammar schools or colleges of Eton, Winchester, Westminster, Harrow, Rugby, Charterhouse, and Shrewsbury, these foundations were regarded as the elite public schools.

Over time, however, the use of the title was extended to include other schools of similar organisation. Initially, these included those institutions founded in the nineteenth century to provide schooling for the sons of the middle classes, who felt themselves to be excluded by the established public schools. Examples of this type of school are Stowe, Lancing and Fettes. More recently it has been applied to all schools who are members of the Headmasters' and Headmistresses' Conference. These schools may also be referred to as independent or private schools and in many people's minds these terms have become virtually interchangeable.

Royal Commission on the Public Schools, the—see Clarendon Commission.

Royal Commission on the State of Popular Education in England, the—see Newcastle Commission.

Schools Inquiry Commission—see Taunton Commission.

Serge—a loosely woven twill fabric, usually made from wool and known for its durability.

Skeleton Suit—from around 1770, young boys might be dressed in what were termed 'skeletons' or 'skeleton suits', often made of nankeen (a strong cotton

cloth of a yellowish-brown colour, originally from Nanking in China (eighteenth century)). The suit consisted of a tight jacket and ankle-length trousers. The jacket generally had two rows of buttons ascending over the shoulders and was worn over a frilled shirt. The trousers appear to have originated from country-peasant attire and are of interest because they were introduced for boys a generation before their use was accepted for men. The term 'skeleton suit' remained in use until around 1830.

Stomacher—a decorative panel of a V or U shape worn attached to, or separate from, the front of a doublet or gown. It formed part of the clothing of men in the late fifteenth and early sixteenth century and appeared in women's clothing from about 1570 until the 1770s. The stomacher was stiffened and reinforced with strips of metal, whalebone or wood in order to maintain the smooth and rigid form of the doublet or gown bodice and descended to a sharp or rounded point at the waist. It was often ornately decorated and was in a different material and colouring from the rest of the clothes.

Sumptuary Law—any piece of legislation designed to restrict personal spending on luxury items including clothing, food, drink and household equipment. The laws were often used as a way to reinforce class boundaries and maintain established hierarchies, they were rarely effective and often widely ignored.

Surplice—a loose linen vestment, usually white, which was worn over a gown or cassock during Christian church services. The garment is still worn today by clergy and choristers.

Tabs—see Bands.

Tail Coat—for the first decade of the nineteenth century the tail coat was cut straight across at the waist in front and fell to long tails at the back. The coat lapels were large, the collar high up to the ears and the sleeves were fitted. Over the next fifty years the coat continued to change in subtle ways, the tails becoming shorter, the collar flatter and the lapels smaller. It continued to be worn until about 1860 for both day and evening wear, but was seen less often after 1855, when it was replaced by the frock coat for daywear. The style has survived in formal evening wear for men.

Taunton Commission—in 1864 the Schools Inquiry Commission, under the chairmanship of Lord Taunton, was appointed to inquire into secondary

education, encompassing all schools which lay between the nine great public schools covered by the Clarendon Commission and the elementary education of the working classes, which had been dealt with by the Newcastle Commission. Its brief was 'to consider and report what measures (if any) are required for the improvement of such education, having especial regard to all endowments applicable or which can rightly be made applicable thereto'.

The Commissioners investigated 782 grammar schools, plus some proprietary and private schools. They found that provision of secondary education was poor and unevenly distributed. Two thirds of English towns had no secondary schools of any kind and in the remaining third there were marked differences of quality. There seemed to be no clear conception of the purpose of secondary education, nor was there any appropriate differentiation of courses adapted to the needs of pupils who left school at different ages.

The Commissioners were also profoundly concerned about the provision of education for girls—there were only 13 girls' secondary schools in the whole of England—and they were not impressed by the quality of education that was on offer.

Taunton Report—in their report issued in 1868, the Commissioners recommended the establishment of a national system of secondary education based on the existing endowed schools. Their report envisaged three grades of secondary education in separate schools. This was essentially the start of the tripartite system which was in place until the education acts of the 1960s introduced comprehensive education (for further detail, see 'Grammar School').

The resulting 1869 Endowed Schools Act created the Endowed Schools Commission and gave its members considerable powers and duties. They were to draw up new schemes of government for the endowed schools and were to extend the benefits of endowments to girls as far as possible.

Tippet—the use of 'tippet' altered over time, but from the sixteenth century onwards it referred to a short shoulder cape.

Top Hat—a tall, high-crowned hat with a narrow brim usually slightly rolled up at the sides but at some dates with an almost flat brim. The style appears to have developed from the English round hat of the late eighteenth and early nineteenth centuries, which had a tall crown and small, rolled brim. The term 'common round hat' appears in the Clarendon Report on the public schools in answer to questions concerning the styles of dress being worn by the pupils. It

can, from other evidence, only refer to the top hat, which was standard wear for men of the upper classes at the period when the report appeared.

Tussore—wild silk, cream or brownish in its natural state, varying in quality and weight depending on the source of the raw silk and the method of weaving. Most tussores came from India, although China was also a source. It was a fabric much used for dress materials at the end of the nineteenth century, as at least some of the varieties of tussore were washable.

Voluntary School—by the early nineteenth century it was clear that educational provision in the United Kingdom was both patchy and inadequate. Several societies were set up to provide basic education for the poorer classes. These societies included the National Society for Promoting Religious Education, the Catholic Poor School Committee and the British and Foreign Schools Society; many, but not all, of the schools created by these societies promoted a particular set of religious beliefs. The schools established by these societies became known as 'Voluntary Schools' to distinguish them from the schools, such as board schools, established by local public authorities (see 'Board Schools'). Under the terms of the 1870 Elementary Education Act, public funds were made available to support the network of voluntary schools.

Zouave Jacket—a style of jacket fashionable in the mid-nineteenth century, the zouave was a collarless jacket worn open in front, with a single fastening at the neck. The style had no back seam and the front borders were rounded off at the bottom corners. It was named after the uniform jacket of the Zouave regiment in Algeria who were involved in the Italian war of 1859.

Bibliography

Primary

Archival

Bridlington High School for Girls Old Girls' Association Records, the Treasure House, Beverley.
Burton Grammar School Archive.
Cheltenham Ladies' College Archives.
Christ's Hospital Collection, London Metropolitan Archives.
Downe House Archives.
GDS Archives, Institute of Education, University of London.
Kesteven and Grantham Girls' School Archives.
Malvern College Archives.
Marlborough College Archives.
New College Library, Oxford.
NLCS Archives.
Roedean School Archives.
Sherborne Girls' School Archives.
SPCK Archives, Cambridge University Library.
St Leonards Archives.
TWGGS Archive.
Winchester College Archives.
Wycombe Abbey School Archives.
Union for Women Teachers Archives, Institute of Education, University of London.

Unpublished Documents

Davidson, Ethel, *History of St Margaret's*, 2005.
Roberts, R., *History of Uniform at Cheltenham Ladies' College*, 2008.

Published

NEWSPAPERS AND PERIODICALS

Blackburn Standard and Weekly Express, 'Thames Rowing Girls', 1 June 1889.
Chicago Tribune, 'The Djibbah has Captured London Society', 23 November 1902.
Cornishman, 'One and All', 18 May 1911.
Daily Mirror, 'School Uniform Rip Off', 14 September 2006.
Daily News, 'Classified advertisement—Sydenham School Uniforms', 15 October 1860.
Devon and Exeter Daily Gazette, 'Woman's Realm', 7 January 1929.
Devon and Exeter Daily Gazette, 'Woman's Realm', 29 April 1929.
Essex County Chronicle, 'The Care of the Children', 12 August 1910.
Freeman's Journal and Daily Commercial Advertiser, 'Advertisement', 15 December 1859.
Fricker, Martin, 'Primary School in Deprived Area Praised for Setting Aside £10k to Clothe its Pupils', *Mirror*, 21 May 2015.
Girls' Own Paper, 'The North London Collegiate School for Girls', May 1882.
Glasgow Herald, 'The Uniform Outlook', 5 June 1997.
Harrovian, 'Scenes at a Public School; First day at Harrow', vol. i, no. 1, March 1828.
Harrovian, 'School Dress', vol. ii, no. 6, 4 July 1889.
Hull Daily Mail, 'Editorial', 6 May 1921.
Hull Daily Mail, 'School Clothes Which Make Mothers Worry', 15 June 1934.
Illustrated London News, 'Chas Baker & Co.'s School Outfits', December 1887.
Isle of Wight Observer, 'Report on Ryde School of Art Calico Fancy Dress Ball', 26 April 1879.
John Bull, 'Female Education', 31 January 1852.
Leeds Mercury, 'An Essay on Collars', 12 November 1887.
Liverpool Mercury, 'Advertisement—B. Hyam and the Spring, 1860', 6 March 1860.
Manchester Guardian, 'French Berets for Schoolgirls', 12 April 1934.
Manchester Times, 'Advertisement—A Novelty in Boys' Jackets', 3 August 1850.
Marsh, Tim, 'Clubbers Night Out at the School Disco', *London Evening Standard*, 11 October 2001 <http://www.standard.co.uk/goingout/music/clubbers-night-out-at-the-school-disco-6352691.html> (accessed 9 July 2015).
Maudsley, Henry, 'Sex in Mind and Education', *Popular Science Monthly*, June 1874.
Moore, Suzanne, 'We're Told that School Uniforms are About Preparing our Kids for the "Real World". Do We Want a World of Dull Conformists?', *Guardian*, 30 August 2012.

Morning Post, 'Correspondence—The Dress of Harrow Schoolboys', 3 December 1886.

Morning Post, 'Correspondence', 7 December 1886.

Moss, Vincent, 'Hague in Uniform Fury', *News of the World*, 2 July 2000.

News Chronicle, 'New Look', 19 November 1948.

Parsons, Tony, 'School Niqab Ban isn't Racist ... Just Common Sense', *Sun*, 28 September 2014.

Penny Illustrated Paper and Illustrated Times, 'The World of Women, Marguerite', 8 October 1892.

Petridis, Alexis, 'Boys and Girls Come Out to Play', *Guardian*, 5 July 2002 <http://www.theguardian.com/culture/2002/jul/05/artsfeatures.popandrock> (accessed 9 July 2015).

Pithers, Ellie, Alice Newbold, Bibby Sowray, Sophie Warburton and Katy Young, 'School Uniform's in for Grown-ups this Summer', *Telegraph*, 11 February 2015 <http://fashion.telegraph.co.uk/article/TMG11403925/School-uniform-trend-for-grown-ups.html> (accessed 9 July 2015).

Pocklingtonian, 'Be Keen!', vol. VIII, no. 2, Michaelmas Term (Second Half), 1899.

Pocklingtonian, 'School Notes', vol. VIII, no. 2, Michaelmas Term (Second Half), 1899.

Queen, The Lady's Newspaper, 'Physical Education and the Liverpool Gymnasium', 5 January 1867.

School Friend, 'The Arrival of Bessie Bunter', 17 May 1919.

Standard, 'Classified Advertisement—School Uniform', 4 February 1860.

Standard, 'Classified Advertisement—Send for Patterns and Directions', 4 February 1860.

Tamworth Herald, 'Tamworth Girls' High School', 1 November 1941.

Tamworth Herald, 'Grammar School Head Appeals to Parents', 27 November 1948.

The Times, 'Back to School', 11 September 1939.

The Times, 'Success of British Film (Arts and Entertainment)', 30 December 1954.

The Times, 'Veiled Insult; The Right Response to the Niqab is Not to Ban it, it is to Allow Liberal Values to Triumph', 15 September 2013.

Wells, Jonathan, 'The Pop-up Restaurant that Turns School Dinners into Fine Dining', *Telegraph*, 8 July 2015 <http://www.telegraph.co.uk/men/the-filter/11722853/The-pop-up-restaurant-that-turns-school-dinners-into-fine-dining.html> (accessed 9 July 2015).

Western Times, 'Advertisement and Notices', 13 October 1920.

Womack, Sarah, 'Pattern Wants "Compulsory School Uniforms"', *Press Association*, 27 November 1993.

OTHERS

Ackermann, Rudolph, *The Microcosm of London* (London: R. Ackermann's Repository of Arts, 1808–10).

Alexander, Cecil Frances, *Hymns for Little Children* (London: Joseph Masters, 1852).

Allestree, Richard, *The Practice of Christian Graces, or, The Whole Duty of Man Laid Down in a Plaine and Familiar Way for the Use of All, but Especially the Meanest Reader* (London: Printed by D. Maxwell for T. Garthwait, 1658).

An Account of Charity-Schools Lately Erected in England, Wales, and Ireland: With the Benefactions Thereto; and of the Methods Whereby They Were Set Up, and are Governed. Also, a Proposal for Enlarging their Number, and Adding Some Work to the Childrens Learning, Thereby to Render their Education More Useful to the Publick (London: Printed and Sold by Joseph Downing, 1706).

An Account of Charity-Schools Lately Erected in England, Wales, and Ireland: With the Benefactions Thereto; and of the Methods Whereby They Were Set Up, and are Governed. Also, a Proposal for Enlarging their Number, and Adding Some Work to the Childrens Learning, Thereby to Render their Education More Useful to the Publick (London: Printed and Sold by Joseph Downing, 1709).

An Account of the Charity School in Oxford (Maintain'd by the Voluntary Subscriptions of the Vice-Chancellor, Heads of Houses, and other Members of the University) for Four Years: vis. From Michaelmas 1711 to Michaelmas 1715 ([Oxford?], 1715).

An Old Rugbeian (R.H. Hutton), *Recollections of Rugby* (London: Hamilton and Adams, 1848).

Arnold, Lorna, *My Short Century: Memoirs of an Accidental Nuclear Historian* (Palo Alto: Cumnor Hill Books, 2012).

Atherton, Florence, 'Florence Atherton', in *Edwardian Childhoods*, ed. Thea Thompson (London: Routledge & Kegan Paul, 1981), pp. 103–20.

Baines Reed, Talbot, *Fifth Form at St Dominic's: A School Story* (London: The Religious Tract Society, 1890).

Benson, Arthur Christopher, *The Upton Letters* (London: Smith Elder and Company, 1906).

Benson, E.F., *As We Were: A Victorian Peep Show* (London: Longmans, Green and Co., 1930).

Black Cat Cigarette Cards: School Emblems, 1929, printed card, nos. 2, 3, 4 and 7, personal collection.

Blake, William, 'Holy Thursday', in *The Complete Writings of William Blake*, ed. Geoffrey Keynes (London: Oxford University Press, 1966), pp. 121–22.

Brinsley, John, *Ludus Literarius: or the Grammar Schoole* (London: Printed for Thomas Man, 1612).

Brittain, Vera, *Testament of Youth* (London: Virago, 1988).

Brontë, Charlotte, *Jane Eyre* (Oxford: Oxford University Press, 2008).

Burstall, Sara A., *Retrospect and Prospect: Sixty Years of Women's Education* (London: Longmans, Green & Co., 1933).

Cameron, David, 'Questions to the Prime Minister', *Parliamentary Debates (Hansard)* (United Kingdom: House of Commons, 4 September 2013).

Carey, Tanith, *Never Kiss a Man in a Canoe: Words of Wisdom from the Golden Age of Agony Aunts* (London: Boxtree, 2009).

Charity School of St Pancras, *A Brief Account of the Charity school of St. Pancras, for Instructing, Cloathing, Qualifying for Useful Servants, and Putting out to Service, the Female Children of the Industrious Poor* (London: S. Low, 1796).

Chase, Joanna, *Sew and Save* (Glasgow: Literary Press Ltd, 1941).

Davies, Elizabeth, *Cost of School Uniform 2015* (Department for Education, 2015).

Davies, Emily, *Emily Davies Collected Letters 1861–1875*, ed. Jerome McGann and Herbert Tucker (Virginia: University of Virginia Press, 2004).

Defoe, Daniel, *Every-body's Business, is No-Body's Business: or, Private Abuses, Publick Grievances: Exemplified in the Pride, Insolence, and Exorbitant Wages of our Women-Servants, Footmen, &c. With a Proposal for Amendment of the Same* (London: sold by T. Warner; A. Dodd; and E. Nutt, 1725).

Dickens, Charles, *Dombey and Son* (Boston: Bradbury and Guild, 1848).

Farrar, Frederic W., *Eric, or Little by Little* (London and Glasgow: Collins' Clear-Type Press, c.1913).

Fergusson, Bernard, *Eton Portrait* (London: John Miles Ltd, 1937).

Graves, Robert, *Goodbye to All That* (London: Penguin Books, 1960).

Guidance to Schools on School Uniform Policy (Bangor: Department for Education, 30 March 2011, re-issued 5 June 2018).

Harroway, J., *The Charity School: A Comic Duet* (London: T. Purday, c.1835).

Hattersley, Roy, *A Yorkshire Boyhood* (London: Abacus, 2003).

Heldmann, B., *Boxall School: A Tale of Schoolboy Life* (London: Nisbet & Co., 1929).

Holdsworth, W.A., *The Education Act 1870 Popularly Explained Together with the Various Orders in Council Issued by the Education Department* (London: George Routledge and Sons, 1870).

Holmes, Oliver Wendall, *The Autocrat of the Breakfast Table* (Boston: Phillips Sampson & Company, 1859).

Holt, Ardern, *Fancy Dresses Described, or What to Wear at Fancy Balls* (London: Debenham and Freebody, 1880).

Holt, Ardern, *Fancy Dresses Described, or What to Wear at Fancy Balls* (London: Debenham and Freebody, 1887).

Holt, Ardern, *Fancy Dresses Described, or What to Wear at Fancy Balls* (London: Debenham and Freebody, 1896).

Hunt, Leigh, *The Autobiography of Leigh Hunt* (London: The Cresset Press, 1949).

Icknield High School, 'Uniform Requirements: Current, September 2014–July 2018' (2014) <http://www.icknield.beds.sch.uk/wp-content/uploads/2015/02/uniform2014.pdf> (accessed 15 January 2016).

Jackson, H.C., *Sudan Days and Ways* (London: Macmillan, 1954).

Kerr, James, 'School Hygiene, in its Mental, Moral, and Physical Aspects', *Journal of the Royal Statistical Society* 60, no. 3 (1897), pp. 613–80.

Laborde, E.D., *Harrow School Yesterday and Today* (London: Winchester Publications Limited, 1948).

Leigh, Felix. *London Town* (Belfast: Marcus Ward & Co., 1883).

Lewis, Dio, *The New Gymnastics for Men, Women and Children* (Boston: Ticknor and Fields, 1862).

Life and Letters of Sir Gilbert Elliot First Earl of Minto from 1751 to 1806, Vol. 1, ed. Countess of Minto (London: Longmans, Green, and Co., 1874).

Lumsden, Louisa Innes, *Yellow Leaves: Memories of a Long Life* (Edinburgh: William Blackwood & Sons Ltd, 1933).

Machyn, Henry, *The Diary of Henry Machyn: Citizen and Merchant-Taylor of London from A.D. 1550 to A.D. 1563*, ed. John Gough Nichols (London: Camden Society, 1849).

Mandeville, Bernard, *The Fable of the Bees or Private Vices: Publick Benefits, Vol. 1* (Oxford: Clarendon Press, 1732).

Mangan, Lucy, *Hopscotch and Handbags: The Essential Guide to Being a Girl* (London: Headline Review, 2007).

Newbolt, Henry John, *Admirals All: and Other Verses* (London: Elkin Mathews, 1898).

Pennant, Thomas, *Of London* (London: Printed for Robt. Faulder, 1790).

Pepys, Samuel, *The Diary of Samuel Pepys: Volume I, 1660*, ed. Robert Latham and William Matthews (London: Harper Collins Publishers, 2000).

Pyne, William H., *The Microcosm of London or, London in Miniature; Volume I* (London: Methuen, 1904).

Pyne, William H., *British Costumes* (Hertfordshire: Wordsworth Editions, 1989).

'Queen's College—London', *Quarterly Review* (London: John Murray, 1850), pp. 364–84.

Raverat, Gwen, *Period Piece: A Cambridge Childhood* (Bath: Clear Press Ltd, 2003).

'Report from Bicester Charity School: Oxfordshire, June 19 1725', in *An Account of Several Workhouses for Employing and Maintaining the Poor; Setting Forth The Rules by Which they are Governed, Their Great Usefulness to the Publick, And in Particular To the Parishes Where They are Erected. As Also of Several Charity Schools For Promoting Work, and Labour* (London: Printed and Sold by Joseph Downing, 1732).

Report of Her Majesty's Commissioners Appointed to Inquire into the Revenues and Management of Certain Colleges and Schools and the Studies Pursued and Instruction

Given Therein; with an Appendix and Evidence, Vol. III. Evidence Part 1 (London: Printed by George Edward Eyre and William Spottiswoode, 1864).

Report of Her Majesty's Commissioners Appointed to Inquire into the Revenues and Management of Certain Colleges and Schools and the Studies Pursued and Instruction Given Therein; with an Appendix and Evidence, Vol. IV. Evidence Part 2 (London: Printed by George Edward Eyre and William Spottiswoode, 1864).

Report of the Commissioners Appointed to Inquire into the State of Popular Education in England, Vol. I (London: Printed by George E. Eyre and William Spottiswoode, 1861).

Ridley, Annie E., *Frances Mary Buss and Her Work for Education* (London: Longmans, Green & Co., 1896).

Rousseau, Jean-Jacques, *Émile: or, On Education*, trans. Allan Bloom (New York: Basic Books, 1979).

Routledge's Handbook of Football (London: G. Routledge & Sons, 1867).

Royston, Sam and Rebecca Jacques, *The Wrong Blazer* (London: The Children's Society, 2018).

Samuel Brothers New Map of London (London: Samuel Brothers, May 1862).

Schild, Marie, *Character Suitable for Fancy Costume Balls* (Lond. &c, 1881).

School of Industry for the Instruction of the Female Children of the Industrious Poor (London: Printed by R. Newton, 1837).

Schools Inquiry Commission, Vol. I Report of the Commissioners (London: Printed by George Edward Eyre and William Spottiswoode, 1868).

Shy, Timothy and Ronald Searle, *The Terror of St Trinian's or Angela's Prince Charming* (London: Max Parrish, 1952).

Starkey, Thomas, *A Dialogue between Reginald Pole and Thomas Lupset* (London: Chatto and Windus, 1948).

Stow, John, *A Survey of London* (London: Printed by John Windet, 1603).

Strype, John, *A Survey of the Cities of London and Westminster* (1720).

The Methods Used for Erecting Charity-Schools, With the Rules and Orders by Which they are Governed. A Particular Account of the London Charity-Schools: With a List of Those Erected Elsewhere in Great Britain & Ireland (London: Printed and Sold by Joseph Downing, 1715).

The Methods Used for Erecting Charity-Schools, With the Rules and Orders by Which they are Governed. A Particular Account of the London Charity-Schools: With a List of Those Erected Elsewhere in Great Britain & Ireland (London: Printed and Sold by Joseph Downing, 1716).

The State of the Ladies Charity-School, Lately Set Up in Baldwin-Street, in the City of Bristol, for Teaching Poor Girls to Read and Spin; Together with Rules and Methods of Proceeding (Bristol: Printed by S. Farley, 1756).

Thomas, C.E., *Athletic Training for Girls* (London: Sir Isaac Pitman & Sons Ltd, 1913).
Trimmer, Sarah, *The Oeconomy of Charity or An Address to Ladies Adapted to the Present State of Charitable Institutions in England* (London: J. Johnson and F. & C. Rivington, 1801).
Urwick, E.J., *Studies of Boy Life in Our Cities* (London: J.M. Dent, 1904).
Vigne, Henry, 'Henry Vigne', in *Edwardian Childhoods*, ed. Thea Thompson (London: Routledge & Kegan Paul, 1981), pp. 143–47.
Vives, Juan Luis, *The Education of a Christian Woman: A Sixteenth-Century Manual*, ed. and trans. Charles Fantazzi (Chicago: University of Chicago Press, 2000).
Watts, Isaac, *The Works of The Rev. Isaac Watts, D.D. in Nine Volumes, vol. VI* (Leeds: Printed by Edward Baines, 1813).
Webb, Wilfred Mark, *The Heritage of Dress: Being Notes on the History and Evolution of Clothes* (London: The Times Book Club, 1912).
Wilson, Annie, 'Annie Wilson', in *Edwardian Childhoods*, ed. Thea Thompson (London: Routledge & Kegan Paul, 1981), pp. 68–101.

Secondary

Aldrich, Richard, *An Introduction to the History of Education* (London: Hodder and Stoughton, 1982).
Aries, Philippe, *Centuries of Childhood: A Social History of Family Life* (New York: Vintage Books, 1962).
Atik, Deniz and A. Fuat Fırat, 'Fashion Creation and Diffusion: The Institution of Marketing', *Journal of Marketing Management* 29, no. 7–8 (2013), pp. 836–60.
Atkinson, Paul, 'Fitness, Feminism and Schooling', in *The Nineteenth-Century Woman: Her Cultural and Physical World*, ed. Sara Delamont and Lorna Duffin (London: Croom Helm, 1978), pp. 92–133.
Auchmuty, Rosemary, 'The School Story from Brazil to Bunty', in *School Stories from Bunter to Buckeridge: Papers from a Children's Literature Conference held at Roehampton Institute, London in 1998*, ed. Nicholas Tucker (Lichfield: Pied Piper Publishing, 1998), pp. 40–50.
Avery, G., *Cheltenham Ladies: an Illustrated History of the Cheltenham Ladies' College* (London: James & James, 2003).
Bamford, T.W., *The Rise of the Public Schools: A Study of Boys' Public Boarding Schools in England and Wales from 1837 to the Present Day* (London: Nelson, 1967).
Baron, G., *Society, Schools and Progress in England* (Oxford: Pergamon Press, 1968).
Belfanti, Carlo Marco and Fabio Giusberti, 'Clothing and Social Inequality in Early Modern Europe: Introductory Remarks', *Continuity and Change* 15, no. 3 (2000), pp. 359–65.

Benhamou, Reed, 'Fashion in the *Mercure*: From Human Foible to Female Failing', *Eighteenth Century Studies* 31, no. 1 (1997), pp. 27–43.

Berghoff, Hartmut, 'Public Schools and the Decline of the British Economy, 1870–1914', *Past & Present*, no. 129 (1990), pp. 148–67.

Bertram, Jerome, *Monumental Brasses as Art and History* (Stroud: Alan Sutton Publishing Limited, 1996).

Bhugra, Dinesh and Padmal De Silva, 'Uniform—Fact, Fashion, Fantasy and Fetish', *Sexual and Marital Therapy* 11, no. 4 (1996), pp. 393–406.

Birley, Derek, *Playing the Game: Sport and British Society, 1910–45* (Manchester: Manchester University Press, 1995).

Bloomfield, Anne, 'Martina Bergman-Osterberg (1849–1915): Creating a Professional Role for Women in Physical Training', *History of Education* 34, no. 5 (2005), pp. 517–34.

Boardman, Kay, 'A Material Girl in a Material World: the Fashionable Female Body in Victorian Women's Magazines', *Journal of Victorian Culture* 3, no. 1 (1998), pp. 93–110.

Bodine, Ann, 'School Uniforms and Discourses on Childhood', *Childhood* 10, no. 1 (2003), pp. 43–64.

Bowen, John R., *Why the French don't like Headscarves: Islam, the State and Public Space* (Princeton and Oxford: Princeton University Press, 2007).

Bowerman, Elsie, *Stands There a School: Memories of Dame Frances Dove, D.B.E., Founder of Wycombe Abbey School* (Chiltern: Wycombe Abbey School, 1966).

Boyd, A.K., *The History of Radley College 1847–1947* (Oxford: Blackwell, 1948).

Brach, Ann Margaret, 'Identity and Intersubjectivity', in *Identities through Fashion: A Multidisciplinary Approach*, ed. Ana Marta Gonzalez and Laura Bovone (London: Berg, 2012), pp. 48–66.

Breward, Christopher, *The Culture of Fashion: A New History of Fashionable Dress* (Manchester: Manchester University Press, 1995).

Breward, Christopher, *The Hidden Consumer: Masculinities, Fashion and City Life 1860–1914* (Manchester: Manchester University Press, 1999).

Breward, Christopher, 'Review: The Politics of Fashion: The Politics of Fashion Studies', *Journal of Contemporary History* 42, no. 4 (2007), pp. 673–81.

Brock, Colin, 'Social and Spatial Disparity in the History of School Provision in England from the 1750s to the 1950s', in *An Introduction to the Study of Education*, ed. David Matheson (Abingdon: Routledge, 2015), pp. 134–52.

Brown, Callum G., *Religion and Society in Twentieth-Century Britain* (London: Routledge, 2006).

Brunsma, David L., *The School Uniform Movement and What it Tells us About American Education: A Symbolic Crusade* (Lanham, MD: Scarecrow Education, 2004).

Bryne, L.S.R. and E.L. Churchill, *Changing Eton* (London: Jonathan Cape, 1940).

Burke, Catherine and Helena Ribeiro de Castro, 'The School Photograph: Portraiture and the Art of Assembling the Body of the Schoolchild', *History of Education* 36, no. 2 (2007), pp. 213–26.

Burstyn, J.N., *Victorian Education and the Ideal of Womanhood* (London: Croom Helm, 1980).

Buszek, Maria Elena, *Pin-up Grrrls: Feminism, Sexuality, Popular Culture* (Durham, NC: Duke University Press: 2006).

Cadogan, Mary and Patricia Craig, *You're a Brick Angela! A New Look at Girls' Fiction from 1839 to 1975* (London: Victor Gollancz Ltd, 1976).

Cadogan, Mary, *Chin up, Chest Out Jemima: A Celebration of the Schoolgirls' Story* (Haslemere: Bonnington Books, 1989).

Campbell, Lachlan, *Eton Colours: An Essential Illustrated Aide Memoire* (Hanford: Glenorchy Publishing, 2008).

Cannadine, David, *The Rise and Fall of Class in Britain* (New York: Columbia University Press, 1999).

Carlson, Jack, *Rowing Blazers* (London: Thames & Hudson, 2014).

Catten, Dawn and Jean Dyke, *100 Years On: Dartford County School, 1904 to 2004* (Dartford: Privately Published, 2004).

Christie, O.F., *A History of Clifton College 1860–1934* (Bristol: J.W. Arrowsmith Ltd, 1935).

Clare, Wallace, *The Historic Dress of the English Schoolboy* (London: The Society for the Preservation of Ancient Customs, 1939).

Clark, Peter, *British Clubs and Societies 1580–1800: The Origins of an Associational World* (Oxford: Oxford University Press, 2002).

Clark, Terry Nichols and Seymour Martin Lipset, 'Are Social Classes Dying?', *International Sociology* 6, no. 4 (1991), pp. 397–410.

Colville, Quintin, 'Jack Tar and the Gentleman Officer: The Role of Uniform in Shaping the Class and Gender-Related Identities of British Naval Personal, 1930–1939', *Transactions of the Royal Historical Society* 6, no. 13 (2003), pp. 105–29.

Colvin, Howard, 'The Origin of Chantries', *Journal of Medieval History* 26, no. 2 (2000), pp. 163–73.

Compton, Rae, *The Complete Book of Traditional Knitting* (New York: Dover Publications Inc., 2010).

Cooper, Tony, *Head on the Block* (Beauchamp: Matador, 2012).

Cox, Jack, *Take a Cold Tub, Sir! The Story of the Boy's Own Paper* (Guildford: Lutterworth Press, 1982).

Craik, Jennifer, *Uniforms Exposed: From Conformity to Transgression* (Oxford: Berg, 2005).

Crane, Diana, 'Diffusion Models and Fashion: A Reassessment', *The Annals of the American Academy of Political and Social Science* 566, no. 1 (1996), pp. 13–24.

Crane, Diana, 'Clothing Behaviour as Non-Verbal Resistance: Marginal Women and Alternative Dress in the Nineteenth Century', *Fashion Theory* 3, no. 2 (1999), pp. 241–68.

Crane, Diana, *Fashion and its Social Agendas: Class, Gender and Identity in Clothing* (Chicago and London: University of Chicago Press, 2000).

Crossick, Geoffrey, 'The Emergence of the Lower Middle Class in Britain: A Discussion', in *The Lower Middle Class in Britain 1870–1914*, ed. Geoffrey Crossick (London: Croom Helm, 1977), pp. 11–60.

Cumming, Valerie, *Understanding Fashion History* (London: Batsford, 2004).

Cunningham, Hugh, *Children and Childhood in Western Society Since 1500* (New York: Longman Publishing, 1995).

Cunningham, Hugh, 'Histories of Childhood', *American Historical Review* 103, no. 4 (1998), pp. 1195–1208.

Cunningham, Hugh, *The Invention of Childhood* (London: BBC Book, 2006).

Cunnington, Cecil Willett and Phillis Cunnington, *Handbook of English Costume in the Sixteenth Century* (London: Faber and Faber Limited, 1962).

Cunnington, Cecil Willet, Phillis Cunnington and Charles Beard, *A Dictionary of English Costume* (London: Adam & Charles Black Ltd, 1976).

Cunnington, Phillis and Anne Buck, *Children's Costume in England 1300–1900* (London: Adam & Charles Black, 1978).

Cunnington, Phillis and Catherine Lucus, *Charity Costumes of Children: Scholars, Almsfolk, Pensioners* (London: Adam & Charles Black, 1978).

Cunnington, Phillis and Alan Mansfield, *English Costume for Sports and Outdoor Recreation: From the Sixteenth to the Nineteenth Centuries* (London: Adam & Charles Black, 1978).

Curtis, S.J. and M.E.A. Boultwood, *An Introductory History of English Education Since 1800* (Foxton: University Tutorial Press, 1966).

Davidoff, Leonore and Catherine Hall, *Family Fortunes: Men and Women of the English Middle Classes 1780–1850* (London: Routledge, 2002).

Davidson, Alexander, *Blazer, Badges and Boaters: A Pictorial History of School Uniform* (Horndean: Scope Books, 1990).

Davies, Stephanie, *Costume Language: A Dictionary of Dress Terms* (Malvern: Cressrelles Publishing Company, 1994).

Davis, Fred, *Fashion, Culture and Identity* (Chicago: The University of Chicago Press, 1992).

de la Haye, Amy and Elizabeth Wilson, *Defining Dress: Dress as Object, Meaning and Identity* (Manchester: Manchester University Press, 1999).

Delamont, Sara, 'The Contradictions in Ladies' Education', in *The Nineteenth-Century Woman: Her Cultural and Physical World*, ed. Sara Delamont and Lorna Duffin (London: Croom Helm, 1987), pp. 134–63.

De Zouche, Dorothy E., *Roedean School, 1885–1955* (Brighton: Dolphin Press, 1955).

Digby, Anne and Peter Searby, *Children, School and Society in Nineteenth-Century England* (London: Macmillan Press, 1981).

Dines, Gail, 'Grooming Our Girls: Hypersexualization of the Culture as Child Sexual Abuse', in *Exploiting Childhood: How Fast Food, Material Obsession and Porn Culture are Creating New Forms of Child Abuse*, ed. Jim Wild (London: Jessica Kingsley Publishers, 2013), pp. 116–29.

Driscoll, Catherine, *Girls: Feminine Adolescence in Popular Culture and Cultural Theory* (New York: Columbia University Press, 2002).

Dussel, Ines, 'When Appearances are Not Deceptive: A Comparative History of School Uniforms in Argentina and the United States (Nineteenth–Twentieth Centuries)', *Paedagogica Historica: International Journal of the History of Education* 41, no. 1–2 (2005), pp. 179–95.

Dyhouse, Carol, *Girls Growing up in Late Victorian and Edwardian England* (London: Routledge & Kegan Paul, 1981).

Earle, Peter, *The Making of the English Middle Class: Business, Society, and Family Life in London 1660–1730* (Berkeley: University of California Press, 1989).

Eidlin, Barry, 'Class Formation and Class Identity: Birth, Death, and Possibilities for Renewal', *Sociology Compass* 8, no. 8 (2014), pp. 1045–62.

Engholm, Ida and Erik Hansen-Hansen, 'The Fashion Blog as Genre: Between User Driven Bricolage Design and the Reproduction of Established Fashion System', *Digital Creativity* 25, no. 2 (2014), pp. 140–54.

English, Bonnie, *A Cultural History of Fashion in the 20th and 21st Centuries: From Catwalk to Sidewalk* (London: Bloomsbury, 2013).

Evans, Eric J., *The Forging of the Modern State: Early Industrial Britain, 1783–1870*. London: Routledge, 2001.

Ewing, Elizabeth, *Women in Uniform through the Centuries* (London: B.T. Batsford Ltd, 1975).

Ewing, Elizabeth, *History of Children's Costume* (London: B.T. Batsford Ltd, 1977).

Faiers, Jonathan, 'Dress Thinking: Disciplines and Indisciplinarity', in *Dress History: New Directions in Theory and Practice*, ed. Charlotte Nicklas and Annebella Pollen (London: Bloomsbury, 2015), pp. 15–32.

Fass, Paula, 'Is There a Story in the History of Childhood?' in *The Routledge History of Childhood in the Western World*, ed. Paula Fass (Abingdon: Routledge, 2013), pp. 1–14.

Finkel, Alicia, '*Le Bal Costumé*: History and Spectacle in the Court of Queen Victoria', *Dress* 10, no. 1 (1984), pp. 64–72.

Fischer, Gayle V., *Pantaloons and Power: A Nineteenth-Century Dress Reform in the United States* (Kent, Ohio and London: The Kent State University Press, 2001).

Fowler, David, *The First Teenagers: The Lifestyle of Young Wage-Earners in Interwar Britain* (London: The Woburn Press, 1995).

Freeman, Gillian. *The Schoolgirl Ethic: The Life and Work of Angela Brazil* (London: Allen Lane, 1976).

Furedi, Frank, 'Celebrity Culture', *Society* 47, no. 6 (2010), pp. 493–97.

Gathorne-Hardy, Jonathan, *The Public School Phenomenon 597–1977* (London: Hodder and Stoughton, 1977).

Gereluk, Dianne, *Symbolic Clothing in Schools: What Should be Worn and Why* (London: Continuum International Publishing Group, 2008).

Giles, Judy, 'Narratives of Gender, Class, and Modernity in Women's Memories of Mid-Twentieth Century Britain', *Signs* 28, no. 1 (2002), pp. 21–41.

Girouard, Mark, *The Return to Camelot: Chivalry and the English Gentleman* (New Haven and London: Yale University Press, 1981).

Gomersall, Meg, *Working-Class Girls in Nineteenth-Century England: Life, Work and Schooling* (London: Macmillan Press Ltd, 1997).

Gorham, Deborah, *The Victorian Girl and the Feminine Ideal* (London and Canberra: Croom Helm, 1982).

Grant, Julia M., Katherine H. McCutcheon and Ethel F. Sanders (eds), *St Leonards School, 1877–1927* (Oxford: Oxford University Press, 1927).

Gregory, James, 'Vegetable Fictions in the Kingdom of Roast Beef: Representing the Vegetarian in Victorian Literature', in *Consuming Culture in the Long Nineteenth Century: Narratives of Consumption, 1700–1900*, ed. Tamara S. Wagner and Narin Hassan (Lanham: Lexington Books, 2007), pp. 17–35.

Greyerz, Kaspar von, *Religion and Culture in Early Modern Europe, 1500–1800* (Oxford: Oxford University Press, 2008).

Grinker, Roy Richard, Stephen C. Lubkemann and Christopher B. Steiner, *Perspectives on Africa: A Reader in Culture, History and Representation* (Chichester: Wiley-Blackwell, 2010).

Guppy, Alice, *Children's Clothes 1939–1970: The Advent of Fashion* (Poole: Blandford Press, 1978).

Hahn, Hazel, 'Fashion Discourses in Fashion Magazines and Madame de Girardin's *Lettres parisiennes* in July-Monarchy France (1830–48)', *Fashion Theory* 9, no. 2 (2005), pp. 205–27.

Hall, Donald E., *Muscular Christianity: Embodying the Victorian Age* (Cambridge: Cambridge University Press, 2006).

Handley, Susannah, *Nylon: The Manmade Fashion Revolution* (London: Bloomsbury, 1999).

Hargreaves, Jennifer, *Sporting Females: Critical Issues in the History and Sociology of Women's Sports* (London and New York: Routledge, 1994).

Hargreaves-Mawdsley, W.N., *A History of Academical Dress in Europe until the end of the Eighteenth Century* (Westport: Greenwood Press, 1978).

Harris, Neville, 'The Legislative Response to Indiscipline in Schools in England and Wales', *Education and the Law* 14, no. 1–2 (2002), pp. 57–76.

Harrison, Pat, *Lancaster Girls' Grammar School: The First Century, Continuity and Change* (Lancaster: Published by LGGS, 2006).

Hartwell, Clare, *The History and Architecture of Chetham's School and Library* (London: Yale University Press, 2004).

Hayward, Maria, *Rich Apparel: Clothing and the Law in Henry VIII's England* (Farnham: Ashgate, 2009).

Hayward, Maria, 'Dressed in Blue: The Impact of Woad on English Clothing c.1350–1670', *Costume* 49, no. 2 (2015), pp. 168–85.

Hendrick, Harry, 'Constructions and Reconstructions of British Childhood: An Interpretative Study, 1800 to the Present' in *Constructing and Reconstructing Childhood: Contemporary Issues in the Sociological Study of Childhood*, ed. Allison James and Alan Prout (London: RoutledgeFalmer, 2003), pp. 34–62.

Heywood, Colin, *A History of Childhood, Children and Childhood in the West from Medieval to Modern Times* (Cambridge: Polity Press, 2009).

Hindle, Steve, 'Dependency, Shame and Belonging: Badging the Deserving Poor, c.1550–1750', *Cultural and Social History* 1, no. 1 (2004), pp. 6–35.

Hobsbawm, Eric, 'Introduction: Inventing Traditions', in *The Invention of Tradition*, ed. Eric Hobsbawm and Terence Ranger (Cambridge: Cambridge University Press, 2013), pp. 1–14.

Hobsbawm, Eric, 'Mass-Producing Traditions: Europe, 1870–1914', in *The Invention of Tradition*, ed. Eric Hobsbawm and Terence Ranger (Cambridge: Cambridge University Press, 2013), pp. 263–307.

Hoggart, Richard, *The Uses of Literacy: Aspects of Working-Class Life, with Special References to Publications and Entertainments* (London: Chatto & Windus, 1959).

Hollander, Anne, *Sex and Suits: The Evolution of Modern Dress* (Brinkworth: Claridge Press, 1994).

Holt, Richard, *Sport and the British: A Modern History* (Oxford: Clarendon Press, 1993).

Holt, Richard, 'The Amateur Body and the Middle-class Man: Work, Health and Style in Victorian Britain', *Sport in History* 26, no. 3 (2006), pp. 352–69.

Holt Sawyer, Corinne, 'Men in Skirts and Women in Trousers, from Achilles to Victoria Grant: One Explanation of a Comedic Paradox', *Journal of Popular Culture* 21, no. 2 (1987), pp. 1–16.

Holtzman, Ellen M., 'The Pursuit of Married Love: Women's Attitudes toward Sexuality and Marriage in Great Britain, 1918–1939', *Journal of Social History* 16, no. 2 (1982), pp. 39–51.

Holyoake, Gregory, 'Survivors of the First Free Schools: London's Charity Children Statues', *Country Life* (13 November 1980).

Horn, Pamela, *The Victorian and Edwardian Schoolchild* (Gloucester: Alan Sutton Publishing, 1989).

Horsler, Val, *All for Love: Seven Centuries of Illicit Liaison* (London: Bloomsbury Academic, 2006).

Huggins, Mike, *The Victorians and Sport* (London: Hambledon & London, 2004).

Hughes, Kathryn, *The Victorian Governess* (London: Hambledon & London, 2001).

Hugh-Jones, Siriol, 'A Short Ramble Round the Old Prison House', in *The St Trinian's Story*, ed. Kaye Webb (Harmondsworth: Penguin Books, 1961), pp. 21–38.

Information Leaflet Number 29: Records of Christ's Hospital and Bluecoat Schools at Guildhall Library (London: London Metropolitan Archives, 2013).

Jarvis, Anthea, '"There was a Young man of Bengal ..." The Vogue for Fancy Dress, 1830–1950', *Costume* 16, no. 1 (1982), pp. 33–46.

Jarvis, Anthea and Patricia Raine, *Fancy Dress* (Aylesbury: Shire Publications Ltd, 1984).

Jones, Ann Rosalind and Peter Stallybrass, *Renaissance Clothing and the Materials of Memory* (Cambridge: Cambridge University Press, 2003).

Jones, M.G., *The Charity School Movement: A Study in Eighteenth Century Puritanism in Action* (London: Frank Cass and Co. Ltd, 1964).

Jones, Robert, *Gender and the Formation of Taste in Eighteenth-Century Britain: The Analysis of Beauty* (Cambridge: Cambridge University Press, 1998).

Jordan, Ellen, *The Women's Movement and Women's Employment in Nineteenth Century Britain* (London: Routledge, 1999).

Joseph, Nathan, *Uniforms and Nonuniforms: Communication Through Clothing* (Connecticut: Greenwood Press, 1986).

Joyce, Patrick, *Visions of the People: Industrial England and the Question of Class, 1848–1919* (Cambridge: Cambridge University Press, 1991).

Kamm, J., *Hope Deferred: Girls' Education in English History* (London: Methuen, 1965).

Kanner, S. Barbara, 'The Women of England in a Century of Social Change, 1815–1914: A Select Bibliography', in *Suffer and Be Still: Women in the Victorian Age*, ed. Martha Vicinus (Abingdon: Routledge, 2013), pp. 173–207.

Kaplan, Joel H. and Sheila Stowell, *Theatre & Fashion: Oscar Wilde to the Suffragettes* (Cambridge: Cambridge University Press, 1994).

King, Keith, 'Should School Uniforms be Mandated in Elementary Schools', *Journal of School Health* 68, no. 1 (2009), pp. 32–37.

Kinsella, Sharon, 'What's Behind the Fetishism of Japanese School Uniforms', *Fashion Theory: The Journal of Dress, Body and Culture* 6, no. 2 (2002), pp. 215–37.

Kinsella, Sharon, *Schoolgirls, Money and Rebellion in Japan* (London: Routledge, 2014).

Koch, H.W., *The Hitler Youth: Origins and Development 1922–45* (London: Macdonald and Jane's, 1975).

Kortsch, Christine Bayles, *Dress Culture in Late Victorian Women's Fiction: Literacy, Textiles, and Activism* (Farnham: Ashgate, 2009).

Kowaleski-Wallace, Elizabeth, *Consuming Subjects: Women, Shopping, and Business in the Eighteenth Century* (New York: Columbia University Press, 1997).

Kuchta, David, *The Three-Piece Suit and Modern Masculinity: England, 1550–1850* (Berkeley: University of California Press, 2002).

Lack, William, Martin Struchfield and Philip Whittemore, *The Monumental Brasses of Cornwall* (London: Monumental Brass Society, 1997).

Lake, Peter and Michael Questier, *The Anti-Christ's Lewd Hat: Protestants, Papists and Players in Post-Reformation England* (New Haven and London: Yale University Press, 2002).

Laver, James, *Modesty in Dress* (London: Heinemann, 1969).

Laver, James, *Costume & Fashion: A Concise History* (London: Thames and Hudson, 1992).

Lawson, John and Harold Silver, *A Social History of Education in England* (Abingdon: Routledge, 2007).

Lee, John S., *Cambridge and Its Economic Region, 1450–1560* (Hatfield: University of Hertfordshire Press, 2005).

Lemire, Beverly, 'Second-hand Beaux and "Red-armed Belles": Conflict and the Creation of Fashions in England, c.1660–1800', *Continuity and Change* 15, no. 3 (2000), pp. 391–417.

Levene, Alysa, *The Childhood of the Poor: Welfare in Eighteenth-Century London* (Basingstoke: Palgrave Macmillan, 2012).

Lloyd, Sarah, 'Pleasing Spectacles and Elegant Dinners: Conviviality, Benevolence, and Charity Anniversaries in Eighteenth-Century London', *Journal of British Studies* 41, no. 1 (2002), pp. 23–57.

Lowther Clarke, W.K., *A History of the SPCK* (London: SPCK, 1959).

Lurie, Alison, *The Language of Clothes* (Feltham: Hamlyn Paperbacks, 1983).

Mackenzie, John M., *Popular Imperialism and the Military, 1850–1950* (Manchester: Manchester University Press, 1992).

Mangan, J.A., *Athleticism in the Victorian and Edwardian Public School: The Emergence and Consolidation of an Educational Ideology* (London: The Falmer Press, 1986).

Mangan, J.A., *The Games Ethic and Imperialism: Aspects of the Diffusion of an Ideal* (Middlesex: Viking, 1986).

Mansfield, Alan, 'Dress of the English Schoolchild', *Costume* 8, no. 1 (1974), pp. 56–60.

Manzione, Carol Kazmierczak, *Christ's Hospital of London, 1552–1598: 'A Passing Deed of Pity'* (London: Associated University Presses, 1995).

Marsden, W.E., *Educating the Respectable: A Study of Fleet Road Board School, Hampstead, 1879–1902* (London: The Woburn Press, 1991).

Marshall, Arthur, *Whimpering in the Rhododendrons: The Splendours and Miseries of the English Prep School* (Glasgow: Fontana Paperbacks, 1983).

Marshall, Dorothy, *The English Poor in the Eighteenth Century: A Study in Social and Administrative History from 1662–1782* (Abingdon: Routledge, 2007).

Marshall, Dorothy, *Eighteenth Century England, 1714–1784* (London: Routledge, 2014).

Mattingly, Carol, *Appropriate[ing] Dress: Women's Rhetorical Style in Nineteenth-Century America* (Carbondale and Edwardsville: Southern Illinois University Press, 2002).

Maxwell Lyte, H.C., *A History of Eton College, 1440–1884* (London: Macmillan and Co., 1889).

McConnell, J.D.R., *Eton: How it Works* (London: Faber and Faber, 1967).

McCrone, David, 'Unmasking Britannia: The Rise and Fall of British National Identity', *Nations and Nationalism* 3, no. 4 (2004), pp. 579–96.

McCrone, Kathleen E., 'Play Up! Play Up! and Play the Game! Sport at the Late Victorian Girls' Public School', *Journal of British Studies* 23, no. 2 (1984), pp. 106–34.

McCrone, Kathleen E., *Sport and the Physical Emancipation of English Women, 1870–1914* (Abingdon: Routledge, 2014).

McDermid, Jane, *The Schooling of Girls in Britain and Ireland, 1800–1900* (London: Routledge, 2012).

McDevitt, Patrick F., *May the Best Man Win: Sport Masculinity, and Nationalism in Great Britain and the Empire, 1880–1935* (New York: Palgrave Macmillan, 2004).

McGoldrick, Dominic, *Human Rights and Religion: The Islamic Headscarf Debate in Europe* (Oxford and Portland: Hart Publishing, 2006).

McNeil, Peter, '"Put Your Best Face Forward": The Impact of the Second World War on British Dress', *Journal of Design History* 6, no. 1 (1993), pp. 283–99.

Meadmore, Daphne and Colin Symes, 'Of Uniform Appearance: a Symbol of School Discipline and Governmentality', *Discourse: Studies in the Cultural Politics of Education* 17, no. 2 (1996), pp. 209–26.

Meadmore, Daphne and Colin Symes, 'Keeping up Appearances: Uniform for School Diversity?', *British Journal of Educational Studies*, no. 45 (1997), pp. 174–86.

Meldrum, Tim, *Domestic Service and Gender, 1660–1750: Life and Work in the London Household* (London: Routledge, 2014).

Mendes, Valerie and Amy de la Haye, *20th Century Fashion* (London: Thames & Hudson, 1999).

Merskin, Debra. 'Reviving Lolita: A Media Literacy Examination of Sexual Portrayals of Girls in Fashion Advertising', *American Behavioural Scientist* 48, no. 1 (2004), pp. 119–29.

Meyrick, S.R. and C.H. Smith, *Costume of the Original Inhabitants of the British Isles* (London: Printed by J. Kay, 1815).

Mikhaila, Ninya and Jane Malcolm-Davies, *The Tudor Tailor: Reconstructing Sixteenth-Century Dress* (London: Batsford, 2006).

Miller, L., 'Cute Masquerade and the Pimping of Japan', *International Journal of Japanese Sociology* 20, no. 11 (2001), pp. 18–29.

Mitchell, Sally, *The New Girl: Girls' Culture in England, 1880–1915* (New York: Columbia University Press, 1995).

Murrell, Deborah, *Mad About Costume and Fashion* (London: Ladybird Books Ltd, 2009).

Musgrave, P.W., *Society and Education in England Since 1800* (Abingdon: Routledge, 2007).

Myerly, Scott Hughes, *British Military Spectacle: From the Napoleonic Wars through the Crimea* (Cambridge, MA: Harvard University Press, 1996).

Nash, David, *Christian Ideals in British Culture: Stories of Belief in the Twentieth Century* (Houndmills: Palgrave, 2013).

Newsome, David, *A History of Wellington College, 1859–1959* (London: John Murray, 1959).

Newton, Stella Mary, *Health, Art and Reason: Dress Reformers of the 19th Century* (London: John Murray, 1974).

Nichols, Tom, *The Art of Poverty: Irony and Ideal in Sixteenth-Century Beggar Imagery* (Manchester: Manchester University Press, 2007).

Nunn, Joan, *Fashion in Costume, 1200–2000* (Chicago: New Amsterdam Books, 2000).

Ogilvie, Vivian, *The English Public School* (London: B.T. Batsford, 1957).

Okely, Judith, 'Privileged, Schooled and Finished: Boarding Education for Girls', in *Defining Females: The Nature of Women in Society*, ed. Shirley Ardener (Oxford: Berg, 1993), pp. 93–122.

Page-Phillips, John, *Macklin's Monumental Brasses* (London: George Allen & Unwin Ltd, 1970).

Park, Roberta J., 'Biological Thought, Athletics and the Formation of a "Man of Character": 1830–1900', in *Manliness and Morality: Middle-class Masculinity in Britain and America 1800–1940*, ed. J.A. Mangan and James Walvin (Manchester: Manchester University Press, 1987), pp. 7–35.

Peacock, John, *The Chronicle of Western Costume: From the Ancient World to the Late Twentieth Century* (London: Thames & Hudson, 2003).

Percival, Alicia C., *The Origins of the Headmasters' Conference* (London: John Murray, 1969).

Perrot, Phillipe, *Fashioning the Bourgeoisie: A History of Clothing in the Nineteenth Century* (Princeton: Princeton University Press, 1994).

Pollock, Linda, *Forgotten Children: Parent-Child Relations from 1500 to 1900* (Cambridge: Cambridge University Press, 1996).

Proctor, Tammy M., 'On my Honour: Guides and Scouts in Interwar Britain', *Transactions of the American Philosophical Society* 92, no. 2 (2002), pp. 1–180.

Planche, James Robinson, *History of British Costume* (London: Charles Knight, 1834).

Plumb, J.H., 'The New World of Children in Eighteenth-Century England', *Past & Present* 67 (1975), pp. 64–95.

Ponsonby, Arthur, *The Decline of Aristocracy* (London: T. Fisher Unwin, 1912).

Postman, Neil, *The Disappearance of Childhood* (New York: Vintage Books, 1994).

Power, Sally, Tony Edwards, Geoff Whitty and Valerie Wigfall, *Education and the Middle Classes* (Buckingham: Open University Press, 2003).

Rappaport, Steve, *Worlds Within Worlds: Structures of Life in Sixteenth-Century London* (Cambridge: Cambridge University Press, 2002).

Razzell, P.E. and R.W. Wainwright, *The Victorian Working Class: Selections from the 'Morning Chronicle'* (London: Routledge, 2013).

Ribeiro, Aileen, *The Dress Worn at Masquerades in England, 1730–1790, and Its Relation to Fancy Dress in Portraiture* (London: Garland Publishing, Inc., 1984).

Richards, Jeffery, *Films and British National Identity: From Dickens to Dad's Army* (Manchester: Manchester University Press, 1997).

Roach, John, *A History of Secondary Education in England, 1800–1870* (London: Longman, 1986).

Roberts, Elizabeth, 'The Family', in *The Working Class in England, 1875–1914*, ed. John Benson (London: Croom Helm, 1985), pp. 1–35.

Roberts, Elizabeth, *A Woman's Place: An Oral History of Working-Class Women, 1890–1940* (Oxford: Blackwell, 1996).

Rocamora, Agnes, 'Hypertextuality and Remediation in the Fashion Media', *Journalism Practice* 6, no. 1 (2011), pp. 92–106.

Roche, Daniel, *The Culture of Clothing: Dress and Fashion in the Ancien Regime* (Cambridge: Cambridge University Press, 1996).

Rolley, Katrina, 'Fashion, Femininity and the Fight for the Vote', *Art History* 13, no. 1 (1990), pp. 47–71.

Rose, Clare, 'The Meanings of the Late Victorian Sailor Suit', *Journal for Maritime Research* 11, no. 1 (2009), pp. 24–50.

Rose, Clare, *Making, Selling and Wearing Boys' Clothes in late Victorian England* (Farnham: Ashgate, 2010).

Rose, Clare, 'Continuity and Change in Edwardian Children's Clothing', *Textile History* 42, no. 2 (2011), pp. 145–61.

Rose, Lionel, *The Erosion of Childhood: Child Oppression in Britain, 1860–1918* (London: Routledge, 2002).

Rose, Sonya O., *Which People's War?: National Identity and Citizenship in Wartime Britain, 1939–45* (Oxford: Oxford University Press, 2003).

Rouse, W.H.D., *A History of Rugby School* (London: Duckworth & Co., 1909).

Rubinstein, David and Brian Simon, *The Evolution of the Comprehensive School, 1926–1966* (London: Routledge & Kegan Paul, 1969).

Ryan, Michael, *Cultural Studies: A Practical Introduction* (Chichester: Wiley-Blackwell, 2010).

Sampson, Walter, *History of Queen Elizabeth's Hospital, Bristol* (Bristol: John Wright & Sons Ltd, 1910).

Savage, Jon, *Teenage: The Creation of Youth, 1875–1945* (London: Pimlico, 2008).

Sayer, Karen, '"A Sufficiency of Clothing": Dress and Domesticity in Victorian Britain', *Textile History* 33, no. 1 (2002), pp. 112–22.

Schneider, Jane, 'In and Out of Polyester: Desire, Disdain and Global Fibre Competitions', *Anthropology Today* 10, no. 5 (1994), pp. 2–10.

Scott, John Wallach, *The Politics of the Veil* (Princeton and Oxford: Princeton University Press, 2007).

Shannon, Brent, 'Re-fashioning Men: Fashion, Masculinity, and the Cultivation of the Male Consumer in Britain, 1860–1914', *Victorian Studies* 46, no. 4 (2004), pp. 597–630.

Shannon, Brent, *The Cut of his Coat: Men, Dress and Consumer Culture in Britain, 1860–1914* (Ohio: Ohio University Press, 2006).

Simonton, Deborah, 'Schooling the Poor: Gender and Class in Eighteenth Century England', *Journal for Eighteenth Century Studies* 23, no. 2 (2000), pp. 183–202.

Skeggs, Beverley, *Formations of Class & Gender: Becoming Respectable* (London: Sage Publications, 2002).

Slack, Paul, *Poverty and Policy in Tudor and Stuart England* (New York: Longman, 1993).

Slack, Paul, *The English Poor Law 1531–1782* (Cambridge: Cambridge University Press, 1995).

Smelser, Neil J., *Social Paralysis and Social Change: British Working-Class Education in the Nineteenth Century* (Berkeley: University of California Press, 1991).

Smith, Chloe, 'Callico Madams: Servants, Consumption, and the Calico Crisis', *Eighteenth-Century Life* 31, no. 2 (2007), pp. 29–55.

Smith, Daniel, 'The Gent-rification of English Masculinities: Class, Race and Nation in Contemporary Consumption', *Social Identities* 20, no. 4–5 (2014), pp. 391–406.

Smith, Frank, *A History of Elementary Education, 1760–1902* (London: University of London Press, 1931).

Snodgrass, Mary Ellen, *World Clothing and Fashion: An Encyclopaedia of History, Culture and Social Influence* (London: Routledge, 2015).

Speed, Lesley, 'Reading, Writing and Unruliness: Female Education in the St Trinian's Films', *International Journal of Cultural Studies* 5, no. 2 (2002), pp. 221–38.

Spencer, Stephanie, 'A Uniform Identity: Schoolgirl Snapshots and the Spoken Visual', *History of Education* 36, no. 2 (2007), pp. 227–46.

Starr, Jennifer, 'School Violence and Its Effect on the Constitutionality of Public School Uniform Policies', *Journal of Law & Education*, no. 29 (2000), pp. 113–18.

Stevenson, Sara and Helen Bennett, *Van Dyck in Check Trousers: Fancy Dress in Art and Life 1700–1900* (Edinburgh: Scottish National Portrait Gallery, 1978).

Strutt, Joseph, *A Complete View of the Dress and Habits of the People of England, from the Establishment of the Saxons in Britain to the Present Time, Vol. I* (London: Printed by J. Nichols, 1796).

Sturt, Mary, *The Education of the People: A History of Primary Education in England and Wales in the Nineteenth Century* (London: Routledge & Kegan Paul, 1967).

Styles, John, 'Dress in History: Reflections of a Contested Terrain', *Fashion Theory* 2, no. 4 (1998), pp. 383–90.

Styles, John, *The Dress of the People: Everyday Fashion in Eighteenth-Century England* (London: Yale University Press, 2010).

Summerfield, Penny, *Women Workers in the Second World War: Production and Patriarchy in Conflict* (London: Routledge, 2013).

Swain, Jon, 'The Right Stuff: Fashioning an Identity Through Clothing in a Junior School', *Gender and Education* 14, no. 1 (2002), pp. 53–69.

Synott, J. and C. Symes, 'The Genealogy of the School: an Iconography of Badges and Mottoes', *British Journal of Sociology of Education* 16, no. 2 (1995), pp. 139–52.

Tanner, Lawrence, *Westminster School* (London: Country Life Ltd, 1951).

Tarrant, N., *The Development of Costume* (London: Routledge, 1994).

Taylor, Lou, *The Study of Dress History* (Manchester: Manchester University Press, 2002).

Tepper Tian, Kelly, William O. Bearden and Gary L. Hunter, 'Consumers' Need for Uniqueness: Scale, Development and Validation', *Journal of Consumer Research* 28, no. 1 (2001), pp. 50–66.

'The Construction of Honour, Reputation and Status in Late Seventeenth- and Early Eighteenth-Century England', *Transactions of the Royal Historical Society* 6, no. 6 (1996), pp. 201–13.

Tinkler, Penny, 'Women and Popular Literature', in *Women's History: Britain, 1850–1945: An Introduction*, ed. Jane Purvis (London: Routledge, 2006), pp. 111–33.

Tod, A.H., *Charterhouse* (London: George Bell & Sons, 1901).

Tosh, John, 'Gentlemanly Politeness and Manly Simplicity in Victorian England', *Transaction of the Royal Historical Society* 6, no. 12 (2002), pp. 455–72.

Tosh, John, *Manliness and Masculinities in Nineteenth-Century Britain: Essays on Gender, Family and Empire* (Harlow: Pearson Education Limited, 2005).

Tosh, John, *A Man's Place: Masculinity and the Middle-Class Home in Victorian England* (New Haven and London: Yale University Press, 2007).

Townsend, John Rowe, *Written for Children: An Outline of English Children's Literature* (London: Garnet Miller, London, 1965).

Tunbridge Wells Girls' Grammar School 1905–2005 (Tunbridge Wells: Published by TWGGS, 2005).

Tyerman, Christopher, *A History of Harrow School 1324–1991* (Oxford: Oxford University Press, 2000).

Valverde, Mariana, 'The Love of Finery: Fashion and the Fallen Woman in Nineteenth-Century Social Discourse', *Victorian Studies* 32, no. 2 (1989), pp. 168–88.

Van Wingerden, Sophia A., *The Women's Suffrage Movement in Britain, 1866–1928* (London: Macmillan Press Ltd, 1999).

Vicinus, Martha, *Independent Women: Work and Community for Single Women, 1850–1920* (London: Virago Press, 1985).

Vickery, Amanda, *The Gentleman's Daughter: Women's Lives in Georgian England* (New Haven and London: Yale University Press, 1999).

Vincent, Susan, *Dressing the Elite: Clothes in Early Modern England* (Oxford: Berg, 2003).

Vincent, Susan, *The Anatomy of Fashion: Dressing the Body from the Renaissance to Today* (Oxford: Berg, 2009).

Wagner, 'Schools and Education', *Historical Boys' Clothing* <http://histclo.com/schun/schun.html> (accessed 10 December 2014).

Walford, Jonathan, *Forties Fashion: From Siren Suits to the New Look* (London: Thames & Hudson, 2001).
Walton, Susan, *Imagining Soldiers and Fathers in the Mid-Victorian Era: Charlotte Yonge's Models of Manliness* (Farnham: Ashgate, 2010).
Wardle, David, *The Rise of the Schooled Society: the History of Formal Schooling in England* (London: Routledge & Kegan Paul, 1974).
Warner, Patricia Campbell, 'The Gymslip: The Origins of the English Schoolgirl Tunic', *Dress* 22, no. 1 (1995), pp. 45–58.
Warner, Patricia Campbell, *When the Girls Came Out to Play: The Birth of American Sportswear* (Amherst and Boston: University of Massachusetts Press, 2006).
Waugh, Norah, *The Cut of Women's Clothes, 1600–1930* (Abingdon: Routledge, 2011).
Webb, Kaye, 'Once Upon a Time', in *The St Trinian's Story*, ed. Kaye Webb (Harmondsworth: Penguin Books Ltd, 1963), pp. 9–19.
Whitington, Fred T., *Augustus Short, First Bishop of Adelaide: The Story of a Thirty-Four Years' Episcopate* (London: Wells Gardner Darton & Co., 1888).
Wilkinson, Rupert H., 'The Gentleman Ideal and the Maintenance of a Political Elite: Two Case Studies: Confucian Education in the Tang, Sung, Ming and Ching Dynasties; and the Late Victorian Public Schools (1870–1914)', *Sociology of Education* 37, no. 1 (1963), pp. 9–26.
Wilson, Elizabeth, *Adorned in Dreams: Fashion and Modernity* (Berkeley: University of California Press, 1987).
Wilson, Kathleen, *The Sense of the People: Politics, Culture and Imperialism in England, 1715–1785* (Cambridge: Cambridge University Press, 1998).
Wilson, Kathleen, *The Island Race: Englishness, Empire and Gender in the Eighteenth Century* (Abingdon: Routledge, 2003).
Wilson, Perry, 'The Nation in Uniform? Fascist Italy, 1919–1943', *Past & Present* 221, no. 1 (2013), pp. 239–72.
Winter, Bronwyn, *Hijab & The Republic: Uncovering the French Headscarf Debate* (Syracuse: Syracuse University Press, 2008).
Wrightson, Keith, *English Society 1580–1680* (Abingdon: Routledge, 2004).
Yarwood, Doreen, *The Encyclopaedia of World Costume* (London: Batsford, 1978).
Young, Linda, *Middle-Class Culture in the Nineteenth Century: America, Australia and Britain* (Basingstoke: Palgrave Macmillan, 2003).
Zweiniger-Bargielowska, Ina, *Austerity in Britain: Rationing, Controls, and Consumption, 1939–1955* (Oxford: Oxford University Press, 2002).

Index

Abbey School, The 103
AC/DC 133
Academic capacity, women 66, 67, 68, 69–70, 139
Academic gown. *See* Gown, academic
Accomplishments 66
Acrylic 122
Adolescence 92–3, 101, 103–4, 121, 122, 125, 129, 131, 133, 134, 135, 142, 146, 149
Adult fiction. *See under* Fiction
Advertising 4, 50, 57–8, 86, 104, 132, 137, 142, 149
Alcohol 35
Aldgate School, The 127
Aldworth, Richard 19
America. *See* United States
Anachronism 24–7, 61, 65, 124
Apron 12, 21, 24, 27, 127
Arnold, Thomas 35–6
Art Nouveau 89
Aspiration 1, 25–7, 34, 56–9, 65, 73, 96, 102, 114, 141, 143
Athletics 53
Austerity 115
Avant-garde 88
Aysgarth School 116, 141

Baden-Powell, Robert 46
Badge 14, 30, 54, 98, 117
Bands 20, 21, 24–5, 26, 27
Bathing costume 74, 75
Beale, Dorothea 68
Beatniks 121
Belgium 77

Belt 50, 77, 79, 81, 85
Benefactor 7–8, 18, 29–30, 143, 144
Beret. *See under* Hat
Bergman-Osterberg, Madame 81, 101
Bicester Charity School 23
Blake, William 6
Blazer 1, 38, 40, 46, 55, 90, 91, 99, 101, 113, 114, 117, 121, 122, 125, 126
Blogging 143
Bloods 40, 54
Bloomers 75, 87
Blouse 74, 77, 79, 80, 81, 83, 84, 85, 86, 88, 90, 98, 100, 101, 109, 114, 116, 118, 122
Blue 11–12, 138
Blue Stockings Society 66
Bluecoat school 19–20
Blues 48
Board school 95, 104–10
Board of Trade, The 115, 118–19, 141
Boat race 38
Boater 38, 63, 80, 84, 85, 122, 131, 132
Bodichon, Barbara 68
Bonnet. *See under* Hat
Boots 72, 76, 106
Boy's Friend, The 53
Boy's Own Paper 53, 60
Brasses, church 14
Brazil, Angela 102–3
Breeches 21, 25, 26, 44
Brent-Dyer, Elinor 103
Bridlington High School 90
Brighton and Hove High School 98

INDEX

Brittain, Vera 93
Bronte, Charlotte 31
Brownhills School 102
Bruce, Dorita Fairlie 103
Buckles 19, 21, 22, 31
Bumfreezer 56
Bunter, Bessie 103–4
Bunter, Billy 103
Burton Grammar School 98–9, 111
Buss, Frances 68, 72–3, 75, 78
Bustle 129

Cadet corps 49, 50
Cambridge, University of 38, 48, 68
Canvas 11
Cap 11, 12, 20, 21, 25, 27, 32, 37, 38, 40, 47, 49, 50, 52, 85, 90, 99, 108, 113, 114, 121, 127
 Mob 127
 Skull 126
 Sugar-loaf 127
Cardigan 84, 90, 117
Career 42, 48, 56, 68, 95, 137, 140, 144
Carr, John 18–19, 143
Cassock 13
Cath Kidston 135
CC41 115
Celebrity 124, 142, 143, 146
Certificate. *See* Examination
Chalet School, The 103
Charity school 1, 3, 5, 6–32, 55, 63, 65, 66, 100, 124, 127, 136, 137–8, 142–3, 144–5, 146, 148–9
Charity School of St Pancras. *See* St Pancras, Charity School of
Charterhouse 33, 44, 54, 138
Chas Baker & Co. 4, 58
Chastity 15–17, 84, 87, 105, 109, 123, 140
Chateau de Koekelberg 77
Cheltenham Ladies' College 68, 71–2, 73, 84, 86, 90, 122
Chetham's Hospital 19
Childhood, history of 31, 92
Children's fiction. *See under* Fiction

Christ's Hospital 10–15, 18–19, 24–7, 28–9, 30, 32, 115–16, 124, 133, 141, 143
Church service 6, 28–30
Cigarette card 60
Civil service 48–9
Clapham High School 98
Clarendon Commission 42–5, 58, 61–3, 95
Class 1, 14, 15, 16, 20, 27, 29, 34–6, 41, 42, 44, 45, 47, 50, 55–6, 64, 65, 66, 73, 94, 96, 100, 101, 106, 110–14, 117, 120, 125, 136–7, 138–9, 144–6, 148
 Middle 5, 8, 15, 26–7, 34, 35–6, 41, 47, 55–6, 57, 58, 65, 66, 69, 71, 73, 84, 91–2, 94, 95, 96–104, 105, 110–12, 136, 138–9, 140–1, 142, 145–6, 148
 Upper 5, 8, 15, 17, 31, 33, 35, 41, 45, 47, 50, 56, 57, 60, 65, 66, 69, 71, 73, 91–2, 103, 105, 138–9, 145–6, 148
 Working 5, 15, 18, 19, 22, 24, 35, 37, 46, 94–5, 96, 102, 104–14, 136, 137–8, 145–6
Classics 7, 33, 41, 67, 95
Cleanliness 97, 105, 106–7, 108, 111, 141
Cliff House 103
Cloak 27, 84, 85, 89, 90, 117
Clubbing 133, 134, 142
Coat 12, 21–2, 25, 26, 43, 54, 72, 74, 90–1, 101, 115
Coif 21, 22
Collar 24, 43, 54, 108
 Eton 58–9, 127, 145
Colleger 43–4
Colours 40, 48, 54, 60, 125
Colston's School 25
Combinations 84
Comprehensive school 121, 123–4, 142, 145
Compulsory education 94, 107, 108, 113, 140–1

Conformity 45, 51, 52, 60–1, 91, 103, 118, 119–20, 133
Consumption 14–15, 16–17, 34, 45, 46–7, 56–9
Coombe Hill School 90
Corporal punishment 34, 124
Corset 71, 74, 81, 99
Cost 41, 48, 63, 101, 109–10, 112, 125, 130, 141
Cotton 122
Cottoning 11
County school 83, 96, 100, 109, 141
Coupon 115, 117, 119, 120, 141
Craft, The 132, 134
Cricket 36, 38, 40, 48, 53, 64, 76, 78
Croft School 82–3, 140
Cross-dressing 130–1, 134
Croydon High School 98
Crucifix 126
Curriculum 36, 41, 48–9, 68, 86, 95, 96, 107, 124, 146
Customization 88

Dacron 122
Dame school 127
Dartford County School 100
Davies, Emily 68, 71
Debenham and Freebody 127
Defoe, Daniel 15–16
Department for Education, The 125–6, 144
Department store 45, 127
Dickens, Charles 32
Dighton, John 128
Dimsie 103
Dinner 44, 47
Discipline 16, 20–1, 36, 51, 63, 86, 105, 106, 124–5, 142, 144
Djibbah 5, 87–90, 98, 120
Dombey and Son 32
Domestic skills 66, 70, 107
Dove, Frances 84–5, 86
Downe House School 89
Dress 79, 85, 98, 106, 110–11, 116, 122
Dress reform 77, 81, 86, 87–8
Dressing up. *See* Fancy dress

Driden Free Charity School. *See* Orange School
Drill slip, Drill tunic. *See* Gymslip
Ducks. *See under* Trousers
Dunce 127

Elementary education 94–5, 96, 102, 104–10, 111, 140–1, 144
Elementary Education Act, The 95, 104
Eleven Plus 113, 121
Elliot, Sir Gilbert 6
Embroidery 88, 90
Empire, British 34, 36, 46, 48, 59–60, 64, 80, 87, 117, 122, 130, 139, 146, 147–8, 149
Empire waist 24
Emulation. *See* Imitation
English Woman's Journal 68
Equality 5, 17, 68–70, 74, 86, 90, 92, 93, 118, 125
Eric, or Little by Little 53
Erotic fiction. *See under* Fiction
Escutcheon 11, 14, 138
Etiquette 34
Eton collar. *See under* Collar
Eton College 2, 3, 7, 26, 33, 35, 40, 42–3, 45, 46, 49, 57, 58, 115–16, 129–30, 138, 141
Eton jacket. *See under* Jacket
Evening wear 25, 61
Examination 49, 68, 71, 110, 112, 113, 121
Expense. *See* Cost

Faithful, Lillian 73, 74
Fancy dress 2, 126–7, 130–5, 142
 Ball 126–7
Fascism 117–18
Fashion 24, 34, 43, 45–6, 47, 49, 56–9, 61, 65, 70–4, 75, 78, 79–80, 81, 82, 83, 84, 86, 87, 88, 93, 100, 101, 115, 121, 122–3, 124, 131, 135, 140, 142, 143, 145–6
Fees 7, 33, 41, 43, 95, 97, 104–6, 110, 112, 114

Femininity 45, 67, 69–74, 75–7, 78, 86, 87, 88–9, 93, 100, 103, 109, 128–30, 131, 133, 139–40, 146–7, 149
Fichu 127
Fiction 30, 31, 87–8
 Adult 31–2, 128–30, 137, 142
 Children's 5, 31, 32, 53, 102–3, 129
 Erotic 131
Field game, the 40
Film 128, 129, 130–1, 132, 135, 137, 142
First World War 100, 148
Fives 81
Flannel 46, 121
Flannels. *See under* Trousers
Food 142
Football 36, 37–8, 40, 48, 129
Founder. *See* Benefactor
Foundling Hospital, The 29, 127
France 49, 84, 102, 126
Frogging 49
Funeral 28–9

Gaberdine 133
Gaiters 38
Galoshes 90
Games. *See* Sport
Garrett Anderson, Elizabeth 68, 71
Gender 1, 3, 5, 7, 27, 34, 35–6, 38, 41, 45, 46, 48, 50, 53, 65, 67, 69–74, 75–7, 78, 86, 87, 88–9, 91–3, 94, 99, 100, 103, 107, 109, 118, 128–30, 131, 132, 133, 136, 139–40, 143, 144, 146–7, 148, 149
Germany 49, 117–18
Gibson, Charles Dana 85
Gibson Girl 85
Gilliat, Sidney 128
Girdle 25, 28, 83, 98
Girls' Day School Trust, The 3, 97–8, 137, 140
Girls' Friend 102
Girls' Own Paper 79, 102
Girls' Reader 102

Girton College 68
Gloves 21, 71
Governess 66, 67, 68
Governesses' Benevolent Institution 67
Gown 12, 21–2, 27, 31, 127
Gown, academic 8, 43–4, 62
Grammar school 3, 7, 33, 83, 95, 98–9, 109, 113, 121, 125, 141
Graves, Robert 54
Great British Bake Off, The 135
Green coat school 20
Greenaway, Kate 31
Grey Coat Hospital, Westminster 19
Grey coat school 19–20
Greyfriars School 103
Gym tunic. *See* Gymslip
Gymnastics 75–6, 77, 78, 79, 81, 82, 98, 116, 140
Gymslip 5, 80–1, 82–4, 90, 91, 93, 96, 97, 98, 100, 101, 109, 110, 112, 114, 116, 118, 120, 122, 130, 132, 136, 140

Hadow Report, The 113
Haileybury 34, 139
Hamlet of Ratcliff School 19
Hampstead Gymnasium 81
Handkerchief 28, 54, 61
Happiest Days of Your Life, The 128
Harrow jacket. *See under* Jacket
Harrow School 3, 33, 38, 41, 42, 45, 48, 52, 58, 60–5, 124, 138
Hat 71, 74, 84, 85, 86, 90, 96, 100, 108–9, 116–17, 133
 Beret 102
 Bonnet 27
 Panama 101
 Sailor 79
 Tam o' shanter 12
 Top 43, 46, 58
Hattersley, Roy 113
Head boy 51, 54
Headmasters' Conference, The 45, 137
Headscarf 125

Headteacher 35, 43, 44, 45, 58, 61, 63–4, 79, 80, 81, 84, 87, 93, 98, 101, 102
Henrietta Barnett School 123
Hierarchy 5, 40–1, 51, 54–5, 60–1, 62–3, 118, 138, 143, 148
High school 84, 96, 97–8, 100, 101, 102, 109, 141
Hijab 125, 126
Historicism 127, 135
Hitler Youth 117–18
Hockey 76, 92
Holt, Ardern 127
Holy Thursday 6
Horse racing 38
Hose 11, 12
Houses 35, 37, 40, 51, 52, 55, 77, 78, 84, 85, 86, 87, 89, 92
Hugh-Jones, Siriol 129, 130, 135
Humility 12, 14, 16, 29, 136, 137
Hunt, Leigh 26
Huntingdon Street School 110
Hurstpierpoint College 33, 139
Hussar trim 49
Hyam, B. 4, 57

Icknield High School 125
Identity 1, 41, 67, 92, 93, 121, 126, 128
 Individual 125, 146, 148
 Institutional 51–3, 54–5, 65, 114, 117, 118, 121, 124, 138–9, 144, 145
Ill health 72–3, 106, 108
Imitation 15, 25–7, 55–60, 86–7, 90, 96, 136, 137, 140, 142, 145, 147
Independent school 121
Industrial revolution 34, 56, 127
Inferiority, women 66, 67, 80
Informality 46, 63, 121, 122, 123–4, 145
Interwar 46, 90, 92, 99–100, 103, 104, 108, 111, 141
Islam 87, 125–6, 143

Jack Wills 125

Jacket 44, 49, 54, 61–2, 79, 80, 85, 86, 116
 Eton 56–7, 58–9, 86, 127, 137
 Harrow 57
 Rugby 57, 58
 Zouave 49
Jane Eyre 31
Japan 80, 128, 131–2
Jersey 37, 38, 40, 79
Jumper. *See* Sweater

Kensington High School 98
Kensington Society, The 68
Kerchief 12
Kersey 11
Kesteven and Grantham Girls' School 122
King's College 67
Kipling, Rudyard 53–4
Knickerbockers 77, 79, 81, 83
Knickers 84, 90, 98, 117

Lacrosse 76
Ladies' Charity School 23
Lancaster Girls' Grammar School 120
Lancing College 33, 139
Latin. *See* Classics
Launder, Frank 128
Leaver's hoody 125
Leg of mutton sleeves 85
Lesbianism 129
Lewis, Dio (Diocletian) 75, 77, 81, 100, 140
Liberty bodice 84
Linen 86
Lisle 122
Liverpool Blue Coat School 28
Liverpool Gymnasium 76
Livery 15, 16, 27
Lolita 131
London School of Industry 27
Long dormitory 35
Love 92
Lumsden, Louisa 77

Machyn, Henry 11, 28
Mackintosh 90

Madonna 133
Magnet, The 103
Malvern College 34, 38–9, 138
Manchester High School 84, 100
Mandeville, Bernard 29
Marlborough College 33, 50, 51, 138, 139
Marriage 66, 68, 70, 91–2, 93, 139
Marshall, Arthur 128
Marvel 53
Marylebone Cricket Club 38
Masculinity 35–6, 38, 41, 45, 46, 48, 50, 53, 65, 76, 87, 118, 131, 139, 146–7, 148
Masquerade 127
Maudsley, Dr Henry 69
Maynard Girls' School 112
Mealtimes 29, 137
Medievalism 37
Merchant Taylors' School 33, 42
Microcosm of London, The 29
Middle class. *See under* Class
Military 36, 46, 48–9, 50–1, 80, 115, 131, 139, 148
Mob cap. *See under* Cap
Modern school 113
Modesty 17–18, 29, 34, 84, 87, 138, 140, 142–3, 148–9
Modification 4, 128, 131, 132, 133–4, 137
Morality 15–17, 54, 87, 96, 100, 103, 105, 109, 123, 129, 132, 136, 138, 140, 148
Morning coat 62–3
Motherhood 69–70, 92, 107, 139
Mourning 42
Multiculturalism 2, 125–6, 136, 142–3, 148, 149
Muscular Christianity 38, 139, 149
Muslin 127

National identity 1, 59–60, 64, 121, 122, 126, 129–30, 136, 139, 141, 147–8, 149
National Union of Women's Suffrage Societies 74
Nautical 79–80
Nazi 117–18
Neckcloth 43
New Gymnastics for Men Women and Children, The 75
New Look 122–3
Newbolt, Sir Henry 40–1, 51, 129–30
Newcastle Commission 94–5, 105
Newlands High School 101
Newmarket Agreement 38
Nicholls, J. 56–7
Niqab 125–6
North London Collegiate School for Girls 3, 68, 72–3, 75, 78–9, 82, 116–17, 140, 141
Norwood Report, The 113
Nostalgia 135
Nylon 115, 121–2

Old boy network 52
Oppidan 43–4
Orange School 20
Orlon 122
Orphan 10, 29, 49
Oundle School 33
Outfitters 88, 91, 99, 113–14, 118, 120, 139
Oxenham, Elsie J. 103
Oxford Charity School 24
Oxford, University of 38, 48

Panama. *See under* Hat
Patriotism 59, 80, 117, 122, 147
Peer pressure 45, 51–2, 60, 61–3, 91, 109–10, 119–20, 121
Pennant, Thomas 30
Pepys, Samuel 22–3
Petticoat 12, 21, 25
Pin up 129
Pinafore 110–12
Piping 49, 50
Pleasure garden 127
Pocklington School 47, 54–5, 138
Polo shirt 124
Polyester 122, 133
Ponsonby, Arthur 48, 52

Popular culture 5, 30–2, 53, 80, 92, 126, 127–35, 137, 142, 143
Pornography 131
Portsmouth High School 98
Poverty 8, 10, 14, 18, 20, 28, 95, 105–7, 109–10
Practicality 1, 37, 46, 63, 65, 73, 74, 76, 80, 81, 82, 86, 91, 101, 105, 122, 130, 133, 135, 136, 137, 138, 140, 144, 147
Prefect 51, 54, 79, 135
Preparatory school 46, 116
Primary education. *See* Elementary education
Prince and the Pauper, The 32
Private school 33, 121
Procession 6, 28–30, 137
Profession. *See* Career
Prostitution 16–17, 109
Puberty. *See* Adolescence
Public school 96, 99, 109, 114, 115–16, 118, 121, 124, 125, 144
 Boys 5, 33–65, 76, 77, 86, 90, 92, 95, 129–30, 136, 138–9, 140, 144–5, 146–8, 149
 Girls 5, 65, 66–93, 97, 100, 102, 129, 136, 139–40, 146–7
Public school ethos 34, 35–6, 41, 46, 48, 50–1, 52–3, 55–6, 59, 61, 64, 65, 76, 86, 141, 147
Public Schools Act 33, 42
Puritan 18, 24
Purity. *See* Chastity
Putney High School 98

Queen Elizabeth's Hospital 18–19, 143
Queen's College 67

Racquets 40
Railway 50, 55
Rational Dress Society, The 81
Rationing 115–20, 141–2
Reading Blue Coat School 19
Red Maids' School 127
Religion 1, 16, 17–18, 20, 38, 94, 95, 125–6, 136–7, 138, 139, 142–3, 144, 148–9

Respectability 59, 65, 84, 96, 97, 102, 105–6, 108–9, 127, 140, 145, 149
Riding habit 74
Ritual 35–6, 41, 118
Roedean School 5, 79–80, 84, 87–9, 102, 120
Rotherhithe Charity School 27
Rowing 36, 38, 40, 79
Royal Commission on the Public Schools, The. *See* Clarendon Commission
Royal Commission on the state of popular education in England, The. *See* Newcastle Commission
Royalty 2, 42, 61, 69
Rugby 36, 40, 48
Rugby jacket. *See under* Jacket
Rugby School 33, 35, 37, 43, 48, 58, 138
Ryde School of Art 126–7

Saffron 13
Sailor hat. *See under* Hat
Sailor suit 70, 86
St Anne's Soho 19
St Botolph's School 127
St Leonards 77–8, 79, 84, 85, 89
St Margaret's Hospital 20
St Margaret's School for Girls 71–2
St Mary Abbots School 138
St Mary Rotherhithe 22
St Mary's Board School 107
St Mary's Gate School 122–3
St Pancras, Charity School of 16
St Paul's Cathedral 6
St Paul's School 42
St Trinian's 128–31, 135, 137, 142, 149
St William's RC Girls' School 111
Samuel Brothers 50
Scarf 79, 90, 113, 125
Schild, Marie 127
Scholarship 53, 110, 112, 114
School Dinners 134, 135
School Disco 134, 135
School Friend 103–4

School story 5, 35, 53, 102–3, 129
Schoolgirls' Own 103
Schoolgirls' Weekly 103
Schools Inquiry Commission, The.
 See Taunton Commission
Scott, Walter 127
Scouting 46
Searle, Ronald 128, 129, 142
Second-hand clothing 120
Second World War 82, 115–20, 128, 141, 148, 149
Secondary education 95–104, 110–14, 140–1
Serge 46, 79, 86, 100, 133
Servant 15–16, 27, 34, 138
Sewing 23–4, 107, 135, 141
Sexual liberation 128, 129, 131
Sexualization 2, 84, 131–4
Sheffield City Grammar School 113
Sheffield High School 98
Sherborne Girls' School 80
Shift 12, 21
Shirt 1, 12, 21, 24, 28, 38, 40, 46, 63, 83, 86, 87, 90, 91, 99, 122, 133, 140
Shoes 11, 21, 25, 27, 31, 79, 84, 90, 96, 108, 117
Shooting 47
Short, Augustus 34–5
Short, Thomas Vowler 35
Shorts 38, 46, 47
Shrewsbury School 33
Silk 83, 88, 115
Silks 38
Skeleton suit 56–7
Skirt 74, 75, 77, 79, 80, 82, 85, 86, 90, 91, 98, 111, 120, 122, 133, 147
Skull cap. See under Cap
Slang 41, 103
Soccer. See Football
Social media 135, 143, 146
Society for Promoting Christian Knowledge, The 3, 20–1, 23, 25, 137
Socks 38, 42, 54, 98, 115, 121, 122
Somalia 87
South Hampstead High School 98

Spandex 122
Spears, Britney 132–3, 134
Sport 5, 34, 35, 36–41, 46, 47–8, 51, 53, 65, 74–81, 88, 92, 97, 98, 99, 100, 103, 116, 119, 129, 133, 138, 140, 144, 147
Sporting colours. See Colours
Squash 64
Stalky & Co. 53–4
Stanley, Arthur Penrhyn 35
Starkey, Thomas 8
Statue 21–2, 138
Status 12, 14, 15, 27, 29, 42, 44, 50, 55–6, 62, 65, 73, 87, 96, 105, 112, 117, 124, 138–9, 140, 143, 144–5, 148
Stockings 21, 25, 26, 31, 32, 79, 90, 96–7, 98, 115, 121, 122, 131
Stomacher 21
Stow, John 11
Stowe School 46
Streatham Hill High School 98
Strype, John 25
Student event 134, 135
Sudan 48
Suffrage 68, 74
Sugar-loaf cap. See under Cap
Suit 44, 46, 50, 60, 99, 109
Sumptuary laws 27
Sweater 84, 90, 98, 113, 122, 133
Sweatshirt 124, 125
Swimming 81
Swimming costume. See Bathing costume
Synthetic fabric 115, 121–2

Tabs. See Bands
Tail coat 24, 32, 46, 61–3
Tam o' shanter. See under Hat
Tamworth Girls' High School 120
Tamworth Grammar School 120–1
Tartan 49, 76
t.A.T.u. 133
Taunton Commission, The 28, 75, 94, 95–6
Technical college 113
Technology 121–2, 135, 143

Teddy Boys 121
Tennis 38, 71, 81
Tie 1, 40, 42, 51, 54, 74, 83, 85, 86, 87, 90, 91, 99, 100, 108, 121, 122, 133, 140
Tights 122
Tilly Films 128
Tippet 24, 27
Tom Brown's Schooldays 35, 53
Top hat. *See under* Hat
Tradition 24–6, 34, 61, 63, 64–5, 102, 124, 148
Triacetate 122
Trousers 24, 37, 38, 44, 49, 56, 58, 63, 77, 87, 99, 108, 121, 125, 127, 147
 Ducks 40
 Flannel 40, 54, 99
 Turkish 76
Tunbridge Wells County School for Girls 83, 96–7, 140
Turban 125, 126
Turkish trousers. *See under* Trousers
Tussore 98
Twain, Mark 32
Tweed 63

Underwear 81, 83, 84, 119
United States 79, 85, 87, 121, 148
Upper class. *See under* Class
Upton 53
Upton Letters, The 53
Urwick, Edward 107–8
Utility 115

Vanity 16, 73, 109
Velvet 83, 88, 90
Vindication of the Rights of Women, A 66
Vintage 135
Violence 34–5, 129
Vitaï Lampada 40–1, 51
Vives, Juan Luis 17–18
Voluntary school 95
Volunteer movement 34, 49, 50

Waistcoat 21, 24, 42, 44, 58
Wall game, the 40, 48
Watts, Isaac 16
Wellington College 49–50, 55
Westminster Blue Coat School 19
Westminster School 7–8, 26, 33, 34–5, 43
Winchester College 7–9, 33, 38
Woad 12
Wollstonecraft, Mary 66
Wool 11, 12, 20, 21, 31, 32, 115, 122
Working class. *See under* Class
World War I. *See* First World War
World War II. *See* Second World War
Wycombe Abbey School 85–6, 89, 90–1, 102, 117, 122, 140

Yellow 12–13
Young, Angus 133
Youth. *See* Adolescence
Youth culture 103–4, 121, 131–2, 142, 146

Zouave jacket. *See under* Jacket

www.ingramcontent.com/pod-product-compliance
Lightning Source LLC
Chambersburg PA
CBHW020057020526
44112CB00031B/282